Basic oral
communication

SECOND EDITION

Basic oral communication

Glenn R. Capp
Baylor University

G. Richard Capp, Jr.

Prentice-Hall, Inc., Englewood Cliffs, New Jersey

Library of Congress Cataloging in Publication Data

CAPP, GLENN RICHARD
 Basic oral communication.

 Originally published under title: How to communicate
orally.
 Includes bibliographies and index.
 1. Public speaking. I. Capp, G. Richard (date)
joint author. II. Title.
PN4121.C23 1976 808.5'1 75-28193
ISBN 0-13-065961-4

To Thelma, Carol, and Catie

Printed in the United States of America

10 9 8 7 6 5 4 3 2 1

Basic Oral Communication, second edition, is the fourth edition
of the book formerly titled *How to Communicate Orally,* second
edition.

Prentice-Hall International, Inc., *London*
Prentice-Hall of Australia, Pty. Ltd., *Sydney*
Prentice-Hall of Canada, Ltd., *Toronto*
Prentice-Hall of India Private Limited, *New Delhi*
Prentice-Hall of Japan, Inc., *Tokyo*
Prentice-Hall of Southeast Asia (Pte.) Ltd., *Singapore* ·

Contents

Preface, *vii*

PART **1** *Understanding communication and self,* *1*

 1 The process and standards of good oral communication, *3*

 2 Developing yourself as a good communicator, *25*

 3 Efficient listening and good communication, *51*

 4 Analyzing listeners and occasions, *71*

 5 Small-group communication, *92*

PART **2** *Preparation and composition,* *117*

 6 Selecting the subject and purpose, *119*

 7 Finding, recording, and analyzing materials, *137*

 8 Selecting and evaluating supporting material, *157*

 9 Organizing your message, *187*

 10 Preparing for presentation: methods and outlines, *213*

PART **3** *Verbal and nonverbal communication,* 231

11 Principles of delivery and nonverbal
 communication, *233*

12 Verbal communication: language, *255*

13 Verbal communication: voice, *286*

PART **4** *Special areas of communication,* 313

14 Resolving conflicts through debate, *315*

15 Communication for special occasions, *342*

Appendixes

A Student speeches for analysis, comparison,
 evaluation, *381*

B Group approach to oral assignments, *400*

C Forms for classroom use, *405*

Index, 413

Preface

This new edition of *Basic Oral Communication* makes more changes than any of the former editions. It retains the practical skills approach of previous editions with emphasis on public communication, but it broadens the base to include an introduction to interpersonal communication and greater emphasis on small groups.

Part 1 discusses principles common to all oral-communication situations—the processes and standards, the sender, the message, the receiver, and the interaction inherent in the processes. Parts 2 and 3 treat the preparation and presentation of messages that apply to all situations. Part 4 applies the principles discussed in the first three parts to special areas of communication. In short, this edition helps prepare the student for his many everyday two-person communication encounters, for his frequent participation in small groups, and for his less frequent but equally important appearances before audiences.

The original author's son joins him as co-author of this edition. During the revision and after five years of teaching in oral communication at Humbolt State University and at Pacific Lutheran University, he decided to enter the insurance business. His recent teaching experiences and his present business activities enabled him to contribute a freshness and practical business approach to the volume.

This edition makes at least five major changes in and/or additions to the previous edition. Perhaps the most significant change is one of emphasis, as already explained—broadening the scope to include interpersonal and small-group communication. To accomplish this change, a significant new section was written for chapter 1; the chapter on public discussion was rewritten as small-group communication and moved from part 4 to part 1; the chapter on audience and occasion analysis was changed to listener analysis for all communication situations and moved from part 2 to part 1; and all chapters in part 1, and to a lesser extent in parts 2 and 3, were revised to conform to the new emphasis.

The alternate oral assignments listed at the end of each chapter, and explained in detail in appendix B, are based on four years of experimen-

tation in teaching beginning speech courses using group activities. We sought the best methods to combine interpersonal, small-group, and public communication into a single course and to teach larger skills classes without reducing the number of oral assignments. We believe that this plan will enable most professors to teach classes with forty-eight students as effectively as they formerly taught twenty-four. The sample forms and evaluation sheets included in appendix C should prove helpful, especially for classes that use the group approach to oral assignments.

Other changes consist of the following: the updating of basic principles based on research since publication of the previous edition; many new illustrations from contemporary and historical speeches designed to exemplify the rhetorical principles discussed; and a deletion of some less significant sections and three of the student speeches in appendix A. Some of the deletions were made to keep the length of the book to manageable proportions.

This text continues to emphasize rhetorical skills and will perhaps serve best in performance-oriented courses. We believe that it is much more than a "how to" approach, however, because it consistently stresses the ethics of the communicator, the worth of proper evaluation, and the importance of weighing carefully the validity and accuracy of what one talks about. We believe that a student develops himself as a communicator in proportion to how well he develops himself as a person. In brief, the text emphasizes both how and why we should talk sense, not nonsense. If we seem to overemphasize these factors, perhaps we do so because we are alarmed that many of the men and women involved in unethical communication practices uncovered by the Watergate hearings were former college debaters and students of communication.

We appreciate the permission of numerous publishers and individuals to quote copyrighted materials and brief excerpts from speeches as listed in the footnotes. Several of our present and former colleagues made helpful suggestions on this and former editions: Professor and Mrs. Thomas B. Abbott, Bernard C. Kissel, Chloe Armstrong, Lola Walker, Gardner Gateley, George Stokes, Mary Booras, Edna Haney, Lee Polk, James Enfield, and Ann Staton. We are especially indebted to Professor Cecil May McDavid for her help with the chapter on voice; to our wives Thelma and Carol; and to our daughter and granddaughter, Catie, the three-year-old who effectively gets what she wants through either verbal or nonverbal communication. The evaluations of several professors who used the previous edition, provided by Mr. Ted Arnold of Prentice-Hall, Inc., proved exceedingly helpful. The new speech editor, Mr. Brian Walker, and the production editor, Ms. Carolyn Davidson, were most helpful in the final stages of publication. Lastly, we thank our present students who patiently permitted us to try out our ideas on them.

PART **1**

Understanding communication and self

The process and standards of good oral communication

Have you ever thought how much time you spend daily communicating with yourself and others? Over 500 students in beginning oral communication courses kept logs for three days to help them make an estimate. They averaged approximately three hours reading, two writing, four speaking, four and one-half listening, and two communicating silently as they engaged in thought and meditation; a total of fifteen or sixteen hours per day. A larger study of a cross section of Americans showed that they spent more than 70 percent of their waking hours communicating verbally and nonverbally, either speaking and writing or listening and reading.

Industry and the professions are increasing their demands for persons trained in communication, a factor that has caused sharp increases in educational programs in this field. No academic discipline has received more emphasis nor made more advances in the past 40 years than the field of oral communication. The 1934 Volume I of *Speech Monographs,* an official publication of the Speech Communication Association, lists some 1,400 theses and dissertations written from the beginning of graduate studies in speech (first master's degree in 1902, first doctoral degree in 1922) to 1934. The *Bibliographic Annual in Speech Communication* for 1972 lists 3,985 graduate degrees for 1971 alone, and states that a total of 44,218 graduate degrees in speech communication have been reported in the *Bibliographic Annual* and *Speech Monographs.* Although the *Bibliographic Annual* no longer publishes this annual index, its listings of theses and dissertations indicate that there will be well over 80,000 studies completed by 1980.

Despite the increasing call for accurate and effective communication in life situations and the rapid progress made in the training program, you are probably taking your first course in communicating orally. No doubt it will be a study unlike any you have undertaken before. How can you get off to a good start? What is the nature of the study?

As a college student you may be interested in several approaches to training in oral communication. At first you desire to learn about the principles of composition and presentation and to acquire skills that will make you a more effective communicator. These purposes are usually associated with the beginning courses. Later you may wish to learn more about communication theories—how they developed, why they sometimes conflict, and how their validity has been tested. This information is usually included in advanced courses available to students who major in communication. Finally, you may be interested in conducting humanistic and experimental studies designed to add to the knowledge of the field—aims associated primarily with graduate courses.

This text is intended for those who aspire to the first purpose: to become accurate and effective communicators in society. You should be aware, however, that facility in oral communication requires knowledge about communication and how people interact, as well as skill in composition and presentation. It requires careful study, sustained practice, and dedication. Before you begin your study of the principles involved, determine first what constitutes good communication. What do you hope to accomplish by your study? How will you know if you accomplish your aims? This chapter will help you answer these questions.

First you must dispel the popular notion that communicating is easy and consists of a few simple formulas for controlling your listeners. You must do more than master the skills of presentation, important as these factors may be. You must also develop yourself as an able person with a broad background of information. In short, your worth as a communicator will consist of what you know, the type of person you are, and your understanding and skill in organizing and presenting your ideas.

TYPES OF ORAL COMMUNICATION

Consider the various life situations in which you communicate.

Intrapersonal

First, you communicate intrapersonally; that is, you communicate with yourself as you go about your daily tasks. This type of communication ranges from daydreaming to reflecting as you study for your next speech

assignment to talking aloud to yourself or writing yourself a note. Professors Wayne Pace and Robert Boren explain the process as follows:

> *Communication in its most basic sense is something which occurs, first of all, within the individual. The essence of communication—the process of assigning meaning to stimuli—must take place internally, inside the mind. Following this premise, we may say that the basic communication format for each of us is the process of holding an internal conversation within our individual consciousness. . . . Communication occurs when a person sits quietly in his study and gazes across a meadow while he is reflecting on an impending flight to a large urban center. This type of communication, since it takes place in response to internal cues, is referred to as intrapersonal communication!* [1]

The psychological and physiological bases of intrapersonal communication constitute an interesting study, but its full development is outside the scope of this text. Some of the principles are applied throughout this text but especially in the chapters on listener analysis, and nonverbal and verbal communication. The suggested readings at the end of this chapter include books that develop the subject in some detail.

Interpersonal *with others*

The more commonly considered way ~~that you~~ communicate is interpersonally; that is, you communicate with other persons. Interpersonal communication may be person-to-person, ~~in small groups, or~~ before public audiences, and each type takes many forms.

1. *Person-to-person.* Almost all people communicate more through person-to-~~person contacts~~ than any other way. This across-the-desk communication ranges from informal conversations with your roommate to structured interviews for your first position. You may encounter a classmate as you walk across the campus and stop briefly to compare notes about your upcoming communication assignment. After class you remain to discuss with your professor the plans for your speech; then, after giving the speech, you call on your professor in his office for a detailed critique. Perhaps you seek a campus position and call on the director of student employment; he arranges an interview for you with the manager of the bookstore, who seeks a student salesman; the manager interviews you to explain the duties of the position, to determine your qualifications,

[1]From **THE HUMAN TRANSACTION** by R. Wayne Pace and Robert R. Boren. Copyright © 1973 by Scott, Foresman and Company. Reprinted by permission of the publisher.

iccutes—

and to see if you can reach a mutual agreement. All these situations, some of which you encounter almost daily, call for face-to-face communication. How well you understand, prepare for, and participate in them will help determine your future. Part of the material in this text, especially chapter 5, will help you with such person-to-person communication situations.

2. Small groups. Much of the business of society and your everyday activities are carried out in small groups. These types of discussions range from chance bull sessions to well-planned conferences or committee meetings. Small groups may meet to exchange ideas and information or to decide on some action. For example, your professor may arrange your class in groups for planning discussion or speaking programs for presentation in class. Your first session might involve organizing your group, deciding on a general and subordinate topics, and exchanging preliminary ideas; at a later session you explore the problem, pool your information, and exchange ideas on your specific topics; finally you present your program to the entire class. Perhaps you and your fellow dormitory residents become dissatisfied with food services and decide to do something about it. You meet to discuss the matter, draw up a specific proposal, and elect a delegation to present your proposal to the dean. The delegation calls on the dean to explain the grievance and presents your proposal. Such small-group sessions bulk large in our daily activities; much of this text discusses principles and methods designed to help you understand and meet these occasions effectively.

3. Person-to-persons. You may experience communication situations that call for person-to-persons communication or public speeches. Such occasions range from classroom practice speeches or talks before informal learning groups to formal speeches on momentous occasions. On July 20, 1969, former President Richard M. Nixon set a record in speechmaking when he talked to an audience estimated at over 500,000,000 people and transmitted his message by electronic devices over a distance of some 250,000 miles. It may seem unlikely that you will ever talk to a man on the moon, but the occasions for public communication in classrooms, civic and study clubs, educational and church organizations, and business and professional enterprises here on earth are increasing almost daily. The principles of this type of communication, written about extensively since the Classical period, include instructions on how to select and prepare topics, organize and support ideas, plan the wording and presentation of the completed idea, and adapt ideas to particular listeners. A major part of the principles discussed in this text are immediately applicable to speech-making.

THE PROCESS OF COMMUNICATING

Several of the texts listed at the end of this chapter present detailed communication models designed to explain the human interaction present in any communication situation. They assist in understanding the process and the variables involved, and in isolating communication problems. For the purpose of this discussion, simply remember that no interpersonal communication exists in a vacuum. For communication to take place a sender must send a message to a receiver through some medium and the receiver must hear, understand, and react to what is said. You do not deliver an idea as a salesman delivers your new car, because the idea you present is never received by your listeners in precisely the way you conceive it in your mind. How your listener receives your message depends in part upon his experiences with what you talk about, the attitudes he has acquired from his parents and associates in the environment in which he grew up, and the various ideas and philosophies to which he has later been exposed. As a communicator, you express ideas and present information that arouse feelings and cause reactions, compelling your listeners to further inquiry, thought, evaluation, and perhaps response or feedback.

In brief, look upon the act of communicating as a circular reaction, as follows:

INTERNAL ——→ SENDER ———→ MESSAGE ————————→ RECEIVER
(stimulus) (speaker) (verbal–nonverbal) (listener)

RECEIVER→ (reacts to) →MESSAGE/SENDER→ (causes) → REACTION/
 FEEDBACK

Communication is initiated by a stimulus in the mind of a sender, who verbalizes a message to a receiver, who reacts to both the message and the sender, which results in reaction and feedback by the receiver and the sender. As we shall learn in part 3, the communicator bases his reaction on both what he hears (verbal) and what he sees and feels (nonverbal).

The essential factors in any interpersonal communication situation are (1) the speaker or sender, (2) the message or speech, and (3) the listener or receiver.

The speaker

Since the speaker originates the message, the worth of any communication act depends largely on his intelligence, character, and attitudes, or at

least on how these attributes are perceived by his listeners. Writers since the Classical period have stressed that an able communicator develops himself as a whole, that he cannot be one type of person as a communicator and another type in other pursuits. Modern writers have given this principle a name—the "able-man theory"; this concept is developed in some detail in chapter 2.

Why is this concept important to the speaker? Listeners accept your ideas in part because of their impressions of you as a person. They form impressions of your credibility, accepting your ideas because they consider that you know and properly appraise the facts and opinions you express. They may believe that you have an earnest desire to communicate and that you would not purposely mislead them. Further, they may form impressions that your training and experience have prepared you to speak with authority. If your listeners react positively, your chances for successful communication multiply several-fold. Unfortunately, your listeners may also form the opposite impressions.

The message

Any act of communication begins with an idea that you desire your listeners to understand, believe, or act upon. To attain these aims, your listeners must perceive that your statements reflect a mature appraisal of the situation. The basis of such judgments depends in part upon your listeners' perception of how well you are acquainted with the facts, how thorough your research has been, how your training and experiences qualify you to appraise the situation with authority, and what your interests are in the position that you have taken. To assert that something is true or that an idea has value is not enough; you must back up your assertions with evidence—explanation, examples, statistics, comparisons, and quotations from authority. In short, the validity of your message constitutes a basic requirement for effective communication.

How you organize your message also counts heavily. In person-to-person and small-group situations many of your contributions may consist of brief statements of fact or opinion; others may call for the development of a sequence of ideas, much like public communication. For public speaking or extended comments in person-to-person situations or small groups, you arrange your ideas into main divisions, subpoints, and supporting material for the purpose of developing a central idea. The sequence of points should present a unified, logically developed idea; the introduction, body, and conclusion are usually clearly distinguishable. Various methods for arranging ideas and material are discussed in chapter 9.

Express clearly

Finally, the message must be expressed clearly. The keynote in your use of language should be to convey your meaning precisely and accurately, not to impress or confuse your listeners. Accurate description and evaluation should be your first concern; then you attempt to express your meaning with the rhetorical skills discussed in detail in chapter 12 that are designed to achieve clarity, appropriateness, and interest.

The listener

Since an act of communication aims at informing, entertaining, stimulating, convincing, or actuating the receivers of your message, your aims can best be attained if you understand why people react differently and the exact nature and makeup of your particular listeners. As we explained earlier, listeners consider what you say in relationship to their exposure to experiences about which you speak, and their experiences largely determine their beliefs and attitudes toward your message. For example, we have recently heard much discussion of the generation gap. If you proposed to bring about a better understanding and acceptance of the new morality, your approach would be very different in discussing the subject with your peers than with contemporaries of your parents. If you desired to justify streaking as a student prank, you would no doubt be better received by the members of your student living group than by a group of law enforcement officers. You might secure acceptance of your ideas from each of these groups, but not without understanding why the various groups react differently and adapting your message to their existing beliefs and attitudes.

Suppose you believe strongly that what your student newspaper publishes should be controlled entirely by students. You are asked to present your views before the student council and again before the faculty senate. What factors should you consider in preparing your message? Since the question has become an issue on your campus, you would probably reason that little time needs to be spent in getting your listeners' attention or in holding their interest. Yet the students would probably be more emotionally involved than members of the faculty because their authority is more directly at issue. You would need to consider your listeners' probable attitude toward your thesis: although most members of the student council would likely be favorable, attitudes among the faculty would probably vary, with some being hostile to your position. In considering how much you could depend upon your prestige to help achieve acceptance of your ideas, you would reason, "Surely more from the student council than from the faculty senate because of differences in attitudes." Other factors to consider in your pre-message analysis

would be the age, knowledge and experience, and social and cultural background of your listeners. The details of listener and occasion pre-message analysis are discussed in chapter 4.

Where do we get standards for good communication? No absolute rules exist which can turn all persons into standard communicators. Would not communciation be tiring if all speakers did everything exactly the same way? All principles must allow for individual differences. We cannot designate only one way to make speeches or participate in conferences and discussions; there may be many equally acceptable ways.

Although no formal rules prevail, certain general principles have evolved during the two thousand years the subject has been taught, some based upon empirical data and others derived from experimental studies. These principles include a body of information and skills which can be learned and which will help you develop your potential ability as a communicator. The principles come primarily from two sources: the rhetoricians—those teachers and writers of oral communication since the Classical period who have set forth their findings and practices; and outstanding speakers—those who have used communication effectively throughout history. A brief look at the contributions of these two groups will help you understand what constitutes good communication. Although the following discussion applies primarily to public speaking, with some adaptation the principles discussed apply to person-to-person and small-group communication.

WHAT THE RHETORICIANS SAY

The Classical rhetoricians come to our rescue when we attempt to characterize good communication. Although these men wrote over two thousand years ago, much of what they said forms the basis of modern-day communication. Their writings give us at least four different, and sometimes conflicting, concepts of what good communication should do.

The Sophist theory SOPHIST THEORY

The early Greek Sophists had their beginning in Sicily about 465 B.C., when Corax and his pupil Tisias first set down a system of rhetoric. The system grew out of legal disputes primarily over land titles, for law trials had become public spectacles. Juries consisted of at least 501 persons, and litigants pleaded their own cases. There were also numerous opportunities for speaking on public issues. Public measures were decided at town meetings open to adult male citizens, all of whom had the right to be heard, and much depended upon the effectiveness of their speaking. With

this emphasis on competition of ideas, can you doubt that communication training became popular?

The Sophists advocated persuading by any means available. To them the ends justified the means; they cared little about the ethics of the communicator. Consequently, they taught methods that might easily deceive. In short, they taught questionable practices and measured the success of their communication by the results obtained.

Measured by this standard alone, communication can be deceiving. A person could succeed by complying with the prejudices of his listeners, by avoiding the issue, or by simply evoking an audible reaction from his hearers. He might even be declared successful despite the invalidity of his material if he succeeded in deceiving.

As unethical as this theory appears, some of this doctrine persists today. Some textbooks and many communication courses deal primarily with "how to be effective," with little concern for the ethics of the speaker or the value of his message. Ministers occasionally measure their success by how many people come forward at the invitation, without questioning the methods used to create an emotional state conducive to impulsive action. Lawyers may go on emotional tirades designed to conceal rather than to reveal the facts of the case. Politicians sometimes skillfully comply with the prejudices of their listeners to win votes. Some speakers attempt to rush their audiences to thoughtless decisions. Business executives sometimes exert pressure at board conferences to override opposition. Professors may refuse to confer with students to see if they have justifiable complaints. These persons say, in essence, "The results are tangible; therefore, the communication must be effective." The Sophists said the same thing over two thousand years ago, and the belief is just as questionable today as it was then.

The "knowledge is eloquence" theory

Plato, 429–327 B.C., was the chief exponent of the theory which states that knowledge per se makes for eloquence. This theory regards formal training in oral rhetoric as unnecessary. Plato argued in part that knowledge brings eloquence automatically, that eloquence is implicit in knowledge.

Much of Plato's writing on rhetoric attempted to expose the Sophists. Most modern rhetoricians believe that he overstated his case in his zeal to expose their hypocrisy. The importance of subject matter seems apparent; it may be termed the requirement from which all others spring. That knowledge does not constitute the *only* requirement seems equally apparent. Many intelligent men fail to communicate their ideas and feelings because they do not analyze their listeners properly, fail to speak so that they may be heard, or do not arrange their ideas understandably.

Recently a physician delivered a university commencement speech. His knowledge of medicine and his maturity of judgment were unquestioned, but he read his speech poorly, mumbled his words, and rarely looked up from his manuscript. In five minutes he lost his audience, yet he droned on for forty. Many persons expressed regret about the choice of speaker; however, an experienced teacher of communication, reading the speech at a later date, labeled it an outstanding written address. The fault lay with the speaker, not the speech. He simply could not express himself orally. Occasionally capable persons with wide knowledge of the subject for discussion fail to speak up in conference or committee meetings because they are reticent; they have trouble participating in any situation calling for communication with others. In short, knowledge of subject matter is essential, but it is not the only requirement for successful communication.

The "able man" theory

Quintilian was the chief exponent of the theory—although Cicero and other early rhetoricians also discussed it—which stresses the moral qualities of the communicator: his intelligence, character, and attitudes of goodwill. Thus a good communicator is an able man; he develops skill in communicating by developing himself as a whole. Quintilian stressed training as a lifelong process of study, and asserted that a man cannot be a good communicator without this background. In his 12 books, he discussed what can be done to develop a person in this training "from the cradle to the grave." He contended that a good communicator must be both a good man and a wise man.

This theory needs more emphasis today among those who contend that effective communication may be developed with a minimum of training and who make sweeping claims for short courses for adult groups. Persons who restrict their training only to rhetorical skills could improve their communication by reading the classical writers on this subject.

That no communicator is better than his intrinsic worth as a person can hardly be denied. That the concept is an all-inclusive criterion for judging a person's worth should be questioned. The theory contains much sound advice, but it does not go far enough. Although a good communicator must be a capable man, a capable man may not be an effective communicator. He may be unable to communicate orally.

The methods theory

Aristotle was the original exponent of the methods theory, which measures communication in part by the methods employed in arranging and

presenting it. As developed by Aristotle, this theory embraces the other three already discussed. It evaluates communication partly by the ethics of the communicator and his knowledge of subject, but it adds the standard of skills in organization and presentation. The theory looks upon rhetoric as a science and an art that can be learned and can enable an otherwise capable person to become a competent communicator.

Most modern-day teachers of communication follow this theory, for it is, in fact, the basis of all training in oral communication. Training in communication offers a body of principles and skills for the arrangement and presentation of ideas that is not taught elsewhere in the modern school curriculum. A person who acquires a broad background of knowledge and high ideals goes a long way toward becoming an able communicator, but he must also learn skills of arrangement and presentation to round out his training.

WHAT EFFECTIVE SPEAKERS DO

The rhetoricians give us a solid basis for judging good communication. Those leaders in history who used communication accurately and effectively in accomplishing their programs also made significant contributions. Although few of these men ever set forth their theories of communication, they helped establish standards by usage. Thus we can learn about what constitutes good speech by studying the significant speakers and speeches of history. Chapter 7 lists the best anthologies of speeches both historical and contemporary. To supplement your study of the rhetorical principles in this text, analyze how some of these speakers applied the principles.

Remember too that not all of these people made their greatest contribution through public speeches; some were at their best in conferring with one person or small groups of persons. Former President Lyndon B. Johnson, for example, stated in print that he did not enjoy making public speeches, but his "come, let us reason together" attitude carried the day on many of his proposals as he conferred behind the scenes with persons individually or in small groups.

A poll was conducted among 400 professors of rhetoric in American colleges to determine which speeches they considered the most famous in American history.[2] The two speakers ranked highest may be compared to illustrate how great speakers help establish standards. For illustrative purposes, we shall compare Abraham Lincoln's "Gettysburg Address" and Franklin D. Roosevelt's "Declaration of War."

[2] Glenn R. Capp, *Famous Speeches in American History* (Indianapolis: The Bobbs-Merrill Co., 1963), p. 3.

Perhaps no American statesman illustrates the "able man" theory better than Lincoln. Born in a log cabin near Hodgenville, Kentucky, on February 12, 1809, his early environment and humble circumstances afforded him the opportunity for only one year of formal education. Yet his inquiring mind and zest for life caused him to educate himself beyond most men of his time. His awkward bearing, ungainly appearance, and high-pitched voice marred his effectiveness as a speaker, but his knowledge of human nature, his penetrating mind, and his clever repartee more than made up for his rhetorical deficiencies. In him the characteristics of an able man—intelligence, character, and goodwill—helped to establish principles of effective speaking.

Lincoln's "Gettysburg Address," presented at the dedication of the cemetery at Gettysburg, Pennsylvania, on November 19, 1863, commemorated those who had lost their lives at the Battle of Gettysburg. Edward Everett of Boston was the principal speaker, but President Lincoln was asked to give a "few appropriate remarks." Although his speech took no more than three minutes to deliver, he reemphasized his basic political philosophy that the equality of men must be preserved, that their rights must be protected, and that government of, by, and for the people must prevail. The speech was organized chronologically, emphasizing in turn that our nation was established on the principles of liberty and equality, that those principles were being threatened by the Civil War, and that they had met to dedicate the cemetery in honor of those who gave their lives for the protection of those principles. After paying homage to the dead, Lincoln stressed the task remaining—to honor their memory by protecting our original concepts of freedom and equality.

Many rhetoricians consider Lincoln's speech a masterpiece of arrangement and style. The text of the speech that follows, known as the "Bliss copy," is perhaps the most accurate of the several texts that exist. Study it as a model of excellence that helped establish standards, especially for the use of language.

Four score and seven years ago our fathers brought forth on this continent, a new nation, conceived in Liberty, and dedicated to the proposition that all men are created equal.

Now we are engaged in a great civil war, testing whether that nation or any nation so conceived and so dedicated, can long endure. We are met on a great battle-field of that war. We have come to dedicate a portion of that field as a final resting place for those who here gave their lives that that nation might live. It is altogether fitting and proper that we should do this.

But, in a larger sense, we can not dedicate—we can not consecrate—we can not hallow—this ground. The brave men, living and dead, who struggled here, have consecrated it, far above our poor power to add or detract. The world will little note, nor long remember what we say here, but it can never

forget what they did here. It is for us the living, rather, to be dedicated here to the unfinished work which they who fought here have thus far so nobly advanced. It is rather for us to be here dedicated to the great task remaining before us—that from these honored dead we take increased devotion to that cause for which they gave the last full measure of devotion—that we here highly resolve that these dead shall not have died in vain—that this nation, under God, shall have a new birth of freedom—and that government of the people, by the people, for the people, shall not perish from the earth.[3]

Franklin D. Roosevelt's early life and training offer an interesting contrast with those of Lincoln. He exemplifies the methods theory because he not only was a man of wide knowledge and experience, but also was afforded the best training of his day for developing skills in communication. Born at Hyde Park, New York, on January 30, 1882, of wealthy and aristocratic parents, he received his early training from private tutors and extensive travel abroad. Later he attended Groton School, Harvard College, and the Columbia University School of Law. During his undergraduate days he was an avid debater, editor of the Harvard newspaper, and an enthusiastic student of history and government. These activities served him well in developing facility in oral communication, skills which he used extensively from the time he entered public life in 1910 until his death on April 12, 1945.

Roosevelt's "War Message" declaring war on Japan on December 8, 1941, was delivered before a joint session of Congress and members of the Supreme Court. Roosevelt had dictated his war message soon after the attack on Pearl Harbor, and it was delivered with only minor changes the next day.

This short speech, which took only six minutes to deliver, gives an excellent example of arrangement, style, and psychological appeal. Roosevelt's arrangement is, like Lincoln's, chronological; he started by reviewing the attack on Pearl Harbor the previous day, discussed its present effect, and expressed confidence in the outcome of the war. The simple and direct style shows force and action. Although he showed restraint, the pathos of the occasion comes through in his choice of language and reference to matters which the American people hold dear. A study of the text that follows will show how Roosevelt helped establish standards for good speech.

To The Congress of The United States: Yesterday, December 7, 1941—a date which will live in infamy—the United States of America was suddenly and deliberately attacked by naval and air forces of the Empire of Japan.

The United States was at peace with that nation and, at the solicitation of

[3] John G. Nicolay and John Jay, eds., *Complete Works of Abraham Lincoln* (New York: Appleton-Century-Crofts, 1894–1905), *9*, 209–10.

Japan, was still in conversation with its government and its Emperor looking toward the maintenance of peace in the Pacific. Indeed, one hour after Japanese air squadrons had commenced bombing in Oahu, the Japanese Ambassador to the United States and his colleague delivered to the Secretary of State a formal reply to a recent American message. While this reply stated that it seemed useless to continue the existing diplomatic negotiations, it contained no threat or hint of war or armed attack.

It will be recorded that the distance of Hawaii from Japan makes it obvious that the attack was deliberately planned many days or even weeks ago. During the intervening time the Japanese government had deliberately sought to deceive the United States by false statements and expressions of hope for continued peace.

The attack yesterday on the Hawaiian Islands has caused severe damage to American naval and military forces. Very many American lives have been lost. In addition American ships have been reported torpedoed on the high seas between San Francisco and Honolulu.

Yesterday the Japanese government also launched an attack against Malaya. Last night Japanese forces attacked Hong Kong. Last night Japanese forces attacked Guam. Last night Japanese forces attacked the Philippine Islands. Last night the Japanese attacked Wake Island. This morning the Japanese attacked Midway Island. Japan has, therefore, undertaken a surprise offensive extending throughout the Pacific area. The facts of yesterday speak for themselves. The people of the United States have already formed their opinions and well understand the implications to the very life and safety of our nation.

As Commander in Chief of the Army and Navy I have directed that all measures be taken for our defense.

Always will we remember the character of the onslaught against us.

No matter how long it may take us to overcome this premeditated invasion, the American people in their righteous might will win through to absolute victory.

I believe I interpret the will of Congress and of the people when I assert that we will not only defend ourselves to the uttermost but will make very certain that this form of treachery shall never endanger us again.

Hostilities exist. There is no blinking at the fact that our people, our territory, and our interests are in grave danger.

With confidence in our armed forces—with the unbounded determination of our people—we will gain the inevitable triumph—so help us God.

I ask that the Congress declare that since the unprovoked and dastardly attack by Japan on Sunday, December 7, a state of war has existed between the United States and the Japanese Empire.[4]

The study of these two representative speeches indicates that the way in which great men speak at crucial periods in history helps establish principles of good speech, as does what the rhetoricians say should be

[4] *Congressional Record, 87,* Part 9, December 8, 1941.

done. Both those who speak well and those who write about how to speak help establish standards.

STANDARDS FOR JUDGING GOOD COMMUNICATION

As we have already suggested, a good starting point in your training consists of drawing up criteria for judging what constitutes good communication. These standards will help you measure your progress. The five following standards come partly from a study of the rhetoricians and partly from an analysis of significant speakers.

Evaluate properly what you talk about

You, like most other Americans, cherish your right of freedom of speech. We think of freedom of speech as a basic American concept. Unfortunately, many speakers who proclaim this freedom the loudest do the least to assume their corresponding obligation to evaluate properly what they talk about. The Senate investigation of the Watergate scandals revealed that many of the most convincing and glib speakers were most guilty of perjury and other unethical practices. They used their communication skills to cover up their activities and thus gave a false evaluation of the facts. The speaker in any communication situation has an obligation to present factually true information and mature ideas upon which his listeners may depend.

While on a vacation, a motorist drove into a gasoline station in an unfamiliar city to ask directions. The attendant, in a pleasing and effective manner, gave specific directions which carried the vacationist without difficulty across the city through heavy traffic over unfamiliar territory. He encountered only one hitch, but a vital one—upon arriving where he had been instructed to go, he found that he was farther from his destination than when he started. The attendant had talked complete nonsense effectively. He rated "A" on method but "F" on evaluation. It matters little whether a person gives factually false information by design or ignorance; he still deceives his listeners.

Some communicators say what will be popular with their listeners, rather than what needs to be said. They seek approval and applause, to make a favorable impression. Consequently, they choose and interpret facts in the light of how well they may be received, and they usually change their interpretations from time to time to correspond with the prejudices of their listeners. To illustrate: If a person has a choice among several examples, he selects the one most acceptable to his listeners without regard to which is the most accurate. An example should

represent a true sampling of all possible examples; choosing unrepresentative examples on the basis of popularity instead of accuracy deceives listeners.

Other communicators use ideas gained from collections of published speeches or other writings without giving credit to the sources of information. An almost nationwide scandal occurred in college forensic circles several years ago when a young man won several original oratory contests using a previously published speech. Others quote important people by taking statements out of their context, thus giving a false impression of the intent of the author. Some may quote persons popular with their listeners but who are not qualified to speak on the point at issue. These misleading devices result in a misevaluation of the subject and thus fail to measure up to the first criterion for judging adequate communication.

Let your first principle be—learn the facts, then communicate. Recognize that you have an obligation as well as a right as a communicator. Make sure that the information you give your listeners is factually true.

Make your basic appeal on rational grounds

In his writings on rhetoric, Aristotle deals with three factors important to the standard of rationality: (1) the ethical factors residing in the communicator—impressions that the audience forms of his character, ability, and attitudes as revealed by his reputation, what he talks about, and his manner of speaking; (2) his emotional appeal—statements the communicator makes that affect people's basic motives, desires, and needs; (3) the argument itself or the logical appeal—the evidence and reasoning the communicator uses to support his points.

A good communicator uses all three of these means of proof, but he will not center too largely on one to the exclusion of the others. The easiest way to evoke an immediate response is through an excess of emotional appeal. Almost any experienced speaker can work up an audience to an emotional state conducive to irrational action. However, the quality of such impulsive decisions is low. A sensational revival preacher aroused his audience to such an emotional pitch over the use of tobacco that members of the audience marched to the front and deposited their pipes, cigarettes, and cigars in containers, with firm resolves never to smoke again. Within a week after the close of the revival, the local stores reported sales of tobacco unparalleled in the history of the small community.

A defense lawyer employed such emotionalism in a sensational criminal case that the jury recorded an eleven to one vote for acquittal within the first hour of their deliberations. Six hours later they brought

in a unanimous vote for conviction, thanks to one juror who kept his head. After time for more mature deliberation, a person emotionally induced to take a particular stand may waiver or repudiate his impulsive decision. Excessively emotionalized speaking may accustom listeners to depend on emotional stimulation for decision, thus forsaking rational grounds in making decisions.

Logic depends primarily on evidence and reasoning. Evidence consists of the facts used to support ideas, and reasoning of the process of drawing inferences from the facts. Illogical reasoning consists of such devices as quoting unqualified authorities, presenting unrepresentative examples, citing limited statistics, drawing sweeping conclusions from meager evidence, making inferences from negative instances, and drawing conclusions by comparing objects not comparable. A good communicator avoids such fallacies and makes his basic appeal to logic.

Let your second principle be—avoid the overuse of emotionalized appeals; avoid mistakes in reasoning; appeal primarily to logic.

Conform to rhetorical principles

Scholars of rhetoric from the time of the Classical writers have treated five factors of oral discourse: invention, arrangement, style, delivery, and memory. An explanation of these factors as they apply today will help you understand rhetorical principles. A detailed development comes later; this discussion defines these principles.

Invention includes what you talk about in your communication—methods of argument, fallacies, logic, and proof. The term also includes forms of support—examples, analogies, illustrations, statistics, quotations from authority, explanation, and narration. In short, invention refers to the substance rather than the form of the message.

Arrangement means the composition of the message. Organize your thoughts into a simple, direct development of a completed idea so that your listeners will remember the central thought of your statements.

Style refers to the language used in expressing your ideas. Style, more than other skills, varies with changing times. Note the more ornate style of speeches of the nineteenth century as compared to those of the twentieth. Simplicity and directness form the keynote in style today. Language should conform to accepted standards of grammatical construction, but it should also be colorful, direct, and simple. Language indicates feelings about ideas as well as meanings of ideas.

Delivery treats the skills employed in presenting messages orally—voice, bodily action, and poise. The voice should be pleasing in quality, distinct, and capable of being heard throughout the hall. It should be free of affectations to avoid diverting attention from what you say.

Bodily action refers to the movement of the whole body or parts of the body for the purpose of emphasizing and clarifying meaning. Correct bodily action never calls attention to itself but helps in making ideas meaningful and forceful. Poise refers to general bearing before an audience. A communicator shows poise when he gives the impression of self-confidence, without arrogance or condescension.

Memory pertains to the methods employed in recalling ideas and materials. Memory is less important today than during the Classical period because we have perfected methods of recording our ideas through written form. Facility at recall assists the communicator, however, for it makes frequent references to notes or manuscript unnecessary.

Let your third principle be—use rhetorical skills to communicate your message effectively; never use them for exhibition purposes.

Present a worthy message

Unfortunately you may conform to the preceding requirements and still not make a worthwhile contribution. Your idea may not be worth presenting in the first place; it may be trivial or immature. A worthy message results from diligent research, careful thinking, and mature judgment. You waste the time of all your listeners, not simply your own, if you have nothing worthwhile to say. Thus, if you speak on a trivial subject for 30 minutes to 500 people you waste 250 man-hours. If you have nothing worthwhile to contribute in a conference, you impede rather than facilitate the understanding and solution of problems. Consider the maturity of your ideas as carefully as you do their preparation, arrangement, and presentation.

A worthy message does not mean that you must have a completely arranged speech every time you speak. The circumstances of the occasion indicate the type of speech expected or the appropriate remarks in an interview or conference. Some occasions seek simply to maintain morale, as in a speech of the sales director to his salesman, the alumnus before the university homecoming gathering, or the director of the fund-raising campaign before his solicitors. Such speeches take the form of a pep talk; if the speaker succeeds in arousing fervor for a worthwhile purpose, he fulfills the requirements of a worthy idea.

Some occasions call for speeches to provide interesting diversion, such as dinner occasions and social club meetings. At such meetings the speaker uses the speech situation to provide pleasantry. If he succeeds in entertaining his hearers, he accomplishes a worthwhile purpose.

Many occasions aim at presenting information, such as the teacher before his class, the lecturer at the study club, or the business executive

before his employees. In these situations the communicator must be careful to know the facts and properly appraise his subject. If he gives accurate information, he presents a worthy idea.

Numerous occasions arise for persuading others, like the lawyer before the jury, the statesman before the deliberative body, or the business executive before the board of directors. Democratic society could not carry on its activities without the able advocate. Unfortunately, some advocates distort the facts in attemping to make their positions sound convincing. If a person gives a distorted appraisal, he fails to meet the standard of a worthy idea. The able advocate gives a true-to-fact evaluation of his findings while arranging the most convincing case possible.

A persuasive message may aim at stimulating listeners to think or to work toward solutions to problems. It may define an idea, teach mental skills, raise perplexing questions, present unsolved problems, or attempt to break through myths, prejudices, or dogmas. Such messages challenge listeners to recall their experiences or to use their powers of reasoning. Messages that generate criticism, analysis, and reflection meet well the standard of a worthy idea.

Let your fourth principle be—talk sense, not nonsense. Do something constructive for your listeners; never mislead them through design or ignorance.

Accomplish what you set out to do

The final test for judging good communication is—did it get results? Did it entertain, inform, or persuade the listeners? Much of the business of a society is carried on through communication. The most effective communicators usually make the most noteworthy contributions.

You may say, "This standard closely parallels the Sophist doctrine." There is one basic difference. This standard is used in conjunction with four others equally as important. Furthermore, you are not justified in accomplishing your purpose by misleading your listeners. The *end* never justifies the *means.* You do not need to deceive to be effective. The most effective communicators evaluate their facts properly, make their basic appeal upon rational grounds, conform to rhetorical principles, and present worthy ideas. Each of these standards is noteworthy individually; when applied together, they will help you attain the final standard of getting results.

As you begin your study to improve your communication, remember that you must develop yourself as an able person, increase your knowledge, and improve your skills in arranging and presenting ideas. You must accept your obligation to present factually true information and

never purposely to deceive your listeners. By following these standards, you will eventually develop the ability to communicate ideas, information, and feelings effectively.

SUMMARY

Oral communication constitutes one of the most rapidly expanding parts of the modern college curriculum. Although a student may be motivated to enter the study for several reasons, this text focuses on those beginning students who desire to improve their skills and learn about the principles of communication. Avoid shortcuts to effective communication. Develop yourself as an able person, with a background of information, and with skills in communication.

Intrapersonal communication takes place within the mind and consists of daydreaming, thinking, reflecting, and internal conversation with oneself—the origin of communication. Interpersonal communication occurs when people talk together person to person, in small groups, or before public audiences. People communicate when a speaker sends a message to a listener who hears and reacts. The way listeners receive messages depends upon their prior experiences, attitudes, and feelings toward the subject matter of the messages, and upon their opinion of the speaker. The essential factors of interpersonal communication are the speaker, the message, and the listener.

The Classical writers gave us at least four theories upon which we may draw to formulate criteria for judging effective communication. (1) The Sophist theory judges a speech by its results. (2) The "knowledge is eloquence" theory judges a message by the truth of the information presented. (3) The "able man" theory judges by the intrinsic worth of the communicator. (4) The methods theory includes the above theories but adds skills in rhetorical principles. Modern schools of speech communication hold to the last theory because they believe that rhetorical principles can be taught and that learning them is important. Significant communicators throughout history have also helped establish standards by usage.

A set of standards for judging a good communication is: (1) Evaluate properly what you talk about; (2) make your basic appeal on rational grounds; (3) conform to rhetorical principles; (4) present a worthy message; (5) accomplish what you set out to do.

QUESTIONS

1. How do you account for the recent rapid increase in the college oral communication curriculum?

2. Distinguish between intrapersonal and interpersonal communication.

3. Explain the functions and relevance of the speaker, the message, and the listener to the process of communication.

4. Compare the rhetorical theories of the Classical rhetoricians discussed in chapter 1. Why do present-day teachers of communication follow the Aristotelian concept?

5. How do effective speakers throughout history add to rhetorical principles?

6. Briefly discuss the five-point criteria for judging good communication. Which standard do you think needs greatest emphasis today?

7. Can you add to the standards for judging good communication discussed in chapter 1?

ASSIGNMENTS

Written

Write a brief autobiography which includes such information as whether you were born in a rural or urban area, the economic and cultural environment in which you grew up, how many brothers and sisters you have, your father's and mother's occupations, and any other information that you think will help your professor understand you better.

Oral

Plan A This assignment is for classes that emphasize public communication and whose enrollments do not exceed about 20 students. Prepare a three-minute speech about yourself for oral presentation to the class. Attempt to cause your fellow class members to remember the following facts about you: (1) your name, nickname, and native state; (2) your major subject and some interesting facts about it; and (3) your aims and aspirations. You may have notes, but try to avoid using them excessively. Attempt to make the speech interesting by injecting some humor and interesting incidents.

Plan B * This assignment is for classes that prefer to include interpersonal, small-group, and public communication assignments. This plan can be used successfully in classes with 40 to 50 students by arranging the class in groups and having the small-group assignments held simultaneously. The plan calls for each group to select a broad general

* See Appendix B for a detailed explanation.

topic and for each student to choose a subtopic for special study and for his oral assignments.

The first oral assignment consists of a classroom discussion about major issues important today that would prove interesting and profitable for study and oral assignments throughout the semester. Best results can probably be attained if the professor leads this discussion.

READINGS

ADLER, RON, and NEIL TOWNE, *Looking Out/Looking In: Interpersonal Communication,* chaps. 1–8. New York: Holt, Rinehart and Winston, 1975.

BRYANT, DONALD C., and KARL R. WALLACE, *Oral Communication,* 4th ed., chap. 1. Englewood Cliffs, N.J.: Prentice-Hall, 1975.

EWBANK, HENRY L., SR.; A. CRAIG BAIRD; W. NORWOOD BRIGANCE; WAYLAND M. PARRISH; and ANDREW T. WEAVER, "What is Speech?—A Symposium," *Quarterly Journal of Speech, 41* (April 1955), 145–53.

JEFFREY, ROBERT C., and OWEN PETERSON, *Speech: A Text with Adapted Readings,* 2nd ed., chap. 2. New York: Harper & Row, Publishers, 1975.

McBURNEY, JAMES H., and ERNEST J. WRAGE, *Guide to Good Speech,* 4th ed., chap. 1. Englewood Cliffs, N.J.: Prentice-Hall, 1975.

PACE, R. WAYNE, and ROBERT R. BOREN, *The Human Transaction,* chap. 1. Glenview, Ill.: Scott, Foresman, 1973.

PATTON, BOBBY R., and KIM GIFFIN, *Interpersonal Communication: Basic Text and Readings,* chap. 1. New York: Harper & Row, Publishers, 1974.

ROSS, RAYMOND S., *Speech Communication: Fundamentals and Practice,* 3rd ed., chap. 1. Englewood Cliffs, N.J.: Prentice-Hall, 1974.

TUBBS, STEWART L., and SYLVIA MOSS, *Human Communication: An Interpersonal Perspective,* chaps. 1, 2. New York: Random House, 1974.

WALLACE, KARL R., "An Ethical Basis of Communication," *The Speech Teacher,* 4 (January 1955), 1–9.

WILSON, JOHN F., and CARROLL C. ARNOLD, *Public Speaking as a Liberal Art,* 3rd ed., chap 1. Boston: Allyn & Bacon, 1974.

TWO

Developing yourself as a good communicator

Dr. Robert C. Jeffrey, former president of the Speech Communication Association, in his presidential address "Ethics in Public Discourse"[1] referred to "practices in our world today that threaten our ethical communication conduct."

One of those practices is the employment, with tax monies, of an "Executive Flunky," if you will, as a mouthpiece for the President of the United States . . . an institution that permits our highest elected officer to test public opinion in a quasi-official fashion. If reaction to the statements attributed to the President is negative the President can deny responsibility for the statement. With this simple mechanism of public statement by proxy we encourage both deliberately designed deception and abrogation of responsibility.

Later in the speech Dr. Jeffrey stated:

We . . . too often train our students to be experts in the art of plotting the creating of deceptive practices rather than unmasking and indicting those practices. The loss of respect for the spoken word, an inevitable product of image making, has led former Attorney General John Mitchell, referring to the Nixon Administration, to assert, "You will be better advised to watch what we do instead of what we say."

These and other questionable practices uncovered by the Watergate hearings and impeachment investigations of the mid-1970s show that

[1] Text furnished by Dr. Jeffrey with permission to quote. Speech delivered to the annual convention in New York, November 11, 1973.

communication skills are as much available to the unethical communicator as to the most ethical. Communication skills have no built-in features that insure accurate evaluation or the ethical use of those skills. These attributes reside in the communicator, not the process.

Despite these unethical practices, most of us agree that we have the right to know the facts and to be exposed to the conflicting ideas on all issues. During the presidential campaign of 1968, American Independence Party candidate George Wallace was prevented from speaking in Minneapolis, Minnesota, because of heckling by certain members of the audience. The next day, July 4, President Lyndon B. Johnson spoke out against such behavior:

> *Freedom to speak, freedom to listen, the full and open right to communicate and reason together are essential to our system of government and our fulfillment as individuals. However ardently we may disagree with what a man says, we must stand with Voltaire in our defense of his right to say what he will.*[2]

Almost all Americans will probably agree with Dr. Jeffrey that unethical practices prevail today and with former President Johnson that a man has the right to express his ideas freely; but as we explained in chapter 1, perhaps a lesser number would recognize that this right carries with it an obligation to speak responsibly—to evaluate the facts properly and make mature judgments. As a student of oral communication, you no doubt aspire to become both a competent and a responsible communicator. This chapter will help you realize these aims by raising and answering four questions: (1) What characterizes acceptable oral communication? (2) What should you derive from a course in oral communication? (3) How can you develop yourself as a communicator? (4) How can you acquire poise and self-confidence?

WHAT ORAL COMMUNICATION MEANS

Your professor has no desire to make you a silver-tongued orator; instead, he hopes to help you meet the everyday problems of both informal and formal communication. The old-time orator with his emphasis on high-sounding phrases and flamboyant style went out with the age of elocution (the latter part of the nineteenth century), but unfortunately his memory

2 Text furnished by the White House. For a more detailed explanation, see J. Jeffrey Auer, *The Rhetoric of Our Times* (New York: Appleton-Century-Crofts, 1969), p. 210.

remains. What then, you ask, characterizes acceptable communication today?

Good oral communication is conversational and direct

The speech world today strives for a direct, communicative, conversational manner for the purpose of arousing thought and feeling. Do not regard communication as an occasion to exhibit your skills; rather, consider it an opportunity to communicate ideas, information, and emotions. If what you do while speaking detracts from the subject matter of your message, your skills defeat your purpose.

To make your communication effective, project yourself to your listeners. You talk *with* people, not simply *about* a subject. For example, suppose that you arrive early for your class and start talking with the one student present about your visit to Europe the past summer. Other students arrive and begin to listen. Soon your professor comes in and asks you to stand and continue your explanation to the entire class. When did the private conversation become a public message? Was it when several students started listening? Was it when you stood, raised your voice, and started using gestures? Was it when you first realized that you were addressing an audience? There can be no correct answer because the fundamental process was the same at all times. You can talk in a direct, communicative manner before one person, a small group, or a large audience.

The process before a large group is more formal than before one or a few people, but the aim of communication remains the same. Develop simple, direct, communicative, extemporaneous speaking for all occasions.

Good oral communication consists of having something to say and saying it well

To be an effective communicator, you must have a balance between knowledge of subject and skill in organization and presentation. Some think that knowledge alone guarantees effective communication. Others think that the way one talks overshadows what one says. Both concepts are equally fallacious. Since knowledge of the subject and presentation skill are both essential, their relative worth does not matter. Why argue whether the "heads" or "tails" side of a nickel is more important; both sides are essential to make the nickel legal tender.

Knowledge of the subject can hardly be overemphasized, yet knowledge without skill in presentation accomplishes little. The speaker may read from his prepared notes while his audience sleeps, looks out win-

dows, or reads something else. The conference participant may speak with so little animation and feeling that others depreciate his statements. If no one listens or believes, it matters little if the communicator reflects maturity of judgment. Equally bad is the person who speaks well but says nothing. He may induce his listeners to accept immature ideas, factually false information, and ill-conceived judgments. Knowledge of subject and maturity of judgment constitute prerequisites to the right to communicate. Skills in speaking cause communication to accomplish its purpose. Each performs an indispensable function in developing a well-rounded communicator.

A minister and his wife each had reputations as excellent speakers, but were divergent types. He was noted for his wide knowledge, penetrating mind, and maturity of judgment; she, for her fluency, beauty of expression, and dignity. One professor remarked that the minister could tell his wife what to say and she could outspeak him, two to one. Another demurred, stating that knowledge of subject constitutes an essential part of speaking effectiveness. They agreed that if the minister and his wife each had the other's ability plus his own, each would possess the desired qualities. Having something worthwhile to say and saying it well are the goals for oral communication.

Good oral communication does something constructive to the participants

The ultimate effect of communication may be measured by what it does for its listeners or readers. What lasting effect does it have on the issues discussed? If a person gives new insight into a problem, adds to the total of information on it, clarifies his listeners' thinking or attitude, he makes a measurable contribution.

The role effective communication has played during different periods of history probably accounts for the varying degrees of emphasis it has received. A study of the history of communication shows that the emphasis placed on training varied in relation to the degree of democracy practiced. The greater the degree of democracy, the more emphasis communication receives.

Communication was the core of the curriculum for the schools of rhetoric in ancient Greece. And little wonder, for the Greek city-states represented pure democracy. Public measures were decided at town meetings, and litigants pleaded their own law cases.

When the center of civilization shifted to Rome, a gradual lessening of the emphasis on communication training resulted largely because individuals employed advocates to represent them in the courts and carried out their public business through representatives.

During the Dark Ages after the collapse of the Roman Empire communication training almost disappeared. With the decline of democracy, there was no reason for speaking because speech had little or no effect on public policy.

Democracy regained its own in the Parliament of England. It regained power gradually, receiving its first major impetus from the founding of the House of Commons in 1265. With the union of England and Scotland in 1707, democracy became entrenched, and gained its full vigor in the latter part of the eighteenth century. Thus the reason for communication came back.

Perhaps free speech attained its greatest vigor in the New World. The colonies were made up largely of Englishmen who brought with them ideas of self-government. All of the colonies had elective assemblies that provided endless occasions for public discussion. But communication was not confined to legislative halls. It took place on public platforms, in political campaigns, in town meetings, and in forums. Free speech flourished in America because speaking counts in a democracy. The good communicator does something constructive for his listeners by bringing ideas into focus, dispensing useful information, or influencing belief.

WHAT YOU SHOULD DERIVE FROM A COURSE IN ORAL COMMUNICATION

You may next ask, "What should I expect from a course in oral communication?" By setting up goals early in your study, you can direct your efforts toward attaining them. Before considering specific goals, determine how communication relates to other subjects you will study. Communication training offers a body of information and skills distinguishable from other fields, although it uses the subject matter of many fields. For example, studies in the social sciences aim at securing an understanding of subject matter, at assessing causes and effects, and at exploring different concepts. The student of communication strives for understanding too, but he goes further; he disseminates his acquired knowledge orally. He uses his knowledge for an added purpose. The student of English literature learns about great literature; the student of communication shares great literature with others through oral performances. The student of drama learns about dramatic literature; the actor portrays the characters to an audience. The principle of communicating orally distinguishes communication training from other studies. The following skills should be developed by training in oral communication.

How to think through a problem

We consider many problems and make countless decisions each day. Some decisions may be of little moment, such as what clothes we shall wear. Others are considerably more important, such as whom we shall vote for in the gubernatorial election, whether we should make the loan to the applicant, or whether we should expand our business. Still other decisions determine largely our lot in life, such as what profession or business we shall follow, what college we shall attend, or what church, political party, and organizations we shall join. How much intelligence do we exercise in thinking through such problems? Probably less than we care to admit. What about your opinion on major issues? Do you think that integration in our public schools is the right policy, or do you subconsciously consider an educated minority a potential threat to your future economic, social, or political postion? Or, probably more important, do you think at all about the problem?

You will improve your ability to think constructively if you succeed in becoming competent in oral communication. The communicator develops the ability to think through a problem objectively and intelligently so that he may attain the goal of doing something constructive for his listeners.

How to investigate, analyze, and evaluate a problem

A student council committee met to consider what could be done to alleviate the problem of automobile parking on the campus. One committee member moved immediately that parking permits be denied to freshmen and sophomores. Another member suggested that the committee investigate the question and bring evidence to bear on the problem. This suggestion prevailed and the chairman appointed subcommittees to investigate various facets of the problem and to report at a later meeting. These reports formed the basis for further deliberations and for the final decision of the committee.

Some people like to decide matters in a hurry. Impatient with investigation and deliberation, they prefer to settle the matter at once regardless of the value of the decision. Others are overly cautious in making decisions. They say that they will not decide until all the facts are in, not realizing that such is an impossibility. Of course, during times of crisis decisions must be made in a hurry, but normally the wiser course calls for investigation and analysis before decision.

The communicator usually has time for thorough investigation and analysis. He has learned how to find the facts, how to analyze them, and

how to judge their worth. Chapters 7 and 8 bear directly on these skills, and other chapters treat them indirectly. The successful communicator has acquired the ability to separate the essential from the nonessential, the valid from the invalid, the facts from propaganda.

How to organize ideas

Some people have mature ideas and can find the facts, but they lack facility in organizing their thoughts for either written or oral communication. Thus the reader or listener must surmise what the writer or speaker means. No doubt the communicator has an idea, but he fails to organize a sequence of points that develop a central theme.

For example, some speakers attempt too much for a single speech. One statesman spoke on the eve of an election on "Ten Commandments for Successful Voting." The timeliness and appropriateness of his topic were excellent, but he tried to make too many points. A few points thoroughly developed with illustrative material accomplish more than numerous ideas without adequate support. Some conferences also attempt too much for a single session. A conference permits the pooling of ideas and information and a cooperative solution. If the conference is organized to require a hurried decision, the purpose of group decision is defeated.

Another common fault in arrangement comes from improper sequence of ideas. A student in a speech class spoke on "The Foreign Aid Program of the United States." He developed these three points: (1) the future of our aid program, (2) suggestions for reform, (3) the nature of the problem. His points were well chosen but poorly arranged; they did not follow in logical sequence. By reversing the order, an improvement is made: (1) the nature of the problem, (2) suggestions for reform, (3) the future of our aid program. Why discuss reforms before you show the need for them? The future of the aid program can best be discussed in the light of the speaker's suggested reforms.

Chapter 9 treats organization in detail and suggests several plans for arranging ideas. The instructions deal specifically with oral presentation but they apply as well to written communication.

How to understand human interaction

Most people think of communication as a transfer of information or ideas from one person to another, but it is more than that. The communicator does attempt to formulate meaningful messages which he hopes will elicit responses in his listeners congruent with the ideas he has in mind. But he realizes that his ideas will be received differently by his listeners in keeping with their varying attitudes, beliefs, and exposures

to what he talks about. He understands also that people base their re-
actions not only on the verbal message or what they hear, but also on
the nonverbal message or what they see, feel, and perceive. Thus com-
munication concerns how people relate to and interact with one another
about the ideas expressed.

If a sender of a message, for example, presents ideas with which his
listeners already agree, he will get quite a different reaction from them
than from listeners who already disagree. Some people tend to listen
favorably only to ideas that conform to their preconceived opinions, and
to discredit or refuse to listen to contrary views. Different people hearing
the same idea or viewing the same incident react differently depending
upon their training, experiences, and exposures to the idea or incident.
Communication is thus largely a process of human interaction.

How to present ideas orally

In chapter 1 we mentioned a survey that revealed that most college stu-
dents spend between 15 and 16 hours daily communicating. The survey
also showed that students spend considerably more time in oral than in
written communication. Although many rhetorical principles apply to
both oral and written forms, their application may vary widely. Oral
language is usually more direct, informal, and repetitious than written
language. More effort must be given to getting attention and holding
interest in oral communication, because the listener cannot turn back
the pages if his attention wanes, as can the reader. Nor can the listener
stop to ponder an idea that may not be clear to him. This text makes
specific application of rhetorical principles to oral presentation and lis-
tening.

Most of us spend a great deal of time communicating, yet how much
of it is effective? Why cannot we settle more of our conflicts by talking
them through? Talk is not only an inexpensive method for settling prob-
lems, but it is also the most civilized. When talk breaks down, people
resort to belligerent methods: labor strikes against capital, capital boy-
cotts labor, friends grow angry and will not speak, absenteeism runs high
in industry, nations go to war. The causes for breakdowns in communica-
tion are treated in chapter 5. It is sufficient here to call attention to the
importance of improving your ability to communicate orally.

How to listen critically

Listening and memory received more attention during the Classical
period than they do today. Without methods of printing, ideas and in-
formation were passed on orally from generation to generation. Prin-

ciples of listening and memory bulked large in the ancient schools of rhetoric, therefore, because they were essential to the preservation of knowledge. In the early history of America, listening also received major stress because oral communication was the principal means of disseminating ideas and information. With the coming of the printing press and advances in education, we relied heavily on the written word for mass communication. In recent years, the advent of radio and television has caused a shift back to the spoken word as the principal medium of communication. Recent studies indicate that most people listen more than they read. Furthermore, people devote a greater percentage of each day to listening than they may realize. Studies among various groups show the extent—nurses, 42 percent; dietitians, 63 percent; business executives, 40 percent; students, 57 percent; and a cross section of business and professional groups, 45 percent.

Unfortunately many people hear but do not listen. Modern mass communication media have encouraged careless listening habits. One student insists that he must have his radio on to study effectively. Another requires the constant noise of his air conditioner to counteract other noises. Still another watches television, reads the evening paper, and eats his dinner all at once. Do you wonder that we have developed indifferent listening habits?

The slovenly listening habits of everyday living affect listening in communication situations adversely. Some students only half listen as the instructor lectures. They worry about their unfinished essay in English while attending their history lecture, work their mathematics problems in psychology class, and plan their social activities as the speech teacher lectures. The salesperson plans a sales interview while attending the sales conference; the lawyer thinks about his trial as the minister preaches; and the homemaker plans a shopping trip during the discussion at the study club. The failure to listen prevents the communicator from attaining his purpose—the communication of ideas and feelings.

Who must assume responsibility for the loss of communication caused by poor listening? We formerly blamed the speaker exclusively in person-to-persons situations. Members of an audience seem to say, "Here I am; see if you can win the battle for my attention." More recently educators have contended that the listener must assume part of the responsibility. Many able people have worthwhile ideas, but their presentation skills are not effective enough to command the attention of the audience. By considering oral communication as a two-way process, we may realize its greatest potential.

You may ask, "How can a course in oral communication improve my listening?" Largely by two means: (1) by a study of methods and techniques for effective listening, and (2) by providing exercises that en-

courage listening. Through a cooperative effort by speaker and audience and by participants in less formal groups, communication may be improved. A course in oral communication should help you become a more effective listener.

HOW YOU CAN DEVELOP YOURSELF
AS AN ABLE COMMUNICATOR

A good starting point in developing yourself as a communicator is to take stock of your limitations. What do you consider your chief weaknesses in oral communication? Analyze your needs by answering the following questions.

Do you lack a background of knowledge on which to draw for ideas and subject matter? If so, the solution to your problem consists of cultivating an interest in and an inquiring attitude toward the many sources of knowledge. Chapter 7 details a program for acquiring such interests.

Do you feel insecure in a communication situation? If so, your problem may be caused by a lack of knowledge about communication or of experience in participating. This book proposes to familiarize you with the processes, while the class procedures will give you the opportunity to practice before your class. The next section of this chapter explains how to gain confidence and poise.

Do you lack facility in presenting your ideas orally? Then, give special attention to part 3 of this textbook. Practice in communicating will cause you to get the feel of your listeners; thus you can improve your ability to communicate orally.

Whatever your analysis reveals, your next question concerns what you can do to prepare yourself for oral communication. As we explained in chapter 1, a good communicator is an able person with a background of information and ideas. What can you do to develop these characteristics? Consider the following six suggestions.

Desire to improve your communication

Without a genuine desire to improve your oral communication and a willingness to work hard, you have little chance of success. You learn to communicate by communicating. The training program provides practice periods on subjects that lead you step by step through the necessary procedures. To succeed, your desire for improvement must exceed your inertia. This requirement does not mean an insatiable desire that drives you continually. It does mean that you must work intelligently to develop an analytical mind, an interest in research, an ability to arrange ideas

logically, and an eagerness to improve your voice, language, bodily action, and poise. Regardless of your professor's ability and training, he cannot teach you to become an effective communicator unless you earnestly desire self-improvement. The impetus must come from you.

Develop yourself as an able person

As we mentioned in chapter 1, the able man theory includes the moral character of a person as expressed in his regard for truth and good works, his sincerity of purpose, and his search for moral, spiritual, and social values. It also encompasses his qualifications to communicate, his experience and knowledge, his maturity of judgment, and his skills in arranging and presenting ideas orally. Further, it relates to the type of person he becomes—his zest for life, his attitudes of goodwill toward people, his controlled emotional state, and his unselfish aspirations.

These ideas have been expressed in several ways by rhetoricians and communicators throughout history. Aristotle frequently refers to and discusses various phases of this theory in his *Rhetoric*. In one of his dialogues, Cicero has his character Cato state that "a good orator is a good man skilled in speaking." Seneca declared, "Whatever the man is, such is the orator." Quintilian lays major stress on this theory in his 12 books on rhetoric. Later writers Lew Sarett and William T. Foster said, "Speech is effective, other things being equal, in proportion to the intrinsic worth of the speaker." [3] Recent writers James H. McBurney and Ernest J. Wrage state, "Good speech reveals a person of competence, integrity, and good motives." [4] Alan H. Monroe and Douglas Ehninger write, "Above all, if a man is to win acceptance for his ideas, he must be respected as a person of character and moral worth by those who hear him." [5]

Upon what basis do listeners form impressions of you as a person? Some of the more important follow.

1. *You are judged in part by the reputation that precedes you.* Toward the end of his career, Dr. George W. Truett, former pastor of the First Baptist Church in Dallas, Texas, and president of the Baptist World Alliance, became so loved and honored throughout the South that he was received with respect wherever he went. Perhaps his originality and powers of discernment decreased with the years, but his reputation was never

[3] Lew Sarett and William Trufant Foster, *Basic Principles of Speech* (Boston: Houghton Mifflin Co., 1936), p. 18.

[4] James H. McBurney and Ernest J. Wrage, *The Art of Good Speech* (Englewood Cliffs, N.J.: Prentice-Hall, 1953), p. 43.

[5] Alan H. Monroe and Douglas Ehninger, *Principles and Types of Speech*, 6th ed. (Glenview, Ill.: Scott, Foresman, 1967), p. 3.

greater than in his declining years. His reputation had been earned by a life of useful works and service, and it stood him in good stead as a speaker. Persons of authority and accomplishments naturally have the advantage in this respect over younger people who have not yet made their mark in the world, but all who aspire to successful communication should keep in mind that one's reputation affects listener receptivity.

2. *You are judged in part by your introduction.* If you are unknown to your listeners, the person who introduces you may perform a real service by increasing respect for you. Properly done, the speech of introduction informs your listeners of your qualifications on your subject and creates goodwill toward you as a person. The person introducing you should tell who you are, your position, your experiences and training in the field of your subject, any outstanding accomplishments, positions of authority you have held, and sufficient human-interest material that will cause an audience to like you. Where possible, a person who knows the speaker well should give the speech of introduction. The better known the person already is to the audience, the less need be said.

3. *You are judged in part by what you talk about.* "Speech is the mirror of the soul: as a man speaks, so is he." This statement by Publius Syrus is more than a maxim; it contains sound advice to the communicator. If you talk about low and degrading things, your listeners will be likely to consider you that type of person; but if you express intelligent and mature thoughts, your listeners will regard you as an able person. Some years ago a public relations man representing a large corporation spoke to a Lions Club meeting. Before his all-male audience, he not only resorted to off-color stories, but also engaged in rank vulgarity. The reaction of the audience was spontaneous: the men ceased laughing even out of courtesy. The display caused one speech teacher in attendance to label the speech as a new low in his 20 years of professional experience. Most audiences can appreciate an occasional risqué story but will not tolerate situations that exceed the bounds of common decency.

Substantial evidence, sound reasoning, and maturity of judgment affect not only the logical adequacy of the speech, but also the ethical adequacy of the speaker. A student was heard to remark following a speaking program, "If Mr. X does not find the facts to his liking, he simply changes the facts." Following a speech by Mr. Y at a ceremonial occasion, one listener remarked to another, "I am disappointed that the speaker did not give us a more substantial idea." The other retorted, "Mr. Y made it quite apparent that he does not have substantial ideas to give." What you talk about reveals much about you as a person.

If you choose illustrative material that expresses sordid or trivial

thoughts, you create an atmosphere on that level. If you quote unqualified people, irresponsible sources, and questionable literature, your listeners will question your scholarship and judgment. Conversely, if you give illustrations from good literature, quote men of scholarship and learning, and refer to responsible sources, your listeners will form favorable impressions of you as a person.

4. *You are judged in part by how you communicate.* "Mend your speech, lest you mar your future." This maxim aptly states the importance of communication skills in creating favorable impressions of you as a person. If you mumble your words, look away from your listeners, show undue anxiety or extreme egotism, you will be likely to repel your listeners. Your conduct on the platform creates impressions of your worth as a person. Conduct yourself in a pleasant, businesslike manner with neither a condescending nor a self-conscious attitude. By your manner of speaking strive to leave the positive impression that you are a person of integrity who is well qualified to speak on his subject; show that you have made thorough preparation, that you are in a good emotional state, and that you sincerely desire to communicate a worthwhile idea.

5. *You are judged in part by statements that evince ethos.* Some people may question the ethics of a communicator's using statements designed to induce approval of himself by his listeners. Whether you use statements of your qualifications by design or in passing, such statements, judiciously used, do create favorable impressions. Examples follow: (1) statements of sources studied in your preparation; (2) references to special studies you have made which qualify you to know the facts, e.g., your membership in the student council's fact-finding committee; (3) statements of positions held, honors received, or other accomplishments which put you in a position to know the facts; (4) statements of places visited which bear on your subject, e.g., your visit inside the Iron Curtain for your opinion of conditions in the Soviet Union. Such material will usually be brought into your dscussion by indirection, through illustrative material. It should never be given in braggadocio.

References to matters which people hold in high esteem will usually create favorable impressions of you as a person. For example, if in your speech to the athletic association you illustrate a point by giving an incident involving your work in a boys' summer camp, your audience will know that you speak from experience. An incident relating your experiences on the honors program will show your academic attainment. An example pertaining to your work in the United Fund drive stresses your interests in civic activities. Such statements tend to create favorable impressions of you as an able person.

Build a storehouse of information

To develop yourself as an effective communicator, you must have a storehouse of information and ideas upon which to draw. Acquiring such a background is a lifelong process of interest and inquiry into the many sources of useful information. Many persons become experts in specific fields of knowledge, but their range of knowledge becomes too restricted for practical value to them as communicators. A diversity of subject matter that comes from a continuous study of the liberal arts serves the communicator well.

A distinction should be made here between *direct* and *indirect* preparation for communicating. Direct preparation consists of the specific research and planning you do for a particular speech, conference, or interview. Indirect preparation comes from your general habits of reading and inquiry, your experience, travel, associations, and observations. The former consists of your preparation for a specific speech; the latter contributes both to a specific speech and to all your speeches.

Both types of preparation serve you well, but people often tend to overlook the importance of a broad general background of learning. Your general background may be the difference between your making an occasional successful participation and your becoming a successful communicator. The latter prepares himself by continuous study and intelligent thinking throughout his life. He can draw on the fields of literature, art, history, government, and philosophy for ideas and supporting material on many subjects. Broad inquiry also affects a person's attitudes, making him broad-minded, tolerant of new ideas, and willing to experiment. Suggestions for acquiring a background of information and ideas are found in chapter 7.

Observe communicators in action

Time spent listening to participants in communication situations, analyzing their ideas, and observing their skills serves the student of communication well. Do not, however, pattern your style after any one successful communicator. Do not try to become a second John Kennedy, Billy Graham, Winston Churchill, Gerald Ford, or Leon Jaworski. Although the observation and study of successful speakers should aid you in developing your potential ability, you should develop your abilities into an individual style.

Analyze successful communicators for pointers on both composition and delivery. What do they do that makes them effective? What distracting influences do you note? Can you reproduce the central idea of a

message several hours after hearing it? Apply the five standards of good communication discussed in chapter 1 as you listen. These procedures will not only help you develop your communication ability but will also make you a better listener.

Do not restrict your observations to one or a few types of occasions; listen to diverse types. Analyze the minister's sermon on Sunday morning; go to the courthouse and listen to an interesting criminal case; attend the lecture or discussion series sponsored by your university; visit a meeting of your student governing board or the local city council; view a television news program, observe your professor's lectures critically. Make lists of good and bad techniques that you observe. These procedures should make you aware of your shortcomings and inspire you to improve your communication skills.

Study the great speakers and speeches of history

Read critically oratorical masterpieces of history, current representative speeches, and winning student speeches. This suggestion supplements the recommended program of listening to outstanding speakers. Analyze such masterpieces of history as Patrick Henry's "Call to Arms" speech, Daniel Webster's "Reply to Hayne," Abraham Lincoln's "Gettysburg Address," Henry W. Grady's "The New South," and the Lincoln–Douglas debates.

Although you cannot study presentation skills in published speech, you can study composition, language, forms of support, and reasoning. For the present, analyze famous speeches by the standards discussed in chapter 1. After studying later chapters, you can analyze the three following rhetorical principles from a published speech. (1) *Organization*—Study the composition of the speech according to the principles discussed in chapter 9. What type of organization does the speaker use? Can you follow his central idea easily? Does he support each idea well? (2) *Forms of support*—How effectively does he support his ideas according to the discussion in chapter 8? Does he use a variety of examples, comparisons, statistics, and quotations? Which form does he use most effectively? (3) *Style*—Does the speaker's use of language comply with the principles discussed in chapter 12? Does he express himself precisely? Does he use colorful language?

Practice communicating

The adage, "you learn to do by doing," applies especially to communication skills. Practice under the direction of a skilled critic, however, or your practice may simply make permanent, not perfect. Practice talks in classes prove more beneficial than those in private sessions; you get the

"feel" of communicating by speaking before the class. Speeches or discussions before clubs, church organizations, and other classes offer realistic audiences. Accept as many such assignments as possible during your period of training.

Practice periods outside class with your instructor or an advanced student as critic afford the opportunity for immediate criticism and appraisal. If possible, record some of your practice sessions. After receiving your criticism, play back the tape and note your errors. Several sessions of this type will prove invaluable.

Practice your message several times before giving it in class. Observe these rules in practice: (1) Use an empty room so that you can speak aloud. (2) Imagine yourself before your audience. (3) Speak through the outline extemporaneously from beginning to end. Do not stop and go back over a particular section. (4) Space your practice periods over several days. Several short sessions prove more valuable than one or two long sessions. (5) Force yourself to practice regardless of how artificial the rehearsals appear at first. (6) If you experience difficulty in expressing yourself, try writing out your first few messages. Go over the written manuscripts and improve your choice of language and sentence structure. Do not memorize the message but read your manuscript over several times.

HOW YOU CAN DEVELOP POISE AND SELF-CONFIDENCE

Almost all conscientious people feel some degree of nervous tension when facing an audience or engaging in interviews or small-group discussions. Beginning students often testify that this feeling constitutes their most perplexing problem. Although experience in communication situations tends to lessen the degree of tension, few people ever lose the feeling completely. Instead they learn to bring the feeling under control; they learn not to show the outward signs of tension. More important, they learn to put their tensions to constructive use. A desire to do well increases a person's feeling of anxiety, prodding him to prepare adequately. It also causes him to be alert and energetic while participating. It speeds up his thinking and makes him sensitive to his listeners' reactions.

Tenseness in communication situations has been discussed periodically since the time of the Classical rhetoricians. Volumes have been written about the subject without settling it, but an open discussion of tenseness helps many students; they learn that their feelings of anxiety are not abnormal.

Tenseness is usually more apparent to the communicator than to his listeners. Excessive anxiety, reflected in signs apparent to listeners, may be termed stage fright. Students in communication classes taught over a

20-year span were asked to indicate the degree of anxiety that they experienced while speaking. Their feelings ranged from slight apprehension to extreme stage fright that prevented them from continuing. They were also asked to rate other class members on their poise and confidence. Almost without exception the students ranked themselves lower than did their classmates. Professor E. C. Buehler of the University of Kansas conducted a survey on positive and negative factors in effective speaking among 1,750 students in speech classes and 77 nationally known speech educators. The results showed that the students considered lack of self-confidence as a more serious problem than the teachers did. "The widest difference between experts and beginners occurs on 'self-confidence.' Experts rank it at the bottom of the scale, beginners rank it at the top." [6]

These and other studies indicate that beginning students tend to magnify the problem of anxiety out of proportion to its importance. That the problem is real cannot be disputed; that it produces the harmful results considered by some students must be questioned.

The question arises, "Will taking communication courses help one overcome feelings of anxiety in communication situations?" Speech students answer yes. Of more than two thousand students surveyed over a 20-year period, only four students felt that they experienced more tenseness after taking a course than before. The degree of improvement reported ranged from slight to almost complete control.

Ernest Henrikson of the University of Minnesota concluded, after a survey, that speech training tends to promote confidence both in and out of the classroom. He asked 205 students to indicate on a 10-point linear scale the degree of stage fright that they experienced in speaking. On the scale, 1 indicated no apprehensions; intensity of apprehension increased with each succeeding number, with 10 denoting extreme stage fright. The students reported an average gain in confidence of 6.67 points on the scale as the result of a speech course extending over a quarter-term. The students were also asked to indicate what they considered the reasons for their decrease in feelings of anxiety. Practice in speaking led the list, with 68.8 percent listing this factor.[7]

Tenseness may be partly explained by the fact that most persons fear that which they do not understand. As a beginning student you realize that communication situations constitute a complex process that you do

[6] E. C. Buehler, "Progress Report of Survey of Individual Attitudes and Concepts Concerning Elements Which Make for Effective Speaking." Mimeographed Report. University of Kansas, August 1958. For details of study, see E. C. Buehler and Wil A. Linkugel, *Speech: A First Course* (New York: Harper & Row, Publishers, 1962), pp. 388–91.

[7] Ernest Henrikson, "Some Effects of Stage Fright of a Course in Speech," *Quarterly Journal of Speech, 29:* 4 (December 1943), 490–91.

not fully comprehend. Inasmuch as communication courses familiarize you with the process and give you an opportunity to practice before sympathetic and critical listeners, you may normally expect gains in self-confidence. This discussion considers tenseness from three standpoints—signs, causes, and controls.

Signs of tenseness

Internal signs are rapid beating of the heart, dry lips and mouth, and discomfort in the stomach. In some cases a communicator may experience a lapse of memory that makes recall of his outline difficult.

External signs are excessive perspiration, fast breathing, twitching muscles, nervous swallowing, and a flushed face. Tense feelings may cause such mannerisms as shifting of the eyes, looking away from the listeners, clasping and unclasping the hands, and unnatural variations in rate, pitch, and bodily actions.

Excessive apprehension may account in part for variations in fluency as reflected by increases in rate, excessive use of "ers," "ahs," and "uhs," and a general reluctance to pause. The timing of one's speaking may become affected, causing improper emphasis. A person may give the impression of racing through his material to get it over with.

Undue anxiety may be reflected in the voice in unnaturally high pitch, lack of adequate volume, and breathlessness. Extreme cases may result in a tremble in the voice. In an attempt to prevent these signs from showing, some people force their voices, causing huskiness and hoarseness.

Tenseness may be indicated by such mannerisms of bodily action as too formal posture, swaying body, shaking knees, trembling hands, excessive leaning on the lectern, aimless movements, or restless playing with a pencil or other article. To cover these signs, some speakers assume an unnaturally slouchy posture. They may sit on the desk, slouch over the speaker's stand, rest their weight on one leg, or move aimlessly about with their hands in their pockets. In either extreme, the communicator focuses his attention on what he does rather than on what he says. The mannerisms described here may come from causes other than anxiety, but anxiety is often indicated by these signs.

Causes of tenseness

Psychologists and physiologists disagree on the causes of tensions. Usually tensions result from several causes, and no two people react exactly the same. Despite the varying nature of apprehensions, certain causes can be isolated and explained. An understanding of the causes should precede attempts at control. Consider the following four causes:

1. *Some tenseness is a normal condition of many conscientious people.* According to Professor Bert Bradley, "stage fright is defined as a normal form of anxiety, or emotional tension, occurring in anyone confronted with a situation in which the performance is important and the outcome uncertain." [8] As a speaker, you realize the importance of directing the thinking of your listeners. You realize that the success of your message depends largely upon your ability. Psychologically, almost all people have a certain fear of failure and a desire for success. Directing the thinking of a group constitutes a high type of activity. Because of these factors you desire to succeed but may doubt whether you can measure up to your assignment. Capable people experience these normal reactions.

As a beginning student you may take heart from the story about a great singer who became unusually tense at an important performance. He stopped in the middle of his performance and said: "Yesterday ven I was in ze bath tub I zang zo gloriously I pat myself on ze back and zay, 'Oh, how I vish I vere on ze platform zinging.' Now zat I am on ze platform, I vish I vas back in ze bath tub." His audience laughed with him, and he felt more relaxed during the remainder of the concert.

Some tenseness is not only normal, but desirable. To relieve yourself entirely of apprehensions would deprive you of an important stimulant for your best efforts. Look upon it as nature's way of causing you to be alert. One does better work under controlled emotional stress than when placid or unconcerned. Nevertheless, although tenseness may be normal, excessive nervousness manifested by outward signs mars communication effectiveness.

2. *Excessive tenseness may be caused in part by poor physical condition.* Poor physical condition may cause a person to become nervous while participating in a communication situation. Lack of sleep, improper diet, and lack of physical exercise affect the nervous system. Persons who neglect their physical health decrease their chances of gaining control over their physical mechanism.

Busy people may put off preparing. Since they are not properly rested, they become nervous.

Persons with chronic poor health or physical exhaustion may brood over the seriousness of the assignment and magnify it beyond its importance. Such people may have acquired physical habits that encourage tensions.

3. *Tenseness may be caused in part by lack of proper preparation.* If you feel unsure of your material, fail to prepare adequately, and neglect

[8] Bert Bradley, *Speech Performance* (Dubuque, Iowa: Wm. C. Brown Company, 1967), p. 31.

organizing your ideas properly, you have reason to be apprehensive. Feelings of uncertainty about your subject and preparation may be the greatest cause of anxiety, especially if you consider your listeners well informed on your subject. Poor choice of subject, shoddy preparation, and inadequate organization may build up tensions in experienced communicators; they most certainly will cause apprehensions for the inexperienced.

4. *Tenseness may be partly psychological.* Anxiety may come from a general feeling of insufficiency or inferiority, due to one or a combination of factors. The person who has a physical defect or ungainly appearance, whose economic condition has forced him into inferior environmental conditions, whose efforts have been ridiculed, or whose social aspirations have been thwarted may have developed feelings of inferiority. Some unpleasant experience or questionable action in his life may cause him to fear exposure. These feelings of inferiority may cause him to show fear, or he may attempt to cover his real feelings by an arrogant and blustering manner.

Outward signs of anxiety may be more apparent in some than in others. Some people do not believe sufficiently in themselves. They find trouble adjusting to any social situation and often feel inferior to people less capable than themselves. They have difficulty in adjusting to new situations. Since communication situations involve complex activities, they doubt their ability to cope with their complexity and cannot cover their feelings. Knowledge about communication and practice in the classroom help to allay these fears.

Control of tenseness

The control of excessive tenseness must start with correcting the causes. Consider the following suggestions:

1. *Realize that tenseness is natural.* Students in communication classes often request conferences with their professors to discuss their problems of anxiety. Many of them seem disturbed and consider themselves abnormal because of their apprehensions. When the professor explains that their feelings are normal, they seem relieved. This starts many of them on the road to control of their tensions.

Like these students, you must accept your tensions as normal for many beginning speakers. Try first to control only the outward signs of tenseness; then as you gain more experience in communication and greater understanding of the process, your feelings of anxiety will become less severe. Consider tenseness as a matter to be controlled, not eliminated.

2. *Realize that excessive tenseness can be brought under control.*

Sometimes students who request conferences with their professors report that they still feel apprehensive after the second or third assignment in class. They seem impatient with the slowness of their progress and want results immediately. Unfortunately, a program for bringing tensions under control may be slow and tedious. It can be done, but it takes time and effort. If you expect miracles from your course in communication, you are likely to be disappointed. With some the progress may be so slow as to be hardly perceptible; others make rapid progress. Above all, keep trying. Look upon each new assignment as an opportunity to progress toward your goal of complete control.

Many professors can look with pride on the progress made by some of their students. During his first communication assignment, one student became so nervous that he could not finish. He asked to try again before the class period ended and this time managed to stumble through, but without distinction. On succeeding assignments he always asked to be first and welcomed each opportunity to participate. He later joined the forensic group, where he made such progress that during his senior year he won the award as the outstanding debater. At the annual banquet concluding the forensic year he stated, "When I first started taking speech, I could hardly talk for shaking. Now after taking ten courses, I have learned to talk while shaking." A student who can look on the humorous side of the problem has a better chance for progress than one who takes the matter too seriously. Professors sometimes assign students to try to appear nervous. Unfortunately some students do not have to act, but the assignment gives the class an opportunity to look at the lighter side of the problem.

Many great communicators and performers of history have testified to extreme stage fright. In the Classical period Demosthenes and Cicero wrote of their efforts to overcome excessive tensions. Such outstanding speakers as Benjamin Disraeli, Daniel Webster, Abraham Lincoln, Booth Tarkington, Eleanor Roosevelt, and Booker T. Washington have discussed their apprehensions in print. William Jennings Bryan refused to eat before important speaking assignments for fear his anxiety would make him ill. Lily Pons, Madame Ernestine Schumann-Heink, and Eva Le Gallienne have written of their tenseness at public performances. All these outstanding people and others had one thing in common—they put their tensions to constructive use as they brought their apprehensions under control.

3. Prepare thoroughly. The realization that you know your subject well increases your feelings that you can give your listeners properly appraised facts and mature judgments. You feel confident because of superior understanding.

The processes of preparation form the subject matter of chapters 6

through 10. The application of these processes also affects your feelings of confidence, for you know you have prepared properly. A program of preparation starts with an analysis of your listeners and the occasion. An awareness that you conform properly to the occasion gives you a feeling of social well-being. Knowledge about your listeners assures you that you will communicate in terms that they understand. Such knowledge tends to build up your confidence.

Your choice of subject also affects your self-confidence. You will be more confident if you discuss subjects from your experience and background of knowledge than if you communicate on subjects developed entirely from research. Familiar subjects give you an inner feeling of confidence in your ability to appraise them intelligently.

Do not confuse time spent and time spent *properly* in preparing a message. Proper preparation consists of more than spending many hours in forced preparation. The best preparation comes from thinking through your subject at varying times when ideas occur. The longer you think about your subject, do research on it, and discuss your ideas with others, the more confident you will become. When the idea of your message evolves, it becomes a part of you. You no longer fear that you may forget, for the outline has become mental as well as written.

In developing your subject, observe the following steps: (1) think the ideas through and form a tentative outline; (2) do research to correct original impressions and to gain factual information; (3) revise your original plans in keeping with your investigation; (4) think through your outline and practice your speech. Through careful preparation you help develop a feeling of self-confidence.

4. *Keep physically fit.* Students who put off studying an assignment and then neglect their sleep in last-minute preparation may increase their tensions. Making speeches or participating in interviews or conferences is hard work; it burns up more energy than manual labor for some people. When you are confronted with increased emotional strain under conditions of physical fatigue, the result may be stage fright. Prepare your assignment sufficiently in advance of the occasion to permit proper rest.

Relaxation helps maintain proper physical condition. Over-tensed muscles may cause uncontrollable shaking of hands and knees. If you feel yourself stiffen, attempt to relax by conscious effort; take several deep breaths, put the weight of your body on your heels, or lean your weight on the table or lectern. If you tend to become excessively nervous, attempt to keep physically fit and rested; take time out for rest and recreation; refrain from brooding over your assignment.

5. *Adopt a success attitude.* If you feel a lack of confidence in yourself, try giving yourself a mental pep-talk occasionally. Think in terms of

success, not failure. Concentrate on those communication occasions when you did well, not on those when you felt that you had failed. Think of pleasant experiences, not unpleasant ones. You cannot experience opposite types of emotional reactions at the same time. Thinking in terms of success helps overcome feelings of inferiority.

As you await your turn to speak, focus your attention on your subject matter, not on yourself; think through your outline, not about what impression you may make. Instead of thinking, "How am I doing?" say to yourself, "This subject is important and needs to be discussed. I have prepared my subject thoroughly and can make my point of view understood and accepted." For assignments outside the classroom, remember that you have earned the right to speak; otherwise you would not have been selected.

Attempt to get a physical response from your listeners early in your message. The response may be laughter at an amusing story, applause for a striking statement, or nods of approval for statements with which your listeners agree. Once you feel the response of your listeners, you will concentrate on what you have to say and forget to think about yourself. Thus you will bring your tensions under control without being aware that you have done so.

SUMMARY

Good communication is conversational and direct, balances content and presentation, and does something constructive for the participants. A course in oral communication should develop a person's skills in thinking through a problem, investigating it, organizing ideas, understanding human interaction, presenting ideas orally, and listening critically.

A starting point for developing yourself as a communicator is to take stock of your limitations. Your weaknesses may be considered in three categories: (1) lack of background knowledge, (2) insecurity in the communication situation, and (3) lack of skills in presentation.

To attain oral communication skills, you must desire to improve your communication, develop yourself into an able person, build a background of information and ideas, observe great speakers in action, study great speeches, and practice.

To establish poise and confidence, attempt to bring your tensions under control. Almost all persons experience anxiety in communication situations. Excessive anxiety is termed stage fright. The signs of stage fright are both internal and external. Tenseness is (1) partly a normal condition, (2) partly a result of poor physical condition, (3) partly a result of lack of proper preparation, and (4) partly psychological.

To control tensions, (1) realize that tenseness is natural, (2) realize that excessive tenseness can be controlled, (3) prepare thoroughly, (4) keep physically fit, and (5) adopt a success attitude.

QUESTIONS

1. In reference to Dr. Jeffrey's and former President Lyndon B. Johnson's statements opening this chapter, what do you think should be the relationship between "freedom of speech" and "responsibility to speak responsibly"?

2. Characterize good oral communication today and compare present-day aims with those of 50 years ago.

3. This chapter develops six goals for studying oral communication. What are they? Which goal do you think will be the most difficult for you to attain? Can you add to the goals discussed?

4. Analyze critically the requirements discussed in this chapter on how you can develop yourself as an able communicator. Do you think any of the factors discussed are inconsequential? Can you add to the requirements?

5. On the basis of the discussion of self-confidence in this chapter, how do you rate yourself: completely confident, confident with some reservations, average confidence, lack sufficient confidence, extremely self-conscious? What is your opinion of the section on how to control excessive tenseness?

ASSIGNMENTS

Written

Listen to a speech during the next week and answer the questions listed below about the speaker and his speech. Do not take notes during his speech, but listen carefully and write out your answers from memory. The speaker may be a business executive, one of your professors, a speaker at a civic club, or any other speaker. Reconsider this question after reading chapter 3.

1. In a short paragraph, state the central theme of the address.
2. What were the speaker's main points in developing his theme?
3. Did you have difficulty following the organizational pattern of the speech? Explain.
4. How well do you think the speaker met the standards for judging a good speech as explained in chapter 1? Make a brief comment for each standard.

5. Analyze the speech from the standpoint of (a) invention, (b) arrangement, (c) style, and (d) delivery.
6. What effect do you think this project had on your ability to listen intelligently to a speech?

Oral

Plan A For your second oral assignment prepare a simple reporting speech. Read an article in a current magazine and give a five-minute oral report on it in class. Remember that you are not responsible for the content or organization of the article; your only duty is to report it to the class. Proceed as follows:

1. State the title and date of the magazine, the author's name, and the title of the article.
2. Review the article.
3. Give a brief appraisal or evaluation of it.

Plan B For your second classroom discussion, bring to class three suggested general topics that you would like to see discussed during the term. These topics should grow out of your first classroom discussion. Be prepared to defend your choices and show how each general topic can be divided into subtopics. Following this discussion, the professor should prepare a preferential ballot of those topics most frequently mentioned for submission at the next class period. From these ballots the professor can arrange the class into groups for future oral assignments (see Appendix B).

READINGS

ANDERSON, KENNETH, and THEODORE CLEVENGER, JR., "A Summary of Experimental Research in *Ethos*," *Speech Monographs, 30* (June 1963), 59.

BAIRD, A. CRAIG, FRANKLIN H. KNOWER, and SAMUEL L. BECKER, *General Speech Communication*, 4th ed., chap. 4. New York: McGraw-Hill Book Co., 1971.

CAPP, GLENN R., *Famous Speeches in American History*, pp. 1–16. Indianapolis: The Bobbs-Merrill Co., 1963.

CLEVENGER, THEODORE, JR., and THOMAS R. KING, "A Factor Analysis of the Visible Symptoms of Stage Fright," *Speech Monographs, 28*, No. 4 (November 1961), 296.

GIFFIN, KIM, and KENDALL BRADLEY, "Group Counseling for Speech Anxiety: An Approach and a Rationale," *The Journal of Communication, 19,* No. 1 (March 1969), 22.

MONROE, ALAN H., and DOUGLAS EHNINGER, *Principles and Types of Speech Communication,* 7th ed., chap 4. Glenview, Ill.: Scott, Foresman, 1974.

SCHEIDEL, THOMAS M., *Speech Communication and Human Interaction,* chap. 3. Glenview, Ill.: Scott, Foresman, 1972.

WISEMAN, GORDON, and LARRY BARKER, *Speech/Interpersonal Communication,* 2nd ed., chap. 4. San Francisco: Chandler Publishing Co., 1974.

THREE

Efficient listening and good communication

We learned in chapter 1 that the receiver of a message is an integral part of the communication process and that efficient listening is one of the basic skills the study of oral communication seeks to develop. A listener not only hears the sender's message but reacts to what he hears in relation to his previous exposure to the ideas of the message. The feedback by the listener creates reaction by the sender, who may modify his message as a result. This circular response between sender and receiver results in the communication of information, ideas, and feelings.

The receiver reacts not only to what he hears but also to what he sees and feels. He forms impressions of such factors as the sender's emotional state, his interest in his subject, his knowledge of and qualifications to appraise his subject, and his attitudes toward himself and his listeners. Impressions formed from nonverbal factors often come from subliminal cues, of which the receiver himself is not completely aware. If asked to justify these impressions, the receiver would probably be hard pressed to give a logical explanation.

Have you ever carried on a conversation with someone only to reflect afterward, "We simply did not communicate?" Almost any experienced teacher has explained an assignment or concept in detail only to have a student raise his hand and ask a question, the answer to which the teacher had just given. One student in a classroom panel discussion caused great merriment when he broke into the discussion and related an incident germane to a point which the panel had concluded five minutes earlier. Perhaps you have had the experience of suddenly realizing

during a class lecture or public speech that you had no notion what the speaker was talking about. On these occasions you obviously were present in body only.

Why do we fail to listen? Perhaps your conversationalist had just had an emotionally upsetting experience and was in no frame of mind for small talk. It may be that your professor gave an illustration that caused you to recall a similar experience, so you mentally forsook the lecture to reflect on your experience. Perhaps your conferee had an important meeting coming up for which he felt poorly prepared and was too worried to listen to your problem. It might be that your date of last evening was more interesting to think about than your professor's lecture on omissio in Cicero's speeches. Even if we cannot pinpoint the causes precisely, we know that failure to listen causes a breakdown in communication.

Recent studies reveal a significant breakdown in communication between speakers and audiences. After reviewing several experiments in listening, Professor Ralph G. Nichols concludes that "it is accurate and conservative to say that we operate at almost precisely a 25 per cent level of efficiency when listening to a ten-minute talk." [1] Even in less formal speaking situations an average listener retains no more than 60 to 70 percent of what the speaker says. What causes this breakdown? Most authorities believe that the sender and the receiver of messages share the blame. To help improve listening, consider the following questions: Why listen? What are the requirements for efficient listening? How can you improve your listening habits?

WHY LISTEN?

Listening and reading are the principal methods for acquiring knowledge, ideas, and concepts. As we discussed in chapter 2, most of us listen more than we read. The teaching of listening has been neglected until recent years, but most educators today realize that listening involves a body of knowledge and skills that can be learned and practiced. In short, listening can be improved. Furthermore, listening is as important to communication as speaking, reading, and writing—qualitatively *more* important. What are the principal purposes of listening?

To acquire facts

Scholars obtain most of their facts through research and experimentation. The average citizen spends little time in research and practically none

[1] Ralph G. Nichols, "Do We Know How to Listen? Practical Helps in a Modern Age," *The Speech Teacher, 10:* 2 (March 1961), 120.

in experimentation. He may read the daily newspaper, a few magazines, and an occasional book, but he gets most of his information from listening to the radio or television, from conversing with associates, from participating in conferences, or from listening to speeches. As a source for obtaining facts, listening proves invaluable for the average citizen.

Scholars and speakers also obtain some of their facts by listening. Suppose you decide to speak or participate in a discussion on juvenile delinquency. You may begin your study by interviewing a professor of sociology for facts about social aspects of the problem, a law professor for legal implications, a probation officer for facts on the extent of the problem, and the superintendent of schools and a minister for opinions on how education and religion apply. You may also listen to speeches, lectures, or panel discussions on aspects of the subject. You may discuss your ideas with members of your family, your roommate, or others. In each of these instances you obtain facts through listening. Wilson Mizner, celebrated wit and playwright, says, "A good listener is not only popular everywhere, but after a while, he knows something."

To analyze facts and ideas

Finding facts is an essential first step to understanding, but after acquiring the facts you must ask, "What do the facts mean?" The process of appraising the facts, of breaking a subject into its constituent parts, and of assessing causes and effects is termed analysis. Chapters 7 and 14 explain the process of analysis in detail.

The point at issue here is "How does listening affect analysis?" Consider the mental processes of a critical listener. He constantly analyzes what a person says; he talks back in his mind. The sender of messages sets up trains of thought which the receiver considers in relation to his knowledge and experiences. Speakers talk at a rate of 120 to 150 words per minute, but listeners can comprehend at a rate of 300 to 500 words per minute. A critical listener uses the time afforded by the speaker's slower rate to analyze the speaker's ideas and facts. In short, listening provides an occasion for analysis.

To evaluate facts and ideas

Having determined what the facts and ideas mean, the listener asks next, "What are the facts worth? How accurate and valuable are they?" He may think, "I agree; what you say corresponds with my experiences and understanding." Conversely, the listener may think, "I disagree; your point contradicts my experiences" or "I am not sure; you still have to show me."

If the listener agrees with the speaker, he usually labels the speaker's

ideas as mature and his facts as accurate. If he disagrees, he may consider him prejudiced because of his economic, political, or social philosophy. He may think that the sender has been influenced by propagandists or that his ideas reflect his own interests. He may believe that the communicator has made an immature evaluation of his subject, that he does not know what he talks about. He may conclude that his statistics cover only a limited phase of the subject, that his examples reflect extreme cases, that the objects he compares are not comparable, or that the authorities he cites are incompetent. In short, the listener passes judgment, weighs assertions, and evaluates facts and opinions.

For inspiration

We sometimes listen, not for information or ideas, but to be inspired. Inspirational speeches abound in our society because they fulfill certain human needs. Professional people often attend conventions or institutes more from a desire to renew their enthusiasm than to acquire information.

A well-planned convention begins with a keynote speech designed to create enthusiasm or to inspire the delegates. Speeches of anniversary and dedication seek to increase listeners' respect for organizations or great movements in history. Sales managers, directors of promotional organizations, and campaign managers hold meetings designed to promote their programs. Many religious services, patriotic rallies, and homecoming gatherings are based on the need for inspiration. In brief, the desire for inspiration constitutes a worthy reason for listening.

For entertainment

We often listen for no other purpose than pleasure, for relaxation and entertainment. Enjoyment is a basic desire of humanity, a desire for release from the cares of everyday living. We sometimes invite people into our homes on social occasions for the pure enjoyment of conversing. We listen to radio and view television basically for entertainment. We attend the movies, plays, and sports events for pleasure. We are entertained on many occasions, such as banquets, club meetings, and parties. We derive entertainment from the human or light notes introduced into persuasive and informative speeches. In brief, entertainment serves a valuable purpose for listening.

To improve your communication

A perceptive person can improve his communication through observation. We sometimes attend local council meetings or legislative sessions

in part to observe the skills of the participants. To listen efficiently, we must have a plan for analyzing the message and the communicator. The plan should include much that will be learned in this text: how the sender of messages conforms to the standards of effective oral communication, how he adapts his remarks to his listeners, how he composes his material and supports his points, and how he makes coordinated use of mind, body, voice, and language for effective presentation.

REQUIREMENTS FOR EFFICIENT LISTENING

The sender of messages must understand the prerequisites of efficient listening in order to improve communication. Upon what does efficient listening depend? Why do people listen attentively to one speaker or participant in a conference, and not to another? The answer depends on any one or a combination of the following factors: (1) the listener's attitude, (2) the listener's interest, (3) the listener's motivation, and (4) the listener's emotional state. In short, listening depends largely on the listener's readiness and willingness to listen.

Listening depends on attitudes

Probably no single factor affects efficient listening more than the listener's attitude. Efficient listening requires an objective, unprejudiced, cooperative attitude. If the listener has a biased attitude he may hear only those facts and opinions that conform to his beliefs. Opinionated people usually make poor listeners. They refuse to listen to opposing views because of their prejudices. A person may be objective on some questions but subjective on others. Some years ago a university committee of department chairmen was appointed to revise the list of required courses. On many other questions these professors showed considerable objectivity; on the topic of required courses they were highly subjective because they feared that their subjects might be left off the required list. Many people have difficulty maintaining an objective attitude when their interests are at stake.

Sometimes our political, economic, and social attitudes are formed early in life as a result of our environment. We do not want those fixed opinions challenged; questioning them disturbs our complacency. We therefore refuse to listen to ideas that might shake our beliefs. Because a person dislikes communism or anything else is no reason for him to refuse to listen to viewpoints opposed to his own. As will be explained in chapter 7, we become unteachable when we think that we know the final answer to any question; we refuse to listen. Consider your opinions on

such questions as the Watergate scandals, segregation, religion, and prohibition. Do you find difficulty being objective on these topics?

Our attitudes may be influenced by our knowledge of and experience with the subject discussed. An educated person usually is a more perceptive listener than an uneducated person. A perceptive listener relates what he hears to his knowledge and experiences. Conversely, people with little knowledge often become passive listeners. They have little knowledge to which to relate the speaker's ideas, so they have difficulty in understanding them; they stop listening or only half-listen.

Professors Elizabeth Andersch, Lorin Staats, and Robert Bostrom emphasize that you must *want* to listen:

> *Regardless of our feelings toward a speaker or his subject, we must make up our minds to reconstruct his message or our presence in the communication situation is a fraud. The good listener keeps looking for values in the speaker's message. Even if he considers the delivery of the speaker poor and the subject dull, he must try to understand and refuse to be diverted by his own subvocal criticisms of the speaker's failings.*[2]

A person who wants to listen profitably neither strongly agrees nor strongly disagrees with the speaker early in his message. Rather, he maintains a questioning, open-minded, creative attitude. He withholds final judgment until the speaker develops his idea.

Listening depends on interests

We listen to ideas that interest us. In chapter 4 we shall distinguish among primary, secondary, and momentary interests. The distinction also applies to listening. We have a primary interest when we have a direct stake in what the speaker talks about, when his proposal affects our daily living. You may consider some phases of education purely academic; but when the speaker suggests an increase in tuition rates at the university you attend, you become actively interested. The businessman may be mildly interested in the subject of taxation, but he becomes greatly interested when his conferee proposes an increase in taxes on his business. The professional woman may show little interest in social security, but she becomes intensely interested when the speaker proposes that she be included in the program. We listen when what the sender of messages says relates to our primary interests.

We show interest also when the sender appeals to our secondary interests. As citizens of a community we view the public works program

[2] Elizabeth G. Andersch, Lorin C. Staats, and Robert N. Bostrom, *Communication in Everyday Use*, 3rd ed. (New York: Holt, Rinehart and Winston, 1969), p. 208.

of the federal government with fleeting interest; but when the president vetoes an appropriation bill which halts construction on our new dam, we become alive to the issue. When a person proposes a new civic center, we listen because the proposal affects our common interests. Many subjects relate to our secondary interests, and we show interest when a communicator refers to them.

Other matters may command our momentary interests. We show more interest during election year about the financing of elections than we do in an off-election year, just as we became intensely interested in the powers of the president during the Watergate and impeachment hearings. We are more receptive to the proposal to abolish football when a member of the local team suffers a serious injury than when the team enjoys a healthy and successful season. We show momentary interest in many matters of a temporary nature, and we listen when a sender of messages refers to those momentary interests.

We also show more interest in familiar than in unfamiliar things. Students are interested in campus problems, teachers in matters of education, business executives in finance and investment, and lawyers in legal rights. The automobile worker in Michigan is more interested in the steel strike in Pennsylvania than in the longshoremen's strike in San Francisco. Similarly, the sharecropper in Appalachia shows more interest in the president's program for combatting poverty than does the steel worker in Pennsylvania. We become interested when our conferee talks about familiar problems, matters close to us.

We are also interested in active and novel ideas. When a sender of messages shows enthusiasm, talks about striking and concrete things, and uses language of action, we show interest.

Listening depends on motivation

We listen when a person appeals to our basic desires and needs. We become interested when he shows that his proposal means money in our pockets, increased prestige in our community, greater authority over other people, or the preservation of things which we hold dear. People's basic motives have been classified variously by many writers. A. E. Phillips, former director of Phillips School of Oratory in Chicago, gives us a comprehensive and workable classification: (1) self-preservation, (2) property, (3) power, (4) reputation, (5) affection, (6) sentiment, and (7) taste.[3]

1. Self-preservation. Self-preservation is perhaps the most basic of all motives. Animals reflect the instinct to survive, and have characteristics

[3] A. E. Phillips, *Effective Speaking* (Chicago: The Newton Co., 1910), p. 48.

that help make survival possible. Small animals have protective coloring and can conceal themselves effectively; others can move rapidly and avoid detection; still others have the strength and agility to protect themselves by force and dexterity.

People are governed to a large extent by their desire to survive—to obtain food and shelter, to protect their health and comfort, to preserve their minds and bodies. They lock their homes to protect their possessions; they resort to the courts to protect their rights; they call mass meetings to protest high taxes and inflation; and they go to war to protect their way of life. Self-preservation is a basic law of nature. When a sender of messages links his proposal with the basic desire for survival, listeners pay attention.

2. Property. The desire for material things is important in the lives of most people. We all desire land, goods, and money—things that we can call our own. Modern advertising often makes its basic appeal to this motive with the result that some people buy more than they can afford. Differences in the basic appeal of the government bond campaigns show how advertising uses the appeal to basic motives effectively. During World War II, the basic appeal was made to self-preservation: "Buy bonds and help protect the American way." After the war, the basic appeal was to property: "Invest three dollars now and get four dollars back."

The desire for material things inheres in our system of free enterprise. It motivates people to devise more efficient ways of increasing profits. It causes merchants to sell at the lowest prices consistent with maximum profits to induce people to buy more. It causes laborers to form unions, capitalists to organize pressure groups, and professional people to join associations. If a sender of messages can show his listeners how to increase their profits, how to do their tasks more efficiently, how to save money, or how to add to their material possessions, he makes them want to listen.

3. Power. Authority and influence are strong motivating factors with some people. Assistant managers strive to become managers; lieutenants work to become captains; instructors seek professorships. Ambitious people strive to improve themselves. They seek responsible positions of power and authority over others.

The desire for power motivates students to strive for high academic records and excellence in extracurricular activities. It causes adults to take correspondence and evening division courses. It causes business and professional people to attend conventions and refresher courses. People desire to improve themselves so that they may extend their influence. The communicator who can show his listeners how to increase their influence and authority will increase their desire to listen.

4. Reputation. The desire for recognition and admiration is a universally compelling motive. Most people strive for social approval, to be respected by their associates. They accept positions of responsibility—civic, church, professional—because it increases respect for them among their associates. They wage political campaigns to be city council member, mayor, member of the school board—positions that require much time and effort with little or no financial reward—because they desire social approval. Students strive for medals, awards, and prizes in part because they desire the admiration of their fellow students.

The salesperson appeals to reputation when he seeks to sell a new home, household furnishings, and the latest-model automobile. The real estate promoter stresses that the new subdivision is restricted to homes of distinction. The insurance salesperson furnishes a list of influential citizens who have insured with his company. He stresses the importance of "keeping up with the Joneses." In the same way that the salesperson gains acceptance of his product by an appeal to reputation, the sender can get the idea of his message accepted by showing how it will enhance his listener's reputation.

5. Affection. Love of family, friends, and country constitutes a strong motivating force. Love of family is perhaps the strongest kind of affection. The insurance industry was built largely upon this motive. Educational savings programs owe their popularity to love for one's offspring. Attitudes of goodwill toward all people have their inception in love of friends. Civic pride, school spirit, and church loyalty are based upon the warm feelings we have for members of our social groups. Love of country causes us to go to war. We may criticize our neighbors, institutions, and country; but when these are threatened, we rally to their support.

Our ethical standards of fair play, personal honor, and respect for others are motivated largely by love and affection. Religious convictions arise from love for a supreme being. The sender of messages who appeals to affection causes receivers to listen.

6. Sentiment. Sentiment determines our sense of loyalty and patriotism. We go to great expense to establish museums, restore historic buildings, and preserve historical documents, largely for sentimental reasons. Sentiment occasions protests from the alumni when a college administration proposes to replace the original campus building with a more modern structure. We may be reluctant to move to a modern home out of sentiment for the old home. We lament the passing of the local literary society because we have formed a sentimental attachment to it. Our sense of loyalty causes us to maintain friendships with people with

whom we no longer have anything in common. The communicator who appeals to sentiment gives his listeners an added inducement to listen.

7. Taste. The love of beauty, adventure, and new experiences forms a compelling motive for sensitive people. Not all our actions are motivated by practical considerations; some stem from aesthetic appreciation. We appreciate the works of the masters in painting, music, poetry, drama, and sculpture because they appeal to our aesthetic sense. Automobile manufacturers go to great expense to design streamlined cars with attractive colors and decorations; we call in interior decorators to harmonize the color and design of our new home; we vacation in the beauty spots of our country. We do all these things because of our sense of beauty and harmony. The communicator who defers to our aesthetic appreciation motivates us to listen.

Listening depends on emotional state

Our willingness and ability to listen depend in part on our emotional state. Undesirable emotional conditions for listening may be the result of an emotional upset, a reluctance to attend the speaking occasion, a lack of interest in the subject, or a crowding out of desire to listen by other pressing problems. On the other hand, failure to listen may result from attitudes toward the communicator. We may consider him incapable of a constructive analysis of his subject because of his youth; his lack of training, experience, and prestige; or his immaturity of judgment. Something the speaker says may cause us figuratively to tune him out. He may express extreme, illogical, or dogmatic statements that offend our sense of intelligence. He may make statements contrary to our political, economic, or social beliefs and thus antagonize us. He may fail to support his ideas with adequate evidence and thereby reveal his lack of knowledge. Any of these factors may cause us to stop listening or to listen with negative or antagonistic attitudes.

Another idea explained earlier in this chapter affects our emotional conditions for listening. We tend to listen to what we want to hear and refuse to listen to ideas contrary to our existing beliefs. We listen to what pleases us.

Professor Ralph G. Nichols of the University of Minnesota and freelance writer Leonard A. Stevens, in their book *Are You Listening?*, state:

> *In different degrees and in many different ways, listening ability in all of us is affected by our emotions. Like the troubled college student, we often "reach up and turn off" what we don't want to hear. Or, on the other hand, when we especially want to hear, we open our ears wide, accepting anything —truths, half-truths, or fiction.*

We might say, then, that our emotions act as filters to what we hear. At times they, in effect, cause deafness, and at other times they may make listening altogether too easy.

When the emotions produce deafness, it can happen like this: If we hear something that opposes our most deeply rooted prejudices, notions, convictions, mores or complexes, our brains may become over-stimulated, but not in a direction that leads to good listening. We mentally plan a rebuttal to what we hear. Or sometimes we formulate a question designed to embarrass the talker. Or perhaps we simply turn to thoughts that support our own feelings on the subject.

When emotions make listening too easy, it usually results from hearing something which supports our deeply rooted inner feelings. When we hear such support, our mental barriers are dropped and everything is welcomed. We ask no questions about what we hear; our faculties are put out of commission by our emotions.[4]

In short, good listening depends upon the emotional state of the listener. The sender should understand that his receivers listen best when they are free of emotional disturbances, when they disregard their strong prejudices and feelings and adopt attitudes of willingness to listen.

In summary, efficient listening depends upon the attitudes, interests, motivation, and the emotional state of listeners. An understanding of these requirements will aid both the speaker and the listener in attaining improved listening.

HOW TO LISTEN

Having learned the requirements for efficient listening and how the communicator may encourage listening, we now consider the listener who asks, "How can I improve my listening habits?" First, consider how listening differs from reading as a basis for understanding the methods for efficient listening.

The reader depends largely on the printed page. The listener receives impressions not only from what he hears but also from the nonverbal cues of the sender of messages—his emotional state, his self-confidence, and his use of voice and bodily action.

The reader can stop to ponder or to reread ideas not fully understood at first reading. The listener at a public-speaking occasion must understand instantaneously; he cannot ask the speaker to repeat or stop while he considers what has been said. Even in a less formal communication

4 Ralph G. Nichols and Leonard A. Stevens, *Are You Listening?* (New York: McGraw-Hill Book Co., 1957), pp. 90–91.

situation the listener must work harder than the reader to comprehend; he must remain alert at all times.

Consider the following suggestions as aids to listening: (1) concentrate, (2) understand what to listen for, (3) listen critically, and (4) use mechanical aids for listening.

Listen with concentration

To concentrate, you must prepare yourself to listen. Adopt a cooperative and objective attitude; create an interest in the subject; realize how the subject matter of the message can help you; and turn off your emotional blocks. Try to anticipate the occasion; review what you already know about the subject; think through the topic and attempt to anticipate how the subject may be developed. These suggestions will help you to concentrate.

To improve listening, you must realize that concentration requires effort. As explained earlier, listeners can comprehend at a faster rate than speakers can talk. Use the excess time to think, weigh, and review what the speaker says. If you spend your time thinking of other matters, daydreaming, or solving personal problems, concentration becomes impossible. Nichols and Stevens stress this factor in concentration as follows:

> *The brain deals with words at a lightning pace, but when we listen, we ask this brain to receive words at an extremely slow pace. It might seem logical to slow down our thinking when we listen. . . . But slowing thought processes is a difficult thing to do—almost painful. Therefore, when we listen, we continue thinking at high speed while the spoken words arrive at slow speed. In the act of listening, the differential between thinking and speaking rates means that our brains work with hundreds of words in addition to those we hear, assembling thoughts other than those spoken to us. To put it another way, we can listen and still have spare time for thinking.*
>
> *What do you do with your spare thinking time as you listen? The answer to this question holds the key to concentration in listening.*[5]

Concentration requires continual, not spasmodic, attention. Some people listen attentively for a few minutes, think of other matters or daydream for a while, and then turn their attention again to the speaker. This irregular type of listening may be caused by one or more of many reasons: distracting influences such as outside noises or late arrivals, peculiarities of the speaker's manner or presentation methods, uncomfortable physical arrangements, or lack of interest in the subject. Regard-

[5] Ibid., p. 79.

less of cause, spasmodic listening prevents comprehension of the fully developed idea. The listener must try to ignore distracting influences.

In short, concentration is a basic requirement for efficient listening. Concentration requires an attitude conducive to listening, a willingness to work at listening, and continual attention to the speaker. Listening is not a passive thing; it requires a great deal of effort.

Learn what to listen for

To listen efficiently, you must know what to listen for in various communication situations. Listening to speeches or fully developed ideas in conferences is perhaps the most difficult type of listening, because properly constructed messages often develop several ideas, each based on the other; to miss part of the message destroys the sequence of ideas. Communicating in person-to-person or small-group situations is more fragmentary and repetitive than in public speaking. If you do not understand at first, you can ask your conferee to repeat or to expand an idea.

An understanding of the process of oral composition will aid your listening materially, for then you will have a blueprint of what you should look for in a message. Part 2 treats content and arrangement in detail. As you read this part of the text, consider how the principles apply to listening as well as to communicating. Not all the principles discussed in part 2 apply to listening, but those that apply to communicating may be summarized as follows:

1. Determine the purpose of the message. Listen to determine if the main purpose is to persuade, to inform, or to entertain. The nature of the occasion or the statement of the topic usually suggests the purpose, or the communicator may reveal it in his introduction. For a persuasive message, the critical listener demands adequate evidence and logical reasoning. For an informative message, he asks for mature judgments and accurate evidence. For entertainment, he wants humor in good taste. Understanding the purpose helps the listener prepare to listen.

2. Listen for the partition of the message. Listen to how the communicator reveals how he intends to limit and develop his subject, how he states the central theme, and how he defines technical terms and makes necessary explanations for an understanding of his subject. The partition may consist of only a few sentences, but they are important to listeners because here the speaker explains what will follow.

3. Determine the central theme of the message. Listen for a central theme that unifies the message. Since the main points are built around this central theme, it aids the listener in keeping the message in focus.

The central theme may be stated in a concise sentence or two as part of the partition, or it may unfold as the communicator develops his main points.

4. Determine the communicator's main points. Since the main points consist of the three or four principal divisions of a message organized in the several ways discussed in chapter 9, listen to determine which method the communicator uses. The main points bring out or develop the central theme; they are the legs that support the table, the main ideas that support the thesis. A knowledge of how communicators arrange their main points aids the listener because he knows what to look for in a message.

5. Listen for the forms of support. Listen to determine how the forms of support fill in the structure of the message, what types of support the communicator uses, and how much support he gives. The forms of support consist of such illustrative materials as examples, analogies, statistics, and quotations from authority. They aid the listener because they fill in the details essential to understanding a point or argument.

6. Listen for restatement and summary. Listen to determine how the communicator restates his points—verbatim, in different words, or through quotations. Listen for restatements of ideas within a point, at the end of a point, and at the conclusion of the message. In the final summary, see if the communicator restates all the points and relates them to the central theme. Since almost all listeners fail to understand all that a communicator says the first time, restatement and summary serve the listener well in giving unity and coherence to a message.

In such person-to-person communication situations as an interview, the opening serves to establish rapport between the interviewer and the interviewee through discussing some pleasantry or matter of mutual concern. The content of the interview is carried out through well-planned questions designed to elicit the desired information or instructions. The closing rechecks the information obtained or recommendations made, and concludes the interview pleasantly. For a small-group problem-solving conference, attention is first centered on the purpose of the session and on a mutual understanding of the problem; next the problem is explored as to its causes and effects; then possible solutions are considered in hopes of agreeing on a mutually satisfactory solution; last, methods for implementing the desired solution are discussed.

Listen critically

Listeners can be classified into four groups: (1) Some do not listen; they tune the sender out and think of matters foreign to his subject. They

get little from a message. (2) Some only half-listen; their spasmodic listening fluctuates all the way from careful attention to no attention. They understand fragments of the message but do not see the idea as a whole. (3) Some listen with passive acceptance; they accept all the sender says without question. Because of their lack of discrimination, they add little to what he says from their own experiences. (4) Some listen with discrimination; this critical type of listener gets the most from a message. If you adopt the following measures you will soon find yourself a member of the last group.

1. Relate what the sender says to your experiences. As you listen, trains of thought will be set up in your mind which will stimulate you to think constructively. Relate what the sender says to your studies and experiences. You may agree with him on some points because you have had similar experiences; you may disagree on some others because through your study you have come to a different conclusion. On still others you will find yourself reserving decision until you can give them further thought and investigation. By considering these relationships you will be practicing an important aspect of critical listening—you will be thinking constructively.

2. Review and arrange what you hear. Draw together what the sender says and your thoughts, by summarizing and synthesizing the whole. Think ahead of the sender and anticipate how he will develop his central theme. An intelligent speaker organizes his message to bring out a well-developed theme; you help the speaker by summarizing previous points in your mind, by predicting the next point, and by relating all points to the basic philosophy and central idea of the message. Realize that communication is a two-way street; you, as a critical listener, participate actively in the communicative process.

3. Analyze and evaluate what you hear. Listen to understand, but do more than that—analyze and weigh what the sender says. Neither believe nor disbelieve all that he says. Listen with discrimination. First, analyze by breaking down ideas into their constituent points, subpoints, and supports. Then, weigh the sender's statements (1) to test the adequacy of evidence, (2) to test the validity of reasoning, and (3) to determine the sender's true purpose. Apply these criteria:

1. Adequacy of evidence. Does the evidence come from reliable sources? Does it accurately represent what the sender says it represents? Is it sufficient to justify his conclusions?
2. Validity of reasoning. Do the sender's conclusions follow logically from his premises? Does he conform to acceptable rules for logical reasoning?

3. True purpose. Distinguish between subjective and objective material, propaganda and fact, dogmatic assertion and well-supported conclusions. Do you perceive any propaganda techniques, manipulations of language?

When you have completed this process, you will be able to assess the message in its entirety. And you will know that if the message embodied something of value, you have plucked it out for yourself; conversely, if the message was a "hidden persuader," you will know that you have not been "taken in."

In summary, to be a critical listener you must understand the dual processes of communication—the sending and the receiving. You must participate cooperatively by adding to what the sender says from your experience: by reviewing, by synthesizing, by analyzing, and by evaluating what you hear. You must be active on the responding end of oral communication.

Note-taking as an aid to listening

The question arises, "Should I take notes as I listen?" The answer depends on what use you intend to make of what you hear. If you listen for inspiration, for entertainment, for an evaluation of the communicator's methods of composition and delivery, or to add to your general knowledge, notes serve little purpose. If you listen to get facts, to analyze what the sender says, or to evaluate what you hear, notes will probably assist you. If you intend to use what you hear at a later date to pass an examination, to support a point in a speech, or to illustrate ideas in an essay, notes may be of great value.

Note-taking can aid listening by encouraging concentration, by providing materials for review, and by assisting recall. However, if the system of note-taking itself requires concentration, it can interfere with listening. Consider the following suggestions for efficient note-taking. These will also be useful in taking notes in course lectures.

1. Use an informal system, the simpler the better. The rules for outlining given in chapter 10 are too detailed and cumbersome for note-taking. Use a simplified form of outlining that combines short paragraphs, sentences, phrases, and single words. The notes need be intelligible only to you.

2. Make your notes brief. Take down only the salient points and factual material. Take notes while the sender makes transitions, when he restates his ideas, when he summarizes his points, and when he pauses.

3. Use abbreviations and symbols. Shorthand and speedwriting serve the note-taker well. If you do not know these systems, devise one of your own. Use

symbols to represent phrases, and single letters or abbreviations for words. Try to cut the time spent in writing to a minimum.

4. Make your notes clear. Despite the foregoing suggestions, make sure that your notes are intelligible to you. Then, if you want to later, you will be able to make a permanent record by expanding your abbreviated class notes.

5. Mark important points for emphasis. Underscore or mark important points with asterisks. As you scan notes, such markings will help you recall the gist of your notes without having to read them fully.

6. Review your notes periodically. For class purposes, review your notes several times during the progress of the course. Relate your daily notes to the course units. Before final examinations, study your notes carefully and relate them to the course as a whole.

SUMMARY

Listening, the counterpart of reading, is an important part of oral communication. Knowledge about communication aids the listener because it teaches him what to look for in a message. The answer to "Why listen?" is sixfold: (1) to acquire facts, (2) to analyze facts and ideas, (3) to evaluate facts and ideas, (4) to be inspired, (5) to be entertained, and (6) to improve speaking.

Requirements for efficient listening consist of four listener factors: (1) attitudes, (2) interests, (3) motivation, and (4) emotional state. The listener's attitude should be objective, unprejudiced, and cooperative. His interests in the sender's subject are either primary, secondary, or momentary. The main motives that make listeners want to listen are self-preservation, property, power, reputation, affection, sentiment, and taste. Undesirable psychological feelings that prevent sustained attention may result from the listener's emotional upsets, his antagonistic attitudes toward the sender, or his objections to statements made by the sender.

To listen efficiently, the listener must listen with concentration, know what to listen for, listen critically, and take notes effectively. Concentration requires effort and a cooperative attitude. The listener should look for the principles of composition and delivery discussed in the two following parts of this text. To listen critically, the listener must add to what the sender says from his own experience, review and arrange what he hears, and analyze and evaluate what he hears. When performed effectively, note-taking aids efficient listening. For effective note-taking observe the following principles: (1) use an informal system, (2) make notes brief, (3) use abbreviations and symbols, (4) make notes clear, (5) mark points for emphasis, and (6) review notes periodically.

QUESTIONS

1. What do you think accounts for the breakdown in communication between the sender and the receiver of messages? How significant is this breakdown?
2. Of the six reasons given for why we should listen, which do you consider most important? Can you list other reasons for listening?
3. Upon what does efficient listening depend? How do you account for your variations in listening?
4. Explain what is meant by a critical listener. How can you improve your ability to listen critically?
5. Explain some advantages and disadvantages of note-taking as an aid to listening.

ASSIGNMENTS

Written

You will have two weeks for this assignment. Listen to two types of public speeches and answer the questions below about them. For one speech, do not take any notes; listen carefully and write your answers within two days after listening to the speech. Take notes on the second speech, observing the suggestions made in this chapter. Use your notes in answering the questions listed below. You may attend any type of speaking occasion you desire—for example, a formal lecture, a church service, or a college debate—or listen to a radio or television speech.

1. What general purpose did the speaker have—to inform, to persuade, or to entertain?
2. Could you isolate the partition of the speech as a part of the introduction? Did the speaker define any technical terms? If so, what terms and how did he define them? Did he narrow or limit his subject? How?
3. In one or two sentences, state the central theme of the speech. Did the speaker state the central theme specifically or did it unfold as he spoke? In your opinion, did the speaker make effective use of the central theme?
4. How many main points did the speaker have? List them. In your opinion, were his main points well chosen? Did the main points develop the central theme adequately?
5. Did the speaker use a variety of the types of support? Did he seem to favor one form over others? In your opinion, did the speaker support each point adequately? Interestingly? Explain your answers.

6. Did the speaker restate ideas within a point? If so, on some points or on all points? Did he summarize at the end of each point? Did he give a detailed summary in the conclusion? Of the three types of summaries explained in this chapter, which type or types did the speaker use?
7. What effect do you think that this assignment had on you as a listener? Of the four types of listeners characterized in this chapter, how do you classify yourself?

Oral

Plan A For your third speaking assignment, read an editorial or a syndicated article in a newspaper or magazine and disagree with it in a speech limited to five minutes. Proceed as follows:

1. Briefly review the editorial or syndicated article and clearly state its central point.
2. State the reasons why you disagree.
3. Support each reason with statistics, examples, illustrations, or quotations.
4. Briefly summarize your points.

Plan B For the third oral assignment, the class groups will meet simultaneously for the purposes of organizing and getting acquainted with other members of the group. The professor should designate a temporary chairman of each group. Follow this procedure:

1. Each student gives a two-minute biographical sketch.
2. After the biographical sketches, elect a permanent chairman and secretary.
3. Discuss specific topics under the general subject and designate a specific topic for each group member.
4. If time permits, exchange ideas on the general topic and on where materials can be located.
5. At the end of this session, the secretary should hand the professor a list of subtopics chosen for each student and the names of the permanent chairman and secretary.

READINGS

BARKER, LARRY, *Listening Behavior.* Englewood Cliffs, N.J.: Prentice-Hall, 1971.
BROOKS, WILLIAM D., *Speech Communication,* 2nd ed., chap. 4. Dubuque, Ia.: Wm. C. Brown Co., 1974.

JOHNSON, WENDELL, *Your Most Enchanted Listener.* New York: Harper & Row, Publishers, 1956.

LEWIS, THOMAS R., and RALPH G. NICHOLS, *Speaking and Listening,* chaps. 2, 3, part C. Dubuque, Ia.: Wm. C. Brown Co., 1965.

MONROE, ALAN H., and DOUGLAS EHNINGER, *Principles and Types of Speech Communications,* 7th ed., chap. 17. Glenview, Ill.: Scott, Foresman, 1974.

NICHOLS, RALPH G., "Do We Know How to Listen: Practical Helps in A Modern Age," *The Speech Teacher, 10,* no. 2 (March 1961), 118.

NICHOLS, RALPH G., and LEONARD A. STEVENS, *Are You Listening?* New York: McGraw-Hill Book Co., 1957.

WISKELL, WESLEY, "The Problem of Listening," *Quarterly Journal of Speech, 32,* no. 4 (December 1946), 505–8.

Analyzing listeners and occasions

We have already learned that effective communication depends upon both the sender and the receiver of messages. The receiver can do much to improve communication by employing the instructions given in chapter 3. The sender can make the receivers' task easier by adapting his message to their interests and capacity for understanding, to make them willing or even eager to listen. This sharing of responsibility for communication applies whether your listeners consist of one person, a small group, or a large audience. Analyzing a large audience may be more difficult than analyzing one person or a small group, but the same principles apply. To make the proper adaptations, the speaker must learn all he can about his listeners and the occasion to guide him in preparing and presenting his message. Only by making such an analysis can the communicator predict the probable effect of his message on his listeners.

WHY ANALYZE LISTENERS AND OCCASION?

A professor received a telephone call inviting him to speak to a women's study club. He was busy when the call came, so he asked few questions about the occasion or the probable audience. Recalling that another member of the faculty had spoken to the club earlier, he asked her about the type of audience and the nature of the occasion. The friend said that the women met monthly to hear addresses on national and international problems and that they would expect a speech reflecting considerable research and thorough analysis. Consequently he prepared a speech on "The Possibilities of Peace through World Government."

He arrived at the meeting place only to discover that the women were staging their annual banquet, not a regular meeting. At this social

occasion merriment formed the keynote. A hillbilly band and singer preceded his speech. He saw that his planned speech did not fit the occasion. Although he attempted to inject some humor before making his address, there was no getting around the inappropriateness of his talk. He simply had failed to analyze his audience and occasion properly.

The essential factors of any communication situation include not only the sender and his message but the receiver and the occasion as well. The professor's unhappy experience reflects the importance of prior analysis of the audience and the occasion for public communication in determining the subject, the type of speech, the methods of appeal, the elements of interest, and the choice of supporting materials. Consider these factors as an essential part of the total communication situation. They apply to person-to-person and small-group occasions as well as to large audiences.

Since you desire to communicate in terms that your particular listeners will understand in relation to their experiences, training, and interests, make listener analysis the initial step in each preparation. Include the following: (1) analyze the listeners, (2) analyze listener feedback, and (3) analyze the occasion.

HOW TO ANALYZE LISTENERS

Your listeners will differ considerably from one another in background, experience, and interests. Since you cannot adapt your message to each individual except in person-to-person situations, you must seek out common characteristics of each particular group of listeners—those factors that caused their attendance at the same occasion. This analysis applies especially to public audiences, as explained by Professors Martin Andersen, Wesley Lewis, and James Murray:

> *Audiences are composed of individuals who have met together at a specific time, in a real place, to listen to a particular speech, which should have some effect on their knowledge, beliefs, or perhaps future actions. The essence of prespeech analysis is to obtain facts related to the common and diverse experiences and characteristics of the particular audience, those which determine its attitudes toward the subject and the speaker's purpose.*[1]

The faculty of the department of oral communication in an American university and the city public school administration invited a well-known

[1] Martin P. Andersen, Wesley Lewis, and James Murray, *The Speaker and His Audience* (New York: Harper & Row, Publishers, 1964), p. 176.

television executive to the city for consultation about establishing a cooperative educational TV program. He first met with the university department faculty and outlined a program which met with their enthusiastic approval. Next he appeared before a committee of the public school board of education, where he outlined the same program. It was rejected.

How can you account for the different results? Consider these factors: (1) The interests and desires of the faculty were more homogeneous than those of the committee members; the faculty had a primary interest in television, but the committee members had only a secondary interest since they represented various businesses and professions. (2) The faculty had a favorable attitude toward the value of television in education; the committee members' attitudes varied, but many might have been characterized as neutral. (3) The faculty knew and respected the consultant, whose credibility was high with them; the committee members knew little about the consultant, so his prestige did not help much in winning acceptance for his proposals. (4) The faculty members had much in common with the consultant because they were near the same age, had similar education and experience backgrounds, and came from largely the same social and cultural environment; these factors differed considerably among members of the committee and the consultant.

The consultant had apparently had the faculty members in mind as he prepared for the conferences and had underestimated the importance of the committee members, who differed widely in interests, attitudes, and backgrounds.

This actual incident points up the importance of determining as much about your probable listeners as possible when you accept an assignment. It also indicates how you should analyze your listeners. Consider the factors of analysis in more detail, as follows:

Determine listener interests

The first point considered in the foregoing incident was listener interests. The university faculty members in the department of oral communication had an intense interest in educational television because they realized its vast potential in education, its importance in keeping their department abreast of the times, and its value in extending the department's influence in the university. They had been studying the problem for several years. The consultant did not need to capture their interest, stress the importance of his subject, or sell them on the need for educational television. But he needed to do all these things in his conference with members of the board of education, because their prior training and experiences had

not created the same interests. Perhaps the consultant's failure to analyze properly the differences in the interests of these two groups of listeners accounts for his lack of success with the board members.

Another incident occurred when a commercial photographer was asked to address a press club on the subject of commercial photography. He made careful preparation and felt that he had made a good speech. Later a university faculty club asked him to make the same speech. This time he felt that he had failed miserably. He gave the same speech; why the difference?

He had planned the speech with the first audience in mind. He chose illustrative material and ideas that appealed to their interests. In short, he spoke their language. But the language of the first audience was not the same as that of the second; their interests and problems varied greatly. When you plan your speech, keep your specific audience in mind as you choose your ideas, supporting material, and elements of interest. What interest factors should you consider?

1. Primary interests. Attempt to determine if your listeners have a common primary interest. Are they of the same profession or business? If so, your problem is much simplified because people in the same profession have certain common interests. Relate your ideas and illustrative material directly to those interests; talk in terms that your listeners understand. A large propaganda organization considers audience interests of such importance that whenever its representatives have important speaking engagements, the organization sends an advance agent into the community to sound out local interests. The speech is then rewritten in view of the findings. High-salaried specialists write such speeches. These organizations realize the importance of audience interests. You can profit by their experience.

2. Secondary interests. If your listeners do not have common primary interests, determine if they have common secondary interests. Suppose you agree to speak at the annual banquet of the country club. Your audience will represent many professions with a variety of primary interests, but they have a community of secondary interest in recreation and entertainment. Choose your subject, ideas, and supporting materials from these fields. How about talking on the problem of leisure-time activities in America? In our computer age of short work days and even four-day work weeks, this problem assumes major importance among thinking people. An annual banquet of persons engaged in a common social activity provides an excellent setting.

3. Momentary interests. If your listeners do not have common primary or secondary interests, consider their momentary interests. Discover

matters of local concern that interest most persons in the community. Suppose you speak to a civic club in a city where the local university's football team enjoys a winning season. You can be assured that the businesspeople will be interested in the team's victories. Capitalize on this momentary interest. Recently a visiting speaker gave the commencement address at a Southern university. He illustrated his points so well with instances of local common interest that his listeners were delighted with his knowledge and concern for them. The city had recently witnessed a devastating tornado. The speaker seemed to know as much about the details of the tragedy as did members of the audience. What members of the audience did not know was that the speaker had subscribed to the local newspaper for a month before the speech. Furthermore, he arrived in the city a day before his engagement and busied himself in seeking out local problems and interests. Speaking to an audience with diverse primary and secondary interests, he did a remarkable job of supporting his ideas with matters of momentary interest in the community.

In short, never plan a message to be given in a vacuum. Remember that you talk with people, not simply about a subject. Discover their interests and let these interests guide you in each step of your preparation.

Determine listener attitudes toward the subject

In the example of the television consultant, the conferees from the communication faculty favored his thesis from the beginning because they were seeking a means to establish a community educational-television program. He needed only to outline a program, explain its costs, and give evidence that it would work. The members of the board of education were somewhat skeptical since they were not directly involved with television. They wanted to know why the program was needed, how it could materially help the public schools, and how the costs could be justified. Their differing attitudes toward his subject called for different approaches by the consultant.

In a local-option election a speaker addressed an audience of temperance workers in the interest of their campaign. Although members of the audience favored the speaker's position, he berated them for over an hour on the horrors of strong drink. He shouted and raved with such vehemence that one listener remarked that he appeared to be full of his subject. Did this well-meaning speaker do his cause any good? Did he give the right type of speech for the audience? His dogmatic approach probably did his cause more harm than good. Some people were probably driven from their original positions. Did the speaker need to discuss the evils of drink? Obviously not, to a believing audience. Rather, he needed to discuss procedures for conducting the campaign and to emphasize the

importance of active participation. Members of the audience wanted to know what they could do to forward the campaign, not to be harangued on a thesis with which they already agreed.

Consider the following possible attitudes that your listeners may have toward your subject: (1) They may be favorable—in agreement with your thesis; (2) they may be hostile—opposed to your point of view; (3) they may be apathetic. To treat your subject the same way before these different groups invites failure. What are some characteristics of these types?

1. Favorable attitude. Why speak before favorable listeners? You may need to strengthen their belief or increase their enthusiasm and fervor for the cause you represent. You may want to move them to action, to indicate how they may help in a common endeavor.

A businessman addressed several kinds of audiences when he campaigned for a place on the local school board. Since the election came soon after the Supreme Court's decision on segregation, this issue played an important part in the campaign. His first invitation to speak came from some black leaders. Since the candidate favored integration for the local schools, he simply explained his position and outlined how the listeners could help in the campaign. He appealed to them on rational grounds and asked for a common-sense approach to the problem. He used little emotional appeal; the members of the audience already wanted to assist with the campaign. An emotionalized speech on the moral, social, and economic injustices of segregation would have been both unnecessary and unwise; it might have induced irrational behavior in certain members. This favorable audience needed a plan of action and admonition to show restraint in putting it into effect.

As a starting point for communicating, analyze the beliefs of your listeners; then plan your message to do something constructive for them in view of their existing beliefs.

2. Hostile attitude. Consider listeners hostile to your position. Here you run a real danger of doing your cause more harm than good. The speaker mentioned in a preceding section had one message on prohibition which he gave indiscriminately before temperance workers, liquor distillers, or any others who would listen. You can imagine the effect he had on hostile audiences when he spoke as if all who opposed his position were stupid, evil people. He probably increased the vigor of their opposition.

Yet some of the outstanding speeches in history have been those properly presented to hostile audiences. Henry W. Grady's "The New South" illustrates this point. Here we find a Southern editor addressing an Eastern audience during the Reconstruction period following the Civil

War. The hostile feeling against the South had recently been intensified with the election of Grover Cleveland, a Democratic president, in 1884. The New England Society of New York City, to which he spoke, consisted of a highly conservative group who opposed Grady's defense of the South. Yet they arose at the end of his speech with an acclaim rarely accorded any speaker. How did Grady accomplish this difficult feat?

No doubt Grady's magnetic personality and attitude of goodwill helped. His psychological appeals also helped. He started his speech by quoting Benjamin H. Hill, a man respected by members of his audience. Then he expressed appreciation for being asked to address the society. He injected humor in excellent taste, some of which poked fun at himself as well as at his audience. He made a reference to fair play and emphasized that intelligent men should consider varying points of view. He paid a tribute to Abraham Lincoln and dealt with matters on which the audience agreed. He apparently succeeded in getting a series of "yes" responses from his audience and then led gradually into his defense of the South, which he then developed on rational grounds. Grady's methods may be adapted to many hostile audiences.

3. Apathetic attitude. A different problem arises when your listeners are apathetic. Consider first how to awaken your listeners to the importance of your subject. Link it with the basic drives, needs, and desires in people. Show your listeners why they should be concerned.

In the latter part of 1919, Woodrow Wilson was confronted with such audiences in his speaking campaign in the interest of the League of Nations. The nation had just concluded a devastating war, and most persons were trying to forget the problems of war and peace as they turned their thoughts to more personal things. They simply were not interested. In his speech at Des Moines, Iowa, on September 6, 1919, he attempted to shock them into concern. Note these words of his introduction, "My fellow countrymen, the world is desperately in need of the settled conditions of peace, and it cannot wait much longer. . . . The world is not at peace." He made an impassioned plea for the United States to take the initiative in formulating a permanent program of peace through the League of Nations, to show the way for nations not accustomed to freedom. Did his speaking program awaken the people from their apathy? Many would say no because we did not join the League of Nations. But who knows? Perhaps his efforts had a delayed effect that caused us to help establish the United Nations some 25 years later.

In summary, try to determine the attitude of your listeners toward the ideas of your message. If it is apathetic or hostile, plan your approach to induce them to accept your ideas.

Determine listener attitudes toward the sender

The television consultant described earlier had an initial advantage in his conference with the communications faculty because his conferees considered him an expert on educational television. They had used his textbooks, heard him speak at professional conferences, and read his research reports. They accepted his ideas in part because his credibility was high with them. He was not held in such high regard by his conferees from the board of education because they had little reason to know of his reputation. They were elected representatives from various businesses and professions not primarily concerned with educational television. They required that the consultant use more facts, logical proofs, and psychological appeals than he had with the communication faculty. A person's reputation and credibility help significantly in getting his ideas accepted.

Several years ago an aged doctor gave a series of lectures to a university student body and faculty. He was one of the most beloved persons in the community, having devoted his life to unselfish service. A communication teacher was heard to remark that, although he did not hear a new idea in the lectures, he valued highly the opportunity to hear the speaker; the doctor exemplified "a good man, skilled in communicating." How different this comment was from one made by a student after hearing a lecture by a disgruntled professor: "The trouble with Professor X is that he stopped having ideas 20 years ago; how unfortunate he did not stop teaching them." What listeners think of you affects how your ideas may be accepted.

A young person speaking before mature people faces a problem that a respected older person does not. Since the young person does not have the reputation to command respect, his message must reflect careful analysis, conscientious judgment, and rational appeals, and must marshal adequate evidence, to compensate for his lack of maturity. Young speakers can command respect. Henry W. Grady was only 36 when he gave his famous speech, "The New South"; Booker T. Washington was under 40 when he delivered his Atlanta Exposition Speech.

Consider these possible attitudes of your listeners toward you: (1) favorable, (2) unfavorable, (3) neutral.

1. Favorable attitude. If your listeners like and respect you, they will accept much of what you say because they want to; they respect your worth as an individual, your knowledge of your subject, and your ability to make mature judgments. This kind of reputation does not come easily; it usually comes from a life of useful works and sympathetic understanding of people.

Dr. Alexander Jerry Stoddard addressed a school board on the subject

of educational television. He discussed problems that the group had previously considered, but he did so with such understanding that the group was able to decide on several problems largely through his influence. They respected his judgment partly because of his years of successful school administration in such places as Denver, Philadelphia, and Los Angeles. More important, they felt the influence of his personality, his kind and sympathetic understanding, and his humble and simple approach. He did not claim to know all the answers, but he gave the impression that his advanced years had dulled neither his inquiring mind nor his desire for more knowledge. He did not have to "act big," because he *was* "big."

Few communicators enjoy so high a regard from listeners as Dr. Stoddard. All should strive for better acceptance. Conversely, those who have attained favorable acceptance should be careful to appraise accurately what they talk about because listeners may accept their ideas at face value.

2. Unfavorable attitude. If your listeners are unfavorably disposed toward you as a person, your approach should be twofold: (1) Attempt to create an atmosphere of fair play wherein your listeners will withhold judgment pending the development of your message. (2) Develop your message through a preponderance of logical proof.

Note how Patrick Henry attempted to create an atmosphere of fair play in his "Liberty or Death" speech before the Virginia Convention at St. John's Church, Richmond, Virginia, on March 23, 1775. Preceding speakers had set a tone unfavorable to Henry's position and many members of the convention were opposed to Henry as a person.

> *Mr. President: No man thinks more highly than I do of the patriotism, as well as abilities, of the very worthy gentlemen who have just addressed the house. But different men often see the same subjects in different lights. . . . The question before the House is one of awful moment. . . . I consider it as nothing less than a question of freedom or slavery; and in proportion to the magnitude of the subject ought to be the freedom of debate. It is only in this way that we can hope to arrive at truth, and fulfill the great responsibility which we hold to God and our country. Should I keep back my opinion at such times through fear of giving offense, I should consider myself as guilty of treason toward my country. . . .[2]*

Although the speech as a whole could hardly be classified as one based primarily on logical proof, Henry did show excellent skills in

[2] William Wirt, *Life and Character of Patrick Henry*, 25th ed. Philadelphia: Claxton and Company, 1881, p. 38.

creating a tolerant atmosphere. Note that Henry showed a friendly attitude toward his opponents and the audience, appealed to their sense of fair play, showed where they had common interests and beliefs in the problem, gave evidence that his opinion came from careful study, and stated that he should speak out in justice to himself and the convention. These techniques may well be adapted to many unfavorable audiences.

In the 1952 presidential campaign, vice-presidential nominee Richard M. Nixon received $18,000 from a group of supporters that some charged was appropriated to his personal use. The incident created considerable unfavorable reaction and some opposition leaders asked that he withdraw his candidacy. Mr. Nixon took his case to the people with an address over national radio and television on September 23, 1952. The introduction to the speech follows:

> *My fellow Americans: I come before you tonight as a candidate for the vice-presidency and as a man whose honesty and integrity has been questioned.*
>
> *Now, the usual political thing to do when charges are made against you is either to ignore them or to deny them without giving details.*
>
> *I believe we have had enough of that in the United States, particularly with the present administration in Washington, D.C.*
>
> *To me the office of the vice presidency of the United States is a great office, and I feel that the people have got to have confidence in the integrity of the men who run for that office and who might attain them.*
>
> *I have a theory, too, that the best and only answer to a smear or to an honest misunderstanding of the facts is to tell the truth. And that is why I am here tonight. I want to tell you my side of the case.*[3]

Although subsequent events have caused the same speaker to use the same theme and methods on other occasions, there is no denying that he has been one of our most experienced speakers in facing hostile audiences and that his skills kept him in public office for almost 30 years. The introduction emphasized that the issue must be met head-on, that integrity of political candidates is important, that an accused person has the right to present his side of the case—principles which Americans cherish. Psychological appeals go far in overcoming the opposition of listeners even if the results may sometimes prove embarrassing.

3. Neutral attitude. If you are little known or consider your listeners neutral toward you, attempt to establish rapport by finding a

[3] Associated Press release, September 23, 1952. Reprinted by permission of the White House.

common bond with them. In Senator Tom Connally's early years in the United States Senate, he spoke to students at a university whose president had been his roommate while in law school. Senator Connally delighted the students by relating incidents about escapades in which he and their president had engaged while students. His good-natured fun directed toward the dignified president won over the student body.

If the speaker is unknown to an audience, the person introducing him should furnish information about his training, experience, and accomplishments. A good speech of introduction helps to impress the audience with the speaker's credibility and authority, as do judicious statements by the speaker himself. For example, statements about special studies made by the speaker, honors received, and sources studied in preparation enhance the speaker's qualifications. Such statements should never be made with braggadocio, but should rather be brought into the discussion indirectly.

In summary, try to determine in advance the possible attitudes of your listeners toward you. Prepare your message with this analysis in mind. Capitalize on favorable listeners by emphasis on subject matter, not by unnecessary introductory remarks designed to create acceptance of you as a person. With unfavorable or neutral listeners, spend adequate time in establishing rapport with them so that they will more likely accept your ideas.

Determine facts about your listeners

To guide your choice of subject, purpose, interest appeals, and the idea of your message, determine as many facts as possible about your listeners in advance. Consider the following: age, size of group, background of training and knowledge, social and cultural background, opinions and beliefs.

1. Age. Why determine the approximate age range of your listeners? Some communication situations consist primarily of young, middle-aged, or older groups. With such specialized audiences, you should choose ideas, support them, and use appeals, illustrations, and language directed at their particular age level. Other listener groups are heterogeneous; they may range from young to old. In this type of listener situation, you may want to direct your message to a particular age group. At commencement exercises, for example, you may direct your message to the graduates; the parents and friends simply observe. As a member of the student council, you would direct your remarks to other members of the council although other age groups might be present to observe

the proceedings. In a televised public speech, you must decide whether to direct your message to the specialized live audience present or the heterogeneous mass-media audience.

Regardless of what your analysis reveals, you will need to consider certain psychological factors that apply to differing ages. We have previously discussed the credibility of the communicator; his ideas will be accepted in part because his listeners perceive him to be qualified and trustworthy. Thus a well-known and respected older person will have greater credibility than a little-known younger person. As a young person, you will have greater credibility when communicating with your fellow students than with members of the faculty or citizens in the community. As a college student, your credibility may be high when you return to address the students in your hometown high school—especially if you have received local recognition for some outstanding accomplishment in college.

Consider also that young people are usually more open-minded to new ideas than older people. Conservatism usually comes with age; perhaps the young have less to lose by their liberal tendencies. Normally they are more willing to experiment with new ideas than are older people; therefore, they may require fewer logical and psychological proofs than older people on proposals designed to change the established order.

The very young usually require a more forceful and energetic presentation than do older people. Lacking background of ideas, information, and critical faculties, their attention may be easily diverted. When speaking to such listeners, consider the interest as well as the logical adequacy of material.

2. Size. If you have ever had the experience of planning a message for a small, intimate group only to find yourself confronted with a large, formal audience, you will understand the importance of determining audience size. Consider the following reasons: (1) The smaller the group, the more unified it is in the several respects we have already discussed, and one must choose a subject and develop it accordingly. Before a small audience of experts in a particular field, for instance, one speaks in more technical language; given the same topic, one speaks in more general terms before a large audience of nonexperts. Likewise, before a small group with unifying primary interests, one can develop an appropriate subject intensively, knowing the listeners will comprehend; before a large group with a diversity of primary interests, one cannot go so deeply into the subject. (2) Meetings generally are held in rooms proportionate in size to the size of the audience. Small rooms are acoustically better than large ones; therefore, one can speak more rapidly in a small room, whereas one may have to speak at an unusually slow rate in a large room. This must be taken into consideration in planning the length of

the message, or, if there is a time limit, in planning how best to develop one's theme in the allotted time. (3) One's feeling of intimacy is stronger with a small group; with a larger group, one must plan to establish rapport before proceeding with the message. These differences make important your determination of probable audience size.

3. Background of training and knowledge. Determine the extent of training and knowledge of your anticipated listeners. Are the listeners college graduates or uneducated people, highly skilled or unskilled workers, business or professionally trained personnel, widely read or poorly informed people? The failure to know such facts may cause you to talk above or below your listeners' capacity to comprehend. Beware of talking down to your listeners; most people can detect a condescending attitude and they usually resent it. Note these psychological factors in point: (1) The less knowledgeable require a more detailed development of an idea with necessary background for understanding it. They may not have the understanding that you might assume, especially if you are an expert in your subject. (2) Beware of selecting illustrations or other supporting materials outside the knowledge of your listeners; for example, you would not refer to Quintilian's treatment of *ethos* in addressing a junior high school speech class, or to the theory of economic equilibrium in addressing an audience of unskilled laborers. (3) The less experienced and trained are usually more suggestible; they accept your assertions with less proof than do people with advanced training. (4) The less educated require a more lively and forceful presentation; their attention may be diverted more easily than that of the well educated.

4. Social and cultural background. What is the social background of your listeners? The general environmental background of individuals often determines their attitudes toward social, political, and economic problems. Their interests and ability to understand vary with their social background. For example, factory workers would probably not be interested in, nor understand, references to mythology, poetry, or the classics. Such references would be more appropriate to business executives or professional people. Those with poor social and cultural backgrounds are usually more suggestible and more susceptible to forceful presentation than are those with better backgrounds.

5. Opinions and beliefs. Listener opinions and beliefs evolve as a result of such factors as economic status, religious and political affiliation, association with ethnic groups, membership in organizations, and business or professional affiliations. These attitudes arise largely from environmental associations, the conditions under which people grow up and the ideas to which they have been exposed. To avoid antagonizing or offending your listeners, consider their probable opinions and beliefs

toward the thesis of your message. If you propose right-to-work laws, for example, your approach would be different before an audience composed of labor-union members than one consisting of business executives. If you oppose pari-mutuel betting, you would likely have a favorable audience when speaking to church organizations but a hostile audience when addressing race-horse breeders. If you favor reforms in the financing of political campaigns, your approach would differ when addressing the Young Republican and Young Democrat clubs on your campus. This admonition does not mean that you should seek out listener beliefs and opinions and advance ideas which they favor; that would be the worst kind of sophistry. It does mean that you should use a reasoned approach and avoid antagonizing your listeners as you speak your convictions.

In short, determine the general age level, number, background of training and knowledge, social and cultural background, and opinions and beliefs of your listeners so that you can plan your messages with these factors in mind.

ANALYZE LISTENER FEEDBACK

We learned about the circular nature of the communication process in chapter 1. The sender sends a message which the receiver receives and reacts to; the sender in turn receives feedback from the receiver, which may cause him to modify his plans for his message. The feedback from the receiver may be in the form of a verbal response as well as a physical reaction in person-to-person or small-group communication situations; it will be in the form of cues from audiences which the public speaker must interpret. These cues come from physical reactions and consist of overt behavior. Writing of the overt reaction of audiences, Professor Theodore Clevenger states:

> *More often than any other type of information, the overt behavior of the audience is used as a basis for inferring process responses to communication. The speaker who maintains close visual directness with his audience is constantly monitoring their behavior and on that basis inferring their momentary responses to his speech.*[4]

Rarely will your preliminary analysis of your listeners and communication occasion be entirely accurate. Hence, keep close watch on the reactions of your listeners during your message. You may be able to make adjustments to correct such factors as inattention, misunderstanding, or disagreement.

How do listeners react? An attentive person sits forward and moves

[4] Theodore Clevenger, Jr., *Audience Analysis* (Indianapolis: The Bobbs-Merrill Co., 1966), p. 62.

occasionally; he shows reaction in his face, by head and shoulder movements, and by eye contact. He may show approval by nodding his head, smiling, laughing, gesturing, or applauding. He may show disapproval by frowning, shaking his head, whispering to his neighbor, making hand gestures, or booing. A quiet audience is not necessarily an attentive audience. Some experienced speakers can sense audience attention from signs of which they are not completely aware.

If you feel that your listeners are losing interest, failing to understand you, or disagreeing, consider the following: (1) You may need to be more enthusiastic about your subject. You cannot expect to arouse listener interest unless you show enthusiasm yourself. (2) You may need to change the rate, volume, or pitch of your voice. A monotonous presentation invites inattention. (3) You may need to make your material more interesting by relating it to the interests of your listeners. Bring your message close to your listeners through illustrative material within their experience. (4) You may need to define and explain technical terms or be less abstract. You may be speaking at your listeners rather than communicating with them in terms that they understand. (5) You may need to be more tolerant or less dogmatic in stating your views. Most people are willing to listen to opposing views if they are expressed diplomatically but they expect the communicator to be reasonable. (6) You may be going too much into detail or developing your points in too elementary a fashion. Listeners react unfavorably if they sense that a person speaks down to them or belabors his ideas. (7) You may need to correct peculiarities of presentation. Alter objectionable mannerisms or change your stance and position. Use bodily action to help express yourself; action generates enthusiasm. (8) You may need to correct faulty room ventilation. An overheated room is especially conducive to listener inattention.

Listener monitoring should continue throughout a speech, discussion, or conference. Sometimes listener reaction may change noticeably during the course of a public speech or small-group discussion. In person-to-person situations you may sense that your conferee is not in the proper frame of mind for a productive conference; therefore, you may terminate the appointment as soon as possible and await a more appropriate time. Experienced communicators seem to sense the reactions of listeners and modify their plans accordingly.

HOW TO ANALYZE THE OCCASION

A business executive received a telephone call asking him to participate in a panel discussion at a conference on leadership. Since he had discussed this topic on previous occasions, he readily consented. After arriving at the meeting, he discovered that his conception of a panel discussion was

different from that of the program chairman. In educational parlance, the term *panel discussion* means an informal discussion without set speeches. To the layman, apparently, the term means whatever he wants it to mean at the moment. To the program chairman of this meeting, it meant a prepared 15-minute speech by each of the four panel members. The speaker was somewhat perturbed by this turn of events. Thereafter, he used more caution in determining the requirements of the occasion.

What would you do if you found yourself in similar circumstances? Avoid getting yourself into such a position by making the proper inquiry about the occasion and purpose of the meeting. What should you know about the occasion? Consider the following points:

What is the purpose of the meeting?

A school administrator was asked to give the commencement address at the summer exercises of a university. He chose as his subject, "How to Get a Position." He covered such points as the importance of combing your hair, pressing your trousers, and cleaning your fingernails in preparing for a job interview. His topic would probably have been appropriate to an eighth-grade class in hygiene, but it hardly met the propriety of the formal occasion of a university commencement program.

A communicator should know the purpose and circumstances of the occasion. Is it a regular meeting of some organization, such as a civic club, that customarily includes speeches on the program? If so, the choice of subject and type of speech will usually be left to the speaker. Suppose you agree to speak at the laying of the cornerstone of the new school building. On this formal occasion you should treat some educational problem in a dignified manner. The type of speech required for a homecoming rally would be quite different from one prepared for a chapel program arranged by the same college. Be sure that plans for your speech conform to the reasons for the meeting.

Instead of a public address situation, suppose the occasion is a person-to-person or small-group conference. It is nonetheless important to know the exact purpose of the meeting to enable you to prepare properly. Usually the person arranging the conference will give the reason for calling it and, for group meetings, will furnish an agenda. For such occasions, your preparation will be more general than for a public speech, but understanding the purpose makes for improved conferences.

Does the occasion call for a regular ritual?

A businessman accepted an invitation to speak at a church during the absence of the minister. Because of a mix-up in the church office, no

program was printed. The businessman reported that he felt ill at ease because he was not sure how to proceed. Many communication occasions have regular customs and rituals. To avoid embarrassment, you should inquire in advance about such matters. Will other speakers appear on the same program? Will a discussion follow your speech? Does the organization have a set procedure? Is the occasion formal or informal? How much time should you take? Knowledge of these facts will help you plan your speech intelligently.

Some programs may be so poorly arranged that the proper atmosphere will not be created for your talk. For example, one speaker planned a speech with a serious purpose, but the humorist who preceded him created an atmosphere of merriment. The speaker overcame his unforeseen difficulty by first fitting in with the mood created by the previous speaker and then gradually changing it to an atmosphere appropriate for his speech. The situation would not have occurred if he had found out beforehand the general plan for the evening or requested that the program be made specific.

What physical conditions will prevail?

The less a communicator leaves to chance, the greater the likelihood of communicating with the listeners. This final analysis applies to the physical conditions likely to prevail. Although physical conditions cannot always be determined with accuracy in advance, by arriving a few minutes early a communicator has time for last-minute adjustments. Consider the following factors: (1) size and shape of the lecture room, (2) outside noises and disturbances, (3) platform equipment, and (4) provisions for visual aids.

1. Conditions of the lecture room. Size and shape of the lecture hall may vitally affect your speaking. Experience in speaking in combination gymnasium-auditoriums, characteristic of some rural schools, shows that the acoustical factors may increase the time necessary to present a speech as much as 20 percent. Usually no attention is given to acoustics in such buildings, and the echo produced necessitates a decrease in rate of speaking. Often an increase in voice volume is required. Failure to consider acoustics may make your speech unintelligible. On other occasions a small audience may be scattered throughout a large auditorium; for best results, the speaker should ask the audience to move to the front of the room.

For informal communication situations, will the participants be seated around a table or in some other arrangement? Will you have room to keep the materials you want to display close by or will it prove awkward

to use them? Will there be a blackboard that you can use for demonstration purpose or should you provide handouts? Will the meeting room be comfortable, the seating uncrowded, the atmosphere pleasant? The more accurately you can anticipate these matters, the greater your chances for contributing constructively.

2. Outside disturbances. Where possible, avoid seating your listeners facing windows, since glare affects their vision and comfort. Face them away from entrance doors to minimize disturbances caused by late arrivals. Outside noises may materially affect communication. If you must compete with construction workers, power mowers, airplanes, or trains, do not show annoyance, for such feelings are contagious. If ringing class bells, telephones, or other temporary noises interrupt, pause until they subside. If they continue, proceed without calling undue attention to them.

During a speech by a British consul to some college students, the loudspeaker blared forth with a recording by a popular pianist. After poking good-natured fun at the appropriateness of his musical accompanist, he paused temporarily to see if the music could be stopped. When informed that the control room was locked, he finished his address without showing annoyance. He received a standing ovation, partly because of an excellent address and partly because of his good sportsmanship in continuing under adverse conditions.

3. Platform equipment. Stage equipment may also affect the plans for your speech. One speaker accustomed to keeping his notes in a loose-leaf notebook found that no lectern would be provided for his high school commencement speech. The speaker had to choose between speaking without notes or using a cumbersome system. He solved the problem by making brief notes on small cards, but he would have felt more at ease with his detailed notes. You need to consider, also, such factors as whether you will speak from a raised stage, whether loudspeaker equipment will be provided, and whether the audience will be comfortably seated.

4. Visual aids. If you plan to use visual aids, provide for their use in advance of the occasion. Some rooms do not have provisions for certain types of projectors or displays; others must provide trained personnel to operate the equipment. Last-minute arrangements may cause inconvenience for those sponsoring the program.

In summary, determine the physical conditions of the lecture hall in advance; attempt to adjust your plans to the size and shape of the room, the outside noises, and the stage equipment; and provide for the display of visual aids.

SUMMARY

To communicate adequately, you must understand the nature of your listeners and the occasion. Analyze your listeners, listener feedback during your message, and the occasion and the physical conditions of the meeting place.

You analyze listeners by determining (1) their interests; (2) their attitudes toward your subject; (3) their attitudes toward you; (4) facts about their age, number, background of training and experience, social and cultural background, and opinions and beliefs.

Analyze listener reactions or feedback as you communicate. Try to determine the causes of inattention or unfavorable reaction and attempt to correct them during the presentation of your message.

You analyze the occasion by determining the following: What is the purpose of the meeting? What rituals or customs will prevail? What physical conditions will prevail?

QUESTIONS

1. Determine the differences in your pre-communication analysis of the following communication situations: (1) The American Institute of Banking plans to hold its annual convention on your campus. They invite you to speak at its opening session as a representative college student. (2) The National Chamber of Commerce plans its state convention in your city. They invite you to speak. (3) You are asked to speak at a mass meeting of local citizens called for the purpose of protesting excessive noise on your campus.

2. How would you analyze the listener situations in #1 as to their primary, secondary, and momentary interests?

3. What would be the differences in your approach to the following types of listeners for a speech on "Reforms in Financing Federal Elections"? (1) They favor your thesis. (2) They are hostile to your point of view. (3) They are apathetic toward your subject.

4. How important do you consider listener feedback? How can you interpret this feedback? What might you do to modify your messages as a result of your interpretation of listener feedback?

5. What information would you need about the communication occasion to guide you in your preparation and presentation?

ASSIGNMENT

Plan A For your fourth assignment, plan a *Problem-Cause-Solution* speech on a topic of your choice. For example, you may speak on the

energy crisis, traffic safety, students' rights, powers of the presidency, outer-space exploration, women's rights, racial relations, inflation, recession, hypocrisy in religion, amnesty for war resisters, or any other problem of local, state, national, or international interest. Proceed as follows:

1. Point up the problem. Cite statistics, examples, comparisons, illustrations, or testimony to show that a problem exists. Support opinions by facts.
2. Explain what you think caused the problem. Beware of stressing only one cause if there may be several.
3. Point out how you think the problem could be solved or the situation improved. State the reasons for your ideas.
4. Summarize your points and end with a quotation, illustration, or appeal.

Plan B For your fourth oral assignment, the class groups will meet simultaneously for the purpose of reporting on your initial readings. Each member of the group will review a magazine article on his or her subtopic; time limit five minutes. Proceed as follows:

1. State the title and date of the magazine, the author's name, and the title of the article.
2. Review the article; report its content to your group.
3. Give a brief appraisal or evaluation of it.

READINGS

BRYANT, DONALD C., and KARL P. WALLACE, *Fundamentals of Public Speaking,* 5th ed., chap. 13. Englewood Cliffs, N.J.: Prentice-Hall, 1976.

CLEVENGER, THEODORE, JR., *Audience Analysis.* Indianapolis: The Bobbs-Merrill Co., 1966.

CRONKHITE, GARY, *Persuasion: Speech and Behavioral Change,* chap. 7. Indianapolis: The Bobbs-Merrill Co., 1969.

ELLINGSWORTH, HUBER W., and THEODORE CLEVENGER, JR., *Speech and Social Action,* chaps. 5–6. Englewood Cliffs, N.J.: Prentice-Hall, 1967.

GRUNER, CHARLES R.; CAL M. LOGUE; DWIGHT L. FRESHLEY; and RICHARD C. HUSEMAN, *Speech Communication in Society,* chap. 3. Boston: Allyn & Bacon, 1972.

HOLTZMAN, PAUL D., *The Psychology of Speakers' Audiences,* part 3. Glenview, Ill.: Scott, Foresman, 1970.

SMITH, DONALD K., *Man Speaking: A Rhetoric of Public Speech,* chap. 7. New York: Dodd, Mead, 1969.

WILSON, JOHN F., and CARROLL C. ARNOLD, *Public Speaking as a Liberal Art,* 3rd ed., chap 3. Boston: Allyn & Bacon, 1974.

FIVE

Small-group communication

We explained in chapter 1 that communication originates in the mind as you assign meaning to various stimuli. This intrapersonal communication consists in part of daydreaming, thinking, reflecting, and even in writing notes and talking to yourself. The next level of communication involves conversing with one person, termed a *dyad*. This interpersonal communication occurs in face-to-face two-person arrangements and ranges from chance conversations to structured interviews. Two persons may communicate socially, to give or receive information, to persuade or influence each other, to solve mutual problems, to counsel or be counseled, to seek or secure employment, or to discuss any other matters of mutual concern. Your success in intrapersonal and interpersonal communication situations depends partly on how you develop yourself as a person, as we discussed in chapter 2. Although this text emphasizes small-group and public communication, many of the principles for developing yourself as a communicator and preparing for and participating in communication situations apply directly to two-person communication.

This chapter centers on small-group communication in which all persons present interact and alternate as senders and receivers of messages. In intrapersonal communication, a person reflects only with himself. In public communication, he interacts with an audience; the speaker does all the talking and the audience listens. Although the listener may mentally "talk back" to the speaker, he usually does not make audible responses. In small groups, all persons present engage in the communication situation as senders, receivers, and reactors to what others say.

Professors Saundra Hybels and Richard Weaver explain the process succinctly:

Small-group communication is multilateral—that is, it takes place from one person to several others, and any one of those several others is free to respond.

Thus, feedback occurs between a number of individuals, each person respond-
ing to all of the others as potential sources of communication. All members
speak and listen with equal responsibility because the primary source of com-
munication is constantly changing. Individuals switch from speaker to listener
and back to speaker again, instantaneously.[1]

The number of participants in small groups may vary widely, and
the degree of interaction usually varies in inverse proportion to the
number of participants. Groups exceeding fifteen participants usually
prevent uninhibited interchange of ideas; groups of three to five usually
serve best. Our interpretation of the small group does not hinge on the
number of participants, but rather on whether those involved interact
both as senders and receivers or at least have the opportunity to do so.

Small groups exist and meet for many purposes: the family is probably
the most basic of all groups; peer groups bulk large in our lives; we as-
sociate in groups for social interchange, for therapeutic purposes, for
exchanging ideas and information, and for solving problems. We are
concerned in this chapter primarily with learning and problem-solving
groups. The oral exercises listed under Plan B at the end of each chap-
ter and explained in some detail in Appendix B emphasize the small
group's function in cooperative preparation and analysis of problems
and in considering solutions to them. Small-group communication is the
principal method by which democratic bodies carry out their business,
and its use has increased greatly in recent years.

John W. Keltner of Oregon State University stated in the late 'fifties:

We can't live alone in our complex society. The day of the cave man mak-
ing his way with a big stick is over. Our democratic way of living demands
that we cooperate with each other through intelligent discussion to solve the
problems of living together. It demands that we develop efficient methods of
group decision-making.[2]

Later, Professor Ernest G. Bormann of the University of Minnesota said:

Teachers of speech and communication have long recognized the role of
discussion in the democratic dialogue, and while that application has con-
tinued to be emphasized in their courses, it has been supplemented by the
discovery that in modern industry, education, and government agencies—that

[1] Saundra Hybels and Richard L. Weaver, II, *Speech/Communication* (New York:
D. Van Nostrand Co., 1974), p. 219.

[2] John W. Keltner, *Group Discussion Processes* (New York: Longmans, Green, 1957),
pp. 2–3.

*is, in nearly all highly developed organizations—most of the important deci-
sions and most of the power transactions are now compromised or negotiated
by small groups of people in discussion.*[3]

More recently, Professor William D. Brooks of Purdue University wrote:

*Small groups operate in every organized human activity. As a student, you
have participated in innumerable problem-solving small groups; the average
professional man or woman, or businessman or businesswoman attends as
many as two or three luncheons or evening meetings a week, in addition to
the many conferences and committee meetings in which he or she takes part
during regular working hours; and representatives of government carry on
most of their work of solving problems and making decisions in small groups.*[4]

Problems that cannot be solved in small-group conferences call for
situations of advocacy that employ debate. Small-group discussion and
debate constitute the principal processes for solving problems and re-
solving conflicts. How are the two processes related?

THE PROCESS OF SMALL-GROUP PROBLEM-SOLVING

Consider the following situation, typical of the problem-solving process.
The student council appointed a student committee to study the prob-
lem of student evaluation of faculty members. At the first meeting of
the committee, the students discovered that they lacked sufficient factual
information to proceed. The chairperson appointed members to investi-
gate the problem—to interview faculty members for their ideas, to inquire
of other universities known to have such programs, and to study relevant
articles in professional journals and student publications.

At the next meeting, the student members of the committee discussed
their findings and the merits of the several plans for student evaluation
which they had discovered. With this information at hand, the commit-
tee drew up a specific plan. After each member had had his say, the
chairperson called for a vote and a motion carried favoring the proposed
plan.

The proposal was then sent to the student council, where the chair-
person of the committee read and moved the adoption of the committee
report. A debate ensued, and after all members had been heard, the
motion passed.

[3] Ernest G. Bormann, *Discussion and Group Methods* (New York: Harper & Row,
Publishers, 1969), p. ix.

[4] William D. Brooks, *Speech Communication*, 2d ed. (Dubuque, Ia.: Wm. C. Brown
Co., 1974), p. 208.

Thus a democratic body faced and solved a problem. The solution was made possible by the use of two essential tools of any democratic process—small-group deliberations and advocacy. In the small-group committee the problem was explored, ideas and facts were pooled, and consideration was given to determine what should be done. Debate was necessary to reach the final decision in the student council, where the proposition was, "Should this committee's recommendation be adopted?" Without small-group and deliberative bodies, the solution would not have been possible; the student council could not have functioned.

Courts of law are one of the principal areas for debate, but lawyers also use small-group techniques before they bring a case to trial, conferring with their clients, potential witnesses, and other lawyers in their firms. Recently, a citizen was summoned to serve on a jury panel. As the judge instructed the members of the jury about their rights and obligations, some lawyers entered the courtroom and called the judge aside. Upon returning to the jury panel, the judge announced that the case had been settled; the litigants had compromised their differences outside the court through small-group conferences. The compromise had been effected by lawyers skilled in cooperative deliberation.

Conflict is inevitable in a democracy. So long as people govern themselves, disagreements will occur. Means may be devised to lessen conflict, but it cannot be eradicated. Our chief progress can be made in improving the methods of solving problems and settling conflicts, the methods employed in small-group conferences and deliberative bodies.

LIMITATIONS OF THE SMALL-GROUP PROCESS

The small-group process permits group decision, a democratic means for solving problems. Usually the decisions reached in small-group deliberations are acceptable because each person contributes to the solutions. As a method, however, the small group has no magical powers that guarantee mature decisions.

A starting point for a study of the small-group method should be a consideration of its limitations. The principal limitations are of three types: (1) limitations due to the method itself, (2) limitations due to participants, and (3) limitations caused by language difficulties.

Limitations of the method

Small-group deliberation recognizes thought-in-process; it requires the cooperative deliberation of problems and operates largely by trial and error. It is not the most efficient method of problem-solving; the greatest efficiency comes where one person has the right of decision. The absolute

dictator has a high degree of efficiency in problem-solving, but he ignores the rights of the individual. Persons committed to a free society consider individual participation in problem-solving, with all its inefficiency, superior to dictatorial decrees.

The small-group method is slow; it must allow persons time to pool their information and ideas and to consider their differences. If immediate decisions become necessary, small-group deliberation is not the best method. We always move toward concentration of power in the executive branch of government during periods of stress such as wars and economic depressions. Increased executive authority becomes necessary because we must have quick decisions.

Limitations due to participants

By the same token that the small group permits a pooling of information and ideas, it allows a pooling of ignorance, misinformation, and immature ideas. The people who operate small groups are themselves limitations.

The attitudes of the participants may make the difference between success and failure. The proper attitude reflects a desire to cooperate toward the end of a mutually satisfactory solution, a recognition that cooperation may mean compromise, and an earnest seeking for the best solution. If individuals assume the attitudes that their ideas must prevail at any cost, the small group has little chance of success. If a person already has his mind made up as he begins deliberations, he will usually exert his efforts to coerce others, preventing cooperative deliberation. A cooperative initial attitude is a prerequisite for success in small-group communication. It must be an investigative, discriminating, and open-minded attitude.

The overly cautious person tends to impede the progress of small groups. Decisions should not be made without a consideration of the facts and varying points of view, but the deliberative attitude may be carried too far. Some persons pride themselves in never making decisions until "all the facts are in," but one can never know all the facts. It is the careful weighing of the *available* facts that makes for mature decisions.

Persons with fixed opinions also delay small-group decisions. The person who weighs all proposed solutions in terms of how they affect his political, religious, or social viewpoints may refuse to consider worthwhile suggestions. Some persons pride themselves on the consistency of their standards for evaluation. Some always champion the cause of the little man, or favor capital over labor, or vote the Socialist ticket, or insist on the separation of church and state, while others hold just the opposite views. Regardless of how remote a particular proposal may be

from these preconceived notions, such persons always evaluate it by their handy criteria. Such an attitude is usually accompanied by a suspicion of the motives of those who differ. Thus, if one expresses a mild opinion that perhaps the federal housing program has helped in slum clearance, he is immediately labeled a New Dealer, a welfare-stater, or a liberal, and therefore a communist. For, "after all, they mean about the same thing"—so says the man with the ready-made standards for evaluation. Small groups operated by such persons have little chance for success.

Then there is the person who often resorts to oversimplification; he puts everything in a nutshell. "Give labor an inch and it will take a mile"; "Spare the rod and spoil the child"; "Bloods don't mix." Such persons usually judge most complex situations as all good or bad; all black or white, never gray. They allow no place for a middle course. Thus, either you believe in the welfare state or you do not; you are either a free enterpriser or a communist; you are either a clean-cut all-American or a hippie. No place exists for degrees or shades of belief. Such all-or-nothing attitudes deter small-group success.

Thinking in a habitual pattern also retards small-group communication. With persons who think by set patterns, tradition looms large. John Locke characterized these persons as "men whose understandings are cast in a mold, and fashioned just to the size of a received hypothesis." [5] Such a person lacks flexibility of mind and the ability to adapt to change. He usually resists change because he indulges his habitual reactions until they become solidified.

In short, small groups are limited by their participants. They cannot be made to work without competent people.

Limitations caused by language

Language is often a barrier to small-group communication. What the communicator means may be understood by his listeners in different ways, depending upon the experiences they have had with what he talks about. Words are simply labels for things; they are not the things themselves. There is nothing in a word that keeps people from having varied reactions to it. The word *table* may mean the desk at which one works, the mahogany table in his living room, or the battered table in his workshop. Confusion arises in small-group communication when one person uses a word in one way and another understands it differently. This may be one of the chief detriments to harmony in industrial relations, and

[5] John Locke, *Essay Concerning Human Understanding*, ed. A. S. Pringle-Pattison (Oxford: The Clarendon Press, 1924–27), p. 366.

it is a serious obstacle to communication in international organizations. Read the section on general semantics in chapter 12 and apply it to the small-group communication process.

In summary, the principal limitations of small-group communication lie in the methods, the participants, and the confusion occasioned by language. A recognition of the limitations of the small-group process should make those who use it more tolerant of it as a problem-solving device.

A PATTERN FOR SMALL-GROUP DISCUSSION

To acheive a degree of success the small-group discussion must be conducted according to an orderly procedure. The following pattern strives to give order and arrangement to the process. It starts with a consideration of the problem and leads step by step through the solution. If all participants understand the pattern, wasted effort will be prevented:

 I. Define the terms and narrow the problem.
 II. Analyze the problem.
 A. Consider the conditions that exist.
 B. Consider the causes that give rise to the problem.
 C. Consider standards for evaluating solutions.
 III. Suggest and evaluate possible solutions.
 A. Explain each possible solution.
 B. Consider the advantages and disadvantages of each.
 IV. Seek agreement on a solution.
 V. Consider methods for applying the proposed solution.[6]

To explain these five steps, we shall use, throughout the rest of this section, a detailed outline for a hypothetical small-group discussion that shows how the pattern may be applied.

Define the terms and narrow the problem

Define and explain terms so that all will have the same understanding of them. Time spent in striving for a meeting of minds on meaning, purpose, and scope of the problem ultimately saves time.

Small-group communication sometimes fails because the group at-

[6] See James H. McBurney and Kenneth G. Hance, *Discussion in Human Affairs* (New York: Harper & Row, Publishers, 1950), chap. 6, and John Dewey, *How We Think* (New York: D. C. Heath, 1910), for more detailed discussions.

tempts too much during a single session. On problems involving major changes, several sessions may be necessary on different phases of the subject. Decide early how to limit the subject, how to dispose of irrelevant matter, and how to accomplish specific goals. The following outline shows how this defining and narrowing process may be accomplished.

Question: How can the education system of the United States be improved?
1. Define the terms and limit the problem.
 A. *Educational system* may refer to any one or more of its subdivisions: (1) elementary education, (2) secondary education, and (3) higher education.
 1. These divisions are defined as follows:
 a. *Elementary education* means the lower six to eight grades.
 b. *Secondary education* means the upper three to six grades, usually referred to as high school or junior and senior high school.
 c. *Higher education* means the training offered in colleges and universities.
 2. This discussion should include all three divisions because each is an integral part of our educational system.
 B. The educational system of the United States includes both public and private schools.
 1. *Public schools* are financed by taxation through governmental divisions.
 2. *Private schools* are financed by private organizations such as religious denominations.
 C. The *United States* includes the federal government, the fifty states, and their subdivisions.
 1. Today the states constitute the main governmental division for educational organization.
 2. Local school districts help finance and administer school programs.
 3. The federal government assists through offering long-term loans, lunch programs, assistance to vocational education, student scholarships, grants, and by maintaining Army, Naval, and Air Force academies.
 D. The term *improved* implies how education can be made more efficient in administration and instruction.

Analyze the problem

After securing a meeting of minds on the meaning and scope of the problem, examine its nature and extent. What are the manifestations of the problem? How serious is it? What facts reveal its true condition? An objective analysis may reveal the problem to be less serious than first believed. An appraisal of the existing conditions should precede a con-

sideration of solutions so that all will understand what conditions need correcting.

Next, determine what factors brought these conditions about. What caused the problem? Any solution decided upon should correct the causes; otherwise the solution will have no lasting effects. An aspirin may give temporary relief for a headache; to effect a lasting cure, one must get at the conditions that gave rise to it.

As a third step, decide on standards to evaluate proposed solutions. Each proposed solution can then be considered in light of the criteria agreed upon to measure the adequacy of possible solutions. Agreement on the criteria for evaluating solutions may pave the way for the ultimate decision.

The following section of the outline on education illustrates the analysis step.

II. Analyze the problem.
 A. Many defects exist in the United States system of education.
 1. The curriculum is not sufficiently substantial.
 a. Students avoid basic subjects.
 b. Trivial courses have been added to the curriculum.
 2. The curriculum is geared to the average and slow student.
 a. All students, regardless of ability, attend the same classes.
 b. Superior students become disinterested; poor students become discouraged.
 3. The teaching profession attracts persons of low caliber.
 a. Certification laws are regarded as a farce in many states.
 (1) They require excessive pedagogy courses.
 (2) They permit persons to teach with insufficient training in subject matter.
 b. Despite recent improvements, the pay for teachers remains incommensurate with their training.
 (1) Teaching remains one of the lowest-paid professions.
 (2) Educational requirements have increased greatly.
 4. Differences in educational facilities and expenditures exist.
 a. Differences exist between rural and urban areas.
 (1) The farm population supports a greater percentage of school children in proportion to income than does urban population.
 (2) The expenditure per pupil in urban areas is almost double that in rural areas.
 b. Differences exist among states.
 (1) The wealthy states have the best-equipped schools.
 (2) The expenditures per pupil vary four to one among the wealthiest and the most impoverished states.

 c. Differences exist between black and white schools.
 (1) Some states still maintain separate schools, at least in practice.
 (2) Despite recent advances, wide differences still exist.
 5. Faculty and student rights are not given proper recognition.
 a. Some faculties still have little authority in formulating education policies of their institutions.
 b. Students continue to demonstrate for a greater voice in their education.

B. The causes of educational problems still exist.
 1. Decentralization of the public school system prevents coordinated action.
 a. Local jurisdictions have too much authority.
 b. Some states will not permit coordination or financial support by a national agency.
 2. The states vary in their ability to support programs.
 a. Seven states receive 54 percent of the national income.
 b. New York receives 17 percent of the national income.
 c. The poor states do not have adequate taxable income.
 3. Local school programs are often controlled by school boards who do not understand educational problems.
 4. Emphasis on mass education lowers the quality of education.
 a. Poor students require too much of the teacher's time.
 b. The curriculum is watered down for poor students.

C. Criteria for judging solutions should be considered.
 1. Education should be available to all American youth.
 a. Superior students should not be neglected.
 b. Students should be given training commensurate with ability.
 2. Equality of educational training should be provided.
 3. The quality of education should be improved.
 4. Administrative, faculty, and student rights should all be recognized.
 5. Improvements in education should be made at the least expense consistent with sound policy.

Suggest and evaluate possible solutions

This step considers possible solutions, not simply those solutions favored by various members. The question is "What are the possibilities?" Consider and explain each possible solution in detail. How would it operate? What are the principles on which it is based? What are its possible advantages and disadvantages? When these questions have been answered for each possible solution, the group is prepared to seek agreement on the best solution. Although this procedure does not assure agreement, it does improve the chances for it.

The following section of the illustrative outline exemplifies this process.

III. Evaluate possible solutions.
 A. Revise and streamline state tax programs.
 1. Some states do not have income and sales taxes.
 2. Much personal property escapes taxation.
 3. Savings could be made by improving methods of tax collection.
 a. Small taxing districts could be abolished or consolidated.
 b. Overlapping tax jurisdictions could be prevented.
 4. The following issues should be considered:
 a. Can taxes be increased in the poor states?
 b. Can sufficient revenue be obtained by improving the collection and administration of taxes?
 B. A plan of school economy is a possible solution.
 1. Overlapping taxing districts cause excessive expense.
 2. School funds are inefficiently managed.
 3. The costs of administrative departments are exorbitant.
 4. The following issues apply:
 a. Is economy in administration possible?
 b. Would economy in administration and efficiency in operation provide sufficient funds?
 c. Is greater economy in administration practical?
 C. Raise educational standards and qualifications for teachers.
 1. Minimum standards for teacher training will tend to standardize education throughout the states.
 2. Increased teachers' pay will attract capable people.
 3. Basic courses will supplant soft courses.
 4. Segregation of students based on ability will permit proper attention to all students.
 5. The following issues are applicable:
 a. Can we raise educational standards and qualifications of teachers with the revenue available?
 b. Can we raise educational standards and maintain our concept of mass education?
 D. Increase federal aid to education.
 1. The federal government has left the management of schools to the states, vocational education excepted.
 2. In the United States 50 separate school systems exist without a unifying agency.
 3. The federal government controls taxation for national purposes.
 4. Education has overstepped state boundaries.
 5. The following issues apply:
 a. Is additional federal aid needed?
 b. Would increased federal aid be practicable?

 c. Would further federal aid be accompanied by serious disadvantages?

Seek agreement on a solution

After considering possible solutions, the leader attempts to gain consensus on one of the solutions or on a compromise among two or more of them. Deliberations sometimes break down at this point because the participants cannot compromise their differences.

The following section of the illustrative outline applies to the solution phase.

IV. Develop a suggested solution.
 A. Plan D appears to be the best solution—increase federal aid to education.
 B. Reasons for this choice:
 1. Education has become a national problem which makes further federal support and regulation advisable.
 a. By federal regulation the states with poor systems can be brought up to a minimum standard.
 b. The federal support of vocational education has resulted in a well-planned national program.
 c. Mobility of population causes a person to be more a citizen of the United States than of any one state.
 d. Coordination of educational programs is possible only through federal aid and regulation.
 2. The federal government can raise taxes more efficiently than can the various states.
 a. It can avoid double taxation and overlapping taxing agencies.
 b. The federal tax program can equalize the burden on the several states.
 3. Federal support and regulation will raise standards.
 a. Backward communities will raise their standards to meet minimum requirements.
 b. The methods and policies of progressive communities will be extended to nonprogressive communities.
 C. Disadvantages of federal aid to education.
 1. The federal government should not assume new burdens in view of its large national debt.
 2. Federal aid will result in federal control and thus remove the democratic spirit of American education.
 3. Federal aid would decrease local initiative.
 4. Federal aid would work to the disadvantage of private educational institutions.
 5. Federal aid would cause the citizens of one state to pay for educating the children of other states.

Consider methods for applying the proposed solution

If the participants agree on a solution, as the final step they consider how to put the solution into operation. Even though the group may not be involved with the execution of policy, its suggestions for application may be helpful. The practicality of the solution will no doubt have been considered in arriving at the solution; this phase attempts to spell out a step-by-step procedure of execution. The following section of the outline illustrates:

V. Make suggestions for putting solution into operation.
 A. The federal government could establish minimum standards of education for each community; wealthy states could go beyond the minimum standard.
 B. The federal government could guarantee a minimum sum per student for each school district.
 C. The federal government could set up minimum standards and cooperate with the states and school districts in raising revenue.
 1. The "matching of funds" plan could be extended.
 2. This plan would give the local districts more incentive for improving their schools.
 D. More substantial curricula should be enforced by the national agency.

This suggested discussion pattern should not be considered a panacea. It does help insure order and arrangement to the small-group process. As such, it enhances the opportunity for successful deliberations.

PARTICIPATING IN SMALL GROUPS

What constitutes successful participation in small-group communication? We learned earlier that the participants often create a limitation. How can we participate in such a way as to help overcome this limitation? Successful participation may be judged by (1) the attitude of the participant, (2) the number of his contributions, and (3) the quality of his contributions.

Attitudes of the participant

The attitude of the participant may mean the difference between the success and the failure of small-group communication. The proper attitude may be characterized as follows:

1. Adopt a cooperative attitude. A cooperative attitude recognizes the common good of the group above selfish interests and evinces a willingness to bypass personal desires for group interests. Small-group deliberations aim at compromising differences and arriving at solutions that represent the consensus of the group. A self-centered, individualistic, and competitive attitude defeats cooperation. Unless the participants strive to attain a cooperative spirit, the small-group discussion has little chance of accomplishing its purpose.

2. Assume your share of the responsibility. This responsibility involves adequate preparation and willing contribution. Small-group communication permits a pooling of information and ideas; but to have adequate facts and mature ideas, the participants must make proper preparation. The deliberations will be no more productive than the ideas expressed by the participants. Each member should assume his proportionate share of the responsibility for getting ready for and participating in the sessions.

3. Avoid the passive attitude. The participant does not withhold ideas simply because he has not had time to think them through thoroughly. Ideas contributed may sometimes come from spontaneous impulses, ideas that occur at the moment. Such ideas should not be thought of as reflecting the same maturity of judgment as those that are thought through in advance. Yet such spur-of-the-moment ideas may prove to be just what the group needs to settle a problem or move forward with it. Someone must express tentative opinions for the group's consideration. One should speak up if he thinks he has an idea that might be worth considering.

4. Contribute objectively. A participant should not hold tenaciously to a point of view because he advanced it originally. It may be that new facts or opinions make his original opinion seem unwise. His purpose is to help the group solve its problem, not to make his own ideas prevail. To be sure, he should defend any position that he considers valid and wise, but he should not hold to an original idea if further consideration causes him to doubt its validity. The objective participant keeps his remarks on the point at issue; he avoids personal statements designed to belittle persons associated with the issue or other members of the group. The objective attitude helps to curb dissension and strife.

5. Be a good listener. Good listening is essential to the give-and-take processes in small groups. One cannot speak effectively on the point at issue unless he understands what others have said about it. The participant must be sure that he understands another's point of view before indicating opposition to it. A good listener responds overtly to what

others say, asks questions for clarification, and thinks before expressing agreement or opposition. If he spends his time thinking of what he plans to say next while others speak, his contribution may not be applicable. One must listen to understand.

Number of contributions

Is there a correlation between the number of times a person speaks and his general worth to the small group? To help answer this question, some experiments were conducted during practice sessions with college classes. One person tabulated the number of times that each participant talked. A panel of five speech teachers scored each participant on a qualitative rating scale.

The experiments showed in general that those who talked the most received the highest qualitative scores. There were, however, several individual exceptions. Some persons talked a great deal but did not say much. Others felt a compulsion to pass judgment on what everyone else said. Some were free in expressing opinions but had little factual information to back up their assertions. A few had competitive attitudes and attempted to argue each point. Despite these exceptions, a majority of those who took the most active part made the most worthwhile contributions. A person can hardly speak too often in small groups so long as he says something constructive. He should be careful, however, not to monopolize the meeting to the extent that others cannot be heard.

Quality of contributions

The quality of contributions in a small-group discussion may be measured by the factual basis for opinions and the maturity of judgments.

Sometimes group discussions fail to produce results because no one has investigated the facts. In one class exercise, the participants argued about how much the price index had risen during the past year. This question should have been investigated, not argued. No amount of argument would change the facts or apprise the participants of them. Had someone known the facts, the stalemate could have been avoided. The tendency to "let George do it" seems to be common when students face the necessity of preparing for small-group communication. Yet a reasonable grasp of the facts is an essential part of participation. The pertinence and validity of facts should be carefully considered. Do they meet the qualifications of accuracy discussed in chapter 8? Valid evidence is just as important for small-group communication as for public communication.

Inferences from the facts also count heavily. What do the facts mean? What conclusion can be drawn from them? Maturity of judgment makes for productive small-group discussions characteristic of many conferences in industry. Reasoning, the process of drawing conclusions, is discussed in detail in chapter 14.

LEADING SMALL-GROUP DISCUSSIONS

The small-group leader must cultivate attributes of leadership conducive to a cooperative atmosphere that draws out the best from the participants. He succeeds in proportion to how well the discussion goes. He may be brilliant, stimulating, and eloquent—and thereby overshadow other members of the group. In so doing, he may defeat its primary purpose—cooperative group action. A good leader need not be the life of the party, but he must be a part of it. To be successful, he must have the proper attitude toward the small-group process, realize the principles of leadership in a democracy, and understand the methods of procedure.

Attitudes on small-group leadership

An experienced professor of rhetoric observed many small groups in action during his 20 years of teaching the subject. Two leaders stand out as the poorest he encountered. They may be an object lesson to you in preparing for discussion leadership.

One was Major Proud, who had recently been promoted. A member of the reserves, he entered the armed services early in World War II and received rapid promotions. In civilian life he had held a position with few leadership opportunities; in the army he commanded many enlisted men and lower-ranking officers. Major Proud delighted in calling conferences on the slightest pretext. He used them primarily for the purpose of "putting his men in their places." He exemplified the class of dictatorial leaders. What methods did he use?

He furnished a detailed agenda and permitted no deviation from it. He dominated the discussions, insisting that his ideas be discussed and that army protocol be strictly enforced. He insisted on passing judgment on contributions by others and often assumed the role of an authority. He took sides on controversial matters and sometimes belittled those who differed with him. In short, he assumed the position of leader without the attributes of leadership.

What effect did his attitudes and actions have? At first, the participants prepared for the meetings and took active part in them. Later, they

stopped preparing and deferred to the major for instructions. The conferences became occasions, not for mutual efforts in solving problems, but for the leader to give his orders.

The antithesis of this condition occurred in conferences led by Professor Mollycoddle. He assumed the chairmanship of his department because he was its most distinguished professor, not because he enjoyed administrative duties. He preferred to spend his time in reading and research and usually called conferences only when goaded into it. Unlike the major, he never prepared an agenda or seemed to know exactly why he had called the meeting. After starting a conference, he usually sat back without further comment and let it drift along. What happened in these conferences?

Other members of the staff vied for leadership and directed the discussions. Personal animosity often developed and shifted the discussions from the issues to personality clashes. Because the leader seldom made positive statements and did not intervene in personal clashes, the conferences drifted along without many productive results.

What can we learn from these two types of leaders? Neither exemplifies the proper type. A good leader is a democratic leader. He works with the group in attempting to solve problems. He should not be dictatorial, nor should he let the discussion drift along without proper guidance. He works out an agenda but permits deviation from it if circumstances indicate the need. He plans the possible course that the conference will take and attempts to keep down personal encounter by keeping the discussion on the issues. He asks discerning, thought-provoking questions. He attempts to create a cooperative atmosphere. He attempts to distinguish the essential from the nonessential and discourages uninformed opinions. If he has ideas and facts, he does not hesitate to contribute them, but he seldom takes sides on controversies that arise. He does not dominate the meeting, nor will he permit others to do so. He attempts to be objective rather than opinionated, patient rather than anxious, stimulating rather than dull, restrained rather than dogmatic. In short, he leads without its being obvious that he does so.

Principles of leadership

The principles of leadership applicable to small groups closely parallel those in any activity in a democracy. A fundamental principle that distinguishes democracy from other concepts of government is its emphasis on the dignity of the individual. The individual has the freedom to speak up; his ideas count. Most business executives find that they can get more efficient production from their employees by leading them than by

driving them. What principles of leadership should guide the leader of conferences? They may be classified into three categories.

1. People will support most readily those policies they help create. If a leader wants wholehearted support from his associates, he will give them a voice in determining policies. If he hands down an order, he will be likely to get compliance with the letter of the command but not with the spirit of it. Why do people support best their own creations? Partly because those who help create policy understand the spirit and philosophy behind it. The tendency to support that which one helps to create characterizes persons accustomed to a free society.

In recent years big business has recognized this principle with beneficial results in productivity. Industries have instituted employee-participation plans that range from suggestion boxes to a share of the profits. Years of service and importance of position are rewarded with shares in the company. The unskilled and semiskilled workers cooperate better because they help elect one of their kind to the managerial board. They produce better because they feel that they are a part of the organization.

How does all this apply to the small-group leader? He should keep in mind that if a person has a contribution to make, he should be encouraged to make it. He should include all those who will have a part in executing the policy. He should create a pleasant and friendly atmosphere conducive to a free exchange of ideas and opinions.

2. Consider free discussion as the safety valve for democracy. Persons with ideas desire to express them. If prevented from stating their views, they will seek more forceful means to express themselves. The failure of some civilizations dates from the time that freedom of speech became suppressed. Insurrection may result from continual suppression of free speech.

A tenet of the armed forces permits uninhibited griping among fellow soldiers. Uprooted from their customary mode of living and thrown into an entirely new environment, many soldiers naturally become frustrated and discouraged. Some soldiers testify to the relief they receive from "sounding off" to their buddies. Modern psychiatry uses free and uninhibited talk as a technique for treating emotional disorders. Perhaps you have sometimes felt better after having unburdened your troubles to a sympathetic listener. This principle has application to the small-group leader. By encouraging free expression of opinions, he paves the way for cooperation among the participants.

3. People in a democracy have the right to make mistakes. The leader must be patient; he must expect mistakes. He cannot rush the

small-group process if he desires to realize its full advantages. He must not expect to arrive at decisions that satisfy everyone. He must realize that people have the right to make mistakes. Fortunately, they often profit by their mistakes.

Techniques of small-group leadership

The procedural methods for small groups need not be formal or stilted. Parliamentary procedures may be necessary with large legislative groups, but informal procedures serve small groups best. Yet the leader cannot let the discussion drift along without direction. What are his duties and obligations?

1. He gets the discussion started. The leader prepares the agenda. If possible, he sends the agenda to the participants before the meeting so they can make proper preparation. He gives any other necessary written materials to the participants before the meeting begins. The reading of materials during the session diverts attention from the proceedings.

He sees that the proper physical arrangements are made beforehand: a rectangular-shaped table with writing pads, pencils, ash trays, and so forth set at each place before the conference starts. Avoiding possible disruptions makes for smooth-running conferences.

He arrives a few minutes early to introduce new participants and engage other arrivals in informal conversation. This may help create a friendly atmosphere and thus set the proper keynote. An unhurried atmosphere is best; this spirit cannot be attained if the leader rushes in at the last minute.

After greeting other participants as they arrive and making the necessary introductions, the leader calls the meeting into session. In his opening remarks he stresses the purpose and importance of the problem. These opening remarks need not be long, but they should include any background about the origin and history of the problem that makes for a better understanding of it. If the discussion is one of a series on the same problem, he briefly summarizes accomplishments of previous sessions and states the purpose and scope of the present meeting. At the end of his introductory remarks, he raises the question of the definition of terms and limitations of the problem.

2. He keeps the meeting moving constructively. Once the discussion is underway, the leader keeps it moving constructively toward its goal by judicious use of the summary and skillful questioning.

The summary has at least four important functions: (1) It is used to give the meeting order and direction. If the discussion has gone so far

that no one seems to know where it is, the leader summarizes to bring it to a focal point. (2) It is used when the group has been discussing a single topic too long and it is necessary to move on. During the summary, the leader indicates what has been accomplished and suggests the direction the discussion should take. Here the summary serves as a transition from one phase of the discussion to another. (3) It is used when a delay procedure is indicated. Sometimes the discussion becomes too heated and tends to get out of hand. At other times the group seems to lose perspective. Here the important thing is to delay. During the summary, the participants will have time to regain their composure. If the leader desires, he need not permit the discussion to return to the topic that caused the dissension. (4) It is used when the leader becomes uncertain of what to do next. Occasionally the leader may become unsure of the best procedure to follow. Usually during the process of summarizing, a new direction will be indicated. The summary gives him time to deliberate on the next move.

Skillful use of the question aids the leader in drawing out members of the group, in securing needed information, and in keeping the discussion moving. At times talk may lag and the meeting seem to bog down. When this condition arises, the leader asks searching inferential questions, not those that can be answered by *yes* or *no*. The following questions are some he may ask:

1. What experience have you had with this problem? How did you solve it?
2. How did this condition come about? How did that happen? What caused it to happen?
3. What do you think about the matter? Why?
4. Can you give an example of the situation you describe?
5. What other possibilities can you suggest?
6. Will you be a little more specific? Will you explain your suggestion in more detail?

Such questions may keep the discussion moving constructively.

3. He keeps down strife and dissension. Undue personal conflict and bickering may kill the atmosphere of pleasantness that should prevail. The leader does not stifle honest differences of opinion, but he encourages differences of opinion agreeably. If he can keep the discussion on the issues of the problem, the occasion for personal conflicts will be lessened. If he knows that personal differences exist on certain matters, he delays their discussion until after the participants have discussed other matters upon which prejudices do not exist. Thus the group may learn to work together before the disputatious questions arise.

The leader does not permit argument or personal-opinion statements when the group is considering possible solutions. He restricts this phase of the discussion to an explanation of how the solutions will work and their advantages and disadvantages. With these facts before the group, the causes for personal differences may be lessened. Above all, the leader is fair and impartial if disagreements do arise. If matters tend to get out of hand, he can use the summary to help bring the conference under control.

4. He provides the opportunity for all to participate. It is desirable to have all members participate and the leader tries to make it possible for all to contribute. However, a person talks best when he wants to talk, not when the leader calls on him. The leader avoids the *what-do-you-think-Mr.-Jones* type of question; rather he raises problems and asks inferential questions that will cause one to want to talk.

The leader may encounter two types of individuals with which he must deal: those who talk too much and have little worthwhile to say and those who do not talk enough.

The leader does not embarrass the talkative individual, because his embarrassment may dampen the fervor of the whole group and cause others to decline to participate. Unobtrusively he suggests that the aim of good discussion is to have all participate; the solution should be a joint endeavor. If Mr. Smith persists in talking the leader interrupts him politely, turns to the group, and states that he would like others to discuss Mr. Smith's idea. After one member concludes, he directs the discussion to another without letting it return to Mr. Smith. Again, the leader may listen to Mr. Smith without commenting on what he said, introduce a new idea, and ask others to give their opinions of the new idea. In short, he lessens Mr. Smith's opportunities to speak without letting it be too obvious that he is doing so.

A different problem arises when a person declines to participate. Capable people sometimes find difficulty in breaking into the discussion, as they do in any situation of social intercourse. Without being obvious, the leader attempts to bring such a person into the discussion; he bides his time for an opportune moment. For example, he might turn to Mr. Jones and say, "Mr. Jones, I recall that a similar problem arose when you served on the Chamber of Commerce Executive Board. How did you people cope with the problem?" This method points up Mr. Jones's importance and gives him an opportunity to speak from experience on the matter. If possible, the leader keeps him talking for some time by asking additional questions. Usually a reticent person will continue to participate once he has made his first contribution.

5. He concludes the meeting. The leader concludes the conference so that it will not simply die out. He concludes it at the appointed time

or when the group ceases to make progress, by giving a concise summary of what has been accomplished. He attempts to clarify what has been said in such a way as to give a sense of direction. If the discussion has reached a decision before the time is up, some time may be devoted to suggestions for putting the solution into operation. If another session is planned on the same problem, the leader should indicate the unfinished work and the phase of the problem for the next meeting.

SUMMARY

Small-group communication occurs when all persons present interact and alternate as senders and receivers of messages. Small-group conferences and advocacy situations are the principal methods for solving problems and resolving conflicts. They find their expression in courts of law, legislative assemblies, and the everyday activities of citizens. Small groups offer the first approach to problem-solving. If they fail, debate applies for resolving the conflict.

Small-group communication has certain limitations: those of the method itself, those due to participants, and those caused by language.

A pattern for small groups gives the process order and arrangement. The pattern consists of five steps: (1) define the terms and narrow the problem, (2) analyze the problem, (3) suggest and evaluate possible solutions, (4) seek agreement on a solution, and (5) consider methods for applying the proposed solution.

Successful participation may be measured by the attitudes of the participants, the number of their contributions, and the quality of their contributions.

Small-group leadership depends upon the attitude of the leader and his understanding of the principles and techniques of group leadership. The leader must get the discussion started, keep it moving constructively, minimize strife and dissension, provide an opportunity for all to participate, and conclude the discussion.

QUESTIONS

1. Distinguish among the processes of intrapersonal, interpersonal, small-group, and public communication.
2. Explain the two principal methods for solving problems and settling conflicts in a democracy. What would be the probable consequence if these methods are unavailable or unsuccessful?
3. What are the principal limitations of the small-group process? Can you add to this list of limitations?

4. Explain the steps in the pattern for small groups. Why should participants understand the pattern?

5. How may we judge effective participation in small groups? What standard do you consider the most important?

6. Characterize the ideal small-group leader. Discuss the procedural techniques that he should follow.

ASSIGNMENT

Plan A For your oral assignment, each member of the class will participate in a small-group discussion. Five or six students will constitute each small group, which will elect a leader and select a topic. Each conference will have a 45-minute time limit. Proceed as follows:

1. The instructor will divide the class into groups. Each group will have a preliminary meeting to elect its chairperson and select its topic. This meeting should be held several days before the discussion.

2. In preparation for selecting the topics, each member of the class should bring to class three suggested topics. These lists will serve as the basis for decision in the preliminary meetings.

3. Each member of the class should make a preparation outline for his discussion. This outline should follow the steps in the pattern for small groups noted in this chapter. Use the outline for preparation purposes only; do not insist that the group follow your outline.

4. Follow each discussion with a critique led by the instructor.

Plan B The groups will present panel discussions before the entire class on their general topics, following the pattern for small groups explained in this chapter. Emphasize (1) the problem—evidence of it, (2) possible causes—what brought the problem about, (3) solutions—what should be done? Reserve ten minutes at the end for an open forum.

READINGS

BORMANN, ERNEST G., *Discussion and Group Methods: Theory and Practice,* 2nd ed. New York: Harper & Row, Publishers, 1975.

BRILHART, JOHN K., *Effective Group Discussion,* 2nd ed. Dubuque, Ia.: Wm. C. Brown Co., 1974.

BROOKS, WILLIAM D., *Speech Communication,* 2nd ed., chap. 8. Dubuque, Ia.: Wm. C. Brown Co., 1974.

CATHCART, ROBERT S., and LARRY A. SAMOVAR, *Small Group Communications: A Reader.* Dubuque, Ia.: Wm. C. Brown Co., 1974.

FISHER, B. AUBREY, *Small Group Decision Making: Communication and the Group Process.* New York: McGraw-Hill Book Co., 1974.

GOLDBERG, ALVIN A., and CARL E. LARSON, *Group Communication: Discussion Processes and Applications.* Englewood Cliffs, N.J.: Prentice-Hall, 1975.

GOLDHABER, GERALD M., *Organizational Communication,* chap. 7. Dubuque, Ia.: Wm. C. Brown Co., 1974.

HASLING, JOHN, *Group Discussion and Decision Making.* San Francisco: Chandler Publishing Co., 1975.

HYBELS, SAUNDRA, and RICHARD L. WEAVER, II, *Speech/Communication,* chap. 7. New York: D. Van Nostrand Co., 1974.

TUBBS, STEWART L., and SYLVIA MOSS, *Human Communication: An Interpersonal Perspective,* chaps. 9, 10. New York: Random House, 1974.

PART **2**

Preparation and composition

SIX

Selecting the subject and purpose

In part 1 we introduced you to the communication process and established standards for judging good communication; we discussed what you must do to improve your ability to communicate; we considered the listener from the standpoints of his function as the receiver of messages and how the communicator should adapt his message to his receivers and the occasion; lastly, we introduced you to person-to-person, small-group, and public communication situations. Part 2, Preparation and Composition, applies to all types of communication but centers primarily on public communication. Unless you take the time to prepare and compose your ideas and messages properly, your communication will be fruitless. Proper preparation and composition are the requirements from which all others spring.

As you analyze your listeners and the occasion, you should consider appropriate subjects and the purpose you wish to accomplish. What governs your choice of subject and purpose?

Suppose that you receive two invitations to speak—one at your college's annual honors award program and the other at a workshop sponsored by the department of business administration of your university. What basic differences distinguish these two requests? For the awards program, the occasion and the subject constitute the main considerations; the propriety of the occasion limits the choice of subject. For the students' workshop, the speaker forms the main consideration; the students want to hear you on a subject of your choice applicable to their interests.

119

TYPES OF SUBJECTS

The topics for person-to-person and small-group communication situations depend upon the reasons for such meetings and are usually known in advance. The choice of subjects for public speeches is often left to the speaker and depends first on whether the subject and the occasion or the speaker predominates. You should understand that this distinction does not apply entirely to classroom assignments because the classroom constitutes a somewhat artificial listener situation. Your fellow students attend not particularly to hear you but because classroom attendance is customary. Many of the principles do apply, however, to both classroom and actual communication occasions.

Where the subject or the occasion predominates

In many speaking situations the audience assembles because of a particular occasion—to commemorate some great event, pay tribute to some outstanding person, lay the cornerstone of a new building, honor the college graduates, or hear a particular subject discussed. These formal occasions, traditional in our way of life, call for subjects that conform to the occasion. How does this affect your choice of a subject?

You should speak on a subject that the occasion suggests. For your speech at the awards program, you should discuss some educational or cultural problem in a challenging manner and attempt to inspire your fellow students to lofty ideals. Usually a person receives an invitation to speak on a special occasion because of his knowledge of appropriate topics and his ability to adapt to the occasion. He should not disappoint or embarrass an audience by choosing inappropriate subjects or by failing to discuss the topic assigned.

You should select an idea from your knowledge and experience that serves your purpose. Your interest in education should give you a background of information on which to draw. Suppose that early in your study you chanced on an editorial entitled "All Dressed Up in Education with No Place to Go." The editorial developed the thesis that education receives too much stress today, that we find ourselves oversupplied with educated people who have no new fields to conquer. You disagree. "Surely," you say, "the demand for educated people increases with progress; technological advances call continuously for a variety of new skills and knowledge. Why does the claim of an oversupply not ring true?" The answer to this question can form the idea for your speech with the possible title, "New Frontiers in Education," in which you point out new fields that call for educated people. Thus, you take a subject from

your background of knowledge and adapt it to the occasion. This is usually the best method.

Where the speaker predominates

Your invitation to speak at the workshop of business students features you, the speaker. The nature of the workshop indicates certain limits for your subject, but not a specific topic. Many speaking situations permit the speaker to choose his subject. Note the frequent requests for speakers by civic clubs, study clubs, school assemblies, church groups, and other organizations with regular meetings. They choose speakers with knowledge and reputations in certain fields and leave the choice of a specific subject to them. What factors should you consider under these conditions?

1. Choose a subject from your background of information. Should you, a speech student, talk on subjects like property values, trends in home construction, or home financing for the workshop of business students? Probably not, because members of your audience will probably know more about these subjects than you. You should seek a subject in your field of specialization and apply it to the occasion.

A fundamental understanding of subject matter affects the speaking situation in many ways. Most important, it permits the speaker to express mature ideas and accurate information. It generates confidence, authority, and enthusiasm. After considering these factors, suppose that you decide to talk on "Effective Speaking in Selling." The audience will consist primarily of students in business administration; they should welcome ideas on how to improve themselves. Supposing that you are a speech major, you are likely to know more about oral communication than do members of your audience. Thus you choose from your field of specialty a subject that vitally affects your audience. Apply these principles the next time you seek a subject.

As a student, you may sometimes have difficulty determining your fields of specialization. You may lack the training and experience from which to draw subjects. Consider the following questions to help determine your area of knowledge.

What do you read during your spare time? You usually read what interests you most; thus, in time you may become a specialist without realizing it. When you read a popular magazine, do you start with the first article and read through to the end? You probably turn first to the table of contents and select those articles that appeal to you most. When you go to the library in search of books for pleasure reading, what subjects do you select? The answers to these questions may reveal your

specialty. We usually learn much from pursuits that give us pleasure.

What subjects in your school work interest you most? Besides your required courses, what subjects do you take? What are your major and minor subjects? You probably have special knowledge in these areas. Suppose the local civic club invites you to speak. Perhaps you are majoring in economics. Look over your texts and notes to discover a topic; for example, business people would be interested in an analysis of inflationary tendencies. Perhaps your major is art. What about a subject on the psychological effect of color on worker efficiency? If your major is sociology, you could perhaps analyze the thinking of students who participate in demonstrations on college campuses or in war moratoriums. The hard-fisted business executive constantly seeks methods to improve industrial efficiency and to understand current student movements. Many interesting and helpful topics may arise from your major subject.

What are your hobbies? Perhaps you like sports. Because of your interest you read considerably about sports in addition to participating in and observing them. How do sports apply to the problem of leisure activities? Because of increased leisure occasioned by shorter work days and work weeks, the proper use of leisure has become an important social problem. It would serve as the subject of a constructive talk to an audience of social workers, the sociology club, or the school recreational directors.

In what activities do you participate? Do you participate in social welfare programs? If so, you could develop a worthwhile idea for the local chapter of the Society for Crippled Children, the Society for Mental Hygiene, or the university speech clinic. Consider your extracurricular activities. You chose these activities because of your interests and aptitudes. If you participate in the school's television program, you might talk on "The Future of Educational Television" or "Advertising by Television." If you belong to a fraternity or sorority, you might discuss the advantages or disadvantages of national social organizations. If you belong to the international relations club, you might discuss such subjects as the future of world government, recent developments in our relationships with China or Russia, or international student unrest. Your outside activities may suggest many topics for worthwhile and novel speeches.

What places of interest have you visited? Have you made some interesting trips? One student visited the United Nations building in New York City and took some excellent photographs. Her visit increased her interest in the United Nations and caused her to make a special study of the organization. She made several speeches about the United Nations for civic and educational organizations and over the local television station. Slides prepared from her photographs added interest to her ad-

dresses. A serviceman made movies and photographs while on duty in England. Several organizations invited him to speak at their meetings and show his slides.

As a sports enthusiast, perhaps you have visited the Baseball Hall of Fame in Cooperstown, New York. The local boys' club, YMCA, or athletic club would welcome more information on this program. Consider interesting places you have visited; they will suggest many subjects on which you have above-average knowledge.

2. Choose a subject in which you have interests and convictions. You chose the subject "Effective Speaking in Selling" for the workshop of business students because of your interest in the subject. Perhaps you have known salespeople who lessened their effectiveness because of slovenly diction, incorrect grammatical construction, and poor voice qualities. You became enthusiastic about this subject because you felt you could give the business students some constructive pointers. Interest and enthusiasm in a subject affect a person's manner of speaking, giving him added confidence and desire to speak. He tends to forget himself, as he loses himself in the idea of his speech.

If you select a subject on which you have strong convictions, you will eagerly share your ideas. A student in an adult speech class chose for one of his class speeches, "Traffic Safety." His interest in the subject grew out of a tragic accident in which his brother had been killed. He spoke so well that the professor submitted his speech for publication. He did well because he was so convinced of his position that he eagerly shared his ideas with others. Another student was apprehended for participating in a streaking event on his campus. Although he was punished, his exemplary record saved him from dismissal. He used this experience as a springboard to discuss the philosophy behind streaking and what gave rise to its popularity in the mid-1970s. Consider subjects that you feel strongly about; they may affect your attitude toward your desire for speech-making.

In summary, when the choice of speech subject rests with you, consider a topic from your training and experience, one that interests you, and one on which you have strong feelings.

LIMITING FACTORS IN CHOOSING A SUBJECT

Although your background of information, interests, and convictions may suggest many subjects, you should consider certain limiting factors which may affect your choice of a specific subject.

Is the subject in keeping with the intellectual capacity of your listeners?

A scientist spoke to the freshman class of a university on the subject of nuclear weapons. He spoke in terms applicable to graduate physicists, not college freshmen. Dr. James B. Conant, then president of Harvard University and former chairman of the National Defense Research Committee, addressed the same group on atomic energy. He started with an elementary treatment and led gradually into technical matters for which his previous elementary treatment had prepared his audience. How did the two situations differ? One speaker gave a speech; the other talked with people. Dr. Conant chose a subject which he could adapt to the persons present. A realization of this simple fact may mean the difference between success and failure in a public speech. Regardless of your thorough knowledge of a subject, you must choose one that will enable you to speak in terms that your audience understands.

Is the subject adapted to your time limit?

A student in a beginning speech course received constant criticism from the instructor for failure to stay on his announced subject. He found the byways more interesting than the main road. Following an unusually severe admonition, the boy announced as his next subject "The Past, Present, and Future of Science, Literature, and Art." Thus he solved one problem, but he ushered in a new one. Even a college student experiences some difficulty in treating so broad a subject in five minutes. Do not decrease your effectiveness by trying to include all phases of your subject. Narrow it to permit adequate treatment in the time allotted.

Suppose that you decide to talk about the United Nations. If you could speak several hours, you could discuss previous attempts at world organizations, events leading to the United Nations, and its organization. For a 20-minute speech you might narrow your subject to the organization and purpose of the General Assembly.

Is the subject appropriate for the size of your audience and the prevailing physical conditions?

Subjects suitable to small audiences with common interests and training may not be appropriate to large audiences with diverse interests. In general, a large audience requires a nontechnical subject with universal appeal which coincides with the members' mutual secondary or momen-

tary interests. An appropriate subject for a small audience would recognize its primary interests.

These variations do not mean that you must abandon your fields of interest; they do indicate that you may need to vary the treatment of your subject. If you speak in a large and uncomfortable auditorium, for instance, develop your speech through illustrative material and narration. If you speak in a small and comfortable room, you may develop the speech in a more technical manner through explanation and specific details.

Is adequate material available on your subject?

Not all of the ideas and facts for your speech need come from books and other printed matter, but it helps to supplement other sources by research. One student, a member of the Young Republicans on his campus, spent the summer of 1972 working for the Committee to Reelect the President. He used this experience as a basis for an excellent speech advocating campaign reform. Many of the ideas for his speech came from his experiences, but he also found useful articles and books that gave information and ideas helpful in preparing his message. These printed materials corroborated and supplemented his ideas and gave them authority and prestige. Before making final decisions on your subject, investigate whether there are sufficient published materials to supplement your ideas.

In summary, choose your subject from your background of training and adapt it to your audience. Select a subject that interests you and in which you have convictions. In making your final choice, consider such limiting factors as the intellectual capacity of your audience, the time allotted, the size of your audience, the prevailing physical conditions, and the availability of published materials.

SELECTING THE GENERAL PURPOSE

You decided on an inspirational speech for the honors award program because this type is best for ceremonial occasions. You hope to persuade your listeners to continue their emphasis on education, that education has new objectives. For the workshop of business students, you decided on an informative speech because workshops aim at acquiring new methods and exchanging ideas.

Will Rogers, the American humorist, was invited to give an after-dinner speech for a group of clothing manufacturers. He spoke on "Set-

tling the Corset Problem of This Country." You can easily imagine his purpose: entertainment. He was interested in neither persuading nor informing his listeners.

These instances exemplify the three basic purposes: (1) to persuade, (2) to inform, and (3) to entertain. In considering this classification of purposes, you should realize that not all speeches fall nicely into one type or another; some partake of more than one purpose. Adherence to this general classification, however, should help in improving speechmaking.

The persuasive message

The ends sought in the persuasive message may be classified as (1) to stimulate thought and emotions, (2) to gain assent, and (3) to move to action. Decide early in your preparation which you seek.

1. To stimulate thought and emotions. You do not seek overt action as a result of your speech to the honor students. Rather, you wish to stimulate the thinking of your fellow students, to indicate a point of view.

Ceremonial speeches often seek this response. For example, in "The Gettysburg Address" Abraham Lincoln paid tribute to those who lost their lives at Gettysburg and indicated the unfinished task that lay ahead. He called for a rededication to the task of preserving free government. He sought simply to stimulate the thoughts and feelings of the audience.

Franklin D. Roosevelt spoke at the ground-breaking ceremony for the Jefferson Memorial in Washington, D.C., in 1938. After explaining the circumstances under which the Jefferson Memorial was conceived, he sought to stimulate the nation's respect for Jefferson and his contributions to free government.

Dorothy Thompson spoke at the commencement exercises at Russell Sage College on the subject, "Freedom's Back Is Against the Wall." She pleaded for greater respect for the freedom enjoyed by Americans and for dedication to the principle of protecting the spirit of freedom. She stimulated her audience's respect for freedom and indicated how Americans can assume their obligations to keep America free.

Theodore Clevenger, Jr., provost of the division of communication arts and science at Florida State University, gave the main address at the dedication ceremonies of the new communication center at Baylor University on May 16, 1974, on the subject "Greatness and Change." He traced the significant growth in communication training in recent years, gave reasons for the increased emphasis, and pointed to new directions for training in communication. He said in part:

We can say with considerable certainty that communication is the growth industry of the seventies, and may well be the dominant feature of the eighties. Physical science was the growth factor of the fifties, and it dominated our lives through the sixties, leading to fantastic industrial growth, enormously complex human organizations, and, unfortunately, a level of social unrest unknown before in our lifetimes. Out of that growth, complexity, and unrest has arisen a massive need for improved human communication and an insistent demand for communication skills.[1]

None of the above speeches sought direct action; they meant to stimulate the listeners, to cause an increased dedication to high ideals. Speeches at homecoming gatherings stimulate alumni; the sales manager's talk stimulates the salespeople. Although the mildest type of persuasion, the speech to stimulate is the most common.

2. To gain assent. Some persuasive speeches seek to convince an audience. This purpose prevails in debates, at many forum meetings, and at some ceremonial occasions. Speeches to convince emphasize reasoned discourse and adequate evidence. The speaker usually shows that a problem exists, that his proposal can correct that problem, and that benefits will accrue.

William Trufant Foster gave the Scholarship Day Address at the University of Maine on the subject, "Should Students Study?" He developed the thesis that success in life can be measured largely by a student's academic attainment—that a positive correlation exists between high grades and success. Through reasoning and evidence, he sought to convince his audience of his position.

Former President Herbert Hoover gave an address over the network of the Mutual Broadcasting System on the topic, "A New Foreign Policy Is Needed." He showed first the problem presented by our foreign policy; then outlined some criteria to govern our foreign policy; finally he presented some specific proposals. He attempted to gain the approval of his audience for his proposed program.

Former President Dwight D. Eisenhower addressed the 59th annual meeting of the Life Insurance Association of America in New York City on the subject "Faith in the Individual." His basic theme, that the powers of the federal government should be limited and greater reliance placed in the individual, sought to convince his audience of his position. Early in his speech he stated his position as follows:

This is the burden of my talk today:
In far too many ways we are heading away from reliance on the citizen's

[1] Text of speech furnished by Dr. Clevenger with permission to quote.

common sense, personal responsibility, and freedom of action toward federal domination over almost every phase of our economy.

This may give to some an immediate sense of material well-being and personal security.

But it is dangerous to our future—because it flouts our basic rights, weakens our moral fiber, restricts individual decision and, in the long run, destroys the incentives that have been responsible for our unmatched productivity.[2]

The speech that seeks assent makes its basic appeal on rational grounds and uses psychological appeal judiciously. Acceptance by the audience, not immediate overt action, is its main purpose.

3. To move to action. The persuasive speech that seeks overt action constitutes the strongest type. The lawyer seeks a favorable verdict, the politician wants votes, the sales manager desires more orders, and the city manager wants the bond issue approved. Many occasions in a democratic society call forth the advocate. Without him, the business of free people could hardly be carried out.

The persuasive speech that seeks action should balance logical, ethical, and emotional proofs. Usually the occasion for such a speech engenders an atmosphere of excitement and enthusiasm that makes for an aggressive presentation. Daniel Webster's reply to Hayne in the Senate in 1830 is a classic example of the able advocate in action. Debate over the Foote Amendment, which proposed to limit sales of Western land, developed into a bitter debate between Senators Webster and Hayne over federal versus state sovereignty. Webster championed the cause of federal supremacy. The speech consists principally of refutation of points raised by Senator Hayne. It contains much reasoned discourse, but it also contains ethical and emotional proofs. It attempted to influence the vote of the senators on the Foote Amendment; thus it sought action.[3]

On January 8, 1964, former President Lyndon B. Johnson presented his State of the Union Message to Congress. In this speech he sought action—adoption of his proposed budget. After spelling out a ten-point program to justify the budget, he concluded by calling for action.

John Kennedy was a victim of hate, but he was also a great builder of faith —faith in our fellow Americans, whatever their creed or their color or their

2 *Vital Speeches, 31:* 8 (February 1, 1965), 228. For analysis and full text of speech, see Glenn R. Capp, *The Great Society: A Sourcebook of Speeches* (Los Angeles, Ca.: Dickenson Publishing Co., 1967), pp. 31–40.

3 For detailed discussion and text of speech, see Glenn R. Capp, *Famous Speeches in American History* (Indianapolis: The Bobbs-Merrill Co., 1963), pp. 45–63.

station in life; faith in the future of man, whatever his divisions and differ-
ences.

This faith was echoed in all parts of the world. On every continent and in
every land to which Mrs. Johnson and I traveled, we found faith and hope
and love toward this land of America and toward our people.

So I ask you now, in the Congress and in the country, to join with me in
expressing and fulfilling that faith, in working for a nation—a nation that is
free from want, and a world that is free from hate; a world of peace and jus-
tice and freedom and abundance for our time and for all time to come.[4]

The Lincoln-Douglas debates in the senatorial campaign of 1858
sought action. Each man was seeking the vote. The contrast between the
speakers and their speeches is interesting to students of public speaking.
Stephen Douglas, a short but imposing figure, had a deep voice and a
powerful delivery. Abraham Lincoln, a tall, somewhat awkward figure,
spoke in a high-pitched voice and with a direct, conversational delivery.
Douglas's speeches were polished and ornate; Lincoln's were homely and
direct.

The informative message

You reason that a persuasive speech would not meet the requirements
of the workshop for business students. Therefore, you decide on an
informative speech—to instruct your listeners on how good speech assists
in effective sales techniques.

The workshop is but one of many situations that call for the informa-
tive speech. Teachers' lectures consist largely of information and ex-
planations. Speeches that explain a theory, demonstrate a process, give
instructions, or report on surveys exemplify the informative speech. They
are given before such groups as study clubs, civic organizations, and
church meetings, where learning is the keynote. In the informative
speech, understanding is the principal objective, although the audience
may be stimulated, convinced, or entertained in the process of reaching
the objective. Keep the end purpose—understanding—in mind to prevent
deviation from the main course.

Ralph Waldo Emerson's address "The American Scholar," presented
as the Phi Beta Kappa address in Cambridge, Massachusetts, in 1837,
exemplifies the informative speech. He explained his educational phi-
losophy and characterized what he considered to be the influences on
man's thinking. Among these influences he included nature, the poet,
and social intercourse. Although much of what he said was controversial,

[4] Lyndon B. Johnson, *A Time for Action* (New York: Pocket Books, 1964), p. 194.

controversy was not his primary purpose. He sought understanding of his views on man's thought processes.

W. Stuart Symington, while secretary of the United States Air Force, addressed the Air War College at Maxwell Field, Alabama, on the topic, "Our Air Force Policy." He stated that he proposed to explain the air force policy of the United States because many people do not understand its functions and purposes. He outlined the goals and concluded that they were being achieved. Instilling an understanding of our air force policy was his primary purpose.

On speaking occasions where you desire to inform, keep understanding as your chief goal. Be sure that you appraise your facts properly and evaluate your material accurately.

The entertaining message

After-dinner occasions, social gatherings, and some club meetings call for entertaining speeches. Entertaining speeches may make use of persuasion and information, but only as a means to the end of providing interesting diversion. Most entertaining speeches include humor, but humor is not a prerequisite. An audience may be entertained by a talk on your visit to Europe, an unusual experience, or an interesting incident. The entertaining speech should be more than a string of unrelated stories or jokes; it should develop an idea in a light and pleasant manner. Heavy subject matter or controversial issues have no place in the entertaining speech. Alternatively, humor may be included in persuasive and informative speeches, but not as primary objective.

Mrs. E. M. Gilmer, who wrote under the name Dorothy Dix, addressed a meeting of the National Education Association on "Experiences of a Woman Columnist." Her speech consisted largely of humorous and unusual excerpts from letters written her for advice about matters of the heart. In a light and delightful manner, she developed the theme of changes in types of advice sought during her long experiences as an advisor to the lovelorn. No doubt her speech offered a refreshing "time out" from the serious speeches of the convention program.

Booth Tarkington talked on "Where We Come From" at an annual banquet of the Indiana Society of Chicago. Using exaggeration, he poked good-natured fun at those who bragged about their home states. Then he outdid them, but contended that he was simply giving facts. His burlesque provided entertainment and was well adapted to the occasion.

In summary, after deciding on the subject for your speech, determine your basic purpose—to persuade, inform, or entertain. Keep this basic purpose in focus as you prepare. For a 30-minute persuasive speech, do not spend 15 minutes giving background information. Rather, after a

brief introduction, state your main contentions and develop them by reasoning and evidence. For an informative speech, do not dwell on controversial matters; stay with your purpose. An entertaining speech may take the form of persuasion or exposition, but entertainment remains the main purpose.

SELECTING THE SPECIFIC PURPOSE

What specific purpose do you wish to accomplish in your honors award speech about education? You want to refute the indictment that education has no new objectives, no new and unsolved problems. So far your preparation has included the following:

Occasion:	Honors award program
Audience:	Honor students, parents, and townspeople
Subject:	Education
General purpose:	To persuade
Specific purpose:	To prove that education has new frontiers

For the workshop of business students, you want to show how good speech aids the salesperson. Your plans thus far include the following:

Occasion:	Workshop for business students
Audience:	Students of business
Subject:	Speech
General purpose:	To inform
Specific purpose:	To show how good speech aids sales techniques

Will Rogers prepared an entertaining speech for the dinner occasion of the clothing manufacturers. His plans would have included the following analysis:

Occasion:	Banquet meeting
Audience:	Clothing manufacturers
Subject:	Importance of clothing industry
General purpose:	To entertain
Specific purpose:	To amuse the audience about corset manufacturers

A specific purpose assists in limiting the scope of the speech, adjusting to the time limit, guiding preparation, preventing rambling presentation,

and selecting ideas and facts. It enables you to crystallize your thinking and your precise aims.

PHRASING THE TITLE

Often the title of a speech appears on printed programs and in newspapers. The person who introduces you will need a specific title to announce. Between selecting your subject and presenting the speech, therefore, formulate a specific title. Make the title interesting and provocative so as to increase interest. Consider the following suggestions:

Select a title in keeping with the occasion

A dietitian chose as his title for an after-dinner speech to an audience of restaurant owners "The Social Implications of a Hamburger." Some student debaters presented a humorous debate at the annual banquet of the Forensic Club on the proposition, "Resolved, That Bachelors by Choice Should Be Compelled To Marry Old Maids from Necessity." The titles reflected the spirit of the occasions and helped create a pleasant atmosphere. A good title should do exactly that.

Nicholas Murray Butler chose as the title for his commencement address at Columbia University "Democracy Versus Dictatorship." Mr. H. H. Kirk used the title, "Academic Freedom: Are We Ready for It?" when he addressed the North Dakota Education Association Convention. C. M. Chester, former chairman of the National Association of Manufacturers, spoke to the Congress of American Industry on the title, "How Liberal Is Business?" These were formal programs and the titles reflected the dignity of the occasions.

These examples of varying types of speeches show how the titles fit the occasion. A humorous occasion demands a humorous title; a formal occasion calls for a dignified title.

Select a title applicable to your subject

The title, "All Dressed Up and No Place to Go," would be provocative for your speech to the honor students, but it might prove misleading. The title, "New Frontiers for Education," meets the requirement of relevancy.

R. W. Jepson chose the title, "Potted Thinking," for a radio address. He characterized several illogical types of reasoning by which some people arrive at conclusions. He drew an analogy between these types of

reasoning and foods we buy in potted form. The title applied directly to his subject.

During the depression, Owen D. Young spoke at the Charter Centenary dinner of the New England Mutual Life Insurance Company on the title, "Courage for the Future." He outlined a philosophy for the insurance people and suggested how they could rescue themselves during the depression. His title was descriptive of the theme of his address.

Although the title should apply directly to the theme of the speech, it should not state explicitly the main ideas. For example, Dr. John A. Schindler addressed an audience at Ohio State University on a medical subject, "How to Live a Hundred Years Happily." Compare this title with "Medical Science's Contribution to Longevity and the Resulting Problems of Leisure Activities." The first title relates specifically to the thesis of the speech; the second statement, while relevant, tends to spell out in detail the main points. It leaves too little to the imagination.

Compare "Paying the Parson" with "The Financial Plight of the Rural Minister in America"; "The Obligation to Talk Sense, Not Nonsense" with "The Obligation of the Public Speaker to Evaluate Properly What He Talks About in the Public-Speaking Situation"; "The Professor Talks Back" with "Educators' Answer to the Comparative Low Wage Scale of Teachers to Other Professions." The first of each pair seem better because they are relevant but do not state the theme of the speeches as explicitly as do the alternate titles.

Select a provocative title

Dr. Schindler's subject "How to Live a Hundred Years Happily" excites curiosity and makes the audience want to listen. A student in an adult speech course announced his title as "How to Add $1,200 to Your Annual Income." He gave pointers on the purchasing and selling of stocks and bonds. Another student used the title "Money in Your Pockets" for his talk on legitimate deductions often overlooked in filing income tax returns. These titles provoked audience interest.

The Reader's Digest uses provocative titles well. A copy chosen at random shows such interesting titles as "Nightmare on the 79th Floor," "Oh, Say, Can You Ski?" "Help Your Husband Stay Alive," "A New Way of Dying," and "They Swapped Everything but Their Wives." Such titles prick one's imagination and create an interest in the articles. A provocative title for a speech has the same effect.

What is your reaction to the sermon title, "Your Obligation to Your Church," to the professor's speech on "Problems of the School Teacher," or to the Chamber of Commerce representative's title, "Your Civic

Duty"? Such titles show a lack of imagination and tend to repel listeners. Make your title excite curiosity and thereby increase interest.

Select a brief title

A brief title usually fulfills the foregoing requirements better than a long one. Most of the titles recommended in the preceding discussion consist of a few words arranged into a catchy phrase. Long titles tend to give away the theme of the speech and leave little to the imagination. The following titles are winning college orations: "The Lie of War," "Cross Patches," "Believe It or Not," "Six Martyred Senators," and "A Rendezvous with Death."

In summary, after selecting your subject and purpose, give consideration to phrasing an apt title. A good title reflects the mood of the occasion, relates directly to the subject, excites curiosity, and is phrased briefly.

SUMMARY

Two principal types of communication occasions affect choice of subjects: (1) when the occasion or the subject predominates, and (2) when the communicator predominates. The former calls for selecting a topic in keeping with the occasion; the latter allows a wider freedom of choice.

In selecting a subject, consider your background of information and your interests and convictions. In making a final decision, consider the following limiting factors: the intellectual capacity of your listeners, the time allotted, the probable size of your audience, the prevailing physical conditions, and the material available.

After selecting your subject, consider your basic purpose: to persuade, to inform, or to entertain. The persuasive message takes one of three forms: to stimulate, to convince, or to move to action. Next, decide on the specific purpose so as to limit the scope of your message and to guide you in your preparation.

Finally, phrase a proper title. Consider these factors: the mood of the occasion, the application to your subject, its provocativeness, and its length.

QUESTIONS

1. What two basic factors determine your choice of a subject for a public speech? Where an occasion leaves the choice of a subject to a speaker, what matters should he consider in making his decision?

2. In what field of knowledge do you consider yourself the most competent? List topics from this field that you think would be appropriate to the following audiences: (1) a meeting of your college scholastic society; (2) a high school communications institute sponsored by your college; (3) a weekly meeting of a local civic club.

3. What should be the basic differences in the general purposes of the messages to persuade, inform, and entertain? Why should you decide on your general purpose early in your preparation?

4. How does the specific purpose differ from the general purpose of a message?

5. What factors would you consider in phrasing the title of a message? Phrase interesting and provocative titles for the subjects you chose in #2.

ASSIGNMENTS

Oral

Plan A For your speaking assignment, give a personal-experience speech of not more than five minutes. Make this speech an interesting narrative. The following topics are suggestions only:

1. An interesting place I have visited
2. An unusual person I have known
3. My most embarrassing experience
4. My most interesting game of sports
5. My most interesting vacation
6. My narrow escape
7. My first public speech
8. My introduction to politics
9. My home town
10. My major subject
11. My favorite hobby
12. My greatest accomplishment

Answer the following questions about the subject you select for your personal-experience speech:

1. Is the subject adapted to your time limit?
2. Does the title meet the requirements listed in this chapter?
3. What is the general purpose of your speech?

4. What is the specific purpose of your speech?

5. Did you get a good response from your audience?

Plan B Arrange a professor-student panel critique of the panel discussions concluded during the last class session. The professor should act as chairperson and the panel should consist of the chairpersons and secretaries for each group. After the professor gives his criticisms for each group, panel members may comment, ask questions of the professor, and offer additional criticisms. Reserve at least ten minutes at the end of the period for an open forum.

READINGS

ALY, BOWER, and LUCILE F. ALY, *A Rhetoric of Public Speaking*, chap. 2. New York: McGraw-Hill Book Co., 1973.

BAIRD, A. CRAIG, FRANKLIN H. KNOWER, and SAMUEL L. BECKER, *General Speech Communication*, 4th ed., chap. 8. New York: McGraw-Hill Book Co., 1971.

BRYANT, DONALD C., and KARL R. WALLACE, *Fundamentals of Public Speaking*, 5th ed., chap. 5. Englewood Cliffs, N.J.: Prentice-Hall, 1976.

HOLM, JAMES N., *Productive Speaking for Business and the Professions*, chap. 14. Boston: Allyn & Bacon, 1967.

McBURNEY, JAMES H. and ERNEST J. WRAGE, *The Art of Good Speech*, chap. 5. Englewood Cliffs, N.J.: Prentice-Hall, 1953.

REID, LOREN, *Speaking Well*, 2nd ed., chap. 5. New York: McGraw-Hill Book Co., 1972.

ROSS, RAYMOND S., *Speech Communication: Fundamentals and Practice*, 3rd ed., chap. 7. Englewood Cliffs, N.J.: Prentice-Hall, 1974.

SARETT, ALMA JOHNSON, LEW SARETT, and WILLIAM T. FOSTER, *Basic Principles of Speech*, 4th ed., chap. 16. New York: Houghton Mifflin, 1966.

Finding, recording, and analyzing materials

Although this text discusses separately the processes of listener analysis, selection of subject and purpose, and gathering of materials, these are in fact almost simultaneous acts. You must keep your specific listeners in mind as you consider possible subjects and begin your preparation. The process of doing research is the same whether you prepare for a person-to-person interview, a small-group conference, or a public speech, but the need for specific research is usually greater when you prepare a well-rounded idea for a public audience. As you proceed to think about your subject and do research on it, your ideas for your message will begin to form. You should begin your preparation well in advance of the occasion to give yourself ample time to think about the ideas for your message. The most constructive preparation comes from thinking about ideas for messages at free moments, when they occur. Ideas often come while waiting for class to begin, dressing, or preparing to retire. Most good messages evolve as the result of thought and deliberation. Rarely can you postpone the plan for a message until a predetermined time set aside to prepare. That time may arrive without any inspiration or ideas.

We have already noted the mental processes that you should go through in selecting your subject, deciding on a general purpose, narrowing your subject to a specific purpose, and phrasing a provocative title. All these decisions must be made with your specific listeners in mind. Now you are ready to begin your preparation. How should you proceed?

SOURCES OF MATERIAL

To gather message material: (1) survey previous background knowledge, (2) interview specialists and listen to speakers, (3) analyze published speeches on allied subjects, (4) collect material through correspondence, and (5) conduct research. A discussion of these sources follows.

Survey your background knowledge

After deciding upon your subject, think through what you already know about it. Make a tentative outline of a possible message based on this background information. A preliminary analysis will reveal where you need more evidence. Then investigate and read for additional ideas and material. After reading for new information, think through your subject again. Revise your preliminary outline and incorporate the ideas and materials gained from your research.

How much you can rely on your previous knowledge will vary according to the subject. You probably know more about most subjects than you think. Through improved methods of communication—radio, television, forums, newspapers, magazines, books, pamphlets—we become exposed to the issues of many subjects. Our general knowledge may remain unused for long periods, but it can be recalled with conscious effort when needed.

Some messages may be made mostly from background knowledge. Persons with inquiring minds, interests in information, varied experiences, and wide travel have much information on which to draw. They need only use their acquired knowledge.

Daniel Webster's famous reply to Hayne consisted of some 30,000 words and took parts of two days to deliver. Yet he had only a few days to prepare. He replied when asked how he could prepare so eloquent a speech on such short notice, "Gentlemen, I have been preparing that speech all my life." In a sense this statement holds true for most great speeches.

But you reply, "I do not have a background of information on which to draw. How can I acquire such a background?" Neither did Daniel Webster in his youth, but he had an inquiring mind and an interest in learning that caused him to acquire it over the years. The supply of useful ideas to be learned is inexhaustible. Your daily habits of inquiry, reading, association with others, and travel can gradually build up a supply of ideas and information. Consider the following program as a starting point.

1. Improve your reading habits. If we devoted to general reading a part of the time that we waste each day, we would soon have a back-

ground of information upon which to draw. Some persons devote an hour or two to general reading before retiring at night; others use part of the noon hour or an early-morning period. The important thing is to acquire a regular habit. Consider the following suggestions:

Read a newspaper daily. Read with discrimination; not all parts of the newspaper will prove helpful. Follow the trends of domestic and international affairs by scanning the front page. Read the editorials and syndicated columns; observe the financial, sports, entertainment, and book-review sections. A good speaker knows what is going on in the world about him.

Read a news magazine regularly. Such weekly news magazines as *Time, Newsweek,* and *U.S. News and World Report* summarize and synthesize the previous week's happenings on the domestic, national, and international fronts. They give a more thorough treatment than do most daily papers. They carry special reports on financial conditions, the entertainment field, books, sports, and other subjects that serve the public speaker well. Read them with discrimination because they tend to reflect political, economic, and social philosophies of particular groups; but they contain information that can hardly be found elsewhere.

Read from some of the better magazines regularly. Such magazines as *Harper's, Atlantic, Forbes, Saturday Review, Fortune, American Economic Review, The National Observer, The Nation, The New Republic, The New Times, Commentary,* and *Vital Speeches* carry articles written by outstanding writers. Among these you will find articles that express varying concepts and attitudes. Your ability to discriminate and evaluate will increase the more you read.

Read from professional magazines and journals. Determine the professional journals in your field of interest and read the more important ones. For example, in the field of finance consult such publications as *Forbes, The Wall Street Journal,* the *Monthly Newsletter of the National City Bank of New York, Monthly Labor Review, Financial World, American Economic Review,* and *Barron's Weekly.* Many fields of specialization have journals that prove valuable to specialists. The speech student will find invaluable such publications as *The Quarterly Journal of Speech, Communication Education, Communication Monographs, The Journal of Communication, ETC, Theatre Arts, Players' Magazine, The American Educational Theatre Association Journal, The Journal of Speech and Hearing Disorders, The Journal of Speech and Hearing Research,* and state and regional publications such as *Today's Speech, Western Speech, Southern Speech Communication Journal,* and *Central States Speech Journal.*

Read good books regularly. Acquire the habit of reading from some good book daily. Although you may find only a few minutes to read

each day, the total mounts up in a year. Maintain a balance between fiction and nonfiction, prose and poetry, contemporary books and the classics. Form the habit of selecting books yourself rather than relying on a book club. In time your ability to discriminate will improve. Consult such sources as the book-review section of the *New York Times,* the *Saturday Review,* the weekly news magazines, and your local newspaper for leads on outstanding current books. Such books as Francis Xavier Meehan's *Living Upstairs: Reading for Profit and Pleasure,* John Mansfield's *I Want! I Want!,* John O'Donnell's *Much Loved Books,* and May Lamberton Becker's *Adventures in Reading* give excellent lists of the great books.

2. *Broaden your scope of interests.* Inquire into as many sources of information as possible. A ministerial student conferred with his counselor about his poor academic standing. He stated that he had little trouble with his courses in religion but that other subjects had little appeal for him. Further, he saw little reason for them because he planned to preach the gospel, not instruct in science, literature, and mathematics. Unless he changes his attitudes, he probably will not go far in his profession; and he may give warped and ill-conceived opinions on religion. How can he understand and evaluate the Bible without a knowledge of the many problems with which it deals? The minister who can draw on literature, history, government, and philosophy will not only understand better the truths of the Bible, but will make his sermons more effective by a variety of supporting material.

The lawyer must understand psychology, history, literature, and philosophy to represent his client adequately; knowledge of law alone will not suffice. Business demands people with a broad general education, not simply specialists in narrow fields. The failure to study broadly may make for narrow thinking, dogmatic assertion, and improper evaluation. The person who aspires to successful communication will broaden his scope of knowledge and interests.

3. *Engage in varied activities.* The broader your interests, the more you learn about how others think and react. Such extracurricular activities in college as sports, debate, dramatics, band, newspaper, yearbook, and study clubs provide not only sources of useful knowledge but also an opportunity for association with others. These associations are an integral part of the educational process and increase your ability to communicate well.

Travel will broaden your scope of interests and knowledge; it may provide incidents for use as illustrative material in messages. Travel also broadens your experiences and increases your understanding of people —both invaluable to the communicator. Photographs or motion pictures of places visited provide excellent visual illustrative material.

Participation in civic, religious, and educational activities will also increase your effectiveness as a communicator. Those who restrict their activities limit their scope of interests, knowledge, and understanding.

4. Develop your social life. Almost all great communicators are social in nature. They learn to know people and to appreciate their problems by associating with them. You must develop yourself not only mentally, physically, and spiritually, but also socially to have a well-rounded personality. Do not deplore time spent in conversation, club activities, participation in sports, attending football games or plays, and other worthwhile social activities. They are a necessary part of preparation for life and are a sound training for communication.

Interview specialists and listen to communicators

Experts in the community may be able to furnish excellent ideas on your subject as well as leads for sources to study. For example, if your subject pertains to labor–capital relationships, plan interviews with some of the following: an economics professor who specializes in labor problems; a law professor, for legal implications of the problem; a history professor, for pointers on the history of the problem; the president of the local labor union, for labor's viewpoint; a local manufacturer, for capital's viewpoint; and the chairman of the local Chamber of Commerce, for facts on labor conditions in the community.

Plan your interview to cause the least inconvenience possible to the person interviewed and to obtain the exact information needed. Proper procedure follows: (1) request an appointment; (2) plan questions on the precise information needed; (3) explain what purpose the information will serve; (4) record accurately the statements of the person interviewed; (5) ask for opinions on ideas you have gained elsewhere; and (6) ask questions about materials for further study.

Listen to communicators on subjects closely allied to your topic. Check the programs of the local university-sponsored lecture series or the community-sponsored forums. Often civic organizations, study clubs, and church groups sponsor lectures and will welcome your attendance. Observe the radio and television logs in your local newspaper for the subjects and personalities on forum and lecture programs. Such sources may furnish excellent assistance in preparing for communicating.

Analyze published speeches on allied subjects

Numerous collections of speeches are published, some annually. They furnish models for oral composition as well as ideas and information for oral assignment. Such volumes have long been used for courses in rhetor-

ical analysis and some professors now use them as supplementary books for the beginning speech course; they add to the liberal arts content of these courses. Some of the more valuable collections follow:

WALDO, W. BRADEN, *Representative American Speeches* (New York: H. W. Wilson, 1937–present).[1]

Vital Speeches of the Day (New York: News Publishing Co., 1934–present).

KARLYN K. CAMPBELL, *Critiques of Contemporary Rhetoric* (Belmont, Ca.: Wadsworth Publishing Co., 1972).

WIL A. LINKUGEL, R. R. ALLEN, and RICHARD L. JOHANNESEN, *Contemporary American Speeches: A Sourcebook of Speech Forms and Principles,* 3rd ed. (Belmont, Ca.: Wadsworth Publishing Co., 1972).

L. PATRICK DEVLIN, *Contemporary Political Speaking* (Belmont, Ca.: Wadsworth Publishing Co., 1971).

DeWITTE HOLLAND, *Sermons in American History* (Nashville: Abingdon Publishers, 1971).

JAMES H. McBATH and WALTER FISHER, *British Public Addresses, 1828–1960* (Boston: Houghton Mifflin, 1971).

ALICE M. DUNBAR, *Masterpieces of Negro Eloquence: The Best Speeches Delivered by the Negro from the Days of Slavery to the Present Day* (New York: Johnson Representatives, 1970).

JOHN GRAHAM, *Great American Speeches, 1898–1963: Texts and Studies* (New York: Appleton-Century-Crofts, 1970).

CARTER GODWIN WOODSON, *Negro Orators and Their Orations* (New York: Russell & Russell, 1969).

ROBERT L. SCOTT and WAYNE BROCKRIEDE, *The Rhetoric of Black Power* (New York: Harper & Row, Publishers, 1969).

PAUL H. BOASE, *The Rhetoric of Christian Socialism* (New York: Random House, 1969).

HAIG A. BOSMAJIAN and HAMIDA BOSMAJIAN, *The Rhetoric of the Civil Rights Movement* (New York: Random House, 1969).

J. JEFFREY AUER, *The Rhetoric of Our Times* (New York: Appleton-Century-Crofts, 1969).

BOWER ALY and LUCILE F. ALY, *American Short Speeches* (New York: Macmillan, 1968).

CHARLES W. LOMAS, *The Agitator in American Society* (Englewood Cliffs, N.J.: Prentice-Hall, 1968).

GLENN R. CAPP, *The Great Society: A Sourcebook of Speeches* (Los Angeles: Dickenson Publishing Co., 1967).

CARROLL C. ARNOLD, DOUGLAS EHNINGER, and JOHN C. GERBER, *The Speaker's Resource Book* (Glenview, Ill.: Scott, Foresman, 1966).

[1] Lester Thonssen and A. Craig Baird are former editors.

GOODWIN F. BERQUIST, JR., *Speeches for Illustration and Example* (Glenview, Ill.: Scott, Foresman, 1965).

THOMAS A. HOPKINS, *Rights for Americans: The Speeches of Robert F. Kennedy* (Indianapolis: The Bobbs-Merrill Co., 1964).

GLENN R. CAPP, *Famous Speeches in American History* (Indianapolis: The Bobbs-Merrill Co., 1963).

ERNEST J. WRAGE and BARNET BASKERVILLE, *Contemporary Forum: American Speeches on Twentieth-Century Issues* (New York: Harper & Row, Publishers, 1962).

ERNEST J. WRAGE and BARNET BASKERVILLE, *American Forum: Speeches on Historic Issues, 1788–1900* (New York: Harper & Row, Publishers, 1960).

A. CRAIG BAIRD, *American Public Address, 1740–1952.* (New York: McGraw-Hill Book Company, 1956)

HAROLD F. HARDING, *The Age of Danger* (New York: Random House, 1952)

WILLIAM HAYES YEAGER, *Effective Speaking for Every Occasion,* rev. ed. (Englewood Cliffs, N.J.: Prentice-Hall, 1951)

LEW SARETT and WILLIAM T. FOSTER, *Modern Speeches on Basic Issues* (Boston: Houghton Mifflin, 1939)

Be sure to give credit to the author when quoting from speeches; do not use others' ideas as your own. Analysis of other speeches may, however, give you valuable suggestions for the preparation of your own.

Collect material through correspondence

Supplement local sources of material by correspondence with individuals or organizations. A student in a communications course chose as his term subject "An Analysis of the Speaking Program of the American Medical Association." He wrote to the Chicago headquarters of the association and received letters from both the secretary and the director of public relations, a pamphlet, and suggestions about additional materials. Most organizations have public relations and research divisions that will send information on request. For the price of return postage, the extension divisions of many state universities will furnish materials on most subjects. A letter to your United States senator or representative will get you materials on current problems pending before Congress. Address the Library of Congress, Washington, D.C., for government pamphlets.

A survey by means of questionnaires may be useful in securing information not available elsewhere. A communications professor received a request to speak on "The Status of Speech Training in the Southwest." Since he could not find published material on the subject, he sent a questionnaire to the chairmen of the communication departments in

other universities. The results of this survey provided the only source of information for the report.

Plan the questionnaire to get the exact information needed; do not ask for needless information. The questions must be sensible so that the person will want to answer. The greater the number of returns, the more representative and valid are your findings. Incorporate the following suggestions in planning your survey:

1. Accompany your questionnaire with a personal letter. State briefly what use the information will serve, and comment that confidential information will not be identified with the person or institution. Express thanks for the courtesy of a reply and agree to send a tabulation of your findings.
2. Type or mimeograph the questionnaire, observing the following procedures:
 (a) Make your questions unambiguous. Ask only questions pertinent to your subject, and avoid duplication of questions.
 (b) Use only one side of the paper and space questions neatly on the page.
 (c) Give specific instructions on how to fill in the answers.
 (d) Provide sufficient space on the form for answers. Do not ask that numerous sheets be appended.
 (e) Request approximations where exact information is not essential. Avoid forcing the one providing the information to consult files, make telephone calls, or be otherwise inconvenienced.
 (f) Keep to a minimum questions requiring written opinions and evaluations. For opinions, put your questions in multiple-choice form. Instead of asking, "What is your opinion of the proposed tax reform?" use the check method:
 _____ strongly for, _____ for, _____ neutral, _____ opposed, _____ strongly opposed.
3. Send your letters and questionnaires by first-class mail in sealed envelopes.
4. Enclose a self-addressed, stamped return envelope.
5. Send a second request within two weeks if you do not receive a reply. Emphasize the importance of complete returns and express appreciation for the courtesy of a prompt reply.

Conduct a research study

The sources of information discussed above will prove valuable, but the most important general source consists of books, periodicals, and other printed matter. The extent of reading and research necessary depends on your background of information and on how productive the sources already discussed may prove. Rarely will you talk about a subject in which some research will not be necessary. The following sources of research should prove helpful.

1. Source books, textbooks, and trade books. These sources will help you acquire a general understanding of your subject. Study the history and principles of your subject first.

To locate pertinent books, consult the card catalog in the library. All books in the library are listed alphabetically by author, title, and subject. In the subject-matter listing, look under various topical headings. For example, if your subject pertains to the foreign-aid program of the United States, look under such headings as "United States Foreign Policy," "Marshall Plan," "Point-Four Program," "Lend Lease," "Technical Assistance," "Foreign Aid," and "National Budget."

2. Newspapers and magazines. These sources furnish valuable current material on most subjects. To locate newspaper accounts, consult the *New York Times Index* if it is available. It is the only complete newspaper index in the United States. Most newspapers, however, will carry the same or similar accounts on approximately the same date. Releases disseminated by the Associated Press and the United Press International appear in most newspapers.

To find articles in magazines, consult the *Readers' Guide to Periodical Literature,* published since 1902, or *Poole's Index* for older articles. Like the card catalog for books, the *Readers' Guide* lists magazine articles by author, title, and subject matter; you must look under various allied headings to find articles through the subject-matter listing. The *Readers' Guide* is published monthly and bound into annual volumes by most libraries, and into three-year volumes by some. However, you must look in the monthly issues for the current year.

3. Encyclopedias, yearbooks, and almanacs. Encyclopedias provide a good source for beginning your study of unfamiliar subjects because they give a condensed history and discussion, an overall view. Encyclopedias are revised about every ten years; the revisions incorporate new material into the numbered volumes. Between revisions, annual supplements keep them up to date. For example, *Encyclopedia Britannica* publishes the *Britannica Book of the Year;* the *Encyclopedia Americana,* the yearbook *The Americana;* and the *New International Encyclopedia,* the supplement *The New International Yearbook.* Articles on most subjects list additional references at the end. Many special encyclopedias are also published, such as *The Encyclopedia of Social Sciences.*

Yearbooks and almanacs provide a wide range of factual material and statistics and give the sources of all data. Consult such volumes as *The World Almanac, The Statesman's Yearbook,* the *Statistical Abstract of the United States,* and various state almanacs.

4. Biographical and literary references. To find information about the authors of books and persons whom you might quote, consult any one

of several biographical references. *Who's Who in America* and its companion volumes are perhaps the best known. *Who's Who in America— Living Authors* and *Who's Who in Education* exemplify specialized reference books. Also consult *Dictionary of American Biography* and *Webster's Biographical Dictionary*. Information on deceased persons may be found in *Who Was Who, Lippincott's Biographical Dictionary,* and the *Dictionary of American Biography.*

For appropriate quotations and literary references consult such volumes as *Bartlett's Familiar Quotations,* Mencken's *A New Ditionary of Quotations, Oxford Dictionary of Quotations, Cyclopedia of Practical Quotations* by Hoyt, *The Speaker's Desk Book* by Luptom, *Brewer's Dictionary of Phrase and Fable,* and *Home Book of Quotations* by Stevenson. These books arrange quotations under topical headings or alphabetically by key words and phrases or by authors. Beware of frequent use of ready-made quotations. Instead, find quotations from reading the original source. One speaker quoted Shakespeare with fluency, but the more he talked the more apparent it became that he did not really know Shakespeare. Most people can detect whether a person speaks from understanding or merely from a surface knowledge.

5. Professional and trade journals. Most professions and businesses have journals which provide valuable material in specialized fields. For example, the medical profession publishes the *Journal of the American Medical Association* for members of the profession and *Hygeia* for the general public. Other large organizations that publish journals include American Bankers Association, American Bar Association, American Federation of Labor, the International Law Association, the National Association of Manufacturers, and the American Telephone and Telegraph Company.

The following indexes will help you find material in trade journals: *Agricultural Index, Art Index, Educational Index, Index to Legal Periodicals, Index Medicus, Bibliographic Annual in Speech Communication, Index to the Quarterly Journal of Speech and Communication Monographs, Industrial Arts Index, Psychological Abstracts,* and *Public Affairs Information Service.*

6. Government publications. The state and federal governments publish pamphlets and documents on a variety of subjects. The *Congressional Record,* the official journal of Congress, carries proceedings of the debates in both houses of Congress. The appendix contains an extension of remarks, speeches made by legislators outside Congress, and frequently speeches by others. Each senator and representative has a limited number of copies of the journal for distribution. Many libraries have them.

To obtain public documents and pamphlets, write the Division of

Bibliography, Library of Congress, Washington, D.C., 20402, for a list of references. These lists specify the prices, usually reasonable. Check the pamphlets desired and send your order, together with a money order covering the charges, to the Superintendent of Documents, Library of Congress, Washington, D.C., 20402.

Many university libraries are depositories of public documents. Consult the *Catalogue of Public Documents* Monthly Catalogue, which gives descriptive information on each pamphlet along with the price and instructions for ordering.

7. Dictionaries and bibliographic indexes. A good dictionary is indispensable to the public speaker. The best known are *Webster's New International Dictionary, Webster's New World Dictionary, American Heritage Dictionary of the English Language,* Funk and Wagnall's *New Standard Dictionary, Oxford English Dictionary, The American College Dictionary* by Random House, *A Dictionary of Contemporary American Usage* by Bergen Evans and Cornelia Evans. *Webster's Dictionary of Synonyms* and Roget's *Thesaurus* will also prove helpful.

To find additional information on your subject consult prepared bibliographies in *Bibliographic Indexes,* look for references at the ends of articles in encyclopedias and chapters in textbooks, and consult the *Reference Shelf* series published by H. W. Wilson Company.

TAKE NOTES

A disconcerting part of preparation is failure to find a previously discovered piece of evidence, illustration, or idea. You can remember the library seat you sat in when you read the article and perhaps the person who sat across the table, but the exact article slips your mind. You need it, so you go back to the library and waste time trying to locate it. Perhaps you copied the title and magazine, but you forgot to list the author. Since you plan to use a direct quotation from the article you must go back to the library for a single piece of information. To prevent these frustrating experiences, acquire the habit of taking notes on what you read. Note-taking must be systematic, but it need not be tedious and unpleasant.

Take complete records for each article, book, or pamphlet that you read. For books, include the author's name, the title of the book, the facts and date of publication, and the page number from which the material came. To illustrate:

John Doe and Peter Poe, *Practical Debating* (New York: J. B. Lippincott Co., 1949), pp. 11–15.

For magazines, bulletins, or pamphlets, use this form: author's name, title of article, name of publication, date, and page number. To illustrate:

John Doe, "General Semantics for the Debater," *The Southern Speech Journal, 19,* No. 4 (May 1954), pp. 295–303.

What should you include in your notes? One plan is first to write a summary of the article, including only enough to recall the gist of it. Since you can never be sure just what material you will need, the summary will indicate whether you should read the article again. Second, copy quotations and pertinent excerpts. In selecting quotations, observe these precautions: (1) Do not lift quotations out of context; they should accurately reflect the opinion of the author. (2) Delete parts of quotations not applicable by using three spaced periods (. . .) if the omission comes within a sentence, or four (. . . .) if at the end of a sentence, but be sure your deletions do not change the meaning of the author. (3) If you insert any explanatory statements, put the insertion in brackets within the quotation. (4) Enclose all direct quotations in quotation marks and give the page number from which they come. You may also find statistical information, illustrations, or other supporting data which you desire to copy. If so, make sure that such information means what you think it means before including it in your notes. Finally, a brief statement of your evaluation of the article may be helpful for future reference.

Be consistent in your methods of accumulating notes. Some persons prefer to use cards, others prefer notebooks. Cards can be obtained in either three-by-five inch, four-by-six inch, or five-by-eight inch sizes. The larger sizes permit more notes on each card, but they may be inconvenient to carry about. The following form is suggested:

> *Author, book, facts of publication, page no.*
> Summary of part read
> Quotations or facts
> Your evaluation

Cards permit an index arrangement and can be easily grouped and classified.

Notebooks are easy to carry about, and a sheet permits more notes than a card. The loose-leaf variety has many of the advantages of cards, as pages may be grouped and classified. The choice depends on individual preference, but do not copy notes haphazardly on whatever may be available at the time. Adopt a consistent plan and stay with it.

All the references used in composing your message are to be added at the end of your outline when it is completed. If you decide to give the message again, reread your references to renew your interest. This simple suggestion saves time and effort.

ANALYZE YOUR MATERIAL [2]

After gathering your material, relate it to your subject and purpose. What does the material mean, and how does it apply to your subject? The process of thinking the question through, relating one item to another, and breaking down the subject into its component parts is termed *analysis*. In short, you must differentiate main ideas from subpoints and subpoints from forms of support, and determine the relative value of items of evidence.

The ability to assess values increases as you read and think about your subject. Yet you cannot wait to collect ideas and facts until you complete your study. Begin by listing all ideas, forms of support, and arguments encountered in your study. List them without regard to value at first; the assessment of values comes later.

Consider the research for your speech to the workshop for business students, "Effective Speaking in Selling." Part of your original list of points, recorded as you might list them, follows. Actually, such a list will be longer, but this one will serve to illustrate.

1. Types of vocabularies—reading, writing, and speaking
2. Value of knowing subject well
3. Positive suggestion and sales technique
4. How to improve vocabularies—read good literature, listen to educated people, write, and speak
5. Requirements of a good voice—breathing, relaxation, forward placement, flexible modifiers
6. Sales techniques and intrinsic worth of individual
7. Errors in use of voice—volume, rate, distinctness, quality
8. Values of bodily action—increases self-confidence, helps hold interest, aids in clarity
9. "A good speaker is a good man, skilled in speaking." (Cicero)
10. "Whatever the man is, such is the speaker." (Seneca)
11. The salesperson's obligation to evaluate his product

[2] See chapter 14 for a discussion of the preliminary steps in analysis. For a detailed discussion, see Glenn R. Capp and Thelma Robuck Capp, *Principles of Argumentation and Debate* (Englewood Cliffs, N.J.: Prentice-Hall, Inc., 1965), pp. 86–100.

12. Aristotle refers to "ethics" 29 times
13. Alfred Korzybski—two easiest ways to get by in life—believe all that you read and hear, don't believe anything
14. Effects of skills on sales technique
15. Procedures for proper evaluation of product
16. Psychology and sales technique

Study this list and decide on the main divisions of the message. Then study the list again to determine the subpoints within each main division. Finally, choose from the list the appropriate supporting material for points and subpoints. See below for a rearrangement of points on the original list as incorporated into your outline.

You will note several items on the original list that were not used in the final outline. Normally you will read and take notes on more material than you can use. Do not consider this wasted effort, however, for all you read aids in your basic understanding of your subject. Understanding reflects itself in self-confidence, enthusiasm, and interest.

In summary, your analysis involves four steps: (1) think the subject through; (2) make a list of points, ideas, and supporting material gathered from your study; (3) arrange the pertinent material into main points, subpoints, and supporting evidence; (4) discard the points and material not applicable.

Main point	I. You develop yourself as an able salesperson in proportion to your intrinsic worth as a person. (Point 6 on original list)
Support: *Quotation*	A. Cicero: "A good speaker is a good man, skilled in speaking." (Point 9)
Quotation	B. Seneca: "Whatever the man is, such is the speaker." (Point 10)
Main point	II. You develop yourself as an able salesperson in proportion to your fundamental knowledge of your product. (Point 2)
Subpoint	A. The importance of proper evaluation of your product. (Point 11)
Subpoint	B. Procedures for proper evaluation of your product. (Point 15)
Main point	III. You develop yourself as an able salesperson in proportion to the skills that you acquire. (Point 14)
Subpoint	A. Understand the psychology of dealing with people. (Point 16)

Support:	
Example	1. Example of shoe salesperson.
Example	2. Example of a private selling war insurance.
Subpoint	B. Understand the principles of good speech.
	1. Develop a good vocabulary.
Support:	
Explanation	a. Types of vocabularies: reading, writing, and speaking. (Point 1)
	b. Improve your vocabulary by (1) reading good literature, (2) listening to educated people, and (3) writing and speaking. (Point 4)
	2. Develop a pleasing voice.
Explanation	a. Errors in use of voice: volume, rate, distinctness, and quality. (Point 7)
Explanation and demonstration	b. Improve voice by: deep breathing, relaxing throat and jaws, forward placement, and flexible modifiers. (Point 5)
	3. Develop relaxed bodily action.

ACQUIRE PROPER ATTITUDES TOWARD RESEARCH

The attitude assumed in research distinguishes the scholar from the propagandist. The scholar looks at data objectively; to him, factually true information constitutes an end in itself. He attempts to find the facts and disseminate them regardless of their effect on any social, political, or economic group. He seeks truth for truth's sake; his main concern is accurate evaluation.

The propagandist, on the other hand, is concerned primarily with the way in which he intends to use the outcome of his investigation. He seeks facts that support his cause. He starts his investigation with a predetermined end and searches until he discovers facts to support his purpose. He has a subjective attitude.

There exists a need for both types of attitudes in our democratic society, but the subjective attitude early in one's study defeats scientific investigation. Regardless of the ultimate use to which you put the findings of your study, maintain an objective attitude in initial stages to insure an accurate appraisal of your subject. To help maintain this objective attitude, consider the following factors:

Develop an inquiring mind

The truly effective communicator does not count the hours spent in study. He investigates new fields because he has a compelling interest in

learning. While preparing, he discovers many more ideas and facts than he can use in his message. You cannot see in advance what material will prove helpful. You may therefore follow many false trails in your efforts to acquire a fundamental understanding of your subject.

Some persons question the wisdom of finding a surplus of material. The tests applied to any idea or piece of evidence in assessing its worth for your message make their contribution to your ability to evaluate. This carried-over material helps develop you into an able person and thus adds to your general preparation as a communicator.

Keep an open mind toward your subject

If you begin a study with your mind already made up, you will read to strengthen existing beliefs. Once a person decides that he knows all the answers about a subject, he becomes unteachable. He refuses to look any further.

Some graduate students attempted to investigate this problem through an experiment. Together they composed a lengthy essay on the controversial subject of racial equality. By design, one-third of the statements in the essay favored racial equality, one-third opposed, and one-third were neutral or explanatory in nature. Then they recruited several hundred students to be subjects in the experiment. First they obtained the students' opinions on social equality by a public opinion test. On the basis of the findings, they divided the students into four groups, two favorable and two unfavorable. One favorable and one unfavorable group were given the graduate students' essay to read and were asked to write a lengthy summary of it. The summaries of each group were handed to the second group of students of like opinion with instructions to write summaries of the original summaries. The results showed that the second group favorable to social equality retained only favorable statements in the final summary, while the second unfavorable group retained only unfavorable statements in their final summary. This experiment supports the belief that we find what we want to find when we do research on questions about which we have fixed attitudes.

The fixed attitude characterizes many people. Whether we like a speaker or writer depends largely upon whether he complies with our existing prejudices. The fixed attitude prevents scholarly investigation. The true scientist seeks and discovers; he has a flexible, not a fixed mind. He adopts a tentative, not a fixed attitude toward knowledge. The scholar accepts findings tentatively, subject to change if further investigation indicates it.

Cultivate a discriminating attitude

The ability to evaluate the findings of one's research is an invaluable asset for the communicator. Some naive people believe everything that they read; they can vouch for its authenticity because they saw it in print. Others believe nothing that they read; they have a propaganda neurosis. The late Alfred Korzybski, prominent general semanticist and author of *Science and Sanity*, states, "The two easiest ways to slide through life are (1) to believe everything and (2) to believe nothing." [3] Either attitude relieves us of the necessity of thinking and evaluating. A more intelligent approach asks that we develop an ability to discriminate.

Present-day procedures encourage dependence upon others and discourage the cultivation of the ability to discriminate. Editorial boards choose what many will read through book-of-the-month selection clubs. Magazine editors select what they consider the best articles of the month and reprint them in digest form. The publishers of book-digest clubs choose certain books and reissue them in abridged form. Some people view a play but wait until they read the review of the drama critic to decide if they liked it. If you purchase certain encyclopedias, the publisher will do your research for you upon request. Ghost writers will do your research and even write your speech for a fee. All these practices discourage us from developing the faculty of discrimination. Those desiring true scholarship will attempt to develop the ability to discriminate.

In short, the desired attitude for research calls for an inquiring mind, an open mind, and a discriminating attitude. These traits will help you develop yourself into an able communicator.

SUMMARY

After deciding upon your topic and purpose, start preparation in earnest. The sources of material include previous knowledge, interviews and listening to speakers, published speeches, correspondence, and research.

To gain a background of information from which you may draw improve your reading habits, broaden your scope of interests, engage in varied activities, and develop your social life.

In doing your research, read (1) source books, textbooks, and trade books; (2) newspapers and magazines; (3) encyclopedias and literary refer-

[3] Irving J. Lee, *Language Habits in Human Affairs* (New York: Harper & Row, Publishers, 1941), p. xx.

ences; (4) professional and trade journals; (5) government documents; (6) dictionaries and biographic indexes.

Take notes as you read; include the complete citation of the source, a brief summary, specific material you think applicable, and a brief evaluation. Use a consistent system for note-taking. Next, analyze your material and organize it into usable form.

The proper attitudes for research include an inquiring mind, an open mind, and a discriminating attitude. These attitudes will help you develop yourself into a competent person and communicator.

QUESTIONS

1. Discuss briefly five sources that would be helpful in preparing for a speech or conference. Can you add to the sources discussed in chapter 7?
2. Differentiate between preparing for a specific message and preparing yourself to become a competent communicator.
3. Of what value is note-taking when doing research? Explain briefly your method of taking notes.
4. Explain how to analyze the materials you obtain from doing research on a subject. What is the ultimate purpose of analysis?
5. Characterize the proper attitude toward research. Differentiate between the subjective and objective attitudes.

ASSIGNMENT

Oral

Plan A For your speaking assignment prepare a five-minute speech on some national problem, for which you get most of your material through research. The speech may be either informative or persuasive. The following general topics are suggestive. They will need to be narrowed to your time limit.

1. Federal income taxation
2. Possibilities of educational television
3. Women's liberation
4. The energy crisis
5. Financing federal elections
6. Modern advertising
7. The problem of crime in America

8. Ecology
9. The motion-picture industry
10. The Broadway theater
11. Ethnic problems.
12. The aftermath of Watergate
13. Amnesty for war resisters
14. Inflation

Complete the following projects relative to the topic you select for your speech.

1. List three books on your subject that you found through the card catalog in your library.
2. List three magazine articles that you discovered through the *Readers' Guide*.
3. List one reference from a professional magazine.
4. List one reference from a standard encyclopedia.
5. Find one newspaper reference on your subject.
6. Interview two specialists in your community and bring to class a summary of your interviews.
7. Find one speech on a closely allied subject from a volume of contemporary speeches.
8. Find one reference on your subject in a government publication.
9. Prepare a brief questionnaire that would be suitable for obtaining additional information on your subject.
10. List five persons of national prominence whom you consider authorities on your subject.

Plan B For your oral assignment, the class groups will meet simultaneously for a workshop session to arrange a program of informative speeches to be presented before the entire class. Decide on a general plan for the program and methods for making it interesting and profitable. Let each student discuss the plans for his or her individual speech; then other members of the groups can make suggestions for improvements. Consider this a planning and rehearsal session that puts a premium on creativity.

READINGS

Braden, Waldo W., *Public Speaking: The Essentials,* chap 2. New York: Harper & Row, Publishers, 1966.

CROCKER, LIONEL, and HERBERT W. HILDEBRANDT, *Public Speaking for College Students,* 4th ed., chap. 14. New York: American Book Co., 1965.

ELLINGSWORTH, HUBER W., and THEODORE CLEVENGER, JR., *Speech and Social Action,* chap. 3. Englewood Cliffs, N.J.: Prentice-Hall, 1967.

GRUNER, CHARLES R.; CAL M. LOGUE; DWIGHT L. FRESHLEY; and RICHARD C. HUSEMAN, *Speech Communication in Society,* chap. 5. Boston: Allyn & Bacon, 1972.

MCBURNEY, JAMES H., and ERNEST J. WRAGE, *Guide to Good Speech,* 4th ed., chap. 7. Englewood Cliffs, N.J.: Prentice-Hall, 1975.

MILLS, GLEN E., *Reason in Controversy,* 2nd ed., chap. 6. Boston: Allyn & Bacon, 1968.

MONROE, ALAN H., and DOUGLAS EHNINGER, *Principles and Types of Speech Communication,* 7th ed., chap. 10. Glenview, Ill.: Scott, Foresman, 1974.

WILSON, JOHN F., and CARROLL C. ARNOLD, *Public Speaking as a Liberal Art,* 3rd ed., chap. 4. Boston: Allyn & Bacon, 1974.

Selecting and evaluating supporting material

As you investigate, analyze, and do research on your subject by following the procedures explained in chapter 7, you will encounter numerous items of material to support your points. The main points and subpoints of your message constitute the main divisions of the basic idea which you develop; they form the skeleton of your speech or contentions in a conference. The supporting material gives the message substance: it clarifies, amplifies, or proves the points. Without the expanding process of supporting material, a message would consist entirely of theoretical ideas, abstract and uninteresting.

HOW FORMS OF SUPPORT APPLY

What types of supporting material should you seek? You will no doubt use a great deal of explanation, description, and reasoning. Then you will need to support those forms with examples, quotations from authority, statistical information, analogies, and reiteration. Although you will not use the same forms of support in every message, attempt to use a variety of support in each.

The same forms of support apply to informative and persuasive messages, but the manner of application varies. In the informative message, the forms of support expand, explain, and develop an idea, giving it clarity and meaning. The persuasive message uses these forms of support as a basis for inference, to prove a point. Note these differences in the discussions of the various types that follow.

R. W. Jepson used analogy to make clear what he meant by "Potted Thinking," the title of a speech that he gave over the British Broadcasting System. After characterizing several ways that people think, he said:

> *Now, we have seen enough of this attitude . . . to give it a name. And I am going to call it Potted Thinking because the opinions it gives rise to seem to me rather like some of the food we buy in potted form. They are concentrated—easy to digest. And they save a lot of trouble. And the potted thinker saves himself a lot of trouble by acquiring his knowledge as well as his opinions in a potted form.*[1]

In this analogy Mr. Jepson sought to clarify the term *Potted Thinking* by comparing it with something with which his audience was more familiar than the term he used. Later in his speech Mr. Jepson illustrated a type of potted thinker by an example. His point concerned the importance of reading beneath the headlines in our newspapers.

> *But the headlines may give quite a misleading impression by themselves. . . . I was badly taken in myself some months ago. I saw on the posters MUSSOLINI VOWS VENGEANCE. I thought at least I should find a fire-eating declaration that would set all Europe ablaze with war. But when I came to read the Duce's speech it was a very moderately worded statement of Italian aims and policy and at the end there was a rhetorical flourish—"We shall avenge our dead." But from the posters this might have been his chief theme.*[2]

In short, to clarify ideas you must expand your explanations by citing examples, making comparisons, giving statistics, or quoting authorities. Ordinarily you will use several types of support for a single idea, the number depending upon the difficulty of comprehension of the point.

In persuasion, you support your points to prove them. Julian Goodman, Chairman of the Board and Chief Executive Officer of the National Broadcasting Company, used explanation and a personal example in leading into the thesis of his speech entitled "Television Really Is an Education" at the annual meeting of the American Association of State Colleges and Universities in San Diego, California, on November 8, 1973.

> *My youngest son tells me that education is "how kids learn stuff." That's a nice, uncluttered definition, but it obviously lays emphasis on learning as something geared exclusively to the young. And that notion of a time limit on education can stay with us too long.*

[1] *Vital Speeches, 4: 5* (December 15, 1937), 136.
[2] Ibid.

> *By the time I left Western Kentucky to join the Army in 1943, I was sure I had learned quite a bit of "stuff." By the time I left the Army and went to work for the government in Washington I thought I knew quite a bit more. When I signed on with NBC, at the age of 23, I felt mature and well-educated. But it didn't take me long to find out that my education was only starting. And tonight I want to share with you something of what I've learned since then.*[3]

Mr. Goodman used pertinent and interesting material that brought in the force of his credibility in establishing his thesis that television has educational advantages.

Later Mr. Goodman gave another personal incident that pointed up some historical facts about the beginnings of radio and television. Note how he brought into his message a specific instance about the Greek-Turkish aid bill.

> *When I started with NBC as a news writer in Washington 28 years ago, our big problem then was persuading public figures to appear on radio and television.*
>
> *I remember spending most of three days riding up and down in a House Office Building elevator, buttonholing the Chairman of the House Foreign Affairs Committee, trying to persuade him to permit live radio coverage of his Committee's hearing on the Greek-Turkish aid bill. He finally gave in, and that became the first live coverage the American people ever had of a Congressional Committee in action.*[4]

In contrasting the early days of broadcasting with present conditions, Mr. Goodman cited statistics to support his point.

> *When television covered its first national political convention in 1948 only seven cities in the East saw those pictures. It was very difficult to get politicians to go before the cameras. So few people could see them they felt it wasn't worth their time.*
>
> *Well, times have changed and the situation is now very different. Television today enters 65 million American homes. It is recognized as the public's primary and most reliable source of news and information. And its problem is not to persuade people to come on the air—it is to try to balance the views and the arguments of the many different voices, public and private, that want to be heard.*[5]

[3] Text of speech furnished by the National Broadcasting Company. Permission to quote given by Mr. Goodman.

[4] Ibid.

[5] Ibid.

At another point, Mr. Goodman quoted David Brinkley, a well-known television commentator, to support his contention that the machinery of government should not restrict the freedom of television networks.

> *Government is operated by a set of hand signals, and when its leadership is perceived to favor some restrictive actions against someone it may be displeased with, there are many people up and down the line throughout government who can make those restrictions stick. That's why I find it necessary to spend so much time speaking around the country, not just in behalf of the broadcaster, but in the interest of the people's right to the information they need to govern themselves. As David Brinkley has said, "There are numerous countries in the world where politicians have seized absolute power and muzzled the press. There is no country in the world where the press has seized power and muzzled the politicians." [6]*

In his conclusion, Mr. Goodman refers to an analogy that he has used throughout the speech to unify it and carry out his thesis.

> *Looking back over 28 years, I'd say it's been a long postgraduate course in a very noisy classroom. Guest lecturers keep coming in from the public and the government with new theories on what the business should be like.*
>
> *But a number of truths stand out: Television is not and can't afford to be a political instrument, nor a social theory or a tool for special interests. It must have the independence enjoyed by a free press to be an effective medium of public information. And it must have enough creative freedom to keep pace with the public's changing interests and expectations.[7]*

The foregoing excerpts from Mr. Goodman's speech illustrate the proper way to use supporting material. They not only apply logically, but they are interesting and call forth the credibility of a man highly respected for his years of service in the broadcast industry.

The use of the forms of support in a persuasive message closely parallels the use of evidence in legal proceedings. What constitutes evidence in courts of law? Broadly speaking, two general types predominate—facts and expert opinions. Facts consist of physical objects and the circumstances surrounding an act. Physical objects consist of a lethal weapon, fingerprints, handwriting, photographs of tire skid marks, or any other objects involved in the case. The circumstances of an act come from witnesses. Witnesses tell what they saw, not what they believe.

[7] Ibid.

[6] Ibid.

Expert opinion comes from persons qualified to make judgments on the basis of facts. For example, the handwriting expert testifies whether two pieces of writing were written by the same person; the ballistics expert states whether the bullet was fired by a particular pistol; the medical doctor testifies whether the poison could have caused death. These are judgments of experts based upon happenings.

Factual evidence applies to persuasive messages much as it does to law cases. It takes the form of statistics and the circumstances of examples and analogies. Expert opinion comes from persons qualified through training and experience to give reliable judgments based on the circumstances. If your professor states that your final examination consists of ten questions, he makes a factual statement. If he states that the examination is difficult, he expresses an opinion. Both facts and opinions serve useful purposes in supporting ideas in a message.

The courts strive for the best possible evidence. To protect the individual, many rules govern what constitutes evidence and what becomes admissible in a case. For example, Richard cannot testify about what John told him concerning Peter's actions, except under clearly defined circumstances. This violates the well-established *hearsay* rule. The best evidence would come from having John testify. His act of telling Richard removes the evidence one step further from the original source, and therefore injects an added possibility of inaccuracy. You cannot testify about the impressions in the bullet taken from the victim's body until you become qualified as a ballistics expert. Otherwise, the possibilities of ill-conceived judgments would be increased. Just as in law, in communicating messages you should strive for only the best supporting material. Unless you do this, improper evaluation may result.

TYPES OF SUPPORTING MATERIAL

From the foregoing discussion we can isolate several forms of support applicable to communicating messages:

1. Explanation
2. Statistics (compilations of facts)
3. Examples (specific instances or detailed illustrations)
4. Analogy (comparisons)
5. Testimony (expert opinion)
6. Repetition and restatement

In a broad sense, reasoning may be considered a form of support although it consists largely of inferences from the forms listed above.

Reasoning is developed in detail in chapter 14 and will not be considered as a separate form of support here.

The various forms receive a three-fold treatment: (1) their meaning, (2) their accurate use, and (3) their effective use.

Explanation

Explanation usually precedes the giving of other forms of support. It serves as the necessary background for examples, analogies, statistics, testimony, and reasoning. It explains the nature and purpose of the points; other forms then support and expand the explanation. Explanation may use other forms of support, especially analogy and definition, in making points clear.

To illustrate, note how Dr. Gerald Kennedy, Bishop of the Los Angeles area Methodist Church, used explanation to introduce a point in his address at the Human Relations Conference in Chicago on August 30, 1963.

There was a ninth-grade student in a Texas high school who handed in a book report with this very perceptive statement, "I think the author was a pretty good writer not to make the book no duller than it was." Well, I think the generation is fortunate to be no worse than it is as it flounders about without very many examples of faith and courage and greatness. People who have no propositions to which they are dedicated, walk in darkness.

So we come to a last thing which needs to be mentioned. The Christian Church must rediscover the main propositions of its Gospel and proclaim them with clear voice. Let us think again what it means when we say we believe in God who is the father of all mankind.[8]

1. Definition. In explanation, definitions play an important role. Dictionary definitions may not always be adequate. A dictionary defines words as a collective process; in a particular message a word may be used in a selective way. The following methods of definition may prove helpful:

1. Definition by etymology
2. Definition by authority
3. Definition by exemplification

[8] Lester Thonssen, *Representative American Speeches, 1963–64, 36:* 4 (New York: The H. W. Wilson Co., 1964), p. 75. By permission of Dr. Gerald Kennedy.

4. Definition by explication
5. Definition by negation [9]

Etymology treats the origin and development of words. Often meaning can be reasoned out by considering the derivation of words. Since words have a history and their meanings sometimes change, definition by this means alone may prove insufficient. For example, consider the meaning of the word *extemporaneous*. If we consider the Latin derivation, *ex* meaning "out" and *tempo* meaning "of the present time," we might reason that the term means speaking without preparation or on the spur of the moment. However, the term now means speaking through a prepared outline with choice of language made as one speaks. The study of the origin and history of words, however, may frequently lead to acceptable definitions.

Citing an *authority* to define a term may be useful. For example, to explain the term *extemporaneous speaking* one might quote from the textbook *Basic Principles of Speech* by Sarett, Foster, and Sarett:

> *By extemporaneous speech we mean speech that is thoroughly prepared through thinking, gathering materials, organizing ideas, outlining, and rehearsing, but it is not written out and memorized or read. The main ideas and the basic structure are firmly in mind but remain flexible, and the language is chosen at the moment of utterance and adapted to the responses of the listeners.*[10]

For an example of how definitions may be made in a message, note how Dr. John A. Schindler, formerly a physician in Monroe, Wisconsin, defined the word *emotion* in a radio address entitled "How to Live a Hundred Years Happily" as a part of the University of Wisconsin's Farm and Home Week program.

> *If we understand what an emotion is, we'll understand how thinking does things to our bodies. The best definition of an emotion comes from our own William James, who took the work of the physiologist Lange about 1888 and formed a definition that's still the best we have. Nobody has improved on it. Occasionally somebody tries but doesn't succeed. William James said that an*

[9] Glenn R. Capp and Thelma Robuck Capp, *Principles of Argumentation and Debate* (Englewood Cliffs, N.J.: Prentice-Hall, 1965), p. 94.

[10] Lew Sarett, William Trufant Foster, and Alma Johnson Sarett, *Basic Principles of Speech* (Boston: Houghton Mifflin Co., 1966), p. 93.

emotion is the state of mind that manifests itself by a sensible change in the body.[11]

The authority should be a recognized expert within the field.

Definition by *exemplification* means the selection of an individual case to represent the whole. The example must be representative and typical. The following statement illustrates this point:

> *Confederation involves a definite organization. It is taken usually to mean an organization of nations. An example of an international confederation is the League of Nations. Another example of confederation was the League of Friendship under the Articles of Confederation. The basic unit of the organization is the state or nation. All final authority is thought of as being vested in the member states.*[12]

Definition by *explication* enlarges on bare statements and attempts to clarify a term by explaining it. The following explanation of the term *federation* illustrates this method.

> *Federation involves a definite organization, but it involves much more. The distinguishing characteristic of this type of international organization is that its authority is delegated to it by member states or peoples. In the realms in which authority is delegated, it is supreme.*[13]

Negation defines by explaining what a term does not mean. For example, the term *federation* may be defined by showing that it does not mean *confederation,* because in this type of world organization the supreme government acts directly on the member states, not directly on the people. It does not mean *regionalism,* because this type of organization provides for joint action of the nations in a region such as the Western Hemisphere. It does not mean *alliance,* because this relationship depends upon a definite agreement or treaty; the member nations pledge their honor to carry out an agreement. Federation means, therefore, the type of world organization that acts directly on the people. It has final authority in fields where it has been delegated power. Thus, by a process of elimination, an acceptable definition emerges.

[11] Goodwin F. Berquist, Jr., *Speeches for Illustration and Example* (Chicago: Foresman & Co., 1965), p. 104. Reprinted by permission of Mrs. John A. Schindler.

[12] Thelma Robuck Capp and Ralph Norvell, *Post-War Organization of Nations* (Waco, Texas: Baylor University Press, 1942), p. 47.

[13] Ibid., p. 48.

2. Visual aids. Visual aids may be helpful in explaining difficult and technical materials. Numerous experimental research studies have been made to determine the effect of visual aids on learning, retention, and recall. In general, they show that a person learns more readily and retains information longer by a combination of visual and oral methods than by oral methods alone.

Visual aids may consist of drawings, diagrams, maps, printed materials, models, slides, motion pictures, or any other physical objects. One student brought his pistol collection to class and demonstrated the principles upon which pistols operate. Others used such aids as blackboard drawings to demonstrate how the compass operates in an airplane, a map of the Middle East to explain the crisis there, a model of an altimeter to demonstrate how it acts in flight, and a diagram of a saw mill to show the processing of logs into lumber. Besides aiding in explanation, visual aids assist in gaining attention and maintaining interest.

Unless used properly, visual aids may confuse rather than clarify. When using visual aids, observe the following precautions:

1. Adapt the visual aid to the size of your audience. A small model proves worthless unless members of the audience can gather around you as you demonstrate. Make your diagrams or drawings and lettering large enough to be seen by all. A visual aid that cannot be seen in detail distracts attention.

2. Stand to the side of the visual aid as you explain it to avoid obstructing the view of your audience or decreasing your communicative directness.

3. If you illustrate by drawings during your message, explain the drawing as you draw it. Periods of silence permit interest to wane. If you plan to use complicated drawings, put them on the blackboard in advance.

4. Use a pointer to indicate specific references to parts of the visual aid as you explain it. A general reference to a visual aid confuses an audience.

5. Do not display your visual aid until you are ready to use it; an unused chart distracts attention.

6. Remove the visual aid when you finish with it. Remove any other visual aids displayed in the lecture room. They divert attention from your ideas.

Statistics

1. Meaning. Statistics consist of compilations of numerical facts or occurrences. Numbers become meaningful when they show the proportion of instances of a specific kind. For example, the fact that the consumer price index stood at 149.8 percent in May 1974 means little unless we know that 100 percent represents the average from the 1967–68

period. It takes on added significance when it is shown that the price index rose .9 percent over the previous month. Thus the significance of the figure makes it meaningful.

To illustrate, note how the Bureau of Public Affairs, Department of State, used statistics in its Foreign Policy Outlines:

> The problem: *About 200,000 people are being added daily to the world's population. In 1950, the global total numbered 2.5 billion. Early in 1975, this total will reach 4 billion; by the year 2000, it will be 7.8 billion if current trends continue. Modern sanitation and public health programs, particularly in less-developed countries, and reduced infant mortality rates, have increased average life expectancy. Today more than half of the world's population (55 percent) is under 25 years of age. The built-in momentum of future population growth, deriving from this high proportion of young people, is enormous.*
>
> *Population growth is unequally distributed. Industrialized countries have reduced their average rate of growth to less than 1 percent per year, but in most developing countries of Asia, Africa, and Latin America, populations are increasing at rates of 2.5 percent to 3.5 percent per year. At these rates, populations are doubling in 20–28 years.*[14]

2. Accurate use of statistics. Of all the forms of support, statistics are the most easily abused. The adage, "Figures don't lie, but figurers often do," presents only part of the picture. Some communicators misrepresent the facts, not by design, but because they do not know their true meaning. The following are the more common causes for misrepresentation by statistics:

Determine the definition of the unit. Failure to define the unit upon which the statistics rest is a common error. For example, what does this statement mean—"There are twenty million illiterates in the United States"? Does it mean anything per se? Not until we define the unit *illiterate.* Suppose the term were defined for a survey as "a person over ten years of age who cannot write in any language." Suppose another survey used the definition "any person over ten years of age who cannot write in English." Many people would be listed as literate under the first definition and illiterate under the second. Since high-level words like *illiterate, criminal, religious,* and *social* have no standard meaning, researchers can define them as they desire for a particular study. When using statistics in a message, determine what the statistics actually mean. Otherwise, you may project your meaning upon the term. Consult the

[14] *Foreign Policy Outlines,* Bureau of Public Affairs (Washington, D.C.: Department of State, June 1974), p. 1.

footnotes and explanations to determine how the compilers defined them.

Compare only figures based on the same unit. Comparing figures that are not comparable creates another abuse in the use of statistics. This error results when two sets of statistics, based upon the same high-level terms but with different definitions, are combined for comparisons and inferences. For example, suppose that the Department of Public Safety of State X issues figures showing five thousand automobile accidents in 1975. The figures of the Department of Public Safety of State Y show only one thousand accidents during the same period. At once the speaker jumps to several conclusions, such as: State Y has a better system of highways than State X, better traffic laws, a more effective inspection system, or newer automobiles. Suppose, however, that State X defined the term *automobile accident* as a collision or upset in which at least 25 dollars' worth of property damage results and State Y defined the term as 50 dollars' worth of property damage. None of the inferences apply because the two sets of figures have different meanings. The figures are not comparable.

Use up-to-date statistics. Out-of-date statistics often lead to improper evaluation. In areas of rapidly changing conditions, current statistics must be used or false representation becomes inevitable.

In a college debate, one debater attempted to support his argument calling for federal revenue sharing with the states by citing statistics that gross receipts from federal income taxation were approximately $100 billion annually. His opponent showed that he had used the figures for 1966 and that by 1968, the last year for which figures were available, the receipts had increased to approximately $135 billion. Thus the debater advancing the original argument gave a false representation of the current situation. The 1966 statistics were no longer meaningful.

Do not make misleading interpretations. Unusual interpretations of statistics often lead to misunderstanding. Statistics lend themselves to abuse through misleading inferences. Averages may be particularly misleading. The boy and his dog, cat, and duck average three legs, but none has that particular number. A man drowned in a lake that averages only six inches in depth.

The way a conclusion is expressed may leave an erroneous impression. A country doctor, near the twilight of his career, treated only two patients one year. One recovered and the other died. He made his report as follows: "I had a very successful year. Fifty per cent of my patients completely recovered, and only one died." Beware of giving distorted impressions by the way you present statistics.

In summary, statistics constitute an effective form of supporting material, but they may be misunderstood. To help achieve accuracy in their

use, (1) determine the definition of the unit, (2) compare only figures based on the same unit, (3) use up-to-date statistics, and (4) do not make misleading interpretations.

3. Effective use of statistics. To be effective, statistics must be made interesting. Citing long lists of statistical data without some embellishment will cause an audience to lose interest. The following factors apply to making statistics interesting and acceptable.

Present statistics in round numbers when dealing with large numbers; they take less time and are more easily understood. Instead of stating that the national debt is $399,634,839,642.51, give it as approximately 400 billion dollars. Note the uninteresting and complicated treatment of statistics used by one student.

> *Reductions (in illiteracy) in the poorer states from 1920 to 1930 were as follows: Mississippi, 17.2 percent to 13.1 percent, or a total reduction of 4.1 percent; Arkansas, 9.4 percent to 6.8 percent, or a total 2.6 percent; Louisiana, 21.9 percent to 13.5 percent, total 8.4 percent; South Carolina, 18.1 percent to 14.9 percent, total 3.2 percent; North Carolina, 13.1 percent to 10.0 percent, total 3.1 percent.*

Your listeners would get lost in the maze of percentage figures. The following rearrangement shows improvement.

> *Reductions in illiteracy in the five poorer states averaged approximately 4½ percent from 1920 to 1930. Louisiana had the greatest reduction, with 8½ percent; Mississippi, with 4 percent, came next; North and South Carolina each had approximately 3 percent, and Arkansas trailed with 2½ percent.*

Make statistics vivid and graphic by relating them to matters familiar to your listeners. The fact that the national debt approximates 400 billion dollars means little to the average citizen; but if one says, "You owe the federal government two thousand dollars as your proportionate share," the figure becomes more meaningful. The communicator might also show how many highways this sum could build, how long it would take to count the sum in five-dollar bills, or how much of our tax money it takes to pay the interest. Newspapers and magazines make statistics interesting and meaningful through charts, graphs, and pictures. The communicator must do the same in word pictures.

Cite the exact source of statistics. Since people have been deceived so often by statistics, you can dispel their doubts by giving the source of

your facts. Avoid such phrases as these: "Statistics prove," "statistics gathered with great care show," "the undeniable facts prove," "facts don't lie," and "here are the facts." Say instead, "These statistics were taken from the book *The Problems of Lasting Peace* by Herbert C. Hoover and Hugo Gibson, page 212."

Check your statistics against other sources to test their authenticity. If you doubt the validity of statistics, check them against known reliable sources such as *The Statistical Abstract of the United States, The Statesman's Yearbook,* or *The World Almanac.* These sources publish objective data and are considered by most people to be reliable.

In summary, statistics prove an excellent means of supporting points for oral communication. They consist of statements that represent the number of occurrences of a particular phenomenon. Their accuracy may be assured by defining the unit, by combining and comparing only those statistics that use the same unit, by giving up-to-date facts, and by drawing valid conclusions from the facts. Statistics can be made interesting and authoritative by presenting them in round numbers, by relating them to the interests of the listeners, by citing the source of facts, and by checking them against sources known to be reliable.

The example

1. Meaning and types. An example may consist of a specific instance, a past happening, or a hypothetical situation used to support the points of a message. It may be used to amplify explanations in the informative message or as a basis for inference in the persuasive message. For example, one cites the League of Nations and the United Nations as examples of the confederate type of world organization to explain how this type operates. In the persuasive message, the communicator may contend that the confederate-type world organization has the greatest chance for success because the people have experienced this type. He cites the League of Nations and the United Nations as the types most acceptable under existing world conditions.

Examples may take the form of specific instances or detailed illustrations. The specific instance makes brief reference to one or several cases with little amplification. For example, in his speech for a declaration of war against Japan on December 8, 1941, Franklin D. Roosevelt cited these specific instances:

> *Last night Japanese forces attacked Hong Kong. Last night Japanese forces attacked Guam. Last night Japanese forces attacked the Philippine Islands. Last night the Japanese attacked Wake Island. This morning the Japanese*

attacked Midway Island. Japan has, therefore, undertaken a surprise offensive extending throughout the Pacific area.[15]

The detailed illustration amplifies a case and presents it in detail. Note how the noted minister Harry Emerson Fosdick, in his sermon "Handling Life's Second-Bests," illustrates his point that success in life does not always consist of attaining our goals.

> *Or consider Sir Walter Scott. We think of him as the novel writer whose stories charmed our youth so that for many years some of us would have voted* Ivanhoe *the best tale ever told. Sir Walter, however, did not want to be a novelist; he planned to be a poet, but Byron's sun rose and dimmed his lesser light. "Byron hit the mark," he said, "where I don't even pretend to pledge my arrow." Then he turned to writing novels. . . .*[16]

Real examples come from history or experiences. They deal with actual happenings. The following example by Harry Emerson Fosdick illustrates this method:

> *Whistler, the artist, for example, started out to be a soldier and failed at West Point because he could not pass in chemistry. "If silicon had been a gas," he used to say, "I should have been a major-general." Instead, he failed in soldiering, half-heartedly tried engineering, and then tried painting—with such remarkable results as one sees in the portraits of his own mother, Miss Alexander, and Carlyle.*[17]

Hypothetical examples consist of imaginary happenings. They may or may not be based on actual cases. Booker T. Washington, outstanding educator, used the hypothetical example in his Atlanta Exposition address:

> *A ship lost at sea for many days suddenly sighted a friendly vessel. From the mast of the unfortunate vessel was seen a signal, "Water, water; we die of thirst." The answer from the friendly vessel at once came back, "Cast down your bucket where you are." And a third and fourth signal for water was answered, "Cast down your bucket where you are!" The captain of the distressed vessel, at last heeding the injunction, cast down his bucket, and it came*

[15] *Congressional Record*, Vol. 87, Part 9, Dec. 8, 1941.

[16] Harry Emerson Fosdick, *The Hope of the World* (New York: Harper & Row, Publishers, 1933), pp. 71–72.

[17] Ibid., p. 69.

up full of fresh, sparkling water from the mouth of the Amazon River. To those of my race who depend on bettering their conditions in a foreign land or who underestimate the importance of cultivating friendly relations with the Southern white man, who is their next door neighbor, I would say, "Cast down your bucket where you are"—cast it down in making friends in every manly way of the people of all races by whom we are surrounded.[18]

2. Accurate use of examples.[19] Although examples cannot be so easily manipulated as statistics, they can be misrepresented. Consider the following factors for properly evaluating examples:

Choose only representative examples. Many persons select examples that most clearly illustrate their points, not the ones that are the most accurate among their choices. An example should represent all cases of a class. If a person selects extreme examples he misrepresents when he attempts to illustrate. For instance, one might challenge the need for formal college training by citing Henry Ford, who attained prominence in industry; Robert H. Jackson, who became a Supreme Court justice; and Harry Truman, who attained the presidency of the United States; all three were without benefit of a formal college education. Rather than exemplifying a general rule, these men are more likely exceptions to the rule. They were self-educated and probably attained preeminence despite their lack of formal training.

As a communicator, do not attempt to show that business is bad by citing the buggy industry, the hairpin manufacturers, and other industries adversely affected by technological advances. Select representative industries like the building trades, steel, and the clothing industry. In selecting examples, be sure that those chosen represent accurately the general rule, not the exception.

State the details of examples accurately. Do not omit parts of the circumstances of an example to make it fit your assertions aptly. For example, if you decide to use the federal income tax as an example of the type of tax that best accommodates the ability to pay, do not omit that many wealthy persons avoid paying income taxes by taking advantage of legitimate deductions.

If you use the annual income of industrial workers now as compared with that of depression days to show the improved status of workers, do not omit the devaluation of the dollar. If you compare teachers' salaries now with those twenty years ago to show how much they have increased,

[18] Booker T. Washington, *Up from Slavery* (New York: Doubleday & Co., 1901), p. 219.

[19] See chapter 14 for a discussion of how examples apply to *generalization,* a process of reasoning.

do not neglect to state that their salaries have increased no more than those in any other major profession. Omitting such facts would constitute intellectual dishonesty and should be condemned.

A student quoted from a Supreme Court decision as an example of recent holdings of the courts on segregation. He was surprised when the professor pointed out that his quotation came from the dissenting opinion of the court. The student deceived his listeners through failure to know the facts. His listeners were misled, however, the same as if he had deceived them intentionally. An ethical communicator learns the facts; then he presents the details of his example fairly and accurately.

Give a sufficient number of examples. How many examples should you give to support your points? The nature of your point and the time available constitute determining factors. If your point relates to explanation and you have an especially appropriate example, one might suffice. If your point concerns a controversial matter, several may be needed. When reasoning by example, you infer that what is true about the cases you present holds universally; they establish a general rule. Therefore, you must give a representative sampling.

Suppose your point to be that 1975 was a good year for the production of citrus fruit. You give as examples the yield in Florida, Texas, and California. On the other hand, suppose your point to be that 1975 was a good year for general agricultural production and you used the yield in the same three states to support your contention. Which point would be supported best? The first, because the examples are representative. Florida, Texas, and California produce most of the citrus fruit in the United States; their climatic conditions are similar to those in other states which produce fruit. The examples chosen represented accurately all those not chosen. The same three states would be poor choices for generalizing about agricultural production as a whole. They do not represent geographical distribution or different types of crops. Examples of states in the Northwest, Middlewest, and Northeast as well as Florida, Texas, and California would be needed to give a representative sampling. Thus, the nature of the point determines in part how many examples should be given.

The time available also affects the choice of specific instances or detailed illustrations. Several specific instances can be given in the time it takes to give one illustration. Yet the illustration may in some instances be more effective, especially in explanation. Several specific cases often prove more effective in persuasion than a few illustrations. In case of doubt, it is better to err on the side of too many rather than too few examples.

3. Effective use of examples. Like other forms of support, examples should interest the listeners. Accuracy comes first, but deference-to-

interest factors cause an audience to listen attentively. The following factors apply in making examples effective:

Make clear the point to be gained. Some communicators seem to drag examples in by the heels; the examples may be interesting, but they hardly apply to the point. This condition often results when speakers take examples from collections of illustrations prepared especially for speakers and writers. It may result when one selects the examples first, then adapts the idea to fit the examples. The ideas constitute the most important part of a message; the supporting material should expand and clarify them.

Choose vivid, swift-moving, and timely examples. Talk about people and active things, not about inanimate objects. Note how Henry G. Roberts, a teacher of speech, does this well in his speech, "Thinking on Your Feet."

> *Can you ever forget how your eyes almost popped out of your head the first time you saw a sleight-of-hand artist take a pigeon, two long-eared rabbits, and an American flag out of a tall silk hat? Can't you feel your heart skip a beat as the "bea-u-ti-ful young lady" vanishes before your very eyes in a puff of smoke? Not one of us in the audience could understand how it was done. . . .*[20]

Familiar examples of recent date prove more effective than unfamiliar and outdated happenings. Talk in terms of your listeners' interests.

Choose examples close to your listeners. Citizen Jones of San Francisco shows more interest in how the Giants fared in their game than in how the New York Yankees fared. But he shows more interest in how his son did in Little League than in the Giants. People show interest in matters close to them, things that concern their everyday lives.

Some years ago two students spoke to the Junior Chamber of Commerce of Waco, Texas, on labor's right to strike. One student illustrated his points with examples of the coal strikes in Pennsylvania, the automobile workers' strikes in Michigan, and the longshoremen's strike in San Francisco. The other talked about the telephone workers' strike and the bus strike in Waco, Texas. The second student received better response because he talked about problems close to his listeners. His listeners knew about these strikes because they had been inconvenienced by them. Other things being equal, choose examples close to your audience.

Choose active examples. One Air Force officer lectured on the construction of the airplane. He divided his discussion into three parts: the engine, the fuselage, and the tail assembly. He discussed each division

[20] William Hayes Yeager, *Effective Speaking for Every Occasion* (Englewood Cliffs, N.J.: Prentice-Hall, 1951), p. 217. Reprinted by permission of Henry G. Roberts.

methodically and in detail. Another officer figuratively started up the motor and explained the various divisions with the airplane in motion. He evoked interest better because his material showed action. Action arouses attention.

In summary, examples may be specific instances or detailed illustrations, real or hypothetical. In choosing accurate examples, select only representative cases, give all important details, and select a sufficient number. Assure interesting examples by making the point clear, vivid, and graphic—close to your listeners, active, and moving.

The analogy

1. Meaning and types. An analogy as a form of support compares two or more things for the purpose of pointing out similarities and differences. The analogy applies especially well to explanation. One student explained how a world federal government would operate by comparing it with the government of the United States. The world government would have authority in matters delegated to it, much like the federal government of the United States. The nations of the world would have a position in world federal government similar to that which the several states have in our form of government. They would have supreme authority in all matters not specifically delegated to the international government. Thus, the student compared world federal government with a government familiar to his listeners.

Abraham Lincoln used analogies effectively. His statement in his second presidential campaign that "you should not trade horses in the middle of a swift stream" compared the dangers of changing presidents during a war to a situation with which his audience was familiar. His analogy that "a house divided against itself cannot stand" compared a division among the members of a family with a Congress divided over the slavery question.

In the persuasive message, the analogy compares known features of two things for the purpose of drawing inferences about unknown features. We reason that likenesses in known features indicate likenesses in unknown features. We argue that because College X resembles College Y in enrollment, purpose, curricula, location, type of students, and social activities, the honor system will prove successful at College X because it has proved successful at College Y. Since they are alike in ways affecting the success of an honor system, they will probably also be alike in the degree of success of such a system.

Analogy may be divided into two types, *literal* and *figurative.* Literal analogy relates to similarities of two objects of the same class. It infers that objects resemble each other in points other than those compared

because they resemble each other in known aspects. For example, an analogy often heard before the rocket probes early in 1965 was that Mars was probably inhabited because it was similar to the earth in atmospheric conditions, vegetation, and other aspects necessary for human habitation. We inferred that because Mars resembled the earth in certain aspects essential to life, Mars, like the earth, contained human habitation. More recent rocket probes and the landings on the moon raise questions of the validity of this conclusion, but the process exemplifies the literal analogy.

Figurative analogy compares objects in different classes. For example, in Christ's statement, "Cast your bread upon the waters and it will not return unto you void," bread represents good deeds and waters represent life. Most speakers use literal analogy more than figurative analogy, especially in persuasive messages.

2. Accurate use of analogy. Although less subject to abuse than either statistics or examples, analogies may be improperly used. The following factors apply to the accurate use of analogies:

The points of similarity should outweigh the points of difference. A large number of similarities between two things does not insure a good analogy. The strength of the similarities is more important than the number. Irrelevant details, even though they may be numerous, have little effect. For example, in the comparison discussed above, you might point out many differences between colleges X and Y, such as size and beauty of campus, condition of buildings, and record of football team. Such differences hardly apply; they have little to do with the success of an honor system. The points of similarity outweigh the points of difference.

The points of comparison must be true. One student compared the conditions among nations today to the conditions among the 13 original colonies in 1789 to prove that such differences as language and social, economic, and cultural problems are no greater now between nations than they were in colonial times between the several states. He contended that a world federal government, therefore, would be successful today because the federal government of the United States has been successful. His comparison overlooked the nature of the governing bodies. People came to the New World dedicated to the concept of individual freedom and the dignity of the individual. Many were motivated to emigrate to escape the oppression of the mother country. Basically, the peoples had similar goals, although they differed in the methods for attaining them. Today, a basic difference exists among nations in the concept of the purpose of government. The world finds itself divided between those holding to the free-world concept and those holding to the collective management of the world's goods. The basic differences are, in fact, greater between na-

tions today than between the states in Colonial times. The points of comparison must be factually true.

Differences in the cases compared must be accounted for. Differences in the cases compared will not necessarily invalidate the analogy, provided they can be shown to be nonessential. For example, in the analogy that an honor system would be successful in College X because it has been successful in College Y, suppose you could show that the colleges differ greatly in capital investments. This difference would not be relevant to the point at issue. The types of student body, curricula, and the purposes of the colleges would be more important. If you can show that points of likeness are relevant and important and that no significant differences exist, the analogy will assist in the effective development of ideas.

3. Effective use of analogy. To insure effectiveness, select interesting analogies. Apply the following requirements:

Compare cases familiar to your listeners. If you compare an unfamiliar object to one equally unfamiliar, you gain little from an analogy. The effectiveness of Abraham Lincoln's communicating came largely from the homely nature of his comparisons. "You should not change horses in the middle of a swift stream" had meaning to his largely agrarian audiences. It would be less effective to an audience of city dwellers who had never ridden a horse. The comparison of world federal government to the United States federal government would be more meaningful to an audience of college graduates than to an audience of unskilled laborers. The communicator who compared the principles of the hydrogen bomb with those of the atomic bomb did little to clarify his subject because the listeners understood the principles of neither. Compare the unfamiliar object to matters familiar to your listeners.

Make your comparisons vivid and colorful. Stephen Vincent Benét wrote vividly of Abraham Lincoln as follows:

> Lincoln, six feet one in his stocking feet,
> The lank man, knotty and tough as a hickory rail,
> Whose hands were always too big for white-kid gloves,
> Whose wit was a coonskin sack of dry, tall tales,
> Whose weathered face was homely as a plowed field.[21]

Benét's comparisons of Lincoln's physical bearing to a hickory rail and his weathered face to a plowed field give a vivid picture.

[21] From: JOHN BROWN'S BODY by Stephen Vincent Benet, Holt, Rinehart and Winston, Inc. Copyright, 1927, 1928 by Stephen Vincent Benet. Copyright renewed 1955, 1956 by Rosemary Carr Benet. Reprinted by permission of Brandt & Brandt.

Harry Emerson Fosdick once preached a sermon on the subject, "The Peril of Worshiping Jesus." He pointed out how people often worship Jesus but fail to practice the principles He taught. They avoid following Him by worshiping Him. Then he drew a parallel to this situation in the life of Abraham Lincoln as follows:

> *Take the truth in a realm quite different from religion and consider Abra-ham Lincoln, who . . . comes as near being worshiped as any American. That began when he died. When he lived men tried to crush him by opposi-tion. . . . When he died, however, they began using the other method to dis-pose of him. They adored him. They garnished his sepulcher. Nothing too marvelous could be said of him. But in the ten years after he died Congress put into effect a policy toward the South that denied everything Lincoln had stood for and wanted. . . . They alike adored Lincoln and refused to follow him, so they made the reconstruction era in the South one of the horrors of our history.*[22]

The use, as illustration, of the way the people worshiped Lincoln and refused to follow him gives us a better understanding of people's atti-tudes toward Jesus. The colorful manner in which Fosdick presents the analogy commands interest.

In summary, an analogy is a comparison between two or more things to determine their similarities and differences. In a good analogy the points of similarity outweigh the differences, the points of comparison are true, and differences in the cases compared are explained. To use the analogy effectively, compare cases familiar to the audience and make them vivid and colorful.

Testimony

1. Meaning and types. Testimony consists of opinion statements of authorities. Opinions reflect conjecture or beliefs; although they do not constitute facts, they usually come from a person's evaluation of the facts. The communicator brings the authority's opinion into his message by quoting him. Thus the term, *quotation from authority.*

You may quote a person for any of three reasons. First, you may quote him as a source for factual material. Suppose Professor Jones made a survey and you desire to use his findings. You quote him for the informa-tion, not for his opinion. Second, you may quote a person to help you explain, describe, or clarify a matter. Suppose Professor Jones has a well-written explanation of the law of supply and demand in his textbook.

[22] Harry Emerson Fosdick, *The Hope of the World,* pp. 98–99.

Instead of putting the explanation in your words, you quote the professor's explanation. Third, you quote a person for his testimony, for the effect that his opinion has in getting your contentions accepted. You desire his evaluation for its probative effect. Quotations of the first two orders should be subject to the tests for factual material already discussed. The third type, testimony, receives treatment in this section.

In one sense, opinion statements should have little probative effect on the acceptance of ideas. On most questions the experts disagree, especially on questions of public policy. An almost equal number of distinguished authorities hold to either side of controversial issues. The claim for logical effect comes from the inference that because an expert holds a certain opinion, you should also. Since the experts disagree, the inference does not count heavily.

Opinion statements should rarely be used without corroborating evidence. They may, however, have strong persuasive effect by lending prestige and dignity to your conclusions. If you reason well, support the reasoning with strong evidence, draw your conclusion, and then quote acceptable corroborating authorities, the quotations may help clinch your point.

President Gerald Ford used quotations effectively in his Inaugural Address on August 9, 1974, when he quoted former Presidents Thomas Jefferson and Abraham Lincoln.

> *I have not sought this enormous responsibility, but I will not shirk it. Those who nominated and confirmed me as vice president were my friends and are my friends. They were of both parties, elected by all the people, and acting under the Constitution in their name. It is only fitting then, that I should pledge to them and to you that I will be the President of all the people.*
>
> *Thomas Jefferson said the people are the only sure reliance for the preservation of our liberty. And down the years Abraham Lincoln renewed this American article of faith, asking: "Is there any better way or equal hope in the world?"* [23]

These quotations added prestige to President Ford's contentions because of the prestige of the men quoted.

2. Accurate use of testimony. Communicators make errors in the use of testimony that approximate those made in modern advertising. To avoid the most common faults, consider the following:

Is the authority prejudiced? Representatives of propaganda agencies—political parties, industrial and labor organizations, and professional as-

[23] *Waco-Tribune Herald,* August 9, 1974.

sociations—issue statements designed to influence the public for the cause that they represent. They work to create good will for their organizations. They conduct subjective studies to find evidence to support their preconceived points of view. If they find unfavorable evidence, they may refuse to divulge it.

The opinions of many persons are governed by political, economic, or social considerations. Who ever heard of a Democrat's praising the policies of the Republicans, a labor leader's agreeing with the opinions of the National Association of Manufacturers, the Southern White Citizens Council's favoring a policy announced by the Americans for Democratic Action, or vice versa? Some writers of syndicated columns are always pro-administration, others always anti-administration. Given the topic and the writer, one can anticipate the writer's point of view.

Some years ago, when the national college debate topic concerned fair-employment practices, one forensic director received materials from 25 pressure groups, all containing biased information. Although much of the information was disseminated under the guise of objectivity, it took little analysis to detect its biased nature. Although pressure groups constitute an integral part of the democratic process, communicators should know that they disseminate biased information. Avoid testimony from prejudiced sources.

To avoid prejudiced statements, quote organizations engaged in objective research. The research divisions of universities and endowed research organizations are the principal agencies of objective research. They discover and disseminate true-to-fact information. They initiate studies to find the facts and hold no preconceived opinions on what they will discover.

Is the authority qualified by training and experience? A common error in the use of testimony comes from quoting persons incompetent in the fields quoted. Some communicators quote well-known persons in activities like motion pictures or athletics because of their popularity, not because of their competence. Modern advertising uses this method frequently. The popular motion-picture actress Glamor Doll attributes her beautiful complexion to Soapy soap, and infers that you too can have a beautiful complexion by using Soapy soap. No doubt Glamor Doll has certain characteristics we can admire, but her judgment of the chemical effect of compounds on the skin is hardly one of them. A dermatologist or another doctor would be a better authority. Muscles John, heavyweight champion, attributes his athletic prowess to his morning bowl of Tasty Chruncheys. Again, a nutrition expert would be a more qualified authority. Perhaps such practices sell soap and cereal, but they would not if the public were more discriminating.

An authority should be in a position to know the facts and to interpret

them properly. Furthermore, he should be a specialist in the field in which he gives testimony. His training and experience should qualify him as an expert.

Is the authority mentally and morally qualified? That a person has attained high position does not mean that he qualifies as an authority per se. He may have attained his position because of an attractive personality or because of influential family connections. He may have been elected to public office because of good showmanship or because he capitalized on the prejudices of his constituents. He may have bought his position as mayor or inherited his position as president of the bank. The author's book may have become a best-seller because it dealt with the trivial so simply and sensationally that all could understand it.

To assess the value of an authority, consider the reasons he gives for his statements. Does he reason soundly? Does he support his reasons with acceptable evidence? Does he show evidence of maturity of judgment? You should be less interested in what a person says than in why he says it. Consider a quotation in relation to the context in which you find it. Does the book or article as a whole give evidence of the author's qualifications?

Further, consider the author's general reputation for truthfulness. Does he have a selfish outlook, or does he seem to consider the common good? Does he have a subjective interest in the matter on which he testifies, or does he give an objective evaluation? A person's mental and moral attributes go far in determining his qualifications as an authority.

Does the quotation accurately represent the opinion of the author? A communicator may give a distorted view of the intent of an author by taking isolated statements out of context and presenting them as the author's opinion. The author may have made the statement in discussing the side opposite to his beliefs or by way of explanation. The school board in a large city banned a civics textbook because they claimed some statements in the book indicated that the author had communist leanings. They released some of the statements to the press. The author replied that he wished that the school board had read the chapters from which the statements were taken, if they could not find time to read the entire book. Further, he stated that a reading of the textbook as a whole would show that he had complete confidence in free enterprise, but that any worthwhile textbook must acquaint students with the varying concepts and the many sides of all questions.

Before quoting an author, be sure that the statement represents his opinion accurately. Acquaint yourself with the entire writing, not the isolated statement alone.

3. *Effective use of testimony.* Although accuracy comes first, also consider how to use testimony effectively. The following methods apply:

Quote authorities acceptable to your listeners. Given a choice between equally qualified authorities, quote the expert best known and liked by your listeners. Quote persons whom your listeners will consider well qualified and unprejudiced. If you quote an unknown expert, give facts about him that will establish his authority.

In a radio debate between students of Baylor University and the University of Texas, the following varying types of introductions to testimony were noted.

We point to the fact that John Eyes, Professor of Economics at Kansas University and perhaps one of the best known economists in the nation, says . . .

Today, the governor of Texas has said . . .

John Marshall tells us that the power to tax is the power to destroy . . .

According to Mr. L. A. Woods, Superintendent of Public Instruction in the State of Texas . . .[24]

The debaters apparently considered that John Marshall and the governor of Texas were too well known to a Texas audience to require qualifying statements. L. A. Woods was introduced simply as state superintendent of instruction, but Professor Eyes of Kansas received several statements about his qualifications because he was not likely to be well known in Texas outside academic circles. These cases exemplify the correct procedures for introducing opinion statements.

Choose interesting and unusual quotations. Quotations should be interest-provoking. Unusual, cleverly worded, or aptly stated quotations add to the interest of a message. The following quotation by the late Dr. J. M. Dawson, prominent Texas minister, in his sermon, "Social Attitudes That Hurt or Help," illustrates this point:

My friend, Charles Forbus Taylor, the evangelist, tells of a corner in Brooklyn that is known as Blindie's Corner, for a well-known reason: "On it stands an old blind man selling newspapers. You cannot buy a newspaper from any newsboy on that corner. A gentleman, not seeing the old man, one day called to a boy running with a sheaf of papers under his arm, 'Here, boy, a paper!' The boy never stopped. The gentleman was rather astonished, because these boys are usually very much on the job. He waited until he saw another boy, but the second boy did exactly as the first had done. The gentle-

[24] Egbert Ray Nichols, ed., *Intercollegiate Debates* (New York: Noble & Noble, Publishers, 1939), 20, 231, 232, 237.

man stopped a third boy and said, 'I have tried and failed to buy a newspaper from two different boys. Now, what's the idea? Don't you want to sell your papers?' The boy answered, 'No sir. Not on this corner, because this is Blindie's corner. . . .' " [25]

In summary, quotations from acceptable authority lend dignity and prestige to conclusions. To test the accuracy of testimony, determine if the authority is prejudiced, qualified by training and experience, and qualified mentally and morally; see that the quotation accurately represents the opinion of the author. Employ testimony effectively by quoting men acceptable to your listeners and by choosing interesting and unusual statements.

Repetition and restatement

Unlike the readers of written communication, your listeners cannot turn back the pages and reread what they missed. Either they get the ideas as you talk or the continuity of your message becomes broken. You as a communicator must prevent this from happening. Repetition and restatement are your principal methods for accomplishing this purpose.

Repetition may be used to clarify an idea or to emphasize it. You may repeat your idea in the same language or restate it in different terms. Repetition may come immediately following a statement or it may come after intervening supporting material. You will usually find it better to vary your method, but use repetition and restatement liberally for clarity and emphasis.

Robert M. Hutchins of the Ford Foundation uses the various methods of repetition effectively in his speech, "What Is a University?" [26] Note how he repeats a statement verbatim in his opening paragraph.

A university is a community of scholars. It is not a kindergarten; it is not a club; not a reform school; it is not a political party; it is not an agency of propaganda. A university is a community of scholars.

In the following excerpt Dr. Hutchins restates his idea in different terms by use of an idea from Socrates.

[25] Joseph Martin Dawson, *Christ and Social Change* (Boston: The Judson Press, 1937), pp. 55–56. (Quotation from *The Riveter's Gang* by permission of the Fleming H. Revell Co., Publishers.)

[26] Lew Sarett and William T. Foster, *Modern Speeches on Basic Issues* (Boston: Houghton Mifflin Co., 1939), pp. 51, 52, 54, 56. Reprinted by permission of Robert M. Hutchins.

Freedom of inquiry, freedom of discussion, and freedom of teaching— without these a university cannot exist. Without these a university becomes a political party or an agency of propaganda. It ceases to be a university.

Socrates used to say that one thing he knew positively was that we were under a duty to inquire. Inquiry involves still, as it did with Socrates, the discussion of all important problems and of all points of view.

Again Dr. Hutchins restates an idea in different terms in his own words.

It must be remembered that the purpose of education is not to fill the minds of students with facts; it is not to reform them, or amuse them, or make them expert technicians in any field. It is to teach them to think, if that is possible, and to think always for themselves. . . .

In his conclusion Dr. Hutchins restates the central idea of his speech in the form of a challenge.

In America we have had such confidence in democracy that we have been willing to support institutions of higher learning in which the truth might be pursued, and when found might be communicated to our people. We have not been afraid of the truth, or afraid to hope that it might emerge from the clash of opinion. The American people must decide whether they will longer tolerate the search for truth. If they will, the universities will endure and give light and learning to the nation. If they will not, then as a great political scientist has put it, we can blow out the light and fight it out in the dark; for when the voice of reason is silenced, the rattle of machine guns begins.

Through skillful use of repetition and restatement, the thesis of a message unfolds and remains intact.

SUMMARY

The forms of support clarify, amplify, and prove the points of a message. They serve the same purpose in communication that evidence does in legal proceedings. Forms of support give the message substance.

The principal forms of support are (1) explanation, (2) statistics, (3) examples, (4) analogy, (5) testimony, and (6) restatement. Explanation usually precedes the giving of other forms of support. It provides a necessary background. It includes the various ways for defining terms: etymology, authority, exemplification, explication, and negation.

Statistics are compilations of numerical facts. Figures become meaningful when they signify relationships. To use statistics accurately, (1) define the unit upon which they are based, (2) compare sets of figures only when they are compiled upon the same unit, (3) use only up-to-date figures, and (4) refrain from drawing unusual or strained conclusions from them. To use statistics effectively, (1) present them in round numbers, (2) make them vivid and graphic, (3) cite their exact source, and (4) check their authenticity against other sources.

Examples take the form of specific cases or detailed illustrations. To use examples accurately, (1) choose only representative cases, (2) state the details accurately, and (3) give a sufficient number. To use examples effectively, (1) make clear the point to be gained; (2) choose vivid, active, and timely instances; and (3) select cases close to your listeners.

An analogy is a comparison between two or more objects for pointing out similarities and differences. In persuasion, we infer that if two things are alike in pertinent known respects they will probably also be alike in respects not known. Analogies may be classified as literal and figurative. To use the analogy accurately, make sure (1) that the points of similarities outweigh the points of differences, (2) that the points compared are true, and (3) that differences in the cases compared can be explained. Use analogies effectively (1) by comparing cases familiar to the audience and (2) by making them vivid and graphic.

Testimony consists of opinions of persons, their beliefs and conjectures. A speaker may quote persons as a source of facts, for their explanations, and for their testimony. The person quoted should be (1) unprejudiced, (2) qualified through training and experience, and (3) mentally and morally qualified. The quotation should represent the author's opinion accurately. To make quotations effective, (1) quote authorities acceptable to your listeners and (2) choose statements that are interesting and unusual.

Repetition and restatement are for the purpose of clarifying or emphasizing ideas. Repetition may be in identical language or in similar terms. It may come within an idea or at the end in form of summary. Restatement draws the central idea of a message together, giving it coherence.

QUESTIONS

1. How do the forms of support apply in message construction? List the principal forms of support.
2. When do numbers become statistics? Illustrate your explanation. Explain several of the more common causes for misrepresentation by statistics.

3. Distinguish between the example and the analogy as forms of support. What are some of the causes for the inaccuracy in the use of each?

4. In your opinion, does testimony have more logical or more persuasive effect as a form of support? Defend your answer. What are some of the common causes for inaccuracy in the use of testimony?

5. Why are repetition and restatement more important in oral than in written communication? What purpose do they serve as forms of support?

ASSIGNMENT

Oral

Plan A For your oral assignment, prepare a five-minute talk in which you sell an idea or in which you speak for a cause.

1. Follow this general plan:
 a. Plan an interesting introduction.
 b. State the idea that you champion.
 c. Support your idea with a variety of forms: explanation, statistics, examples, analogies, testimony, and restatement. Use at least four of these types of support.
2. The following topics are suggestions only; speak for any cause that you wish.
 a. Intercollegiate athletics should be deemphasized.
 b. Taxes should be reduced.
 c. Fraternities and sororities should be abolished in American colleges.
 d. Unconditional amnesty should be given to Vietnam war resisters.
 e. Gasoline should be rationed.
 f. Campaign financing should be changed.
 g. Capital punishment should be abolished.
 h. The social security tax should be decreased.
 i. Presidential powers should be curtailed.
 j. Busing should be abolished.
 k. Poverty is a federal responsibility.
 l. Wage and price controls should be adopted.
 m. The budget for national defense should be reduced.

Plan B Each group will present its program of informative six-minute speeches before the class. The chairperson will preside, introduce the program, call on each speaker in turn, summarize, and conclude the program. If time permits, conduct an open forum following the program. The professor will write a critique of each speech which may include an achievement scale.

READINGS

BROWN, RONALD M., and RALPH G. NICHOLS, *Practical Speechmaking,* chap. 4. Dubuque: Ia., Wm. C. Brown Co., 1970.

BRYANT, DONALD C., and KARL R. WALLACE, *Fundamentals of Public Speaking,* 5th ed., chap. 7. Englewood Cliffs, N.J.: Prentice-Hall, 1976.

JEFFREY, ROBERT C., and OWEN PETERSON, *Speech: A Text with Adapted Readings,* 2nd ed. New York: Harper & Row, Publishers, 1975.

LARSON, CHARLES U., *Persuasion: Reception and Responsibility,* chap. 5. Belmont, Ca.: Wadsworth Publishing Co., 1973.

ROSS, RAYMOND S., *Speech Communication: Fundamentals and Practice,* 3rd ed., chap. 11. Englewood Cliffs, N.J.: Prentice-Hall, 1974.

SAMOVAR, LARRY A., and JACK MILLS, *Oral Communication,* chap. 5. Dubuque, Ia., Wm. C. Brown Co., 1972.

SMITH, DON K., *Man Speaking: A Rhetoric of Public Speaking,* chap. 5. New York: Dodd, Mead, 1969.

WALTER, OTIS M., *Speaking to Inform and Persuade,* chap. 3. New York: The Macmillan Company, 1966.

WHITE, EUGENE E., *Practical Public Speaking,* 2nd ed., chap. 6. New York: The Macmillan Company, 1964.

Organizing your message

Organization means the process of arranging your central idea into main points and subordinate points, and applying supporting materials to each point. In person-to-person and small-group communication situations, plans for arranging your ideas and forms of support must remain elastic, but you can anticipate the trend of most informal situations and arrange your contributions to conform. Sometimes you may be called upon for extended remarks, the arrangement of which closely parallels organizing a public speech. Chapter 5 included a discussion of organizing your messages for informal communication situations; this chapter applies primarily to organizing the public speech, but many of the principles also apply to informal communication.

You begin to form ideas on the central theme and the general treatment of your topic from the time you decide on your subject or receive the agenda for a conference. As you think through your plans and do research, you will discover ideas and materials to support your points by the methods we discussed in the two preceding chapters. These ideas grow and become clearer the more you investigate and think about your subject. By the time you complete your research, your thinking has become crystallized and you have decided on the central purpose, main and subordinate points, and forms of support for each point. Now you find yourself ready to arrange all these ideas, facts, and opinions into a workable organizational pattern. In short, you must now organize and outline your message.

PRINCIPLES OF COMPOSITION

You now raise the question—what principles should guide me as I set out to organize my speech? Consider these criteria:

1. A well-organized speech provides for creating a favorable mood, conducive to the spirit and tone of the message. It creates the proper atmosphere.
2. A well-organized speech provides for arousing immediate interest in the subject. The introduction compels the audience to listen.
3. A well-organized speech gives a clear explanation and partition of the message, a division into its component parts. It provides for an early explanation of the intent of the message and the necessary background for understanding the thesis.
4. A well-organized speech states the central idea in a simple, concise, orderly, and logical manner. It isolates the main purpose and limits the points and supporting material to the accomplishment of that purpose.
5. A well-organized speech keeps the specific purpose in focus. It divides the subject into a logical and convenient number of main points to develop or prove the thesis. It subdivides each main point into a sufficient number of subordinate points to explain or prove the main point.
6. A well-organized speech provides for a full, logical development of each point. It uses a variety of supporting material, explanation, and restatement.
7. A well-organized speech draws the parts of the speech together by use of a summary and indicates the desired response.

With these principles before you, turn your attention to how these standards can be achieved. You can include all of them in the traditional organizational pattern: (1) introduction, (2) body or discussion, and (3) conclusion.

THE INTRODUCTION

The introduction paves the way for the body of the message. A good introduction performs three functions: (1) creates a favorable atmosphere, (2) stimulates interest in the subject, and (3) clarifies and partitions the topic.

Create a favorable atmosphere

In most communication situations, do not plunge immediately into the subject matter of your message. Your listeners will not be ready to listen. Consider the normal conditions of the members of your audience; they have divided interests. One woman tries to remember if she turned the fire off under the roast; a man thinks of the par 72 he almost made in the golf game; an insurance salesman thinks over his list of prospects. You have about as many different thoughts among your listeners as you have

members. Undoubtedly, few have already focused their attention on you. Your first task is to put your listeners into the proper attitude to listen. You must create a receptive atmosphere that will make your audience want to listen. This cannot be done abruptly; gradually polarize their attention on yourself. On some occasions the proper atmosphere may have already been created by a previous speaker. Perhaps the ritual for the occasion creates the proper atmosphere before you begin. Unless the occasion sets the desired keynote, you must do so before you develop your subject.

The proper keynote may be set in part by your manner of delivery, but what you talk about in your opening remarks also helps. Consider the following suggestions:

1. Refer to momentary interests. When occasions arise as the result of crises, at the conclusion of a common endeavor, or where something of unusual interest has occurred, establish a bond between yourself and your listeners by referring to that happening. You may capitalize on something that occurred in the meeting place before your message.

On December 8, 1941, Franklin D. Roosevelt spoke to an emotionally charged audience when he addressed a joint session of Congress and the nation at large for a declaration of war against Japan. The subject matter of his speech was of such momentous interest that he needed only to refer to it:

> *Yesterday, December 7, 1941—a date which will live in infamy—the United States of America was suddenly and deliberately attacked by naval and air forces of the Empire of Japan.*[1]

Former Secretary of State William P. Rogers referred immediately to our landing on the moon, an event which had just captured the attention of the world, in opening his address before the National Press Club at Canberra, Australia, on August 8, 1969.

> *I am happy to be visiting Australia toward the end of what I believe has been a useful and constructive trip.*
>
> *It began by watching the return of men from the moon—an experience shared through the magic of television by over 500 million people, the largest audience in history.*
>
> *The success of Apollo 11 makes any extended comment about it unnecessary.*
>
> *Over 17,000 Americans—scientists, technicians, engineers, military person-*

[1] *Congressional Record,* Vol. 87, Part 9, Dec. 8, 1941.

nel, and others—were involved in direct support of the mission. But the achievement was a cooperative effort. Facilities were made available from 20 other countries. Some 2,000 people in six other nations were directly involved. Notable among these was Australia, whose longstanding cooperation and help on space matters we deeply appreciate.

On behalf of the American people, let me extend our thanks to the people of Australia for your help and your enthusiastic support.[2]

2. Respond to the mood of your listeners. Do not attempt to change abruptly the mood in which you find your listeners. If, for example, you have a humorous message but find your listeners in a somber mood, respond first to this mood and work gradually to change it. When Mrs. E. M. Gilmer (Dorothy Dix) addressed a convention of the National Education Association, she began as follows:

Not very long ago I received a letter telling me about all the harm I was doing. It read: "Dear Miss Dix: I wonder if you know how much harm you are doing in the world. I was in love with a man who did not notice me at all, and I wrote you to ask you how to attract him, and you told me how to do it, and I did, and married him, and now I wish I had not." [3]

3. Refer to special interests of your listeners. If your listeners have engaged in a common effort—attended a convention or workshop, or met regularly for a given purpose—begin by referring to the special interest. Martin Luther King, Jr., used this method when he addressed some 210,000 freedom marchers on August 28, 1963, during their March on Washington. His speech entitled "I Have a Dream . . ." was delivered on the steps of the Lincoln Memorial in Washington, D.C.

Five score years ago, a great American, in whose symbolic shadow we stand, signed the Emancipation Proclamation. This momentous decree came as a great beacon light of hope to millions of Negro slaves who had been seared in the flames of withering injustice. It came as a joyous daybreak to end the long night of captivity.

But one hundred years later, we must face the tragic fact that the Negro is still not free. One hundred years later, the life of the Negro is still sadly crippled by the manacles of segregation and the chains of discrimination. One hundred years later, the Negro lives on a lonely island of poverty in the midst of a vast ocean of material prosperity. One hundred years later, the Negro is

2 William P. Rogers, *The U.S. Role in the Pacific Community* (Washington, D.C.: Department of State Publication 8489, U.S. Government Printing Office, Sept. 1969), p. 1.

3 *Proceedings of the National Education Association, 1937.* Reprinted by permission of the National Education Association.

still languished in the corner of American society and finds himself an exile in his own land. So we have come here today to dramatize an appalling condition.[4]

4. Compliment your listeners on some work well done. If your listeners have completed some project, succeeded in a campaign, or made a contribution to a worthwhile cause, open your message by commending them for their contributions.

Booker T. Washington commended the persons responsible for organizing the Atlanta Exposition and for the opportunities it offered his race in his speech in Atlanta, Georgia, in 1895.

I but convey to you, Mr. President and directors, the sentiment of the masses of my race when I say that in no way have the value and manhood of the American Negro been more fittingly and generously recognized than by the managers of this magnificent Exposition at every stage of its progress. . . .[5]

Stimulate interest in your subject

After focusing the attention of your listeners on yourself and creating a receptive atmosphere, make the first reference to your topic interesting and provocative. The following suggestions will help stimulate interest in your subject:

1. Ask a stimulating question. Ask a provocative question that will cause your listeners to answer in their minds, to think with you on your subject. The question should vitally concern them and be relevant to the central idea of your message.

Dr. Charles Wellborn, chaplain and professor of religion at Florida State University, began his talk at a symposium entitled "Challenge to Morality" at Florida State University with the following question:

What is the "new morality?"
Is it, as its friends say, "A moral ethic that can make man more responsible for his actions than the 'old morality' ever did?"
Or is it closer to the truth to characterize it, in the words of the Englishman, Lord Shawcross, as "the old immorality condoned?"
What's new about the "new morality?" [6]

4 Thonssen, ed., *Representative American Speeches, 1963–64, 36,* 4: 75, p. 44. By permission of Dr. Martin Luther King, Jr.

5 Booker T. Washington, *Up from Slavery* (New York: Doubleday & Company, 1901).

6 By permission of Dr. Charles Wellborn.

You may ask a provocative question in opening, hold it up to review, and reveal your answer as the climax to the message. Such a device helps give unity and coherence to a speech.

2. *Ask a series of questions.* Your listeners' desire to discover the answers will help you get their immediate attention and maintain their interest. If the questions correspond to the main points of your message, they will unify your organizational pattern. Do not ask irrelevant questions simply as an attention-getting device; ask questions that apply specifically to your subject.

Note how former President Richard Nixon used this method in his commencement address at the Air Force Academy on June 4, 1969.

> *The underlying questions are really these:*
> *What is America's role in the world? What are the responsibilities of a great nation toward protecting freedom beyond its shores? Can we ever be left in peace if we do not actively assume the burden of keeping the peace?*
>
> *When great questions are posed, fundamental differences of opinion come into focus. It serves no purpose to gloss over these differences or to try to pretend that they are mere matters of degree.*[7]

3. *Begin with an unusual statement.* Begin with one or several unusual or striking statements; the unusualness or beauty of expression compels interest. The following opening paragraph of a speech by Paul Geren, the late president of Stetson University, illustrates this point:

> *Thomas Carlyle, who had a way of going to the bottom of things, laid down a principle and demonstrated it in his work,* The French Revolution. *This was that principle: "All wrong is based upon falseness, upon hypocrisy." I have applied that principle to what must surely be the greatest wrong in all the world—war, and that greatest of wrongs is based upon the greatest of deceptions. War is a lie.*[8]

4. *Begin with an illustration or narrative.* Stories from life and literature stimulate interest; they have universal appeal. The illustration must relate specifically to the central theme of the message and command attention. Note the fast-moving action in the narrative of the opening paragraph of a speech by Frank Rosson, an attorney in San Antonio, Texas.

[7] Text of speech furnished by the White House.

[8] Reprinted by permission of Paul Geren—a student speech.

Early in the morning on a day in September, 1776, Nathan Hale was hanged in New York for spying on the British Army. General Washington was in need of information concerning the British Army stationed there, made known his need, and Captain Nathan Hale volunteered. He was entreated by his friends to forbear his dangerous mission; he refused their entreaties, disguised himself, and entered New York as a spy. He was discovered and sentenced by General Howe to be hanged. The next morning the body of Nathan Hale swung from a British gallows, a sacrifice for the founding of a nation.[9]

5. Begin with humor. Humor, in good taste and relevant to the subject, often sends a message off to a good start. Avoid long drawn-out anecdotes or humorous stories. The humor should be original, fresh, and entertaining.

Note how former President Lyndon B. Johnson used humor in the introduction of his commencement address at Baylor University on May 28, 1965.

Mr. President, members of the Board of Trustees, faculty, student body, my fellow Americans:
This is a moment I deeply wish my parents could have lived to share. In the first place, my father would have enjoyed what you have so generously said of me—and my mother would have believed it.[10]

The senior author of this book used humor in beginning his remarks of appreciation at the ground-breaking ceremonies of the Castellaw Communication Center at Baylor University on July 20, 1972:

General Douglas MacArthur tells the story of being invited back to West Point on his eighty-second birthday for a special award. As he came out the entrance of the Waldorf Astoria Hotel, his home during his latter years, the doorman greated him, "Top of the morning, General—and where are you off to today?" The General said he was off to West Point. Whereupon the doorman exclaimed, "Beautiful place, General—Is this your first trip there?"
Today, Baylor University is a beautiful place to me—especially this occasion. Although I can safely say that I have been on the campus before, the ground-breaking ceremony for a new communications building is a first for me—something that I have dreamed about, anticipated and tried to finance for many years.

[9] Reprinted by permission of Frank Rosson—a student speech.
[10] *Waco Tribune-Herald*, May 29, 1965, p. 6-A.

6. Start with a provocative quotation. An interesting or unusual statement sparks interest. To be effective, it must state aptly the central theme of the message. A statement may be quoted as a basis for examination and serve as a unifying force for the speech. A statement that makes a hypothesis or prophecy serves best. The senior author used this method in a commencement address entitled "A New Frontier for Education" at the Brownwood, Texas, high school.

> *"Today we have too many people all dressed up in education with no place to go." This statement taken from a recent newspaper article started my thinking on a subject which forms the central thought for my remarks this evening. Is the accusation true—that educated people now have no place to go? Has education through hundreds of years of development overcome all its problems? Put in the form of a query: "Do we have too many people all dressed up in education today with no place to go?"*

7. Present a hypothetical situation. Creating a hypothetical situation in which your listeners take part in an imaginary way helps create and maintain interest. The hypothetical situation adds interest if it asks your listeners to make a decision at the conclusion of your message. Note how Lester Kamin, president of Public Radio Corporation, used this technique effectively in his speech entitled "In Defense of the Jew."

> *I should like for you to picture a courtroom. You shall serve as the jury. Our chairman shall serve as the judge. Today's trial is a most interesting one, for we are trying the arch-enemy of all ages—the Jew. The prosecutor has just finished his case against the accused. I shall present the defense for the Jew. You shall render your verdict when I have finished.*[11]

8. Relate your subject to special interests of your listeners. By relating your topic to some special interest of your listeners you show an awareness of their identities and thus command their respect. They feel that what you say would not be applicable to any other group. Note how C. J. Humphrey, an attorney in Amarillo, Texas, began his speech to a meeting of law-enforcement officers.

> *On the cold bleak ground of the shell-torn fields of France, an American soldier lies in agony. He gasps for breath, rolls over, and is then still. He has helped to pay the price of American democracy.*
> *Twenty years later on a dim-lighted street in America, a human body lies,*

[11] Reprinted by permission of Lester Kamin—a student speech.

his face downward. From his back may be seen the pearl handle of a sharp sliver of steel which has pierced his heart. He has helped to pay the price of American crime.[12]

9. Relate a personal experience. A message that arises from a personal experience commands attention. The experience should be unusual and pertinent to the subject. Some of your best messages may grow out of experiences and incidents that created your interest in a subject. One student used an incident of a tragic automobile accident as the springboard for his speech on traffic safety. For an unusual speech on the subject of kleptomania a young student used an incident in which her roommate was caught stealing. These students held the interest of the class because they were eager to share their ideas.

The opening paragraph of a speech entitled "Legal Death" deals with a personal experience that led to a speech on mental health.

A week ago I observed a murder trial, the State vs. John H. Doe. I saw the experienced counsels examine and cross-examine their witnesses—skillfully bringing out points and information, and just as skillfully trying to conceal other points and information. I heard them sum up for the jury, heard them analyze minutely different items of evidence. . . . I recall the debate on whether John H. Doe was sane; whether he had sufficient presence of mind to know right from wrong.

. . . John H. Doe committed a crime against life, but you have not heard of other awful hours and dark nights when life has been a crime to John Doe.[13]

10. Refer to the problem. The problem that occasions the meeting may be of such vital concern that an immediate reference to this problem gains prompt attention.

Secretary of State Henry Kissinger used this method in his opening remarks at the Energy Conference of Oil-Consuming Nations at Washington, D.C., on February 11, 1974.

On behalf of the President of the United States, I welcome you to this conference.

My great predecessor, Dean Acheson, once observed that "sometimes there is nothing man can do to avert disaster, but more often our failure lies in meeting big, bold, demanding problems with half-measures, timorous, and cramped." The nations gathered in this room are confronted with an un-

[12] Reprinted by permission of C. J. Humphrey—a student speech.

[13] Reprinted by permission of Thomas Webb—a student speech.

precedented challenge to our prosperity, and to the entire structure of international cooperation so laboriously constructed over the last generation. The impact of the energy crisis reaches around the world, raising fundamental questions about the future of the developing countries, the prospects for economic growth of all nations, and the hopes for global stability. . . .

The United States has called this conference for one central purpose: to move urgently to resolve the energy problem on the basis of cooperation among all nations. Failure to do so would threaten the world with a vicious cycle of competition, autarky, rivalry, and depression such as led to the collapse of world order in the thirties. Fortunately, the problem is still manageable multilaterally: national policies are still evolving, practical solutions to the energy problem are technically achievable, and cooperation with the producing countries is still politically open to us.[14]

11. Explain a theory or principle. Begin by explaining a theory or principle related to your subject. An unusual and dramatically presented theory compels attention and sustains interest. The theory or principle may be examined during the message and thus serve as a unifying force.

Note the use of this method by Dr. Theodore Clevenger, Jr., in his address "Greatness and Change" at the dedication ceremonies of the Castellaw Communication Center at Baylor University on May 16, 1974.

In the affairs of mankind, there comes from time to time a major crossroad —a turning point where the myriad, subtle forces of history come together for a moment to set a new course for the future. At such times, it is customary for men to pause, to take special note of what has come to pass, and to consider its significance for what is yet to come.

We here today stand on such a turning point, and it is altogether proper that we should cast a brief glance back down the long road we have come, and forward into the future which the events that we celebrate here today have made possible.[15]

12. Refer to the occasion. Most ceremonial speeches can best be described as occasion speeches. They are given at such occasions as dedications of buildings and monuments, laying the cornerstones of buildings, paying homage to some outstanding person or organization, or paying tribute to the graduates at commencement exercises. You can best get attention by referring immediately to the occasion that brings the

[14] News release, Bureau of Public Affairs (Washington, D.C.: Department of State, Office of Media Services, February 11, 1974), p. 1.

[15] Text of speech furnished by Dr. Clevenger with permission to quote.

listeners together. Note how Abraham Lincoln refers to the occasion in his classical Gettysburg Address:

> *Four score and seven years ago our fathers brought forth on this continent a new nation, conceived in liberty, and dedicated to the proposition that all men are created equal.*
>
> *Now we are engaged in a great civil war, testing whether that nation, or any nation so conceived and so dedicated, can long endure. We are met on a great battlefield of that war.*[16]

Clarify and partition your topic

After creating the proper mood and stimulating interest, clarify your topic and disclose your intentions. You partition a message by dividing it into its component parts, narrowing the subject to a central theme, revealing the main points, and defining technical terms.

Define and explain terms that might confuse your listeners. Explain the meaning that you attach to terms that are subject to more than one interpretation. If you do not define your terms, members of the audience will project their own meaning on them. Use the methods of definition explained in chapter 8.

Indicate how you intend to develop your subject, your central idea, and your attitude toward it. State your main points; give a foreshadowing of your plans. Your listeners will thus know what to expect, and they can follow the central idea of your message.

In an address before the Baylor University chapter of the American Association of University Professors, the senior author indicated his main points by raising three questions.

> *Turning to my topic "Research and the University," I should like to raise three questions for your consideration: (1) How should research fit into the university program? (2) What are the principal problems of research in a university? (3) What can be done to improve research in a university?*

Arthur A. Hartman, assistant secretary of state for European affairs, clarified his subject "The Meaning of Détente" at a recent hearing before the Committee on Foreign Affairs, House of Representatives.

[16] John G. Nicolay and John Jay, eds., *Complete Works of Abraham Lincoln* (New York: Appleton-Century-Crofts, 1894–1905), *9*, 209.

It is important to understand the circumstances that have led to the begin-
ning of a new period in relationships between the United States and the
Soviet Union and to ask ourselves hard questions about the meaning and
durability of those relationships that we sum up in the word "détente."

Literally, détente means a relaxation of tensions. But it is frequently used
as shorthand for a complex process of adjustment. It is not a static condition
or a simple standard of conduct. It does not imply "entente" which is an
understanding or alliance.

What are the dimensions of détente as perceived by both sides?

We have consistently sought to make clear that our pursuit of a relaxation
of tensions in U.S.–Soviet relations is not based on any newly discovered com-
patibility in our domestic systems. It is based on the premise that the two
nuclear superpowers must do everything in their power to spare mankind the
dangers of a nuclear holocaust. In the world as it is today—not as it has been,
and not as we might wish it to be—the United States and the Soviet Union
share a responsibility to minimize the danger of accident, miscalculation or
misunderstanding; to work out rules of mutual conduct; to recognize the
interconnection of our interests; and to enhance communication between us.[17]

Judge Learned Hand addressed the Convocation of the Board of
Regents of New York on the topic, "The Preparation of Citizens for
Their Political Duties." He partitioned his speech as follows:

The theme today is education, as to which you, the Regents of the Uni-
versity, have an overarching superintendence. What I have to say will be
directed towards one aspect of your responsibility: the preparation of citizens
for their political duties. I shall argue that the "humanities," instead of being
regarded only as a solace, a refuge, and an enrichment of the individual—as
indeed they are—are also an essential factor in training him to perform his
duties in a democratic society. . . .[18]

The speakers quoted above clarified their subjects and indicated their
approach; they foreshadowed what the audience should expect.

In summary, a good introduction creates the proper atmosphere for
the message and focuses attention on the speaker, stimulates interest
in the subject, and clarifies and partitions the message. The emphasis on
these factors depends upon whether the occasion makes them necessary.
Beware of wasting time in the introduction, but perform all three
functions unless the nature of the occasion does one or more for you.

[17] *The Meaning of Détente* (Washington, D.C.: Department of State Publication
8766, General Foreign Policy Series 280, June 1974).

[18] *Vital Speeches, 19:* 6 (Jan. 1, 1953), 173–74.

THE BODY OR DISCUSSION

The introduction prepares the way for the body of the message; the body develops the ideas in detail. In developing a subject, do more than talk about it; explain a part of it, convince your listeners on an issue involved, or entertain them with a novel idea. Develop the body through three steps: (1) disclose a central idea; (2) divide the central idea into an organizational pattern; and (3) support ideas with explanation, reasoning, and evidence.

Develop the central idea

In chapter 6 you learned about the importance and function of the general and specific purposes. To attain these purposes, you must have a basic idea underlying your reasons and evidence. The central idea consists of the principle upon which a message rests, the justification, or the general philosophy underlying it. It differs from the main divisions in that you establish the central idea by developing the main divisions.

Suppose you decide to speak in favor of federal aid to education. Your general purpose calls for a persuasive message; your specific purpose requires you to persuade your listeners to accept the principles of federal aid. But what about the central idea? It may be expressed in a single statement, "to show that education in the United States is essentially a federal responsibility, a national problem." Why? Because the results of education transcend state lines and affect the nation as a whole. The benefits of education, or the penalties arising from lack of it, cannot be localized within the community or state where a person receives his education because of migration between communities and states. Since the benefits of an educated populace accrue to the nation as a whole, the federal government should share in financing programs that equalize educational opportunity.

So far your plans, after analyzing your audience and the occasion, take the following form:

Topic:	Federal aid to education
General purpose:	To persuade my listeners
Specific purpose:	To cause my listeners to favor federal aid to education for equalizing educational opportunity
Central idea:	Unequal educational opportunity is a national problem that calls for a federal remedy.

Instead of a persuasive message, suppose you decide on an informative talk on "The Characteristics of a Good State-Tax Program." Your general

purpose will be to inform and your specific purpose to bring about an understanding of the characteristics of a good state-tax program. What central idea will form the principal philosophy? Two factors must be considered in making your decision. First, a good tax program will bear with representative equality on the four basic types of taxation—property, business, income, and consumption. Second, it will apply equally the two basic theories of taxation—the ability-to-pay theory and the benefits-received theory. No specific tax can be judged by itself; it must be considered in relation to the total tax program. The central idea states that a good state-tax program must be equitable and that it must recognize with relative equality the theories of taxation. Thus your plans include the following steps:

Topic:	The characteristics of a good state-tax program
General purpose:	To inform my listeners
Specific purpose:	To show what constitutes a good state-tax program
Central idea:	A good tax program bears with relative equality on the types of taxes and recognizes the basic theories of taxation.

Develop main divisions, subdivisions, and organizational pattern

1. Decide on your main points. After selecting the central idea, decide upon means to develop it. Expand the central idea by breaking it into its component parts or the main divisions. Consider the persuasive message on federal aid to education, discussed in the previous section. The central idea was stated, "Education is a national problem that calls for a federal remedy." Why? What main points will prove that a program of federal aid to education should be accepted? A proposed reform should arise from a need. Unless a problem exists for financing education, why make a proposal? All reform measures have their inception in a felt need that arises from a problem.

"How to correct the problem" is the subject that arises next. A suggested reform must be practical; it must correct or improve the adverse conditions. Show how federal aid to education can improve the problems arising from state and local financing programs. Present a satisfactory plan for doing so. Show that the plan will bring about benefits as well as correct the problem.

Through this mental process you arrive at the following main divisions.

Main point 1:	Unequal educational opportunity constitutes a problem.
Main point 2:	Federal aid to education will equalize educational opportunity.

Main point 3: Federal aid to education is a desirable plan for equalizing educational opportunity.

Consider the main divisions for your informative message on the characteristics of a good state-tax program. How can you divide your message into main points that will develop your central idea? Consider the basic types of taxes and the two basic theories of taxation already discussed. The main divisions or points may be:

Main point 1: An equitable tax program bears proportionately on the principal types of taxes.
Main point 2: An equitable tax program equates the basic theories of taxation.

Consider the following factors in selecting your main points:

The main points must directly support the central idea. Unless a main point relates directly to the central idea, it should not be used as a main division. For example, in the proposed speech on federal aid to education, suppose your point to be "Cost per student varies greatly throughout the United States." Does this point relate directly to the central idea, "Education is a national problem that calls for a federal remedy"? No, but it does support directly the first main point, "Unequal educational opportunity constitutes a problem in the United States." Make it, therefore, a subpoint of the first main point. As such, it relates to the central idea indirectly.

The combined main points must develop the central idea. In the persuasive message, the probative force of all the main points, properly developed, must prove the central idea. For example, to prove a case for federal aid to education you must show that a problem exists, that you can solve the problem, and that you can do so satisfactorily. The failure to advance and prove any of the main points leaves the central idea undeveloped.

The main points should be few in number. The statesman who spoke on "Ten Commandments for Successful Voting" had a good organizational pattern but he advanced too many main points. Listeners cannot remember so many main ideas in one message. The number of main divisions depends upon your subject and purpose, but by limiting the scope of your subject you can limit the number of main points. From two to five main ideas serve best; listeners' ability to retain ideas drops sharply after five.

2. Decide on your subpoints. The combined subordinate points under a main point must develop or prove the main point. For example,

to prove that unequal educational opportunities exist, show that they apply in several categories—expenditures per student, length of school terms, teachers' salaries, teachers' qualifications, and value of school property. Note the following arrangement of subpoints:

Main point:	I. Unequal educational opportunities constitute a problem
Subpoint:	A. Inequalities exist.
Subpoint:	B. Inequalities are detrimental.
Subpoint:	C. State financing perpetuates these inequalities.

Assuming that you can support each subpoint with sufficient evidence, you have adequate development for your main point. Each main point must be developed in this manner. Each subpoint should relate directly to the main point which it supports; the combined subpoints should develop the main points.

3. Decide on your organizational pattern. The organizational pattern means the method of arranging points and subpoints. A study and analysis of the subject will suggest the best method for arranging ideas. No one method, in itself, can be claimed to be superior to another. The choice may be partly arbitrary, but certain methods serve particular purposes better than others, as explained in the following discussion:

The *deductive* method states the point first and then supports it by explanation, reasoning, and evidence. Usually one states the points in the partition of the introduction, then develops them one by one in the body of the message.

The senior author used this method in his commencement address "How Shall I Go from Here?" at Hubbard, Texas, high school on May 22, 1970.

> . . . but I am not so concerned with "where you are going from here" as with "how you are going from here."
>
> We usually measure success by how much money we can accumulate, how high a political position we can attain, the prominence of our social position, how prestigious our position will become. Speakers on occasions like this often give such advice as "There is plenty of room at the top of the ladder; hook your wagon to a star; decide upon your purpose and hold tenaciously to it."
>
> I am not going to say those things because (1) I doubt that there is plenty of room at the top of the ladder—there must be a middle and a bottom; (2) I think that this is doubtful advice—some must do the lesser jobs and do them well.
>
> I desire to give you some better standards for measuring success in life that I will develop in some detail.
>
> A. Your success will be measured not so much in what you can get from our society—but in what you can contribute to society.

B. *Your success will be measured not so much in how high a position you attain—but in how well you play the part you do assume.*

C. *Your success will be measured not so much in whether you achieve your purpose or goals—but in how well you strive at the work at hand.*

The *inductive method* starts with the details and from the examination of them draws a conclusion. The revelation of the point comes at the end, as a climax.

Attorney Raymond B. Fosdick's speech, "Middletown—and the Way Out," provides an example of inductive arrangement. The first part of the speech describes Middletown: ". . . a town in which money is preeminently the measure of value . . . a town where everyone conforms . . . a common pattern runs through the lives of all the people . . . everybody is busy. . . . Idleness is a vice . . . it lives a standardized life." After this description, and near the end of the speech, he raises the question, "What is the way out?" He answers this question as the climax of the speech.

I should like to suggest that the only life worth living at any time in any age is the adventurous life. Now, by the adventurous life I mean primarily a life that has a capacity to be different. I mean a life that is willing to cut loose from the past for the sake of the future, that will take chances in casting off from old traditions and old techniques. I mean by the adventurous life a life unwilling to remain tied up in any port, preferring to ride the high seas in search of fairer lands—a life that finds serenity in growth.[19]

The *problem-solution* method develops a problem and advocates a solution. The method applies well to analyses of sociological and political problems.

Dwight D. Eisenhower used this organizational pattern in his speech on November 7, 1957, concerning the launching of Russia's sputniks.

First, let me tell you plainly what I am going to do in this talk and in my next.

I am going to lay the facts before you—the rough with the smooth. . . . After putting these facts and requirements before you, I shall propose a program of action—a program that will demand the energetic support of not just the government but every American, if we are to make it successful.[20]

[19] Lew Sarett and William Trufant Foster, *Modern Speeches on Basic Issues* (Boston: Houghton Mifflin Co., 1939), p. 24. Reprinted by permission of Raymond B. Fosdick.

[20] A. Craig Baird, ed., *Representative American Speeches, 1957–58, 30:* 4 (New York: The H. W. Wilson Co., 1958), p. 21.

Time-order

Some messages lend themselves to development by chronological order: the *time-order* method. The main points come in the order in which they occurred. For example, suppose you address the local bar association on the anniversary of Clarence Darrow's birth. You desire to inform your audience about his life and works. The main divisions of your speech may appear chronologically as follows:

1. Darrow's early life
2. Darrow's life as a corporation lawyer
3. Darrow's life as a criminal lawyer
4. Darrow's declining years

enumeration order

In some messages the main points may be arranged as simple enumeration: *enumeration-order* method. Your subject lends itself to division, but with little indication of the order of presentation. In such cases, place the most interesting point first and the most important last. This permits you to win interest immediately and to build toward the most important factor.

For the speech on Clarence Darrow, suppose that, instead of a biographical sketch, you decide on a selective arrangement of the beliefs of Darrow. The following arrangement illustrates:

1. Darrow's beliefs on capital punishment
2. Darrow's beliefs on protection of minorities
3. Darrow's beliefs on religion

You might want to speak on the important cases in the career of Darrow, as follows:

1. The *Los Angeles Times* building bombing case
2. The Loeb-Leopold case
3. The Scopes trial

logical order

The *logical-order* method may suggest the best position of points. For example, if you explain the construction of a house, you may divide the subject into main points that follow the order of construction, as follows:

1. Laying the foundation
2. Constructing the walls

3. Building the roof
4. Finishing the inside

For a persuasive message favoring group medical plans you could follow the logical order—need, practical solution, most desirable solution. For example:

1. Medical distribution has created serious problems.
2. Group medicine will correct the problem.
3. Group medicine constitutes the most desirable solution.

cause to effect

In the *cause-to-effect* arrangement, start with circumstances sufficient for a cause and attempt to establish the probable effect. For example, you may anticipate an increase in inflation.

1. Labor is negotiating wage increases.
2. Taxes are being decreased.
3. Credit restrictions are being lifted.
4. Therefore, inflation will increase.

effect to cause

In *effect-to-cause* arrangement, reverse the process; show an effect or existing condition and suggest the prior causes. To illustrate:

Inflation is on the increase today, because
1. Labor received wage increases;
2. Taxes were decreased;
3. Credit restrictions were eased.

Simple to complex

These patterns are based on the belief in causation—every effect must be produced by some cause and every cause will produce its effect unless interfered with by extraneous factors.

By the *simple-to-complex* method you start with the material easiest to comprehend and proceed to the more difficult. This method proves especially effective on subjects of a technical nature. For example, suppose your subject to be "Types of World Collaboration." Start with the method easiest to understand and conclude with the most technical method, as follows:

1. Cooperation
2. Alliance

3. Regionalism
4. Confederation
5. Federation

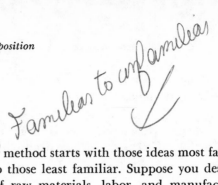

The *familiar-to-unfamiliar* method starts with those ideas most familiar to your listeners and leads to those least familiar. Suppose you desire to discuss the relative effects of raw materials, labor, and manufacturing on the price of commodities. If your listeners are farmers, you would probably follow this order:

1. The effect of raw materials on prices
2. The effect of labor on prices
3. The effect of manufacturing on prices

If you spoke to laborers on the same subject, the following order, from familiar to unfamiliar, would probably serve best:

1. The effect of labor on prices
2. The effect of manufacturing on prices
3. The effect of raw materials on prices

Support your ideas

The central idea forms the spinal column, the organization the skeleton, and the supporting material the flesh of your message. The previous sections explained the purpose and function of the central idea and the organizational pattern. To complete the composition of your message you must expand your ideas with the forms of support discussed in chapter 8; namely, explanations, statistics, examples, analogies or comparisons, testimony, and restatement. The following illustration shows how the forms of support apply:

Main point: I. Unequal educational opportunity is a problem in the United States.
 Subpoint: A. Inequalities exist.
 Support: 1. Explanation, and
 2. Statistics, and/or
 3. Examples, and/or
 4. Analogies, and/or
 5. Testimony, and
 6. Restatement

Subpoint: B. Inequalities are detrimental.
Support: (Support in same way as A.)
Subpoint: C. State financing perpetuates these inequalities.
Support: (Support in same way as in A.)
Main point: II. and III. (Support same as I.)

THE CONCLUSION

The heavyweight champion feels out his opponent in the early rounds and accustoms himself to his style; then he softens him in later rounds with repeated blows to the body and head; finally, when the softening-up process has served its purpose, he deals the knock-out punch. This procedure applies to message construction. The introduction creates a favorable atmosphere, gains interest in the subject, and partitions the message. The body develops the central idea through main points and subpoints supported by ample evidence and arranged into an acceptable organizational pattern. The conclusion rounds out the central idea and purpose. It may do so in three ways: (1) summarizing the main points, (2) amplifying the central idea, (3) indicating the desired action. Any one method or any combination of these methods may be used, depending upon the purpose of the message.

Summary of main points

The summary may take three forms: a verbatim restatement of the main points, a paraphrase or abstract of the main ideas, or a quotation which epitomizes the central idea.

The senior author used the restatement-type summary in his commencement address at Hubbard High School, quoted earlier in this chapter.

> So I say to the 1970 Hubbard High School graduates, "Be less concerned with Where you shall go from here—and more concerned with How you shall go from here." Whatever you do.
>
> A. Be concerned with how you can make your life contribute to the society in which you live.
>
> B. Be concerned with how well you play the part you do assume in life—whatever it may be.
>
> C. Be concerned with how well you strive at the work at hand.
>
> Be concerned with how you shall go from here.

Secretary of State Henry Kissinger paraphrased his central theme and main ideas in his address entitled "Constancy and Strength in U.S.

Foreign Policy" before the American Legion National Convention, Miami, Florida, August 20, 1974.

> *We have a long tradition in this country of arming with great haste when war comes upon us, and disarming with even greater haste when the war is over; we have tended to view our relations with nations in terms of absolutes —friend or foe, ally or adversary, unlimited war or permanent peace. We have acted in cycles of overcommitment and withdrawal, enthusiasm and cynicism.*
>
> *This we can no longer afford. We must commit ourselves for the long haul. The search for peace is not a part-time job.*
>
> *We must learn to deal with nuance, to strive for what is good while never forgetting what is best. Fate has offered us an unprecedented opportunity for creativity in the search for peace.*
>
> *Let us not rest on the achievements of recent years, but let us summon new hope and new faith in ourselves to go beyond.*
>
> *If we are true to ourselves, America can be both strong and purposeful, principled and realistic, equally devoted to deterring war and to achieving man's greatest hopes. Over three decades ago President Roosevelt said of his generation that it had a rendezvous with destiny. Let it be said of this generation that it had—and met—a rendezvous with peace.*[21]

In his presidential address at the convention of the Speech Communication Association in New York on November 11, 1973, Dr. Robert C. Jeffrey concluded with a quotation which restated the theme of his speech.

> *As teachers and scholars in communication, our purpose should be to develop respect for ethical communication and a healthy disdain for deception in and corruption of public discourse. Henry Wieman and Otis Walter wrote in 1957, ". . . Ethical rhetoric has the promise of creating those kinds of communication which can help save the human being from disintegration, nourish him in his growth toward uniquely human goals, and eventually transform him into the best that he can become." That should be our paramount goal as teachers and scholars in communication.*[22]

Restate and amplify central idea

You may either expand and reemphasize your central idea after the summary or use this method without a summary. Note how former President

[21] News release, Bureau of Public Affairs (Washington, D.C.: Department of State, Office of Media Services, August 20, 1974).

[22] Text of speech furnished by Dr. Jeffrey with permission to quote.

John F. Kennedy restated the central idea of his inaugural address held on the Capitol steps on January 20, 1961.

> *And so, my fellow Americans, ask not what your country can do for you: Ask what you can do for your country.*
>
> *My fellow citizens of the world: Ask not what America will do for you, but what together we can do for the freedom of man.*
>
> *Finally, whether you are citizens of America or citizens of the world, ask of us the same high standards of strength and sacrifice which we ask of you. With a good conscience our only sure reward, with history the final judge of our deeds, let us go forth to lead the land we love, asking His blessing and His help, but knowing that here on earth God's work must truly be our own.* [23]

Indicate desired action

You may desire a physical response from your listeners; for example, to subscribe the budget, vote the party ticket, or acquit your client. Such conclusions usually contain emotional appeal. Patrick Henry's conclusion in his "Liberty or Death" speech affords a classic example, although we consider his style too elaborate today. The speech advocated that Virginia ready itself for war against England.

> *It is in vain, sir, to extenuate the matter. Gentlemen may cry peace, peace —but there is no peace. The war is actually begun! The next gale that sweeps from the North will bring to our ears the clash of resounding arms! Our brethren are already in the field! Why stand we here idle? What is it that gentlemen wish? What would they have? Is life so dear, or peace so sweet, as to be purchased at the price of chains and slavery? Forbid it, Almighty God! I know not what course others may take; but as for me, give me liberty, or give me death!*[24]

Other conclusions appeal for acceptance of an idea or proposal. Secretary of State Henry Kissinger appealed to the delegates of the General Assembly of the Organization of American States to "work together for a better life for our children" in his address entitled "Good Partner Policy for Americas" at Atlanta, Georgia, on April 20, 1974.

[23] *Inaugural Addresses of the Presidents of the United States,* 87th Congress, 1st Session, House Document No. 218 (Washington, D.C.: United States Government Printing Office, 1961), pp. 267–70.

[24] William Wirt, *Life and Character of Patrick Henry,* 25th ed. (Philadelphia: Claxton and Company, 1881), p. 42.

In 1900 Jose Enrique Rodo wrote his classic Ariel. *He viewed the two Americas at the turn of the century as in fundamental opposition. Yet he foresaw that another kind of relationship could eventually emerge. He wrote: "To the extent that we can already distinguish a higher form of cooperation as the basis of a distant future, we can see that it will come not as a result of unilateral formulas, but through the reciprocal influence and skillful harmonization of those attributes which give our different peoples their glory."*

Let us here choose such a future now and not in the distance. Let us realize the glory of our peoples by working together for a better life for our children. In so doing we shall realize the final glory and common destiny of the New World.[25]

SUMMARY

Organization means the arrangement of the central idea of a message into main divisions, subpoints, and supporting data. The traditional organizational pattern calls for an introduction, body or discussion, and conclusion.

The introduction performs three functions: creates a favorable atmosphere, stimulates interest in the subject, and clarifies and partitions the topic. Numerous techniques may be employed to attain these purposes.

The body of the message develops the central idea in detail. To develop the central idea, divide it into main divisions and subpoints and expand each with the various forms of support. Organizational patterns include several methods: 1) deductive and inductive, (2) problem-solution, (3) chronological, (4) enumeration, (5) logical, 6) cause-effect relationships, (7) simple-to-complex, and (8) familiar-to-unfamiliar.

The conclusion rounds out the central idea and purpose, in one or all of three ways: (1) summarizing the main points, (2) amplifying the central idea, (3) indicating the desired action.

QUESTIONS

1. What functions does the introduction of a message serve? Discuss how each may be accomplished.
2. Distinguish between the central idea and the specific purpose of a message. Illustrate your answer.
3. How do the main divisions or points of a message relate to the central

25 News release, Bureau of Public Affairs (Washington, D.C.: Department of State, Office of Media Service, April 20, 1974), p. 8.

idea? What principal factors should you consider in selecting your main points?

4. What is meant by the organizational pattern? Explain several methods for organizing a message.

5. What purpose does the conclusion serve? Explain three forms of summaries.

ASSIGNMENTS

Oral

Plan A For your oral assignment, prepare a five-minute demonstration in which you use some type of visual aid: the blackboard, a chart, a mockup, a map, or any physical object. Choose any subject you like.

1. Consider the following suggestions:
 a. Demonstrate various collections in which you may be interested, such as stamps, coins, or guns.
 b. Demonstrate some sport in which you are interested, such as football, golf, swimming, or tennis. Bring the materials to class or make drawings on the blackboard. For example, (1) show some interesting formations in football by blackboard drawings, or (2) demonstrate various golf strokes by using your clubs.
 c. Show how something is made, using a prepared chart or diagram.
 d. Explain the organizational plan of some company by a diagram or demonstration.
2. Observe these precautions:
 a. Make your demonstration a part of a well-developed message. The demonstration should support your idea and should not be an end in itself.
 b. Give special attention to organizing your message. Follow the principles discussed in this chapter for introduction, body, and conclusion.

Plan B For your oral assignment, the class groups will meet simultaneously again for a workshop session to arrange a program of persuasive speeches for presentation before the entire class. Take a stand on some issue relative to your subtopic and attempt to persuade the class members of your position. Decide on the organization plan discussed in this chapter that best serves your purpose. Use several types of supporting material to help prove your contentions. Exchange ideas on each speech and make suggestions for improvement.

READINGS

Barrett, Harold, *Practical Methods in Speech,* 2nd ed., chap. 3. New York: Holt, Rinehart and Winston, 1968.

Bryant, Donald C., and Karl R. Wallace, *Oral Communication,* 4th ed. Englewood Cliffs, N.J.: Prentice-Hall, 1975.

Buehler, E. C., and Wil A. Linkugel, *Speech Communication: A First Course,* part 2, no. 5. New York: Harper & Row, Publishers, 1969.

Eisenson, Jon, and Paul H. Boase, *Basic Speech,* 3rd ed. New York: The Macmillan Company, 1975.

Garner, Dwight L., and Ralph L. Beckett, *Speech Dynamics,* chap. 7. Dubuque, Ia.: Wm. C. Brown Co., 1967.

Gruner, Charles R.; Cal M. Logue; Dwight L. Freshley; and Richard C. Huseman, *Speech Communication in Society,* chap. 7. Boston: Allyn & Bacon, 1972.

Monroe, Alan H., and Douglas Ehninger, *Principles of Speech Communication,* 7th ed., chap. 7. Glenview, Ill.: Scott, Foresman, 1975.

Rogge, Edward, and James C. Ching, *Advanced Public Speaking,* chap. 8. New York: Holt, Rinehart and Winston, 1966.

Preparing for presentation— methods and outlines

Through successive steps you have analyzed your listeners and the communication occasion, selected your subject and decided on your purpose, researched your subject and analyzed the material which you found, selected and evaluated the forms for supporting your ideas, and decided on your points and the organizational plan best adapted to your message. There is one more step to perform: preparing your message for presentation. This step consists of deciding on the method for presentation and preparing the outline.

METHODS OF PREPARING FOR PRESENTATION

The way you prepare your message for delivery may vary according to personal preference and the purpose of your message, but the best plan for most occasions is to prepare for extemporaneous speaking. The four principal methods of presentation follow: (1) reading from the manuscript, (2) delivering from memory, (3) speaking impromptu, and (4) speaking extemporaneously. Consider the advantages and disadvantages of each method in relation to the purpose of your message and the characteristics of your listeners.

Reading from manuscript

This method consists of writing out the message and reading it. Reading speeches and messages from the manuscript has become commonplace

in recent years largely because people in prominent positions find it increasingly necessary to present their ideas to their associates and to the general public. For one untrained in speaking extemporaneously from an outline, reading from the manuscript is perhaps the easiest and safest method of preparation. Radio and television speaking have also added new importance to this method. At least three occasions call for reading a message:

1. Officials in high government or business positions often read their messages because deviation from the prepared manuscript might lead to spur-of-the-moment statements which would cause repercussions harmful to national policy or the reputation of the business organization.

2. Research reports before learned groups such as professional conventions are often read from manuscript. If the speaker presents technical material, statistical information, and quotations of findings not well adapted to extemporaneous presentation, he may well read his report. Usually reports of this type are presented to highly specialized listeners; the material itself commands their interest and holds their attention.

3. Messages prepared for radio may be read without prejudice to the speaker since he cannot be seen. However, the successful radio speaker cultivates the ability to read as though he were speaking extemporaneously. Some speakers read messages for television by means of a teleprompter. The message, printed in large type, is suspended before the speaker outside camera range. The device enables the speaker to give the appearance of looking directly into the camera as he reads. Its use often decreases audience projection because the stare of the speaker does not seem normal.

Although reading from the manuscript is not recommended before diversified audiences where holding attention is important, it does have certain advantages: (1) It permits a careful choice of language for precision of meaning and clarity of expression. (2) It permits economy of expression because the manuscript can be edited. (3) It enables the speaker to develop more fluency than in extemporaneous speaking, for he does not have to choose his language as he speaks. (4) It prevents rambling and digressions. (5) It provides a manuscript for future reference or for publication.

The disadvantages of reading include the following: (1) It decreases listener communication because most speakers cannot read with the same directness with which they speak. (2) It lessens listener projection because the speaker cannot look at his listeners as often as he can in speaking extemporaneously. He loses part of the effect of eye contact and freedom of bodily action, especially gestures. (3) It decreases flexibility because the message cannot easily be adapted to changed conditions, such

as more or less time than anticipated, or to preceding messages. (4) Experienced speakers require more time to prepare the manuscript than to prepare an outline for an extemporaneous message.

If you plan to read your message, consider the following suggestions: (1) Outline your message first and have your supporting material at hand when you start to write. The outline will help prevent rambling, and the supporting material can be inserted readily at the proper place. (2) Write as if you were speaking; imagine your listeners present as you write. Oral style is more informal, repetitious, and direct than written style. Some speakers retain these characteristics of oral style in preparing a manuscript by dictating or recording it. The transcribed manuscript can then be edited. Attempt to make the manuscript retain the freshness of extemporaneous discourse. (3) Read the message several times aloud; imagine your listeners present as you read. Think the thought as you read. Try to grasp whole sentences at a time. (4) Become familiar enough with your manuscript that you can look at your audience frequently. Practice directness and projection as you read. (5) Prepare your manuscript in large type, preferably triple-spaced, and with wide margins. Write in short paragraphs with proper indentation. Some speakers like to write numbers and letters in the margins to indicate main and subordinate points and supporting material.

Speaking from memory

Writing out messages and committing them to memory finds favor with speakers who have difficulty in thinking on their feet. This was the favorite method during the period of elocution, for it freed the speaker to engage his presentation skills.

Certain advantages do accrue. Memorization allows for precision in expression, carefully planned development, a careful choice of language, and more attention to presentation than the extemporaneous method. With most speakers these advantages are outweighted by the disadvantages: difficulty of adaptation to changed conditions, lack of directness in presentation, more time required for preparation, increased chances of forgetting, and lack of apparent spontaneity. Too often the message sounds memorized.

If you use this method, follow the instructions for preparing the manuscript explained in the previous section. Make the manuscript conform to oral rather than written form. For best results in memorizing, read the manuscript over in its entirety until you learn the message as a whole. Do not memorize paragraphs, pages, or sections at a time. Space your

practice sessions over several days. Most persons can memorize better with short practice sessions extended over several days than with longer sessions over a shorter period.

The impromptu method

This method involves speaking without specific preparation. Use the impromptu method only when you are called upon without prior notice. This will happen frequently in conferences and person-to-person situations but rarely in public-speaking situations. Experience in extemporaneous speaking and wide reading are the best preparation. In one sense, you never speak without preparation; rather, you speak from prior experience and out of your background of ideas and knowledge. Otherwise, you would have nothing to say. If you have nothing worthwhile to say when called upon without warning, by all means decline to speak.

When called upon without notice or when contributing in an informal situation, rarely are you expected to make a lengthy speech; a few remarks or expressions of opinion usually suffice. Use deliberation, make a quick analysis of your request, and decide on one or two main ideas. Your opening statement will usually concern the nature of the request or a reference to a previous idea expressed at the meeting.

Some speakers keep a few organizational patterns in mind for such occasions and attempt to put their remarks into these patterns. (1) "Past-present-future" indicates a chronological order. For example, if you are asked to talk on your future profession, the following ideas might serve: brief history of the profession, the status of the profession, your future plans. (2) "Problem-solution" involves facts about the problem and how you think it could be corrected. For example, you are asked how the problem of inflation should be handled. (3) "Social-economic-political" may indicate an organizational pattern for a request such as your opinion on how national elections should be financed. (4) "Theoretical-practical" might indicate an organizational pattern, for example, for your opinion on whether the schools in your community should be structured for a 12-month school year.

The advantages of impromptu speaking are the following: (1) Impromptu speaking calls for an unpremeditated opinion that may more aptly reveal a person's true feelings than would a prepared statement. Industry's use of brainstorming sessions, as we explained in chapter 5, applies this principle. (2) The ideas and opinions must come spontaneously; they are, therefore, usually fresh and alive. (3) Impromptu

speaking encourages thinking on your feet. As a result, you communicate directly because you must think the thought as you speak.

The disadvantages outweigh the advantages in many persons' opinions. (1) Speaking impromptu calls for speaking without complete preparation. Consequently, immature judgments may be expressed, based upon inadequate knowledge. (2) It encourages halting and nonfluent delivery. Many people cannot express themselves fluently on the spur of the moment. (3) It may result in poorly arranged ideas; without time for proper planning, speakers may ramble and present disconnected, incoherent statements. (4) It may induce stage fright. Without time for thought, a person may become emotionally upset.

The extemporaneous method

By this method you speak from a previously prepared outline and choose the phraseology of your message as you talk. The message should be prepared in advance, with a predetermined purpose, well-chosen points, proper explanation and reasoning, and adequate supporting material for each point. Extemporaneous speaking does not mean speaking without preparation, as you might conclude from considering the Latin derivation of the word. The meaning has changed through usage. Speaking without preparation is now termed impromptu speaking.

Final preparation for the extemporaneous message does not end with gathering material and arranging it into an outline; it should include practice in presenting it. Start your practice by thinking through the outline until you can retain a mental picture of it. Then practice presenting it before your class or an imaginary audience until you attain fluency and a ready choice of language. Speak through the entire outline at each practice session; do not go back over certain sections or sentences. Complete the outline several days before the speech, if possible, to give yourself time to become familiar with the outline and to practice.

The advantages of the extemporaneous method are these: (1) It encourages listener communication and directness. (2) It avoids an artificial and stilted manner because the speaker must think the idea as he talks. (3) It permits flexibility; the speaker may shorten or lengthen his message as the occasion demands or as he senses the need. (4) It permits apparent spontaneity; the speech does not sound memorized and rehearsed.

Disadvantages should be considered. (1) It may permit inadequate preparation if one speaks from a hastily-made mental outline. (2) It may encourage poor language choice, since the speaker must choose his language as he speaks. (3) It lessens fluency by requiring an immediate

choice of phraseology. (4) It allows for digressions when the speaker departs from his outline. (5) It does not provide a script for future reference or for publication.

Some speakers follow the practice of writing messages out, reading them several times, but not memorizing them. This practice may aid in choice of language and in fluency. Others record their messages during practice sessions and listen to the tape for self-evaluation. These methods may prove especially helpful to the beginning student.

OUTLINING THE MESSAGE

Experienced communicators who talk on subjects in the field of their specialty may speak from a mental outline with success. For most persons a well-prepared written outline proves invaluable; for the inexperienced it is a necessity. The outline provides a blueprint of the message. It assures realistic thinking on the subject and orderly arrangement of ideas. Speaking without an outline is like building a house without a blueprint; order and arrangement cannot be achieved. The complete-sentence outline distinguishes the relationships between main points and subpoints, and between subpoints and supporting data. The following procedures for outlining apply specifically to the sentence outline.

Rules for outlining

1. Divide the outline into three parts: (1) introduction, (2) body, and (3) conclusion. The introduction includes opening remarks designed to set the keynote, a statement for getting immediate interest, and the partition. Opening remarks often may be suggested at the occasion; to be safe, include a possible opening in the outline. The body of the outline develops the main divisions in detail. The main divisions are divided into subpoints and developed through the various forms of support discussed in chapter 8. The conclusion summarizes the message, restates the central idea, and makes the desired appeal. The parts of the outline for the introduction are illustrated in the sample outline near the end of this chapter.

2. Use a consistent system of symbols. The system of symbols may vary according to personal preference, but one system should be followed consistently. Changing the number and letter designations within an outline destroys the relationships between main points and subpoints and supporting data. The following system serves well.

```
I.   _____
  A. _____
    1. _____
      a. _____
        (1) _____
          (a) _____
          (b) _____
        (2) _____
      b. _____
    2. _____
  B. _____
II.  _____
```

3. Arrange each division into heads and subheads. Each subdivision of a main point should be designated by a separate symbol and proper indentation to indicate the relationship between points and subpoints. Failure to do so obscures the divisional sequence of ideas.

WRONG

It is necessary to distinguish between two types of research: that done by pressure groups or propaganda agencies, and that done by objective groups. Pressure groups are not interested in finding and disseminating factually true information; rather, they are interested only in those facts that serve their purpose. Objective agencies are interested in factually true information. They seek truth for truth's sake and are not interested in what the outcome of a research study may reveal.

RIGHT

I. Distinguish between two types of research.
 A. That done by pressure groups—public-relation or propaganda agencies.
 1. Pressure groups are not interested in finding and disseminating all the factually true information.
 2. Pressure groups seek only those facts that serve their purpose.
 B. That done by objective groups—educational institutions and research organizations.
 1. They seek information for the sake of information.
 2. They seek all the facts and are not interested in what the outcome of a research study may reveal.

4. Use one symbol only for each statement. To designate a single statement by two symbols destroys the relationships between points and subpoints, and between points and supporting data.

WRONG

I. The findings of research studies are disseminated through classroom instruction and through publication.
 A. 1. Classroom instruction forms the more immediate function in meeting the needs of present students.
 2. An instructor may serve a valuable purpose by devoting all his time to this function.
 3. Some persons do not have the facility to serve as both classroom teacher and research scholar.

RIGHT

I. The findings of research studies are disseminated through classroom instruction and through publication.
 A. Classroom instruction forms the more immediate function in meeting the needs of present students.
 1. An instructor may serve a valuable purpose by devoting all his time to this function.
 2. Some persons do not have the facility to serve as both classroom teacher and research scholar.

5. Show a proper indentation for each statement. Each statement subordinate to another should be designated by indentation, while statements of equal rank should show the same indentations.

WRONG

I. Unequal teaching loads can be corrected by the weekly service load.
A. Establish a normal work week applicable to all.
 1. Extra duties such as administration, counseling, research, outside projects, public relations, and committee assignments can be evaluated in terms of hours per week.
 2. The teaching load can be evaluated in terms of time spent in preparation and in the classroom.
 a. Laboratory courses should count more than nonlaboratory courses.

RIGHT

I. Unequal teaching loads can be corrected by the weekly service load.
 A. Establish a normal work week applicable to all.
 1. Extra duties such as administration, counseling, research, outside projects, public relations, and committee assignments can be evaluated in terms of hours per week.

2. The teaching load can be evaluated in terms of time spent in preparation and in the classroom.
 a. Laboratory courses should count more than nonlaboratory courses.

6. Make each statement in the form of a complete sentence. Do not mix sentences, clauses, phrases, and words in the same outline. For the sentence outline, all statements should be made in the form of complete sentences.

WRONG

I. The purpose of a university is to discover, investigate, and disseminate knowledge, and to reveal varying conflicting points of view.
 A. It includes both finding and disseminating information.
 B. Investigation.
 C. What to think—how to think.

RIGHT

I. The purpose of a university is to discover, investigate, and disseminate knowledge, and to reveal varying and conflicting points of view.
 A. It includes both finding and disseminating information.
 B. It includes investigating all possible points of view.
 C. The purpose is to teach students not what to think but how to think.

7. Avoid compound and multiple-idea sentences. Confusion arises in dividing compound and complex sentences into subpoints. It may not be possible to determine to which part of the multiple-idea sentence a subpoint refers.

WRONG

I. Various plans can improve the status of research and classroom teaching.
 A. Sabbatical leaves would provide time for research.
 B. Limiting class size makes for greater individual attention to students.
 C. Were research funds provided, those with significant research projects could apply and get time off.
 D. Credit on teaching load for directing graduate theses would result in improved studies.
 E. Teaching assistants would relieve the teacher of administrative details and paper-grading.
 F. Review sessions scheduled outside the classroom period would assist the backward student.

RIGHT

I. Various plans can improve the status of research.
 A. Sabbatical leaves would provide time for research.
 B. Were research funds provided, those with significant research projects could apply and get time off.
 C. Credit on teaching load for directing graduate theses would result in improved studies.
II. Classroom instruction can be improved.
 A. Limiting class size makes for greater individual attention to students.
 B. Teaching assistants would relieve the teacher of administrative details and paper-grading.
 C. Review sessions scheduled outside the classroom period would assist the backward student.

Types of outlines

The complete-sentence outline like that used to illustrate the preceding section, "Rules for Outlining," is the best type for preparation. For presentation, the phrase and key-word outlines may serve best. The complete-sentence, phrase, and key-word outlines for a commencement address are illustrated below. The comments in the column to the left of the complete-sentence type explain the outline.

1. Complete sentence. The sentence outline helps to show the logical development of ideas. It also aids in choice of language since key sentences must be written out. The beginning student will find the sentence outline especially helpful. Study the following sample outline:

Topic:	New Frontiers for Education
	Introduction
Keynote statement:	I. Commencement time marks a period of beginning.
Interest statement:	II. A recent editorial stated, "Today we have too many people all dressed up in education with no place to go."
Explanation:	A. Do too many seek a college education?
	B. Does education have a place to go?
Partition:	III. Are there new frontiers for education?
Explanation:	A. Are the purposes of education realized?
	B. What new frontiers should guide future emphasis?

Body

Main point:	I. Much emphasis is put on education today.
Subpoint:	A. This emphasis is reflected in student enrollment.
Support:	
Statistics:	1. Total enrollment in colleges and universities in 1974–75 was 8,900,000—and the United States Office of Education predicts 12,000,000 by 1981.
Statistics:	2. Original estimates of the number of veterans who would be interested in the educational provisions of the federal government fell short by approximately 600 percent.
Subpoint:	B. This emphasis is reflected in expenditures for education.
Support:	
Statistics:	1. The nation's educational expenditure in 1974 for elementary and secondary schools was $61.5 billion.
	2. Expenditures for higher education have progressively increased since the war.
Subpoint:	C. Education is rapidly becoming America's number one enterprise.
Explanation:	1. We have many people dressed up in education.
	2. The percentage of high-school graduates who attend college is increasing annually.
Main point:	II. The purposes of education may be broadly stated as three-fold:
Subpoint:	A. The *acquisition of knowledge* comes first in order of time.
Subdivision:	1. Knowledge is necessary in an age of specialization.
Subdivision:	2. There is an aesthetic pleasure in knowledge.
Subpoint:	B. The second purpose is *training the mental faculties*.
Explanation:	1. Some courses are designed to teach people how to think.
Example:	a. This is true largely with law, which teaches through the case method.
	b. Such courses give knowledge plus a well-rounded mental development.
Explanation:	2. Many courses are concerned with both knowledge and reasoning facility.
Subpoint:	C. A purpose often minimized is *training in how to use* acquired knowledge and trained mental faculties.
Subdivision:	1. Failure to stress this purpose constitutes the crucial problem.
Subdivision:	2. Education, improperly directed, may be detrimental.
Examples:	a. Education gives us people who can perfect modern mechanical devices, but these cannot be used because of their effect on the labor market.

b. Education has given us people who can devise ways of using atomic power constructively in industry, but we use it on the battlefield.

Main point: III. Education's new frontier is teaching people *how to live together.*

Subpoints: A. This involves working out a social order capable of coping with material advances.

B. It involves teaching people how to use existing knowledge in the field of social relationships.

Conclusion

Summary: I. Can education cross its new frontier?

Authority: A. Dr. E. Stanley Jones has said that our scientific life is 50 years ahead of our social order and that the next decade will witness a social awakening.

Emphasis of central idea: B. To realize this, we must utilize existing knowledge in the field of social relationships.

Action: II. Education's new frontier can be crossed by putting the proper emphasis upon the utility of education.

2. The phrase outline. The preceding sentence outline is here produced in phrases. The phrase outline may be intelligible only to the communicator, but it may be more usable to him for presentation than a sentence outline.

NEW FRONTIERS FOR EDUCATION

Introduction

I. Time of beginning
II. Recent editorial: "Today we have too many people all dressed up in education with no place to go."
III. New frontiers for education?
 A. Purposes of education realized?
 B. Future emphasis?

Body

I. Emphasis great on education
 A. Reflected in student enrollment
 1. 8,900,000 in 1974–75; 12,000,000 predicted by 1981
 2. Original G.I. estimates 600 percent short
 B. Reflected in expenditures
 1. $61.5 billion last year
 2. Costs increasing

 C. Education number one enterprise
II. Purposes of education threefold
 A. Acquisition of knowledge
 1. Necessary in age of specialization
 2. Aesthetic pleasure in knowledge
 B. Training the mental faculties
 1. Some courses teach how to think
 a. Law as example
 b. Well-rounded mental development
 2. Some courses concern both knowledge and reasoning
 C. Training in utility of knowledge and mental faculties
 1. Failure to stress causes crucial problem
 2. Improperly directed, education may be detrimental
 a. Technological advances
 b. Atomic energy in industry
III. New frontier—how to live together
 A. Social order to match material advances
 B. Use of existing knowledge in field of social relationships

Conclusion

 I. Can education cross new frontier?
 A. E. Stanley Jones—scientific life 50 years ahead of social progress
 B. Apply knowledge in social relationships

3. The key-word outline. The key-word outline supplies a few words and phrases to guide the speaker. Experienced communicators may prefer the key-word outline, especially when talking on familiar subjects. It is not applicable as a preparation outline or for inexperienced communicators.

NEW FRONTIERS FOR EDUCATION

 Introduction

 I. Beginning time
 II. Editorial statement
III. New frontiers?
 A. Purposes
 B. Emphasis

 Body

 I. Emphasis on education
 A. Student enrollment
 B. Expenditures
 C. Number one enterprise

 II. Purposes
 A. Acquisition knowledge
 1. Material
 2. Aesthetic
 B. Trained faculties
 1. How to think
 2. Knowledge and reasoning
 C. Utility
 1. Crucial problem
 2. Improperly directed
 III. New frontier—live together
 A. Material advances
 B. Social relationships

Conclusion

 I. Can education cross frontiers?
 II. Stress utility

MESSAGE COMPOSITION RESTATED

This chapter concludes the discussion of the steps in message preparation and composition that we started in chapter 6. Figure 1 restates and summarizes these steps in graphic form.

SUMMARY

The final steps in message composition consist of selecting the method for delivery and putting the message into outline form. The four methods of presentation follow: 1) reading from the manuscript; (2) speaking from memory; (3) speaking impromptu, that is, without specific preparation; and (4) speaking extemporaneously. Extempore speaking, the recommended method, consists of speaking through a prepared outline as you phrase your ideas.

The last step in composition calls for putting the message into outline form. The rules for outlining should be followed carefully. The types of outlines are: (1) complete-sentence, (2) phrase, and (3) key-word. The complete-sentence outline serves best for preparing the message. The phrase or key-word outline may suffice for presentation purposes.

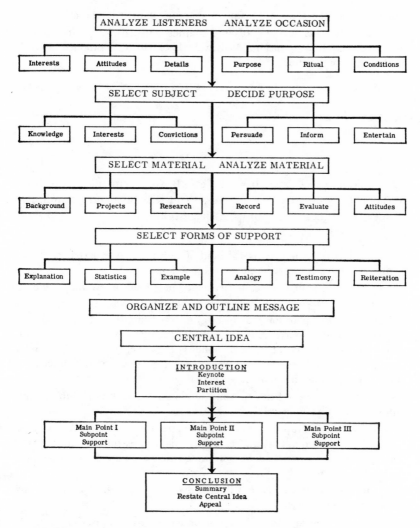

FIGURE 1 Steps in message preparation and composition

QUESTIONS

1. Explain briefly four methods of preparing a message for presentation. What are the advantages of the extemporaneous method?

2. Distinguish among the three types of outlines: complete-sentence, phrase, and key-word. Which type is best as a preparation outline and why?

3. What should be included in the introduction of the outline? The conclusion?

4. Discuss briefly the seven rules for outlining explained in the chapter.
5. Study the chart at the end of this chapter entitled "Steps in Message Preparation and Composition." With your book closed, reproduce as much of the chart as possible.

ASSIGNMENTS

Oral

Plan A Your ninth speech includes all the principles you have learned from studying part 2 of this text. You will be given ten minutes for this speech. Observe the following suggestions:

1. Select a subject from your background of training and experience, one in which you have strong interests and convictions.
2. You may use as your purpose to persuade, inform, or entertain. Decide on this general purpose early in your preparation.
3. Make a tentative plan for your speech first, then find the following sources for study: (1) one source book or textbook, (2) a newspaper story or syndicated article, (3) one account in a news magazine, (4) one article in a monthly magazine, (5) one reference from a government pamphlet, and (6) at least one additional source explained in chapter 7.
4. Interview three authorities in your community about your subject and quote them in your speech.
5. Use each type of support discussed in chapter 8 at least once during your speech: explanation, statistics, example, analogy, testimony, and restatement. This suggestion will not preclude using a single form of support several times.
6. Use any organizational pattern discussed in chapter 9 that you desire. Be able to justify your choice.
7. Decide on a central idea and state it under the title of your outline.
8. Write out a complete sentence outline. List the references that you need in preparing the outline.
9. From your sentence outline, prepare a phrase or key-word outline for use in presenting the speech.
10. Rate yourself and have your instructor rate you on the same basis explained in the exercises for chapter 3.

After you give your speech, list in writing the factors on which you think you have improved since your first speech. List the factors on which you consider you most need additional improvement.

Plan B Each group will present its program of persuasive speeches before the class. Follow the same procedures as outlined for the program of informative speeches, explained at the end of chapter 8.

READINGS

ANDERSCH, ELIZABETH G., LORIN C. STAATS, and ROBERT N. BOSTROM, *Communication in Everyday Use*, 3rd ed., chap. 3. New York: Holt, Rinehart and Winston, 1969.

BAIRD, A. CRAIG, FRANKLIN H. KNOWER, and SAMUEL L. BECKER, *General Speech Communication*, 4th ed., chap. 11. New York: McGraw-Hill Book Co., 1971.

BRYANT, DONALD C., and KARL R. WALLACE, *Fundamentals of Public Speaking*, 5th ed., chap. 9. Englewood Cliffs, N.J.: Prentice-Hall, 1976.

CROCKER, LIONEL, and HERBERT W. HILDEBRANDT, *Public Speaking for College Students*, 4th ed., chap. 19. New York: American Book Co., 1965.

McBURNEY, JAMES H., and ERNEST J. WRAGE, *Guide to Good Speech*, 4th ed., chap. 8. Englewood Cliffs, N.J.: Prentice-Hall, 1975.

MILLS, GLEN E., *Message Preparation: Analysis and Structure*, chap. 5. Indianapolis: The Bobbs-Merrill Co., 1966.

MONROE, ALAN H., and DOUGLAS EHNINGER, *Principles and Types of Speech Communication*, 7th ed., chap. 14. Glenview, Ill.: Scott, Foresman, 1974.

OLIVER, ROBERT T., HAROLD P. ZELKO, and PAUL D. HOLTZMAN, *Communicative Speaking and Listening*, chap. 6. New York: Holt, Rinehart and Winston, 1968.

RAHSKOPF, HORACE G., *Basic Speech Improvement*, chap. 8. New York: Harper & Row, Publishers, 1965.

Verbal and nonverbal communication

Principles of delivery and nonverbal communication

So far we have been concerned primarily with the preparation and composition of a message. The preceding chapters followed a logical sequence based upon the approximate order in which you encounter the principles of composition. Now we must take the finished message and explore how to share ideas with others orally. Although rhetoricians disagree about the principles of effective presentation to a greater extent than they do about composition, they agree that unless a speaker communicates clearly and accurately, the arduous task of preparation will have been in vain.

Delivery consists of the communication of the ideas of a message through visual and auditory signs by means of the coordinated use of mind, body, voice, and language. Professors Huber Ellingsworth and Theodore Clevenger state in their text *Speech and Social Action:*

> *As an instrument of social action, a public speech is something more than the documentary record of its text . . . but, however far-reaching its [social] implications may be, it produces its effect through some immediate audience, and it elicits responses from them only as it is presented to them in visible and audible form. A speech must be spoken to have any effect.*[1]

You sometimes hear people say, "Why take training in communicating orally? We all talk! Why train to do something that comes naturally?"

[1] Huber W. Ellingsworth and Theodore Clevenger, Jr., *Speech and Social Action* (Englewood Cliffs, N.J.: Prentice-Hall, 1967), p. 147.

Some people do speak well without formal training in oral communication, but it is logical to expect that they could do better with training. Those without natural aptitudes in oral communication find training a necessity.

Two incidents show why formal training for delivery does count. A large public-relations organization planned a speech to be given by a nationally known businessman for a college assembly. The advance agent of the organization handed a manuscript of the speech to a speech professor the evening before the speaking occasion. The professor was impressed with the excellence of the speech; the manuscript showed extensive research and careful writing. However, the presentation by the organization's speaker fell far short of the excellence of the manuscript. The speaker had few attributes of effective delivery; he read the speech in a monotone, his voice was weak and high-pitched, he did not use overt bodily action, and he failed to adapt the speech to the interests of the students. His poor presentation caused the students to stop listening and to turn to more interesting pursuits such as reading and conversing with neighbors. An excellent written speech was rendered almost worthless by poor presentation; the speaker simply had failed to communicate.

At another occasion, a dedication ceremony for a new building, the speaker was chosen for his prestige, not for his speaking ability. His chief fault was that he could not be heard. The outdoor meeting required a vigorous and forceful presentation; the speaker read his manuscript haltingly and without animation. Those far back in the audience soon gave up trying to listen because it required too much effort. Later, students in an advanced speech class analyzed a manuscript of the speech and rated it as excellent. It contained mature ideas, it was well organized, and the language was clear and forceful. Again, a good speech was rendered useless by ineffective presentation. The speaker failed to communicate orally.

From the preceding incidents we may conclude that effective presentation is necessary to make a good message accomplish its purpose—the communication of ideas, information, and emotions. The means for attaining communication skills form the subject matter of the three chapters in this section. The chapters include establishing principles of delivery and nonverbal communication, using language accurately and effectively, and attaining an adequate and pleasing voice.

PRINCIPLES OF DELIVERY

A good starting point in a study of delivery is a consideration of principles of effective presentation. These principles differ from the standards

for judging effective oral communication discussed in chapter 1 because they relate only to presentation, while chapter 1 included the total process.

Effective delivery involves the whole person

A brochure advertising a course in oral communication by a high-pressure national organization extolled the benefits that would accrue to those who enrolled. For those who attended the five sessions of two hours each, seventeen major benefits were promised. These benefits included conquering stage fright, learning to understand people, cultivating a pleasing voice, building a large vocabulary, and holding listeners spellbound. The pamphlet boldly raised the question of how all these benefits could be guaranteed in so short a course. It answered its question by stating that all nonessentials were omitted; only those techniques necessary to managing audiences received attention. Furthermore, the brochure claimed that learning the essential features was ridiculously simple. It inferred that one could become a spellbinder in five easy lessons.

We wish that the process were so simple. Unfortunately, like other worthwhile accomplishments, facility in oral presentation comes as a result of long, arduous study and practice. Furthermore, you cannot learn presentation skills in isolation from other areas of development. Effective oral communication requires the development of the whole person. To illustrate, we say that effective delivery calls for an alert, animated, and enthusiastic presentation. Yet you cannot manifest these traits effectively unless you truly feel enthusiasm for your subject. If your feeling comes from within, as a result of a thorough understanding and genuine interest in your subject, your animation will be sincere; if you force enthusiasm, it will probably appear affected.

A normally pitched voice, controlled bodily action, and direct eye contact also characterize good delivery. Yet these factors do not operate independently of the whole person. As a communicator, you must have confidence in yourself, have ideas that you desire to share, and understand your subject well to make effective use of voice and physical action. The factors of delivery work in conjunction with your emotional and intellectual state. You develop presentation skills as you develop yourself as a whole.

Professors Alan H. Monroe and Douglas Ehninger state the matter a little differently:

> *Although success as a speaker depends upon much more than a ready tongue, a flexible voice, and appropriate gestures, these are of great im-*

portance. *Combined with integrity, knowledge, and self-confidence, skill in delivery increases a speaker's effectiveness by helping him reveal to best advantage his inner traits of mind and character.*[2]

Effective delivery uses both visual and auditory signs

Listeners receive ideas from speakers through what they hear, feel, and see. Sometimes what they see is more revealing than what they hear and feel. You can manipulate words to give a false evaluation; you reveal your true feelings by the way you act. You may greet a friend with a loud "good morning"; but if you have a dour expression on your face and use little physical animation, your friend will not believe what you say. A person may reiterate his love for animals, but if his voice and bodily expressions do not indicate his true feelings, even a dog will not believe him. What you say and the way you act combine to reveal your true feelings; to attain maximum results they must be congruous.

You may have had the experience of reading a message and later hearing it presented. How different were the impressions you received? During a political campaign a communications professor heard one candidate speak several times over the radio without being favorably impressed. Later, upon seeing him on television, his opinion of the speaker changed considerably because of his ready smile and animated action. The full force of his warm personality came through by the use of both visual and auditory means, but it did not by auditory means alone.

Visual signs come from bodily movements, facial expression, posture, and gestures. Auditory impressions result from language and voice. Total impressions are conveyed by the coordinated use of both auditory and visual means.

Effective delivery considers the total speaking situation

We learned in chapter 4 about the importance of adapting to the listeners and the occasion as well as the importance of the speaker and the message. Effective delivery considers all these factors.

The listeners and occasion give rise to the purpose of the communication situation. Plan your message with the listeners and occasion in mind. Attempt to communicate in terms that are proper to the occasion and that will be understood by your listeners. Determine what factors of interest and attention will appeal to them by the methods discussed in chapter 4. Knowledge of your listeners will affect your attitude and your eagerness to share your ideas.

[2] Alan H. Monroe and Douglas Ehninger, *Principles and Types of Speech*, 6th ed. (Glenview, Ill.: Scott, Foresman, 1967), p. 9.

The communicator and the message, as parts of the total communication situation, may be reconsidered here for their effect on delivery. If you choose significant subjects from your background of knowledge, you will usually communicate with assurance. Perhaps nothing influences your mental attitude more than the knowledge that you know your subject thoroughly. This assurance increases your self-confidence and reflects itself in your voice quality and bodily action. If you feel that your listeners respect you as a person and have confidence in your judgment, you will have the mental attitude essential for effective delivery. Knowledge of subject, respect for yourself, and an understanding of your listeners give you an inner feeling that will help bring effective delivery skills into play.

Effective delivery communicates ideas without calling attention to techniques

Effective presentation skills do not call attention to themselves; they assist in communicating ideas. Unlike the actor who attempts to portray the character of another, the communicator seeks to be himself. He uses himself as the medium for communicating ideas, information, and emotions to others. If he puts on an exhibition, he may impress his listeners without communicating with them. If his listeners comprehend his ideas and information without being aware of his techniques of presentation, he has used skills of delivery effectively.

Suppose that you received several complimentary statements following a speech. Which of the following would you prize the highest? (1) "Your voice was pleasing." (2) "Your meaningful gestures helped me understand your ideas." (3) "I have never heard a better organized speech." (4) "Would you mind if I used your vivid illustrations about the business executive?" (5) "Your ideas gave me something to think about. Could you suggest other materials on the subject?" Consider your answer before reading the next paragraph.

The first four statements indicated effective use of individual presentation skills, but they also show that the skills called attention to themselves. The fifth statement indicated that you communicated the ideas of your speech effectively and created a desire for further information. If you accept the philosophy expressed in this book, you will accept this statement as the most complimentary of the five.

Professors John Wilson and Carroll Arnold express the matter colorfully as follows:

> *Delivery should be viewed as a means to an end, not as an end in itself. During speaking your message is the most important thing to be exhibited.*

Your mission should never be to show off your body, your grace, or your clothing. You must concentrate on meaning.[3]

Effective delivery is simple, natural, and unaffected. It reflects an earnest endeavor to communicate ideas. It is direct, communicative, and conversational, never exhibitionistic.

Effective delivery establishes rapport with the listeners

Effective delivery involves a two-way communication system. The speaker may do all the talking out loud, but listeners talk back in their minds. The speaker expresses ideas that set up responses in the minds of his listeners. Each listener adds to what the speaker says from his own experiences and knowledge. In short, the speaker directs the thinking of the listeners.

A responding audience forgets about presentation techniques as it reacts to the speaker's ideas. The speaker forgets himself because he feels the response of his listeners; he loses his anxiety because he stops thinking about himself and concentrates on his ideas. He uses bodily action to help express himself adequately. He uses variety in force and rate according to the importance of the idea. In short, presentation techniques are motivated from a feeling within. A speaker uses skills naturally because he has established rapport with his listeners.

Professors Donald Bryant and Karl Wallace state a similar principle as follows:

> *The psychology of delivery is grounded on a single basic principle: conceptions and meaning dominate utterance and bodily behavior. Meanings dominate the listener. They dominate the speaker. In delivery that is judged good, listener and speaker fully attend to meanings during moments of utterance. In delivery that is less than good, some competing stimulus—an irrelevant idea, for example—prevents the speaker or the audience from concentrating on the relevant idea.*[4]

NONVERBAL COMMUNICATION

The foregoing explanation stresses that effective presentation includes both visual and auditory forms. The emphasis until recent years has been

[3] John F. Wilson and Carroll C. Arnold, *Public Speaking as a Liberal Art*, 3rd ed. (Boston: Allyn & Bacon, 1974), p. 252.

[4] Donald C. Bryant and Karl R. Wallace, *Fundamentals of Public Speaking*, 5th ed. (Englewood Cliffs, N.J.: Prentice-Hall, 1976).

on auditory signs, the language we use to express our ideas. We have considered breakdowns in communication as arising largely from a misunderstanding of words or semantic difficulties. Verbal behavior as it affects presentation can hardly be overemphasized, but it does not tell the entire story. Nonverbal behavior is also important. More than an exchange of words occurs when people communicate; people's physical behavior indicates feelings, beliefs, and attitudes as well as does what they say. Such physical behavior includes facial expressions, eye contact, gestures, movements of the whole body, and posture. Other nonverbal factors that affect communication include the environment in which we communicate, our physical appearance and dress, and our vocal cues. Verbal and nonverbal factors work in combination to give a total impression of us as communicators and of the message that we communicate.

Physical action

One of the basic factors of nonverbal communication is physical or bodily action. Listeners accept your ideas in part by what you say and in part by what your physical actions indicate. When your language and your physical action appear congruous the audience usually believes what you say. If language and action contradict each other, your listeners will likely accept what your actions indicate. You may solicit your listeners to accept the student protest movement, but if you speak with your eyes focused on your notes, your hands thrust in your pockets, and your body draped over the lectern, your listeners will probably conclude that you do not believe what you say. The old adage, "actions speak louder than words," applies to communication situations.

Professor James McBurney and the late Ernest Wrage explain a similar position as follows:

> *Bodily action is the visible code of speech. As long as you are in sight of an audience, you are communicating with it, even though you aren't saying a word. Your eyes, facial expression, the tone of your muscles, your posture—all reveal something about you whether you want them to or not. And if words and actions say conflicting things, the audience will intuitively take their cues from your actions. A speaker's manner can make us feel unwanted even though he speaks words of welcome. Bodily actions carry meaning in their own right, and they can reinforce or defeat your words.[5]*

Meaningful bodily action comes spontaneously from inner feelings; it is self-motivated. An uninhibited person uses his body to help him express

[5] James H. McBurney and Ernest J. Wrage, *Guide to Good Speech* (Englewood Cliffs, N.J.: Prentice-Hall, 1965), p. 195.

his ideas and feelings without realizing that he does so. If you describe to your friends the exciting football game that you witnessed, you use your arms and hands, your facial expression, and indeed your entire body to dramatize the event, to express your thoughts and feelings. Watch any group of children at play; they use uninhibited movements and gestures without thought of how they appear. The least educated man helps to make his meaning clear by using his arms, hands, shoulders, head, and face. Most people naturally speak with gestures and the whole body; only when people become inhibited do their physical actions appear unnatural.

Yet, when people step up to the platform to speak, they frequently seem paralyzed and refuse to make gestures and use their bodies; or make only half-gestures or inhibited physical movements which appear unnatural. They say one thing, but their bodies indicate something else. These incongruous physical actions detract from what they say; the listeners' attention is called to the action because the body movements appear weak, indefinite, poorly timed, and unnatural. Effective physical action assists the speaker in clarifying ideas and in expressing emotions because it reinforces what he says.

1. Purposes of physical action. Physical action can help you communicate in at least three ways: by conveying meaning, by holding attention, and by increasing your energy and self-confidence.

Physical action helps convey meaning in part by describing the size and shape of things. To say that the airplane propeller is three feet from the ground gives a word explanation; but if you hold your hand about three feet from the floor, you also give a visual picture. A statement that the get-away car raced down the highway at 90 miles per hour gives some indication of high speed; but if you strike the air rapidly with your hand as you make the statement, you emphasize the high speed. If you say that the box is two feet square, your listeners will visualize the size better if you describe the size with your hands. Descriptive gestures reinforce your language and help express meaning.

Physical action also aids in expressing attitudes and feelings. A shrug of the shoulders may convey your attitude better than a paragraph of words. You may say that you are pleased by being asked to speak, but a smile and pleasant manner indicate your true feelings better than your statement. If you want your listeners to feel your alarm about world conditions, show alarm in your face, shoulders, and whole body.

The whole person should react in every type of behavior. Your voice should not indicate one emotion, your language another, and your body still another. They should work in coordination to give a total impression. Your posture, facial expressions, gestures, and movements must

also work in coordination. Delivery may be explained in terms of activity of the whole body. An uninhibited body acts with mind, voice, and language to express meaning and emotion.

Physical action aids in holding attention. The human body tends to imitate muscularly what it sees and feels. This we call empathic response. The enthusiastic spectator strains practically every muscle in his body to help his team push across the goal line. The great drama tires you physically because you react to the actors. The lecturer describes the bloody battle, and your body reacts covertly with the actions of the warriors. In short, as an active speaker you make listeners become alert. If you use little or no bodily action you seem sluggish, and your listeners become apathetic. They sense that you do not feel what you say.

You walk down the sidewalk without noticing the automobiles parked by the curb; but one races by and your attention becomes immediately drawn to it. The coach explains the new football formation while the players doze; but when he diagrams it on the blackboard and acts out each player's duty, he receives careful attention. A moving object attracts attention and holds interest; so does an active communicator.

Physical action increases energy and self-confidence. A tense person helps rid himself of tautness by physical activity. The athlete engages in warm-up exercises before the game to loosen up his muscles and help him forget his apprehensions. Some speakers take long walks before important engagements. They understand the importance of physical activity in relieving nervous tensions. By providing useful action during a speech, bodily movements release nervous energy. A step forward to emphasize a point or a step backward at the completion of an idea assists in emphasis and transitions; it also provides useful movement that helps release muscular tensions.

Action generates fervor, which in turn results in more action. Soon the speaker becomes active and enthusiastic about his ideas and forgets himself. Physical action may be both a cause and an effect. If a person knows his subject well and has enthusiasm for it, he will normally use physical action. Thus, action may be considered the effect of the enthusiasm for one's subject. Conversely, if a person uses action deliberately at first, he provides the physical activity essential to relieve muscular tension. As his tensions become released, increased fervor for his ideas results. This enthusiasm in turn causes him to forget his inhibitions and to concentrate his attention on his ideas. Thus, physical action may be the cause of increased energy and self-confidence.

2. Types of physical action. The physical action discussed in this section may be overt or covert. Overt action comprises the easily discernible movements of the arms, head, shoulders, legs, or the whole

body. The slightly discernible movements of the muscles of the arms, shoulders, face, or body that indicate the muscular tone of the entire body constitute covert action. Both overt and covert action play an important part in oral communication, but covert action may give an audience more accurate indications of the speaker's feelings and attitudes than overt action. Covert action cannot be easily camouflaged; from these actions listeners form opinions, sometimes subliminal, of the speaker's responsiveness, sincerity, decisiveness, sympathy, and confidence.

Physical action may take the form of movements of the whole body, movements of parts of the body, facial expressions, and posture. These four types of bodily activity work together for total body expression, but they may be considered separately for better understanding of their relationships.

Purposeful movements of the whole body, from one place on the platform to another, will assist your delivery. Random movements call attention to themselves and detract from what you say. Random movements result from nervous tension; besides aimless pacing, they include such movements as shifting the weight from one leg to the other, and slouching over the speaker's stand. To avoid these distracting movements, consider the following descriptions of natural and purposeful movement.

When and how does one move naturally? You move the whole body during transitions or to emphasize points. A forward movement stresses an important point. Suppose you state, "Vote 'yes' on the bond issue. Our schools must keep pace. Accept the challenge for better schools." A step or two forward with both arms raised, palms up in a giving gesture, reinforces your verbal appeal by your bodily movements. Suppose you say, "Vote 'no' on the bond issue. Taxes are already exorbitant. Defeat the proposal for needless waste." A backward step or motion accompanied with a downswing of your arms indicates rejection as well as does your language.

A backward step or two denotes the conclusion of an idea. It says to the audience that it can relax briefly. This movement would follow such statements as these: "Now you have considered the pros and cons of the bond issue. I hope you are apprised of the facts. The decision on how you vote is yours."

Lateral movements indicate transitions from one point to another. They accompany such statements as, "You have heard the issues of the bond election discussed from both sides. Perhaps you have already decided how you will vote. Now let us consider how to mark the ballot." The lateral step would come as you speak the final sentence. It indicates that you are leaving one idea and taking up another.

When speaking behind a lectern or desk, you may occasionally move

slightly to one side of the lectern, back to the original position, then to the other side, but do not pace aimlessly back and forth.

When using a public-address system, make your movements slight to avoid moving outside the range of the microphone. Variations in amplification irritate an audience. You can move the body slightly without stepping outside the area of amplification of the microphone, but you must not turn away from it; keep your voice directed into the microphone.

Gestures consist of movements of parts of the body for the purpose of emphasizing thought or emotion or for reinforcing oral expression. The principal gestures are made with the arms and hands, but they may be made also with the head and shoulders. Specific gestures bring out finer distinctions in meaning than do movements of the whole body, especially when gestures are combined with whole-body movements.

An objective study of gestures may help one understand their use, but gestures should not be used in a studied, formal, and precise manner. They should be natural and spontaneous, not mechanical. If gestures come from an urge within to help express feelings, they are likely to be natural.

Professors Alma Sarett, Lew Sarett, and William Foster elaborate on this point as follows:

> *Because no speaker is quite like anybody else in his physical structure and temperament, his bodily actions will be somewhat different from anybody else's. The walk, posture, and gestures right for one will not only feel unnatural to another who imitates them, but will give the wrong cues to the audience. One's aim should be to develop free, self-motivated bodily action—action that springs spontaneously from the desire to communicate and from the ideas communicated, and that accurately reveals individuality.[6]*

Above all, do not plan gestures in advance to accompany certain statements. Let them come naturally; then in practice sessions correct those that detract from effective delivery. The right use of gestures is a matter of correction and control, not of objective planning. A study of the basic principles of gestures may aid inexperienced speakers in overcoming the initial hesitancy to use them. Beginning students often say that gestures do not come naturally. Gestures must come from feelings and impulses or they will appear unnatural, but it may be necessary to force yourself to use them in practice periods. A study of the following

[6] Lew Sarett, William Trufant Foster, and Alma Johnson Sarett, *Basic Principles of Speech* (Boston: Houghton Mifflin Co, 1966), p. 430.

classification and principles governing gestures should help you free yourself from self-consciousness and show you how to use your body more effectively.

Some movements of the hands and arms have been used so long to indicate a given reaction that they may be classified as *traditional* gestures. Other gestures of the head, trunk, and shoulders are used to emphasize ideas and feelings and may be termed *emphatic* gestures. Others enforce what the speaker says by imitation and have been termed *descriptive* gestures. The distinguishing characteristics of these types and their uses need further elaboration.

Traditional gestures of the hands and arms will not be used in exactly the same manner by any two speakers, but they denote in a general way the expression they accompany.

The clenched fist indicates extreme feeling, determination, or emphasis. This gesture would be used with such statements as, "We must fight to the last man to protect our freedom. We must destroy the dictators. We must put every ounce of energy into the fight."

The hand held in a vertical position and moved from side to side indicates the separation of ideas or facts. Sometimes termed the division gesture, it would be used with such statements as the following: "We should become neither too liberal nor too conservative in our thoughts." "The advantages of this procedure are many; yet we must consider the disadvantages." "On one side we have freedom; on the other, slavery."

Pointing the index finger calls attention to objects, emphasizes statements, or indicates direction. This gesture could be used with such statements as the following: "We must go forward to keep pace with changing conditions." "Freedom is the essence of democracy. Freedom-loving men will never surrender their heritage." "In the words of Abraham Lincoln, ours is 'a government of the people, by the people, for the people.'"

The palm upward in an extended position indicates giving or receiving. If you hand a book to another or receive an object, you extend your arm with the palm up. This movement asks an audience to accept an idea. The gesture accompanies such statements as these: "We must fight or give up our heritage." "Freedom of speech carries with it certain obligations. To protect our freedom we must accept these obligations."

The palm downward denotes rejection. It indicates disapproval or suppression of a proposal. It would accompany such statements as the following: "The idea has no foundation." "The theory is worthless." "To protect our freedom, we must reject the proposal."

Emphatic gestures of the head, trunk, and shoulders, when used in coordination with traditional gestures of the hands and arms, emphasize

feelings and ideas. A nod of the head may emphasize a point or indicate approval or disapproval; a shrug of the shoulders may denote dislike or contempt; leaning forward slightly from the waist may suggest emphasis or show keen interest. These gestures may be used to advantage, but none should be used too often. Too many gestures detract from what one says because the audience becomes aware of the movement. A speaker's constant shrugging of the shoulders, nodding of the head, or bending from the waist may wear an audience out physically.

Descriptive gestures indicate the size and shape or distance and movement of objects by imitation. One uses his arms, hands, and body to assist his oral expression. For example, the speed of the rocket may be indicated by a swift, sweeping movement of the arm and hand. The height of the boy may be indicated by holding the hand as if at the top of his head. The vigor of a blow can be shown by a swift striking of the palm of the hand with the fist. The size of an object may be illustrated by imitative hand gestures that indicate its shape. The spiraling of prices may be indicated by describing the upward movement with the hands and arms.

Posture relates to the position or stance of the speaker while standing or sitting. Just as we have fads in slang, we also adopt fads in posture. These range all the way from ridiculous nonchalance to stiff military rigidity. A speaker should no more stand rigidly with both feet planted flat on the floor than he should slouch forward from apparent lack of ability to stand upright. The ideal posture permits the speaker to keep his head erect, his chin up, his chest out, his shoulders relaxed, and one foot slightly advanced with the weight on the forward foot.

"What shall I do with my hands?" perplexes many beginning speakers. They say that their hands get in their way. While sitting on the platform, they drum on their chair with their fingers, adjust their clothing, nervously clasp and unclasp their hands, or run restless fingers through their hair. While speaking, they clasp their hands behind them, grasp the lectern, put their hands in their pockets, or hold on to their lapels. Constant actions call attention to the mannerism and cause distractions.

None of the hand positions described above detract from delivery unless used excessively or unnaturally. In beginning your message, you may rest your hands on the lectern. Later use them to gesture and to help express ideas. As you concentrate on your ideas and become engrossed in your message, you will tend to forget about your hands; then their actions become natural.

Do not maintain the same posture throughout your message; changes in position come with emphasis on ideas. All instructions about physical

action must allow for individual differences, but changes in posture normally should come during transitions. Make all changes in posture and all movements purposeful; avoid random movements.

Formerly, students of elocution spent torturous hours over charts of facial expressions. The instructions gave formulas for each emotion: to express anger, you were instructed to frown, draw your eyebrows down, pull your lips together, and look fierce; to show fear, you were instructed to draw back, open your mouth wide, and enlarge the openings of your eyes in an expression of stark terror; for expressing love, joy, and other emotions, equally artificial instructions followed. Obviously such rules caused the worst kind of artificiality. The elocutionist so concerned himself about his facial expressions that he could not concentrate on his ideas.

Today, oral communication instruction advises naturalness of expression. Almost all people show their feelings by their facial expressions; only poker players and the feeble-minded have vacuous expressions. To be sure, many normal people do not show their true feelings when self-conscious. The solution to unnatural facial expression is to bring apprehensions under control. As you conquer tenseness, become familiar with your subject, and believe fully in yourself, your facial expressions will reflect your true feelings.

The face of a speaker who has brought his anxieties under control indicates attitudes and opinions almost as well as does what he says. The insincerity of the fixed smile of professional goodwill, the strive-to-please attitude, and the overanxious look are easily detected. To assist in correcting distracting facial expressions, give conscious attention to facial expressions during practice; seek the frank criticism of your instructor; and make movies of class speeches. When before listeners, concentrate on subject matter; as you bring your apprehensions under control, the corrective measures practiced in rehearsals will gradually predominate.

Several recent texts listed at the end of this chapter review the extensive research that has been done about eye contact and eye behavior. These studies have enabled social psychologists to develop theories about personality as related to eye behavior. Professors Abne Eisenberg and Ralph Smith state in their text:

> *Eye movement serves several social purposes. First, by looking at people's eyes, individuals gather much nonverbal information about other people. Second, looking at another person indicates that the channels of communication are open. . . . Third, being looked at is a potential stimulus. For ex-*

ample, speakers sometimes change their strategy to deal with an audience which does not look at them, and many individuals will evade the eyes of another whose gaze is disconcertingly constant and direct.[7]

At point here is how eye behavior affects the communicator and what he can do to improve his eye contact. Physical directness, including eye contact, indicates respect and attitudes of goodwill toward your listeners almost as much as the words you use. If you have cordial feelings toward your listeners and an interest in your subject, such feelings will be evident in your eye behavior unless you experience undue anxiety.

Often speakers let their notes interfere with their directness of presentation. They continually look at their notes and refuse to look at their listeners; they appear to speak at their notes, not with their listeners. Other speakers look out windows, at the walls or floor, or over the heads of the audience. This lack of eye contact decreases audience projection and gives the impression that you lack interest in communicating your ideas.

3. Characteristics of good gestures. Half-made and poorly timed gestures may be worse than no gestures since they call attention to themselves. Do not consider gesturing an absolute requirement; gestures should help you express yourself, but you should not gesture simply because you consider it customary. A study of the requirements for gestures should help you understand their function and purpose.

Good gestures are spontaneous and natural. As we said of bodily action in general, gestures must also come in response to an inward urge. Do not force gestures; unless they come from a desire to express ideas, they will appear unnatural and affected. To gesture simply for effect invites ridicule. Develop a desire to share your ideas, and gestures will come naturally and spontaneously.

Good gestures require a coordinated use of the whole body. This requirement does not mean a perceptible change in the position of the body, but it does mean that the body must be attuned to the gesture. If you attempt to show disapproval of an idea by turning the palms downward at the same instant that you show an approving smile, the meaning of the gesture will be lost. Your listeners will be perplexed because you indicate contradictory feelings simultaneously.

Suppose you ask for acceptance of a proposed plan. We discussed earlier that acceptance gestures are made with the palms upward and the hands extended. Natural accompanying bodily action includes a step forward

[7] Abne M. Eisenberg and Ralph R. Smith, Jr., *Nonverbal Communication* (Indianapolis: The Bobbs-Merrill Co., Inc., 1971), pp. 92–93.

and a slight forward bending at the waist. The entire body becomes attuned to the idea expressed.

Good gestures show proper timing. The stroke of the gesture should come at the exact time that you say the word or syllable to be emphasized. If it precedes or follows the point emphasized, the gesture appears misplaced and calls attention to itself. Comedians of the silent-picture age used ill-timed gestures as a source of comedy. Poor timing of gestures to express serious thoughts makes the communicator appear ridiculous.

Poor timing usually results when a person fails to think about what he is saying. If you rehearse a gesture, poor timing results because you focus your attention on the gesture, not on the thought. Suppose you say, "What is the essence of democracy? It involves many factors, but *freedom* is the basis of all other factors." *Freedom* is the point of emphasis; the climax of the gesture should come as you utter this word.

Good gestures are definite and fully made. Many gestures appear like slight, fidgety movements of the hands. The communicator apparently desires to gesture but refrains from doing so because of his inhibitions. To be effective, movements must start somewhere and end somewhere. Consider gestures as having three stages—the beginning, the climax, and the return. A gesture that includes use of the hands and arms should begin with the movement from the shoulder joints, not the elbows or wrists. It should reach a climax well away from the body on the emphasized word. The arms and hands should then return to the sides in an unobtrusive manner. Never drop the hands to the sides from midair purposelessly.

Make gestures definite and full-sweeping. Exaggerate the sweep of gestures in practice so as to accustom yourself to let go. When communicating, forget about how sweeping gestures should be made; concentrate on the ideas of your message.

Good gestures vary in vigor with ideas expressed. This requirement does not mean that you should pound the table or beat the air aimlessly; it does call for enthusiasm and energy. The vigor of the gesture should conform to the idea expressed. To move your arms slowly through the air when you say, "The jet plane screamed through the air at a speed exceeding sound," would appear humorous and absurd. This statement should be accompanied by a swift movement of the arms to simulate the speed of the plane. You would not strike the palm of one hand with the fist of the other when saying "The gradual rise in prices resulted in decreased consumption." Use a slow, upward-moving arm gesture for this statement. Make the vigor of the gesture conform to the spirit of the idea.

Good gestures are appropriate. The number and kind of gestures depend not only upon the meaning to be conveyed, but also upon the size and type of audience and the occasion. Before large audiences gestures should be wider and more sweeping than before small groups. Conversely,

descriptive gestures would be more appropriate when talking to small audiences than when talking to large audiences. Gestures need to be adapted to type of audience, also. For instance, as a general rule, young people like more action than do older people.

The type of occasion also affects the use of gestures. The speaker at a funeral naturally would not use the vigorous type of gestures that one would use at a patriotic rally. The speaker at a workshop session would probably use descriptive gestures more than the other types, while the speaker at a political rally would normally use emphatic and conventional more than descriptive gestures.

Good gestures have variety. Some communicators use only one or two gestures throughout a message. They use the same gesture to show disapproval, to ask acceptance, to emphasize an idea, or to show extreme feeling. One gesture frequently overworked is the hand-and-arm pumping movement. The speaker stands rooted in one spot or wanders about the platform, pumping his hand and arm up and down for emphasis.

The monotony of the use of one gesture detracts from what the communicator talks about; worse, it is confusing, for the gesture and the idea are incongruous. Most messages contain many ideas that should be emphasized and clarified by a variety of movements, gestures, and facial expressions.

In summary, gestures serve the communicator well, but they should be used to make ideas meaningful, not as an end in themselves. The requirements discussed in this section should assist in making gestures feel natural and be meaningful.

Physical appearance

What effect do physical appearance, dress, and grooming have on getting your ideas accepted in oral communication? Professor Mark Knapp of Purdue University reviewed a large number of research studies in point that indicate physical appearance counts more than we might think.

> *While it is not uncommon to hear people muse about how "inner beauty" is the only thing that really counts, research suggests that "outer beauty" or physical attractiveness plays an influential role in determining responses for a broad range of interpersonal encounters. . . . Physical attractiveness seems to play an important role in persuading and/or manipulating others—whether in courtship, a classroom, or a public speaking situation. Certainly it is very influential on first impressions and expectations for an encounter.*[8]

8 Mark L. Knapp, *Nonverbal Communication in Human Interaction* (New York: Holt, Rinehart and Winston, Inc., 1972), pp. 64 and 68.

Appearance and stage conduct begin before you speak and consist of the way you look and how you act. Initial appearances may go far toward creating the proper atmosphere for your message. They cause listeners to form impressions of you as a person, and thus affect the reception of your ideas.

Avoid affectations in manner and dress for communication occasions. Dress conservatively and in good taste to avoid calling attention to yourself. Usually a dark suit, solid-color shirt, dark tie and socks, and well-shined shoes serve men best. Women should avoid excessive make-up, too much jewelry, and clothing and ornament that detract from what they talk about. Good taste in dress and grooming indicates a person whose evaluations can be trusted and thus helps you to get off to a good start.

Appropriate dress and grooming may also affect your self-confidence. A well-groomed appearance often gives a feeling of well-being that helps you forget your apprehensions.

Vocal cues

The vocal mechanism serves primarily in translating speech sounds into intelligible words, phrases, and sentences—an important part of verbal communication. But the voice may be even more important in nonverbal communication, because it gives the listeners impressions and cues. The vocal cues that accompany spoken language have been termed *para-language*. They consist of such voice qualities as pitch, rate, volume, articulation, resonance, tempo, and rhythm. Most persons can form accurate judgments about others simply from the sound of their voices, especially in determining such factors as sex, age, birthplace, and occupation. Trained observers can usually make accurate judgments about such additional factors as race, education, social class, status, weight, height, and body type. Listeners form impressions from the cues of the speaker's voice as to his personality, emotional state, familiarity with his subject, persuasiveness, and confidence of judgment. Thus, listeners distinguish between verbal and vocal messages, between what is said and how it is said.

Authors Stewart Tubbs and Sylvia Moss emphasize the importance of judgments made from voice cues:

> *Intuitively we feel that we can make some judgments from a person's voice about what he is communicating. Perhaps you have been in an argument during which someone said, "Don't answer me in that tone of voice!" At a point like this, tempers really begin to escalate, for an objection to someone's tone of voice is based on inferences about his feelings. Vocal cues are the sources of*

several kinds of inference, and those that we know most about have to do with emotion.[9]

Professors Ron Adler and Neil Towne reinforce the function of vocal cues:

> *There are many other ways our voice communicates: through its tone, speed, pitch, and number and length of pauses, volume, and disfluencies (such as stammering, use of "uh," "um," "er," and so on). All these factors together can be called "paralanguage," and they can do a great deal to reinforce or contradict the message our words convey.*[10]

Chapter 13 discusses the development of an adequate speaking voice in some detail. As you study this chapter, remember that a good voice applies not only to your verbal message but to your nonverbal communication as well.

Environmental factors

In chapter 4 we discussed briefly the importance of analyzing the physical conditions likely to prevail on communication occasions, including the size and shape of the room or lecture hall, outside disturbances, furnishings and platform equipment, and provisions available for using visual aids. Later we commented on the importance of color, noise, and music as they relate to efficiency in industrial organizations. These are only a few of the factors involved in the effect of environment and space on nonverbal communication.

After reviewing a great many research studies in this field, Professor Mark Knapp concluded in part:

> *The environment in which people communicate frequently contributes to the overall outcome of their encounters. Where we live, the objects which surround us, the architecture, size and visual-esthetic dimensions of the situation, furniture arrangement, and possibly even the climate, operate in subtle ways to influence our communicative behavior. Even the space between two people may have its impact on the relationship. Naturally, as man's knowl-*

[9] Stewart L. Tubbs and Sylvia Moss, *Human Communication: An Interpersonal Perspective* (New York: Random House, 1974), p. 156.

[10] Ron Adler and Neil Towne, *Looking Out/Looking In: Interpersonal Communication* (San Francisco: Rinehart Press, 1975), p. 222.

*edge of these factors increases, he may deliberately use them to help him ob-
tain the response he desires.*[11]

Writing about one aspect of environmental factors—rooms and spaces—
Professors Bobby Patton and Kim Giffin state:

> *Different places have ways of giving us messages. Some places seem to say,
> "Sit down and enjoy yourself; talk things over if you wish." Other places are
> cold, formal, or barren, and contribute to difficulties in overcoming psy-
> chological distance between people. In many ways the physical elements in-
> fluence the behaviors that can be expected in such a place.*[12]

Although the scope of this text does not call for an extended treatment
of environmental effects on nonverbal communication, you should be
aware of its importance in person-to-person and small-group communica-
tion. The readings listed at the end of this chapter should prove helpful
in pursuing the subject.

SUMMARY

This chapter has introduced the subject of delivery and stressed the
importance of nonverbal communication. Knowledge of the principles
and training in the practices of effective presentation are necessary to
complete the processes of oral communication.

The basic principles of delivery stress that effective delivery (1) involves
the whole person, (2) uses both visual and auditory means, (3) considers
the total speaking situation, (4) communicates ideas without calling
attention to techniques, and (5) establishes rapport with the audience.

Physical activity constitutes an essential part of nonverbal communica-
tion; listeners form their impressions in part by the communicator's
actions. Physical action helps convey meaning, aids in holding attention,
and increases energy and self-confidence.

Physical action takes five forms: movement of the whole body, ges-
tures, posture, facial expressions, and eye behavior. Gestures are of three
types: traditional gestures of the hands and arms; emphatic gestures of
the head, trunk, and shoulders; and descriptive gestures. The require-
ments of good gestures include: spontaneity and naturalness, coordina-

11 Mark L. Knapp, *Nonverbal Communication in Human Interaction* (New York:
Holt, Rinehart and Winston, Inc., 1972), p. 55.

12 Bobby R. Patton and Kim Giffin, *Interpersonal Communication: Basic Text and
Readings* (New York: Harper & Row, Publishers, 1974), p. 227.

tion of the whole body, proper timing, definiteness and completeness, vigor, appropriateness, and variety.

Other forms of nonverbal communication involve physical appearance, vocal cues, and environmental factors.

QUESTIONS

1. Explain briefly the five principles of effective delivery discussed in this chapter. Can you add other principles that might apply?
2. Are you more likely to form opinions of a person's emotional state by what he says or by how he acts? Explain and illustrate your answer.
3. Distinguish between verbal and nonverbal communication and explain how physical activity applies.
4. Define gesture, posture, eye behavior, and facial expressions. Discuss their relative value to nonverbal communication.
5. Explain how physical appearance, vocal cues, and environmental factors apply to nonverbal communication.

ASSIGNMENTS

For your oral assignment you will have a choice between two types of speeches. Whichever assignment you choose, give particular attention to the use of bodily action; make abundant use of the types of action discussed in this chapter.

1. Prepare a "speaking-for-a-cause" message on a school or local problem about which you have strong feelings. Let yourself go; use bodily action frequently. Limit your speech to five minutes. The following topics are suggestions only; take the side of the question in which you believe.
 a. The honor system
 b. The grading system
 c. Teacher evaluations
 d. Library rules
 e. Right to see files
 f. Censorship of the school paper
 g. Required versus elective courses
 h. Tuition costs
 i. The new morality
 j. Coed housing
 k. Seating arrangements at football games
 l. Student governments
 m. Entrance requirements
 n. Student rights

2. Prepare a message which explains a process or prepare a "how-to-do-it" speech in which you use a physical object or some other type of visual aid. Review the section on visual aids in chapter 8 and the instructions for the demonstration speech given in the exercises for chapter 9 before preparing this speech. Limit your speech to five minutes. The following topics are suggested:
 a. How the law of supply and demand operates
 b. How to operate a brokerage house
 c. How inflation and recession can exist simultaneously
 d. How to play chess
 e. How the split-T formation works
 f. How political parties operate
 g. How an airplane operates in flight
 h. How to lay tile
 i. The operational plan for a bank
 j. How lumber is processed
 k. Merchandising in a department store
 l. The organization of a television station

READINGS

ADLER, RON, and NEIL TOWNE, *Looking Out/Looking In: Interpersonal Communication,* chap. 9. New York: Holt, Rinehart and Winston, 1975.

BROOKS, WILLIAM D., *Speech Communication,* 2nd ed., chap. 6. Dubuque, Ia.: Wm. C. Brown Co., 1974.

CIVIKLY, JEAN M., *Messages: A Reader in Human Communication,* part. 2. New York: Random House, 1974.

EISENBERG, ABNE M., and RALPH R. SMITH, JR., *Nonverbal Communication.* Indianapolis: The Bobbs-Merrill Co., 1971.

GOLDHABER, GERALD M., *Organizational Communication,* chap. 5. Dubuque, Ia.: Wm. C. Brown Co., 1974.

HOLTZMAN, PAUL D., ed., "A Special Issue on Nonverbal Communication," *The Journal of Communication,* 22:4 (December 1972).

HYBELS, SAUNDRA, and RICHARD L. WEAVER, II, *Speech/Communication,* chap 3. New York: D. Van Nostrand Co., 1974.

KNAPP, MARK L., *Nonverbal Communication in Human Interaction.* New York: Holt, Rinehart and Winston, 1972.

PATTON, BOBBY R., and KIM GIFFIN, *Interpersonal Communication: Basic Text and Readings,* chap. 5. New York: Harper & Row, Publishers, 1974.

TUBBS, STEWART L., and SYLVIA MOSS, *Human Communication: An Interpersonal Perspective,* chap. 7. New York: Random House, 1974.

WISEMAN, GORDON, and LARRY BARKER, *Speech/Interpersonal Communication,* 2nd ed., chap. 12. San Francisco: Chandler Publishing Co., 1974.

Verbal communication: language

You learned in part 2 that the careful organizing and outlining of messages are prerequisites to presenting ideas orally. You learned in chapter 11 that messages come across in part from nonverbal factors—physical action, appearance, cues from the voice, and environmental conditions. The language used to develop your verbal message and to accompany your nonverbal signs also counts heavily. For language to accomplish its maximum usefulness, it must express your message precisely and accurately. If you use language to convey information, ideas, and feelings accurately to others, you make maximum use of language. If you use language to confuse or simply to impress your listeners, you do not use language for its desired purpose. Furthermore, as a communicator you have an obligation not to mislead your listeners by manipulating words, because you can use language to give false evaluations as easily as to evaluate ideas accurately.

How can you develop your use of language so that it will realize maximum usefulness? Consider two approaches: (1) the general semantics approach—using language that accurately represents the ideas and facts with which you deal; (2) the rhetorical skills approach—using language that conforms to acceptable standards of grammatical construction, word choice, unity and coherence, and structure. The two approaches are not antithetical; both must be considered if you wish your language to reach maximum usefulness.

What happens if you master one approach without the other? Consider these examples. While an uneducated man awaited his turn in the doctor's reception room, the doctor came by and said to him, "How is the treatment going, Sam? Do you feel any better?" Sam responded, "Yes, doc, I are feelin' some better. I was afraid it wouldn't work. I had went

too long before doin' nothing. I jest trust the Lord and come to you and now I think I git well." Sam's skills left much to be desired, but he apparently gave an accurate account of how he felt.

Contrast Sam's effort to communicate with Peter's: "Chicago, the largest and most picturesque city in America, lies peacefully on the shores of the blue Danube two hundred miles south of Moscow." Peter's skills far exceeded Sam's, but he talked nonsense and mis-evaluated what he talked about. In fact, one can talk nonsense with as much skill as one uses to express mature thoughts. Communication skills contain no built-in features that distinguish between proper and improper evaluations. We must have more than the principles of rhetorical skills to attain accurate evaluation.

GENERAL SEMANTICS APPROACH

Consider how much of your life you spend associating with words. The average American spends more than 70 percent of his waking hours using words, either speaking and writing or listening and reading. As we learned in chapter 1, college students spend 15 to 16 hours per day communicating.

Lee Loevinger, in writing about mass communications, states:

> *In contemporary society more people spend more time in communicating than in any other waking activity. If there ever was a period when man spent more time manipulating physical objects rather than symbols it is irretrievably past for us. Even in our organization of works we now have more white collar than blue collar workers, and our leisure time activities have long since become predominately vicarious and communicative rather than manipulative and participant.*[1]

In view of the vast number of words in our language, we should be able to express ourselves more effectively. Why don't we? First, we do not develop an adequate vocabulary. Second, we do not develop our ability to use language accurately and understandably. As a result, we fail in day-to-day personal relationships, conferences break down and fail to solve probelms, written reports do not present information accurately, and formal speeches do not get results.

What can we do to improve our use of language? The rhetorician and the general semanticist each has much to offer. The rhetorical approach

[1] Lee Loevinger, "The Ambiguous Mirror: The Reflective-Projective Theory of Broadcasting and Mass Communications," *ETC: A Review of General Semantics*, 26, no. 3 (September 1969), p. 268.

to language relates to the style of speaking and writing. It considers the skills employed in using language effectively so that the communicator avoids errors in composition and presentation. General semantics is a study in how to talk accurately, how to fit words to actual things, how to eliminate language habits which lead to confusion and misunderstanding, or how to talk sense. The late Irving J. Lee of Northwestern University said,

> It [*general semantics*] *has to do with whether or not what a speaker says properly evaluates the situation to which he refers; whether or not what he says is an adequate representation of the actual facts or happenings of which he speaks, . . . with the whole process whereby men in speaking evaluate properly the happenings, objects, feelings, labels, descriptions, and inferences with which they are dealing.*[2]

Dr. S. I. Hayakawa, former president of San Francisco State University, gives an apt illustration to explain the purpose of general semantics in the preface to his book *Language in Thought and Action:*

> *What is the teacher's duty when a child says in class "Taters ain't doin' good this year"? Traditionally, teachers of English and speech have seen their first duty as that of correcting the child's grammar, pronunciation, and diction in order to bring these up to literate standards. The teacher with a semantic orientation will give priority to a different task. He will ask the student such questions as "What potatoes do you mean? Those on your father's farm, or those throughout the country? How do you know? From personal observation? From reports from credible sources?" In short, the teacher of semantics will concern himself, and teach his students to concern themselves, first of all with the truth, the adequacy, and the degree of trustworthiness of statements.*[3]

Consider the following suggestions from the general semanticist:

1. Consider words as symbols

Irving J. Lee said, "We live in two worlds which must not be confused, a world of words, and a world of not-words." [4] The words in our "world

[2] Irving J. Lee, "General Semantics and Public Speaking," *Quarterly Journal of Speech, 26* (December 1940), 597.

[3] S. I. Hayakawa, *Language in Thought and Action* (New York: Harcourt Brace Jovanovich, 1964), pp. vii–viii.

[4] Irving J. Lee, *Language Habits in Human Affairs* (New York: Harper & Row, Publishers, Inc., 1941), p. 16.

of words" are merely symbols by which we may talk about things in our "world of not-words." Words are not the things themselves.

Words have denotative meanings which include all that strictly belong to the definitions of the words. They also have connotative meanings which include all the ideas that are suggested by the words. Thus, the denotative meaning of a university includes "an institution organized for teaching and study . . ."; the connotative meaning may suggest football games, rap sessions, and dances. Words are merely symbols by which we talk about things, regardless of people's interpretations of those symbols. To avoid confusion, we must realize that people do add their own connotations to those symbols.

Confusion arises when we fail to consider that certain words may not have the same meaning to our listeners as they have to us. Our understanding of words is affected by our experiences with the things that they represent. There is nothing in words to differentiate the varying experiences that people have with the things that words represent.

Andrew Weaver, formerly a professor of speech at the University of Wisconsin at Madison, states the matter aptly:

> *Satisfactory communication is more rare than we realize. We naively assume that, since what we say is clear to us, it therefore will be equally clear to others. We fail to comprehend the fact that the speech signs we make have to be filtered through the nervous systems of other persons, on their way to minds made up of experiences different from our own.*[5]

A middle-aged man related how, as a child, he became ill when he slipped into his mother's pantry and ate an entire box of shredded coconut. He reported that 40 years later he still became almost nauseated when he so much as heard the word *coconut*. Yet to most people the word recalls pleasant associations—delicious pies, cakes, and salads.

An army officer related an incident in which several officers' wives from the South were driven to an army post each week for their club meeting by a personable young private from the station motor pool. Since he drove several officers' wives on the same trip, one lady rode in the front seat with him and enjoyed engaging him in conversation. That is, she did until she learned that the driver was part black. Then she refused to ride in the front seat with him any more. She reacted favorably to the young man as a person, but she so reacted to the word which labeled him that her actions were affected.

[5] Goodwin F. Berquest, Jr., ed., *Speeches for Illustration and Example* (Glenview, Ill.: Scott, Foresman, 1965), p. 5. By permission of *Vital Speeches of the Day* (Feb. 1, 1961).

A lady complimented her hostess on the delicious chicken which she had served for dinner. Upon being told that she had not eaten chicken at all, but rather she had eaten frogs' legs, the lady reacted so unfavorably that she became physically ill.

Confusion may arise from nonverbal signs as well as from verbal ones. While in power in Russia, Nikita Khrushchev made an important speech in the United States before a joint session of Congress. At the conclusion of his address, he applauded as vigorously as anyone. Many persons in the television audience thought that his actions indicated arrogance and an egotistical attitude. In fact, a Russian custom calls for the speaker to applaud his listeners as they applaud him as a sign of respect and appreciation for his audience. The misunderstanding from this nonverbal sign arose because of our ignorance of Russian customs, not because of the arrogance of the speaker.

Such misunderstanding may also arise on the verbal level because of failure to know about customs and traditions. The term *to table a motion* means to put it aside in the United States; it means to bring it up in England. An elevator is called a lift in England, a subway an underground, a streetcar a tram, and a pharmacist a chemist.

Our responses to words or terms may vary widely. We usually respond favorably to such words as *love, kiss, beauty,* and *friend;* we respond unfavorably to words like *war, hate, cancer,* and *death.* Several years ago a university drew considerable criticism from its constituents when it instituted a course entitled Sex Education; the criticism almost ceased when it changed the title to Effective Living. A high school offered a course entitled Home Economics for Boys which attracted 10 boys; it changed the title to Bachelor Living and 120 boys enrolled. Labor unions have attempted to substitute the term *job actions* for *strikes* to avoid unfavorable emotional reactions to the latter word. During the 1952 presidential campaign, the opponents of candidate Adlai Stevenson succeeded in labeling him with the term *egghead,* a derogatory substitute for *intellectual.* The field of speech has attempted to avoid the unfavorable association that some people made in linking *speech* with elocution, expression, and oratory by adopting such new terminology as *oral communication, speech communication,* and *communication.* Each of these instances illustrates that we often react to words or terms rather than to the things they represent.

Various social movements and organizations have attempted to avoid unfavorable reactions to words and terms. The word *housewife* has fallen into disrepute as the result of the current emphasis on women's liberation; substitutes such as *homemaker, home manager, household executive,* and *domestic engineer* are sometimes used. During the 1960s, the civil rights movement brought varying unfavorable responses from black

persons to words and terms formerly used in referring to their race. One study listed the terms in this order, from least to most acceptable: nigger, boy, colored, negro, Negro, Afro-American, and black. A business enterprise in California no doubt recognizes the humor of our reaction to words; its sign proclaims, "We buy junk and sell antiques." Second-hand furniture dealers find varying reaction to their products when they are labeled, from most to least favorable, as antiques, second-hand, used, and junk.

In short, confusion arises when we fail to distinguish between things and the words we call those things. Consider words as symbols, as ways of representing things much as maps represent the terrain. The listener must realize that a person may not use terms or nonverbal signs as he understands them. The communicator must recognize that listeners may not receive his ideas as he has them in mind. Both must realize that words are not things, but symbols for representing things.

2. Locate the level of talk

High-level words cause confusion because they may be interpreted in many ways. Low-level words have a more specific meaning because they refer to objects and events. For example, suppose that a person states, "All criminals should be electrocuted." What exactly did he mean by the word *criminal*? A criminal is anyone guilty of a crime, and a crime is any act forbidden by statute or contrary to the public welfare and punishable by law. Crimes may be classified broadly as felony or misdemeanor. Felony refers to the major crimes such as murder, armed robbery, arson, and rape; a misdemeanor refers to less serious crimes. *Felony* and *misdemeanor* are, therefore, more specific words than *crime*. If the communicator meant that all persons guilty of a felony should be electrocuted, he will get agreement more readily than if he meant those guilty of a misdemeanor. The word *murder,* as a type of felony, is more specific than the word *felony;* yet there are types of murder. Some states classify murder as first, second, and third degree. First degree murder consists of premeditated acts with malice aforethought. Second degree murder consists of killings without premeditation, on the spur of the moment. Third degree murder means unintentional killings without malice. The term *first degree murder* is, therefore, a lower-level word than *felony.* Did the communicator mean that all persons who committed first degree murder should be electrocuted?

Misdemeanors also constitute crimes, and traffic violations are misdemeanors. Did the person mean that you should be electrocuted because you ran a red light? In fact, we do not know what he meant. But we do know that if the sender was thinking "first degree murder" and the receiver was thinking "traffic violation" when the sender said, "All

criminals should be electrocuted," the receiver will consider the sender a very stupid fellow.

Suppose a person says, "Religious people are narrow-minded." Did he mean Christians, Mohammedans, Buddhists, or others? If he meant Christians, did he mean Catholics or Protestants? If he meant Protestants, did he mean Baptists, Methodists, Presbyterians, or others? If he meant Baptists, did he mean Southern Baptists, Northern Baptists, or another branch of Baptists? If he meant Southern Baptists, did he mean Orthodox Baptists, Fundamentalists, or hard-shell Baptists? If he meant Orthodox Baptists, did he mean the Baptists in Birmingham, Dallas, Atlanta, or some other place? If he meant the Orthodox Baptists in Birmingham, did he mean John Doe, Peter Poe, Richard Roe, or whom? In fact, John Doe, Peter Poe, and Richard Roe may all be narrow-minded, religious people, but their being so does not necessarily mean that all religious people are.

To be sure, we cannot avoid using high-level terms, but as listeners we can realize that when a person uses high-level terms he may not mean what we think he means. As communicators, we can seek specific rather than general terms; but if we must use general terms, we must realize that listeners may think at one level while we we talk at another. The simple realization of the levels of talk should minimize confusion and misunderstandings occasioned by communication.

3. Locate the time to which you refer

The things we talk about change rapidly; the words we use to talk about changing things remain static. The chair in which you sit is not the same today as it was last year, and it will be much different when you come back to the homecoming celebrations 20 years hence. Things change, but words may not indicate the change.

A middle-aged man related how he returned to his boyhood home after 30 years' absence. He remembered his boyhood home as a large, white castle that sat upon a hill in the suburbs of the city. What he saw 30 years later was a large, dilapidated rooming house in the middle of an industrial district. The house had changed considerably in 30 years; the words *boyhood home* had not changed at all. *Boyhood home* (1945) did not mean the same as *boyhood home* (1975).

Students in a communication class were asked to characterize Clarence Darrow. Their comments included these descriptions: "a famous criminal lawyer," "a champion of the little man," "a liberal," "one who hated capital punishment," "an atheist." The professor then characterized him as "a corporation lawyer of renown," "a champion of large corporations," "a conservative," "one who was little concerned with capital punishment or religious beliefs." Who characterized Darrow correctly, the students

or the professor? In fact, both the students and the professor gave accurate evaluations, but they were thinking of different periods in the life of Darrow. Darrow (1890) was a corporation lawyer who represented the Chicago and Northwestern Railway, and the professor was thinking of that period. The students were thinking of Darrow (1925). The man Darrow changed much in 35 years, but his name did not change.

If a communicator refers to Sigmund Freud's theories of psychoanalysis, you should ask yourself, "Of what period does he speak?" Freud's theories of psychoanalysis changed from his early to his later writings. If a person talks about "principles of speech training," does he refer to the ornate, stylistic principles taught in schools of elocution in 1870 or to the direct, communicative principles taught today?

Professors William Arnold and James McCroskey emphasize that we should figuratively "date" our statements to indicate the differences in time.

> *"Dating" is the term used in general semantics to describe the process of noting changes produced in people or things by time. Writers in general semantics suggest that people frequently ignore the fact that change is basic in human behavior and indeed in all life. Thus subsequent evaluations of people and one's environment represent static rather than dynamic perception. The formulation known as dating states that if our evaluations and our statements about our environment are to be accurate, they must take into consideration the fact that both man and his environment are changing from moment to moment. For example, Richard Nixon (1969) is not exactly the same person as Richard Nixon (1962). Nor is the Vietnam War (1969) exactly the same as the Vietnam War (1962).*
>
> *Dating behavior, then, would force the individual to take cognizance of the factor of change, to evaluate his environment, and to make verbal utterances which fit the life facts as they exist at the moment.*[6]

When we wish to use words which in themselves do not indicate change with time, we must be careful to use other words that will refer to the time of which we are speaking. Thereby we help prevent confusion and misunderstanding.

4 Be aware of abstracting

We cannot talk about all aspects of anything. We abstract and use some of the details and omit others. Writers of history must select certain events and omit others. To write a complete history would be impossible.

[6] William E. Arnold and James C. McCroskey, "Perception Distortion and the Extensional Device of Dating," *ETC: A Review of General Semantics, 26,* no. 4 (December 1969), 463–64.

Can two people testify honestly but differently about an automobile accident which they witnessed? Court trials indicate almost daily that people do. You cannot see all the details of an accident. What you see depends upon when you start looking, where you stood when you looked, and what part of the whole commanded your attention. If you saw the cars approach the intersection, you probably witnessed more of the details than if the impact of the crash attracted your attention. You probably saw more of the details if you stood on the street corner where the crash occurred than if you were a half block away. Your testimony will reflect the details you abstracted from the almost infinite number of details that occurred.

Some three hundred organized religious groups exist in the United States, consisting of religions, denominations, and sects. Does any one of these groups include all the details about religious beliefs in its creeds and doctrines? Each uses a number of the total of religious beliefs and omits others.

Lincoln characterized our form of government as being "of the people, by the people, for the people." It is that and more too. A dictionary defines democracy as a "government in which the supreme power is retained by the people and exercised either directly or indirectly through a system of representation." That definition gives us the most pertinent details of democracy, but it does not give us all the many finer details.

Not only do we abstract from the total of what could be said about a subject when we talk, but we must also remember that the listener is also abstracting selectively from the various possible meanings of our words. Although the general meaning and detailed meanings of the term *labor union* are known to both the laborer and the contractor, each, on hearing the term, may abstract those details for consideration which fit in with his viewpoint. In the same way, the overseas veteran may abstract a set of detailed meanings from the word *war* quite different from those selected by the defense-plant worker. What a communicator talks about sets up varying trains of thought in the minds of his listeners. They abstract from the total of what the communicator says or from the total meaning of words according to their interests and experiences.

Some people are more receptive and at the same time more discriminating than others. They have inquiring minds and an interest in ideas. These people are able to grasp total meanings, and they are able to recognize when and why a person has abstracted details.

In brief, both senders and receivers should realize the impossibility of one's saying all that could be said about anything. All communication consists of abstracting some details and omitting others. A consciousness of abstracting minimizes confusion and misunderstanding and thereby aids proper evaluation.

The late Professors Giles Gray and Claude Wise, formerly of Louisiana State University, state:

> *Abstractions are unavoidable in the use of language. . . . What is important is that in our use of words we should be conscious of the fact that they are abstractions. . . . Unless we are especially conscious of how far we have gone in our abstracting . . . our language will be meaningless, even to ourselves.*[7]

J. Samuel Bois, Director of Research and Education, Viewpoint Institute, Los Angeles, says:

> *In objective abstraction we do not see the individual person as simply a member of the metaphysical class "man." We may see him as an aspect, an element, a constitutive part of a larger unit to which he belongs, be this his family, his nation, or humankind itself. We see him as a fellow participant in a unit to which we belong ourselves, and the welfare or the success of the unit to which both of us belong is much more easily seen as an acceptable concern of yours.*[8]

In summary, in choosing language we should first be sure that our words convey our ideas accurately. To help achieve this goal we must consider words as symbols, locate the level at which we talk, consider the time of which we are speaking, and be aware that we are abstracting some details and omitting others.

RHETORICAL APPROACH

Although accurate use of language comes first, the effective use of language also aids communication. You will go far toward getting your ideas accepted by choosing clear, understandable, and vivid language. Choose language to communicate clearly and precisely, not to display your vocabulary. Like other phases of rhetorical principles, language is for communication, not exhibition.

Oral style is more informal, repetitious, and direct than written style. A writer has time to edit his manuscript, to choose among many words

[7] Giles Wilkeson Gray and Claude Merton Wise, *The Bases of Speech*, 3rd ed. (New York: Harper & Row, Publishers, 1959), p. 507.

[8] J. Samuel Bois, "The Semantic Process of Objective Abstracting," *ETC: A Review of General Semantics, 26,* no. 4 (December 1969), 395.

and phrases. A reader may turn back the pages and reread ideas not immediately clear. Not so with the speaker and listener; the extemporaneous speaker chooses his language as he speaks; the listener either comprehends instantaneously or loses the speaker's idea.

What characterizes effective oral style? Language should be clear, appropriate, vivid, and free from affectations.

1. Oral language should be clear

Above all, language should be clear and unambiguous. An adequate command of language enables a communicator to choose from the many ways of expressing an idea one way which expresses his thoughts with greatest precision. Consider the following factors for achieving clarity:

1. Use specific language. Specific terms convey meaning with greater clarity than do general terms. They aid the communicator in saying precisely what he means and thus in decreasing misunderstanding. Consider the word *communications* in the sentence "I am taking a course in communications." The term *oral communication* is more specific than *communications* because it distinguishes oral from all other methods of communication. Oral communication includes several divisions of study such as public address, interpretation, radio and television, speech correction, and acting. Public address encompasses many courses such as rhetoric, public speaking, discussion, debate, and persuasion. Rhetoric may be divided as classical, medieval, and contemporary. Specificity is achieved, therefore, in inverse order as discussed above: (1) classical rhetoric, (2) rhetoric, (3) public address, (4) oral communication, and (5) communications.

The *chemistry building* is more specific than the *classroom building,* but the *classroom building* is more specific than the *campus building.* *Dog* is more specific than *mammal,* but *mammal* is more specific than *animal. Debate* is more specific than *forensics,* but *forensics* is more specific than *extracurricular activities. Los Angeles* is more specific than *California,* but *California* is more specific than *the West Coast. He stole my watch* is more specific than *he robbed me,* but *he robbed me* is more specific than *he is a thief.* Abstract terms may be useful for expressing general principles, but specific terms help achieve clarity and avoid misunderstanding.

2. Use simple words. If you accept the principle that speech is for communication, not exhibition, you will understand the value of using language understandable to your listeners. Children first learn simple words to express their wants. Through long association, these words remain more meaningful than those learned later in life. Some com-

municators seem to think that big words indicate a mastery of language and profound ideas. Actually, knowledge of a limited number of big words indicates less mastery of language than a thorough knowledge of simple words.

Big words increase the chances of misunderstanding, the failure to communicate properly. [Adapt your choice of words to your listeners, but do not use big words simply to impress under any circumstances.] Consider the following list of simple words in relation to their more complex counterparts:

Complex words	Simple words
imbibe	drink
consume	eat
individuals	persons
domicile	home
inaugurate	begin
expedite	hasten
edifice	building
purchase	buy
endeavor	try
antagonist	foe

3. Avoid technical terminology. Specialists often use terms which lay persons do not understand. The specialist becomes so accustomed to using the special vocabulary of his profession that he forgets that his terminology has little meaning to others. The more highly specialized a person becomes, the greater the risk he runs of using technical terms without adequate explanation. An experienced professor of economics used the following terms without explaining them in addressing a lay audience: *technocrats, blue-sky laws, marginal industries, protected industries, parity prices, union shop, closed shop,* and *economic equilibrium.* Students in an introductory communication course, who composed part of the audience, were later asked to explain the terms. Only 40 percent of the students understood more than half the terms.

The dean of a university addressed the freshman class at its orientation program. At a later session, a freshman counselor found that some of his students did not understand the following terms used by the dean in his address: *honor credits, humanities, liberal arts, median score, exceptional child, overlaid function, honors program, positive correlation, statistical certainty, academic freedom,* and *scientific attitude.* Academic terms understood by college professors may not be understood by college freshmen.

Almost all professional groups have specialized vocabularies. How

many of the following terms, common to specialized professions, do you understand: law—*fee simple, hearsay rule, writ of mandamus, malice aforethought,* and *common law;* ministry—*Holy Ghost, apocalyptic order, millennial, redemption, cataclysmic creed, transfiguration,* and *exorcism;* medicine—*encephalitis lethargica, protozoa, hydrotherapy, psychoneuroses, dementia praecox,* and *agraphia.* In speaking about your field of specialization to a group outside your field, put technical terms in simple language so that your listeners can understand.

4. Strive for economy of expression. Let one word do the work of two, a phrase the work of a clause, and a sentence the work of two or more sentences. Wordiness may decrease clarity by making the thought vague, by injecting irrelevant ideas, and by prolonging the development of a point.

To illustrate, compare the following first draft of a paragraph in a manuscript with the revised paragraph that follows.

The logical development of an idea depends primarily on evidence and reasoning. Evidence may be considered as the material or facts one uses to support his ideas; and reasoning, the process of drawing conclusions or inferences from the facts. Examples of illogical development consist of such devices as quoting one or two unqualified authorities, presenting isolated or unrepresentative examples, quoting statistics covering a limited phase of the subject, and drawing sweeping conclusions from meager evidence. The same may be said for making inferences from negative instances and drawing conclusions from comparisons when the things compared are not comparable. A good communicator will attempt to avoid such fallacies in reasoning as he attempts to make his basic appeal upon rational grounds.

The above paragraph consists of five sentences of 120 words. The revision that follows reduces the paragraph to four sentences of 79 words, a reduction of over 30 percent.

Logic depends primarily on evidence and reasoning. Evidence consists of the facts used to support ideas, and reasoning of the process of drawing inferences from the facts. Examples of illogical reasoning consist of such devices as quoting unqualified authorities, presenting unrepresentative examples, citing limited statistics, drawing sweeping conclusions from meager evidence, making inferences from negative instances, and drawing conclusions by comparing objects not comparable. A good communicator avoids fallacies and makes his basic appeal to logic.

In each instance one or several words were substituted for phrases or clauses. For example, in the second sentence, the adjective *limited* does

the work of the phrase *covering a limited phase of the subject.* By combining the second and third sentences, the introductory phrase for the third sentence, *the same may be said for,* becomes unnecessary. Superfluous modifiers and unnecessary repetitions were deleted; for example, why use two adjectives, *isolated* or *unrepresentative* examples, when one gives the same meaning? Since the nouns *conclusions* or *inferences* are similar, use only one. The term *one or two* in the third sentence slows the reader and adds nothing to the meaning of the sentence. In brief, 41 words shorter, the paragraph seems smoother and expresses the meaning better than the original paragraph.

Wordiness is more easily detected and corrected in writing than in speaking because the writer can edit his manuscript. Skill in editing written messages will, however, eventually improve your language for extemporaneous communication. To correct verbosity, write and edit several messages, record and play back some speeches for self-analysis, and transcribe some recorded messages for editing. The carry-over in language improvement from written to oral communication will soon be apparent if you use these suggestions.

5. *Use repetition and restatement.* Although wordiness should be avoided, oral style must be more repetitious than written style. The writer indicates divisions of ideas by titles and subtitles; he writes in paragraphs and sections. The speaker must state his point, develop it, summarize it, and make a proper transition to the next point. He uses questions to point up an idea. He illustrates his points in many ways—through examples, comparisons, statistics, explanations, and narratives. Since spoken language must be instantly intelligible to listeners, a communicator must restate ideas in many ways to insure understanding.

Note how Franklin D. Roosevelt used repetition effectively in his message to Congress on January 4, 1939:

> *Dictatorship, however, involves costs which the American people will never pay: The cost of our spiritual values. The cost of the blessed right of being able to say what we please. The cost of freedom of religion. The cost of seeing our capital confiscated. . . . If the avoidance of these costs means taxes on my income; if avoiding these costs means taxes on my estate at death, I would bear those taxes willingly as the price of my breathing and my children breathing the free air of a free country, as the price of a living and not a dead world.*[9]

[9] Lew Sarett and William T. Foster, *Modern Speeches on Basic Issues* (Boston: Houghton Mifflin Co., 1939), p. 126. Reprinted by permission of the estate of Franklin D. Roosevelt.

In summary, clarity is achieved in oral communication in part by using specific terms, by using simple words, by avoiding technical terminology, by avoiding wordiness, and by judicious use of repetition.

2. Oral language should be appropriate

To be appropriate, language must be adapted to the personality of the communicator, to the type of message, to the listeners, and to the occasion. An enthusiastic person naturally uses more colorful and lively language than a reserved person. The language for a speech at a homecoming gathering would be more forceful than for a study club. The language for a speech on a formal occasion shows more restraint than one for a social occasion. Despite these variations, certain principles apply to all occasions.

1. Avoid triteness. Acceptable language becomes trite by overuse. Modifiers such as *lovely, adorable, very, most, tremendous, exceedingly,* and *gorgeous* fall into this category.

Many expressions which once were apt, original, and colorful have lost their freshness through repetition. Thus, they have become dull, unimaginative, and commonplace. Speakers use them automatically to relieve the necessity for thinking.

Terms which have become trite and hackneyed are called clichés. Some shopworn phrases pass into this classification each year depending on the frequency of their use in certain occupations, geographical locations, and age groups. The following typical list is by no means exhaustive: *right on, too funny for words, have a good day, last but not least, conspicuous by its absence, at a loss for words, it stands to reason, it goes without saying, it gives me great pleasure, you can say that again, no sooner said than done, method in his madness, they gave their all, with singleness of purpose, sturdy as an oak, dead as a doornail, straight as an arrow, sleeping like a log,* and *hard as a rock.*

2. Use slang judiciously. Slang consists of words or terms of a colloquial type that have not been accepted as cultivated speech by educated people. Distinctions in types of slang are noted by Bergen Evans and Cornelia Evans as follows:

> *In slang the creative forces that shape language are often exceedingly active and much slang is vivid and clever and forceful. Much more of it, however, is merely faddish and infantile and its consistent use does not display the fullness of expression that the user thinks it does but rather a triteness and a staleness that the user is apparently unaware of. Slang ages quickly and nothing so*

stamps a total lack of force or originality upon a man or woman as the steady use of outmoded slang.[10]

We cannot rule out slang entirely because some of it arises from a need for more expressive terms than already exist. It enriches language and aids in conveying meaning. When slang words become generally accepted, they are incorporated in the dictionaries. For example, such words as the following are in common usage today but were formerly considered slang: *jailbird, tightwad, bootleg, racketeer, push-over, crack down,* and *O.K.* Other terms which arose in recent years may well be considered low-grade slang of temporary usage, such as: a *blow-off course* for an easy course; a *mover* for a forward male; *ticked off* for angry; *turned off* for fails to appeal to; *right on* for I agree or that's good; a *fag* for an effeminate male; *zero* for an unsuccessful date; *fox* for a sexy-looking girl; a *turkey* for a dumb person; a *fuzz* or *pig* for a policeman; *to streak* for to run nude in public; *blow it off* for forget it; *out to lunch* for not knowing what's going on.

Although the judicious use of slang adds color and force to language, its overuse indicates a limited vocabulary and careless thinking. Avoid low-grade or temporary slang altogether, and avoid all types on formal occasions.

3. Use foreign phrases sparingly. Foreign words and phrases should seldom be used when an English equivalent exists, especially when addressing lay listeners. They may be understood by specialists in a particular field but not by the general public. For example, the use of the following terms by a lawyer would have little meaning outside his profession: *caveat emptor*—Latin for "let the buyer beware"; *habeas corpus*—Latin for "bring the body before the court"; *compos mentis*—Latin for "of sound mind"; and *de jure*—Latin for "according to law." The same would be true for the minister if he used the following foreign terms: *ecce homo*—Latin for "behold the man"; *grace à Dieu*—French for "thanks to God"; *Jesus Nazaremus*—Latin for "Jesus of Nazareth." Many listeners would not only fail to understand the terms, but they would probably consider the communicator an exhibitionist.

Some foreign words and phrases have been used so extensively that they will be understood by most educated people; for example, *chef*—head cook; *cum laude* and *magna cum laude*—graduation with praise and with great praise; *de facto*—in fact; *de luxe*—of special elegance; *en route*—one one's way; *laissez faire*—noninterference with trade; *nouveau*

[10] From *A Dictionary of Contemporary American Usage,* by Bergen Evans and Cornelia Evans. Copyright © 1957 by Bergen Evans and Cornelia Evans. Reprinted by permission of Random House, Inc.

riche—one newly rich; *per se*—of itself; and *prima facie*—at first view. The safest course for most communicators is to avoid use of foreign phrases. Concentrate on the use of acceptable English words.

4. Avoid vulgarisms and off-color words. Vulgarisms consist of words and phrases used in colloquial speech by uneducated and uncouth people; for example, *where at, ain't, hadn't ought, that there, could of, afeared,* and *can't hardly.* Vulgarisms should be distinguished from faulty grammar, although they may sometimes include improper grammatical construction. For example, in the sentence "Them words hadn't ought to be teach because they ain't nice," *them* and *teach* violate standard grammar; *hadn't ought* and *ain't* are vulgarisms. The adjective *those* should replace the pronoun *them,* and the past participle *taught* should be used for the transitive verb *teach. Should not* should replace *hadn't ought, are not* should be substituted for *ain't,* and *appropriate* should be used for *nice.* As corrected, the sentence reads, "Those words should not be taught because they are not appropriate."

When a communicator uses vulgarisms, his listeners consider that he is either uncouth or he underestimates their intelligence. Listeners like to consider speakers as intelligent leaders, and they resent being talked down to. Avoid the use of vulgarisms on all occasions.

Although off-color words, obscenity, and profanity seem to be more acceptable now than formerly, especially among young people and protest groups, many listeners still resent their use. Some protest speakers say the shock value of vulgar language helps command people's attention, but its use also causes resentment among others. Perhaps the profanity found in many modern novels and plays is partly responsible for increased acceptance. But we should consider that many people tolerate or even enjoy obscenity in literature because reading is private, but they resent its use by persons in oral-communication situations because speaking is public. Listeners often consider persons who use off-color language of low character and poor judgment, and will not be receptive to their messages.

5. Avoid name-calling. Name-calling means giving bad names to things we do not like or good names to things we like. If the name-caller does not like a person's political beliefs, he calls him a *Communist,* a *Red,* or an *extremist.* If he wishes to cast aspersions at his superior intellect, he calls him an *egghead,* a *brain-truster,* or a *brain.* If he dislikes a co-worker he calls him a *rabble-rouser,* a *troublemaker,* or a *goldbrick.* If he resents his employer he may call him a *dictator,* a *demagogue,* or a *dirty capitalist.*

Although name-calling usually attaches unfavorable labels, it may be used positively. Thus we label the proposal for labor reform as the

American way, and its proponent as a *defender of freedom,* or *protector of democracy.* We say that particular proposals uphold *states' rights, free enterprise,* or *separation of church and state.* The name-caller relates his proposal to principles revered by his listeners and thus evokes an immediate desirable emotional response.

The techniques of name-calling encourage uncritical acceptance and permit easy repetition through short, slogan-like phrases. The detrimental effect of name-calling is that it short-circuits the reasoning processes, makes for oversimplification of complex matters, and discourages the critical evaluation of facts. That name-calling succeeds in getting immediate results cannot be denied; that extensive use of name-calling perverts intellectual honesty seems equally obvious.

6. Avoid euphemisms. Euphemisms are the substitution of mild or indirect words or expressions for those which might offend or suggest something unpleasant. For example, for *died* one might use such euphemisms as "passed away," "gone to the great beyond," or "passed on to his reward"; for *leg* he may substitute "limb"; for *eat,* "partake of the evening meal"; for lie, "prevaricate" or "falsify"; for steal, "appropriate" or "filch." The propagandist and the advertiser often use euphemisms to avoid unpleasant associations. Although a communicator should avoid offending sensitive listeners, the excessive use of euphemisms irritates thinking people.

In summary, appropriate language is adapted to the communicator, the message, the listeners, and the occasion. Although language usage varies with the communication situation, for all occasions avoid (1) triteness, (2) excessive slang, (3) foreign phrases, (4) vulgarisms and off-color expressions, (5) name-calling, and (6) euphemisms. The appropriate choice of language increases listeners' respect for the communicator and what he has to say.

3. Oral language should be interesting

Language may possess clarity and appropriateness and yet not command attention or hold interest. To attain maximum usefulness, language must be vivid, graphic, and impressive. It must make use of imagery and must appeal to basic desires so that listeners will want to listen. Oral communication usually aims at specific listeners, not general readers. Language should, therefore, be adapted to the interests and desires of the immediate listeners. Reread chapter 3 for a review of the elements of interest to which you should appeal. In addition, consider the following suggestions for making language interesting.

1. Speak directly and personally. Try for a direct, conversational, communicative style. Make your language say that the message is in-

tended for your immediate listeners, that it could apply to no other group. Use language that causes your listeners to recall their experiences, that relates to their interests, and that appeals to their wants. Consider the following opening paragraphs for a speech on traffic safety:

> *It is well that the people throughout our great nation be informed on the problem of traffic safety in America. It is reported that a family of five was killed last night in one of our neighboring states by a drunken driver who disregarded traffic regulations. This incident should serve as an example to call the problem of traffic safety to our attention. Think with me for a few minutes on the seriousness of the problem.*

This wordy, unimaginative, indirect introduction could apply to any audience; neither the language nor the material has direct or personal application to the immediate listeners. Compare it with the following introduction:

> *At nine o'clock last night a tragic accident befell our fellow citizen, Dr. M. D. Roe. While driving across Broadway at Fifth Street, Dr. Roe, his wife, and their three children were killed instantly by a drunk driver who disregarded all traffic signals. What can we do to prevent such needless tragedy?*

Oral language is more direct than written language. It uses personal pronouns like *I, me, we, you, they,* and *ours.* Instead of saying, "Each person must do his part to alleviate traffic accidents; it is a personal problem," say "We must do our part to prevent traffic accidents; the problem is ours." Oral language uses short, idiomatic words like *think* instead of "contemplate," *eat* instead of "consume," and *me* instead of "myself." Instead of saying, "In order to help the solution of the traffic problem, each person must give his support to the law-enforcement officers," say, "To help solve the traffic problem, support your enforcement officers." Oral language employs contractions like *won't* instead of "will not," *isn't* instead of "is not," and *don't* instead of "do not." Instead of saying, "Will not you help us encourage traffic safety by driving safely?" say, "Won't you help encourage traffic safety by driving safely?"

The rhetorical question makes oral language more direct and personal than written language. It motivates an audience to think about the question. For example, instead of saying, "We must consider the seriousness of traffic violations; we must work to solve the problem," say, "How extensive are traffic violations? How can we solve the problem?"

2. Use colorful words. Simplicity of language does not mean dull and colorless language. The language of oral communication should

indicate attitudes and opinions as well as meaning. Oral communication uses loaded words judiciously, words that call up emotional associations and indicate attitudes. For example, consider the following colorless sentence, "The man walked down the street." How can we indicate attitudes and feelings about *man?* Try substituting some of the following words for man: *dictator, miser, savage, dandy, robber, baron, father, dad, sportsman, cheapskate, piker,* or *chiseler.* The verb *walked* is also colorless and indicates little. Consider substituting some of the following words: *strutted, ran, shuffled, danced, sped, staggered, swaggered, tiptoed, wandered, slunk, toddled,* and *skipped.* The word *street* is also colorless; words with more meaning are these: *thoroughfare, alley, road, highway, lane, footpath, boulevard, avenue,* and *pike.* Thus, "The piker slunk down the alley" has quite a different connotative meaning from "The man walked down the street." Beware of using loaded words as substitutes for facts or for name-calling; use them to make your language colorful and forceful.

Onomatopoetic words lend color to language; they indicate attitudes and feelings by their sounds. They may enhance meaning by creating a mood or by suggesting an idea. Bergen and Cornelia Evans explain this type of words as follows:

> *Onomatopoeia is the technical name for the formation of a name or a word by imitating some sound associated with the thing designated.* Cuckoo *and* whippoorwill *are probably examples.* Bang, fizz, burp, rattle, smack, flop, sneeze *are others.*[11]

3. Use figurative language. Figures of speech use words out of their literal sense to suggest an image or a comparison. They add color and interest to language. Their effective use depends upon originality, vividness, and relevancy to the implied thought. Unlike forms of support such as examples, statistics, analogies, and testimony, figures of speech do not prove or explain an idea; they describe emotions in terms of concrete objects. Winston Churchill's "blood, sweat, and tears" is more colorful and interesting than "life, labor, and sorrow." William Jennings Bryan's "You shall not crucify mankind upon a cross of gold" is more forceful than "You should not force labor to accept the gold standard." Franklin Roosevelt's "We have nothing to fear but fear itself" is more forceful than "Our economic concern has no real foundation." Figurative language stays in the listener's memory; it relates new concepts to familiar beliefs.

[11] Bergen Evans and Cornelia Evans, *A Dictionary of Contemporary American Usage,* p. 388. Reprinted by permission of Random House, Inc.

Of the numerous forms of figurative language, simile, metaphor, antithesis, and personification are used most frequently in oral communication. The simile makes direct comparisons between one thing or idea with those of a different kind, usually by use of *as* or *like*. "He is as cross as a bear," "Her smile is like the flowers of Spring," and "My love is like a red, red rose," illustrate the simile. The metaphor resembles the simile except that the comparison is implied; it drops the connecting word. One thing resembles another; we indicate the resemblance by attributing to one an action which belongs to another. "He is a sly fox," "Window of my soul," "The hounds of Spring are on Winter's traces," illustrate the metaphor. Antithesis sets contrasting phrases opposite each other for emphasis. The contrasting statements are parallel and balance, as: "Governments do not determine man's ideologies; man's ideologies determine his government." "When discussion ends, debate begins." "The idealist has ideas; the realist puts ideas to work." Personification attributes to inanimate things the attributes of living things; objects without life are spoken of as if they were living. The following illustrate: Carl Sandburg speaks of Chicago as the "City of the Big Shoulders"; Eugene Field stated, "The old moon laughed and sang a song"; William Jennings Bryan insisted, "Avarice paints Destiny with a dollar mark."

Although figures of speech add color and interest to oral communication, they should not be far-fetched or contrived. They should suggest associations and comparisons without calling attention to the method used. They should not be used as a substitute for facts or reasons; rather they should be used to embellish them. They should conform to the tone of the content of the message; an informal message calls for simple figures of speech. Although the content of messages comes first, figures of speech aid in making the content interesting and colorful.

4. Use action words. Make your language move by using active words. Do not say, "He was watching when the airplanes collided in the air"; say "He looked on with horror as the planes crashed in midair." Do not say, "The speed of the automobile was 90 miles per hour as it went down the street"; say, "The automobile raced down the street at 90 miles per hour." Instead of "The engine operates well," say, "The engine runs smoothly"; instead of "It is well to analyze the use of language," say, "Analyze your language"; instead of "It is believed that we should all vote," say "We should all vote."

What principles govern active language? First, consider verbs. Use the active voice with verbs that represent their subjects as doing or being something. For example, say, "I believe the theory." The passive voice represents its subject as acted upon; for example, "The theory is believed." For oral communication, "My opponent refuted the argument

with logic" is better than "My argument was refuted with logic by my opponent"; "John won the election" shows better action than "The election was won by John."

Beware also of using noun substitutes for verbs; instead of "It is my belief that the theory is sound," say, "I believe that the theory is sound." Instead of "High wages are a cause of inflation," say, "High wages cause inflation."

To keep your language moving, cut the use of adjectives and adverbs to a minimum. Use definitive adjectives like *"All* men are created equal," *"High* wages cause inflation," and *"Fallacious* reasoning should be avoided"; choose also qualifying adverbs like "Come *early,*" "Step *lively,*" and "Speak *louder."* Avoid modifiers like "The argument is *so very* logical," "The play was *most* unique," "Where did you get that *exquisitely adorable* hat?" "He shouted for help" shows more action than "He called loudly for assistance."

Make liberal use of dialog. Dialog arouses interest by appealing to the familiar and holds attention by putting people into motion. In a sense, effective communicators simulate the give-and-take spirit of dialog by asking questions, issuing challenges, and making accusations. They seek to make their listeners respond—to think, to answer, to argue.

Note how the late W. J. Cameron of the Ford Motor Company shows action largely through dialog in his speech entitled "Too Soon to Quit."

> *Young persons sometimes ask Mr. Ford, "How can I make my life a success?"—as if anyone could answer that question half as well as the one who asks it. But occasionally Mr. Ford does give a valuable tip . . . : "If you start a thing, finish it. . . ."*
>
> *"Yes," one says, "but the thing may not be worth finishing." Of course, when he says, "Finish it," Mr. Ford isn't thinking about the thing at all, he is thinking about you—you, Miss Maiden, and you, Sir Youth. In the preparatory time of life the real job is not what you are working on, but what it is doing to you. You start it with a great gush of interest—you miss your meals for it—then suddenly it goes stale—and you quit. Or you find that your plan is wrong—and you quit. And all that you have as profit from your effort is the knowledge of how to quit! "Well," you say, "the thing wasn't worth it." Quite probably, but you are, and that's the whole point.[12]*

Note how Sargent Shriver, director of the Office of Economic Opportunity and the Peace Corps at the time he gave this speech, created a sense of dialog with his listeners in a speech before the Chicago Anti-Poverty Conference:

[12] Sarett and Foster, *Modern Speeches on Basic Issues,* pp. 41–42. Reprinted by permission of the Ford Motor Company, Dearborn, Michigan.

In community after community the poor are speaking out and the rest of us are learning.

This idea, this approach has been challenged. Many well-meaning people say: "Why ask the poor how to conquer poverty? If they knew they wouldn't be poor. It's all right for them to have jobs in the program—but they shouldn't design the campaign."

To which we reply:

When a man goes to a doctor, the first thing the doctor usually does is ask: "What's wrong? How do you feel? Where does it hurt?"

He lets the patient talk. Only after the talk and the examination does the doctor make his diagnosis. And in making that diagnosis, he knows he has to take account of what the patient has told him.

That's what we are asking the poor. "Where does it hurt?" And then later on we will have to ask and keep asking them, "Is the medicine helping, is the pain going away?" We have to ask those questions—and keep asking them. That's what involvement of the poor is all about.[13]

In summary, to make oral language interesting (1) speak directly and personally to your listeners in a conversational, communicative style; (2) use colorful words that indicate attitudes and feelings as well as meaning; (3) use figurative language that implies comparisons; and (4) use language of action and force.

IMPROVING ORAL STYLE

Understanding the principles of the general semantic and rhetorical approaches to language is the essential first step toward improving oral style. Acquiring rhetorical skills will also help in vocabulary-building and language usage.

Understanding language

Understanding is the principal method for securing proper evaluation, because few skills are involved. Rather, accurate evaluation results from proper attitudes—delaying and questioning attitudes. Listeners must ask, "Is the speaker saying what he seems to me to be saying?" Speakers must ask, "Is the listener receiving my ideas as I have them in my mind?" Each must ask, "Do we have a 'meeting of minds' or do our communica-

[13] *Congressional Digest*, 45, No. 3 (March 1966), "The Controversy Over the Federal Anti-Poverty Program, Pro & Con": p. 81. For an analysis and full text of this speech, see Glenn R. Capp, *The Great Society: A Sourcebook of Speeches* (Los Angeles, Ca.: Dickenson Publishing Co., 1967), pp. 180–85.

tions bypass each other?" Each must realize that communication goes beyond the mere spoken word—its ultimate effect comes from the total impact of language and nonverbal signs, the responses they evoke.

Rhetorical skills involve more than understanding; they involve doing as well as knowing. How can you improve your use of language by improving rhetorical skills?

Improving vocabulary and language skills

We have four types of vocabularies: reading, writing, hearing, and speaking. Our reading vocabularies are usually the largest because some unfamiliar words have meaning within a context. We understand the meaning, at least partially, of many words that we never use in writing or speaking. Our writing vocabularies are next in size. We use some words in writing that we never use in speaking because pronunciation presents no problem. If we are not sure about the meaning of a word, we can look it up in a dictionary. Some words that we do not use in speaking we understand when we hear. Unfortunately for oral communication, our speaking vocabularies are the smallest. We do not use many words with which we have partial acquaintance because we are unsure either of their exact meaning or of their pronunciation. Our goal in oral communication should be to make these four vocabularies as nearly alike as possible.

How can we improve our vocabularies? Techniques and formulas abound in this field. Some say, "Learn a new word each day," but few will carry through with this suggestion. Others suggest that you look up each new word when you encounter it, but this suggestion often proves impractical. Others suggest, "Look it up; write it down; use it seven times within the day, ad infinitum." It may be difficult, however, to maneuver the conversation so that you can use new words seven times within the day. In fact, most formulas have some validity, but rarely does one carry through with them. Several practical suggestions follow.

1. Vocabulary-building. The principal methods for improving vocabulary follow: (1) read good literature, (2) listen to cultured people, and (3) speak and write. An objective study of words helps; but such a study will never supplant reading, listening, speaking, and writing.

Reading good literature introduces one to new ideas. Since we think by use of words, we must learn new words to comprehend new ideas and to communicate those ideas to others. Exposure to new ideas motivates one to consult a dictionary, to think about words, and to use new words in communicating. Herein lies the advantage reading has over formula methods; you learn and use new words because you have a pur-

pose in doing so. By reading poetry, you acquire new concepts of imagery, of colorful words, of figures of speech, of forceful language. By reading prose you acquire new ideas, new words, and new methods for using them effectively. By reading masterpieces of oratory, you gain ideas on how to use language effectively for oral communication. By reading aloud, you learn new rhythmical patterns as well as the pronunciation and meaning of new words. Reread the parts of chapter 2 on how reading assists one to develop into an effective communicator. Review chapter 7 on how to improve your reading habits. Through reading, introduce yourself to new words. Associate with them, play with them, eat with them, sleep with them, make friends with them.

Associating with and listening to educated people also aids vocabulary-building. Like reading, educated people introduce you to new ideas and to acceptable methods for expressing them. Through exposure, one gradually absorbs some of the language style of those with whom one associates. Cultured people may open up whole new fields of learning with their new terminology. One student commented on the many new words that he learned from the lectures of his professor in biology. From the classroom, from the pulpit, from the courtroom, and from the public platform, cultured people express new ideas with skill and force. Radio and television offer countless opportunities for listening to persons who usually use language effectively. Regardless of our opinion of the low caliber of some programs, radio and television have had a beneficial influence on the language habits of the average citizen.

The adage, "We learn to do by doing," has special application to improving language style. New words become a permanent part of our vocabularies when we learn to put them to use through speaking and writing. Speaking and writing have much in common; excellence in one often leads to improvement in the other. A careful writer attends to each word, phrase, clause, sentence, and paragraph, editing, revising, and rewriting. He chooses, from the many words available to express an idea, the one that expresses it with greatest precision and effect. The laborious task of editing leads to improved methods of writing which gradually make revision and rewriting less necessary. Improved writing skills carry over to extemporaneous communication. The knowledge of new words and skills in expressing ideas lead to improvement in the ready choice of language for oral communication. There is no substitute for speaking and writing for improving oral style.

2. Acquiring skills. An objective study of words aids the primary methods for improving vocabulary. The following suggestions make a sort of game of vocabulary-building and word usage. They stress the ready choice of the most appropriate word for extemporaneous speech.

Find words with similar meanings. Words with similar meanings are called synonyms. Knowledge of synonyms aids the speaker to choose the right word to express shades of thought. Practice in choosing them makes for ready choice during extemporaneous communication. The following illustrate:

> bright: *shining, beaming, radiant, gleaming, luminous, effulgent, refulgent, sparkling, scintillating, glittering, glowing, glaring, dazzling, glistening, shimmering, lustrous, brilliant, splendid, resplendent, quick-witted, clever, smart, intelligent, precocious, animated, vivacious, lively, gay, cheerful, favorable, promising, encouraging, auspicious, propitious*
>
> expert: *proficient, adept, connoisseur, master, authority, specialist* [14]

Find synonyms for the following words and check your list in any standard dictionary:

bad	fury	prove
bare	holy	shout
confuse	innocent	uncouth
elevate	move	young

Find words with opposite meanings. Words with opposite meanings are termed antonyms. Practice in selecting antonyms will improve your immediate choice of words to express precise meaning. The following are antonyms for the words used as examples in the preceding section:

> bright: *dull, lusterless, dim, dark, gloomy*
> expert: *novice, tyro, beginner, amateur, smatterer, bungler* [15]

Find antonyms for the following words:

averse	fame	pardon
beautiful	good	proud
calm	large	rich
dim	misfortune	sad

[14] H. G. Emery and K. G. Brewster, eds., *The New Century Dictionary* (New York: Appleton-Century-Crofts, Inc., 1959), pp. 2267, 2301.

[15] Ibid.

Find words with many meanings. Many words can be used in several ways. In some instances the same word may have antithetical meanings; for example, *strike* means "to miss" in baseball, but it means "to hit" in bowling. Some words have different meanings because they serve as different parts of speech; for example, the conference is *brief* (adjective), but the lawyer files a *brief* (noun) of his case. Practice in thinking of the many ways that a word may be used aids the speaker in word choice and helps prevent misunderstanding. Note the several meanings of the word *spade:*

1. To spade the garden (dig it up)
2. To play the spade (playing card)
3. To use a spade (cutter's tool, shovel, two-edged sword)
4. To call a spade a spade (plain talk)
5. An instrument to check recoil on a gun
6. A measure of space
7. A spade-fish (type of fish)

Find several ways in which the following words may be used:

bite	enter	jog
crown	find	kill
detect	grate	love
drive	hang	pattern

Find colorful words for colorless words. As explained in an earlier section, words may indicate attitudes and feelings as well as meaning. Colorful language helps the speaker command attention and maintain interest. Note the following examples:

ruler: *dictator, monarch, autocrat, despot, tyrant, czar, rajah, sovereign, king, queen, emperor, president, governor, chief, lord*
worker: *artisan, craftsman, handicraftsman, toiler, slave, journeyman, peon, coolie, roustabout*

Find colorful words for the following words:

act	cry	person
animal	event	run
bit	flood	show
capture	mad	top

Find substitutes for trite words. Use fresh words for those usually employed to excess. The following illustrate:

great: *large, big, immense, numerous, countless, important, eminent, renowned, famous, lofty, noble, excellent*
lovely: *attractive, amiable, beautiful, charming, pretty, handsome*

Find substitutes for the following trite words:

adorable	marvelous	really
darling	most	stupid
exceedingly	nice	tremendous
gorgeous	precious	very

3. Using the dictionary. The foregoing methods suggested for vocabulary-building make use of the dictionary. To acquire facility with language, you must acquire the "dictionary habit." Although we add to our vocabularies primarily from reading, writing, listening, and speaking, these methods will be aided greatly if we look up unfamiliar words and study their meanings. When you hear a speaker use an unfamiliar word or when you encounter one in your reading, look the word up in a dictionary as soon as feasible.

Review section two of chapter 8 for an explanation of how to define words and terms. Dictionaries give the derivation of many words; by studying roots, prefixes and suffixes, synonyms and antonyms, and etymologies of words, you should improve your vocabulary rapidly.

Look up the following words in a standard dictionary; consider their different meanings and use each in a sentence.

ambiguous	embellish	prescribe
conjugate	genealogy	propaganda
connotative	linguistic	provincial
culinary	predict	vague

In short, you can improve your use of language by thinking about words, studying them, and experimenting with them. Make frequent use of a dictionary. These suggestions supplement the primary methods of vocabulary-building—reading, listening, speaking, and writing.

SUMMARY

This chapter discusses two approaches to oral style: general semantics—fitting words to actual happenings, and rhetorical—using words correctly.

The general semantics approach considers words as symbols, locates

the level of talk, locates the time to which the communicator refers, and recognizes the principle of abstracting. A consciousness of these principles decreases misunderstanding and confusion.

The rhetorical approach stresses that oral language should be clear, appropriate, and interesting. Clarity is achieved by (1) using specific terms, (2) using simple words, (3) avoiding technical terminology, (4) striving for economy of words, and (5) using repetition and restatement. To assure appropriateness, one should (1) avoid triteness, (2) use slang judiciously, (3) use foreign words sparingly, (4) avoid vulgarisms and off-color words, (5) avoid name-calling, and (6) avoid euphemisms. Make language interesting by (1) being direct and personal, (2) using colorful words, (3) using figurative language, and (4) using active words.

Oral style can be improved by understanding the principles of language and by practicing language skills. We have four vocabularies—reading, writing, listening, and speaking. For oral communication, we should strive to make our speaking and hearing vocabularies approximate the size of our reading and writing vocabularies. The principal methods for vocabulary-building are: read good literature, listen to educated people, and practice speaking and writing. Skills in using language may be improved by studying (1) synonyms, (2) antonyms, (3) varying usage of words, (4) colorful words, and (5) substitutes for trite words. Consult the dictionary frequently for the meaning of words.

QUESTIONS

1. Distinguish between the general semantics and the rhetorical approaches to oral style. Do you consider these approaches complementary or antithetical? Explain.

2. Discuss briefly the four suggestions of the general semanticist for achieving more adequate evaluation discussed in this chapter. Can you add to these suggestions?

3. Discuss briefly several methods for making language clear, appropriate, and interesting.

4. Distinguish among the types of vocabularies. Which type is the largest? Why?

5. Discuss several methods for improving your vocabulary and your language skills. Can you add to the methods discussed in this chapter?

ASSIGNMENT

For your oral assignment choose one man or woman from the list below as the subject of a five-minute biographical speech. Tell about the per-

son's life, about his influence on history, and about his ability as a speaker. If you can find a published speech by the person you select, analyze his language style according to the principles discussed in this chapter.

Socrates	Konrad Adenauer
Mahatma Gandhi	Marshal Tito
Gerald Ford	Jawaharlal Nehru
Franklin Delano Roosevelt	Harry Truman
Albert Schweitzer	Susan B. Anthony
Nelson Rockefeller	Claire Booth Luce
Julius Caesar	Eleanor Roosevelt
Wilbur Mills	Madame Chiang Kai-shek
Abraham Lincoln	Helen Keller
Thomas Jefferson	William Jennings Bryan
Clarence Darrow	Nikita Khrushchev
Sam J. Ervin	James Bryant Conant
Henry W. Grady	Woodrow Wilson
Everett Dirksen	Alfred Korzybski
Booker T. Washington	Josef Stalin
Ralph Waldo Emerson	Adolf Hitler
Samuel Gompers	Winston Churchill
Henry Kissinger	Francisco Franco
Eugene Debs	S. I. Hayakawa
Carrie Chapman Catt	Martin Luther King, Jr.

READINGS

Adler, Ron, and Neil Towne, *Looking Out/Looking In: Interpersonal Communication,* chap. 7. New York: Holt, Rinehart and Winston, 1975.

Blankenship, Jane, *A Sense of Style: An Introduction to Style for the Public Speaker.* Los Angeles, Ca.: Dickenson Publishing Co., 1968.

Bois, J. Samuel, "The Semantic Process of Objective Abstracting," *ETC: A Review of General Semantics, 26,* no. 4 (December 1969), 394–97.

Borchers, Gladys L., "An Approach to the Problem of Oral Style," *The Quarterly Journal of Speech, 22* (February 1936), 114–17.

Brooks, William D., *Speech Communication,* 2nd ed., chap. 3. Dubuque, Ia.: Wm. C. Brown Co., 1974.

Condon, John C., *Semantics and Communication,* 2nd ed. Riverside, N.J.: Macmillan Publishing Co., 1975.

Hayakawa, S. I., *Symbols, Status, and Personality.* New York: Harcourt Brace Jovanovich, 1963.

HYBELS, SAUNDRA, and RICHARD L. WEAVER, II, *Speech/Communication*, chap. 4. New York: D. Van Nostrand Co., 1974.

LEE, IRVING J., *Language Habits in Human Affairs*. New York: Harper & Row, Publishers, 1941.

McCROSKEY, JAMES C., *An Introduction to Rhetorical Communication: The Theory and Practice of Public Speaking*, chap. 9. Englewood Cliffs, N.J.: Prentice-Hall, 1968.

TUBBS, STEWART L., and SYLVIA MOSS, *Human Communication: An Interpersonal Perspective*, chap. 6. New York: Random House, 1974.

THIRTEEN

Verbal communication: voice

We distinguished in chapter 11 between how voice cues affect nonverbal communication and how effective use of voice aids verbal communication. The following actual life incident reemphasizes this distinction.

The victim testified that he recognized the voices of the culprits although he had never seen them. His testimony was the most damaging in the chain of circumstantial evidence that brought conviction. The oil magnate had been kidnapped and held captive for three days by two men and a woman. He had been hit from behind as he dozed in a chair of his study and had been kept blindfolded throughout his captivity. He knew his captives only by the sound of their voices. Yet, his identification of their voices proved damaging to the culprits' defense.

On the nonverbal level, your voice may prove almost as accurate an identifying factor as your handwriting or fingerprints. It gives strong indications of your personality and emotional state.

On the verbal level, a distinct and pleasing voice constitutes an important part of effective presentation. You sometimes hear it said, "What does voice matter so long as you have something to say?" Conversely, one might also ask, "Of what value is having something to say if you cannot be understood?" Voice is not the only element in effective presentation, but it is an integral part of it. Thus a person with a poor voice can make an acceptable contribution in oral communication only if his delivery is otherwise competent. He makes a worthwhile contribution despite his poor voice.

An adequate voice does not insure effective communication, but it helps good communication accomplish its purpose. A poor voice irritates, invites inattention, obscures meaning, and lessens the pleasure of the

286

listener. A good voice commands respect; it helps in holding attention, in securing understanding, and in gaining acceptance of ideas. This chapter aims at helping you understand and improve your voice.

REQUISITES FOR AN ADEQUATE VOICE

An adequate voice is not an end in itself; it is a means to the end of communicating ideas, information, and emotions. If the voice calls attention to itself, it detracts from communication. Properly used, it aids communication. What are the principal characteristics of an adequate voice? Consider the following requisites:

An adequate voice is intelligible

A good voice is understood easily throughout the room or meeting hall. In auditoriums that have public-address systems or excellent acoustics, making one's voice heard presents no serious problem. Other halls such as combination gymnasium-auditoriums may present serious difficulties. Some communicators, accustomed to favorable communication conditions, find difficulty adjusting to less favorable conditions. Since they become accustomed to speaking with little force when using a loud-speaker, they tend to use insufficient force when speaking without one. A rapid rate may be easily understood in a well-constructed auditorium; the same rate may prove unintelligible in a poorly constructed hall. One student described his experience while speaking in a hall with poor acoustics as "my voice came back and hit me in the face." He had to decrease his normal rate and volume to be understood.

To be heard does not necessarily mean to be understood. Distinctness of utterance also counts. You should strive for clarity of diction; do not omit or slur syllables. Good articulation is as important to intelligibility as proper volume.

An adequate voice has pleasing quality

A poor voice may be characterized as raspy, guttural, breathy, thin, harsh, whining, or monotonous. Desirable voice characteristics include flexibility, modulation, and animation, as well as controlled melody, pitch, rate, and force. Why does one speaker have a pleasing voice while another does not? The difference is due partly to training; by putting into practice the principles discussed in this chapter, one should develop a more pleasing voice quality. More important, a warm, pleasant, sympathetic voice is the product of a warm, pleasant, sympathetic person. A

person with a zest for life, with a desire for knowledge, and with attitudes of goodwill normally reveals these attributes in his voice. Pleasant voice quality has close connection with the able man theory discussed in chapter 2.

An adequate voice is free of affectations

When a communication teacher's colleague from another department heard a particular student speak, the colleague remarked, "That young woman sounds just like an oral communication major." Regardless of how the professor meant the statement, it was not complimentary to the communication teacher. The young woman used overly precise diction and other affectations that called attention to her speech and detracted from what she said. Her use of voice represented the antithesis of the goals sought.

A good voice does not call attention to itself. It makes the ideas of a message understandable in a manner pleasing to the ear. Some beginning students and other improperly trained communicators show affectations in voice because they have not perfected voice control. They may be in the "show off" stage when they make a major production of all they do. True art conceals itself; properly used, one's voice aids in accomplishing one's purpose without calling attention to itself. It is free of affectations and passes unnoticed in any cultured group.

An adequate voice is flexible

A speaker with an unusually strong voice delighted in displaying its full force on every occasion. He used the same loud volume when talking in a room seating 50 people as he did in an auditorium seating 5000. He proudly boasted on many occasions that he developed his strong voice calling pigs on his father's farm. What he did not learn was that the ears of most human beings are apparently more sensitive than those of pigs.

Some people speak in a montone throughout their message. Others use the same rate at all times, whether explaining Einstein's theory of relativity or describing a heavyweight fight. Many use little or no variation in pitch regardless of subject matter. Still others acquire a singsong or stereotyped pattern. All these types create monotonous patterns that prove irritating to listeners.

A well-managed voice shows variety in keeping with the content of a message. The communicator varies the volume, rate, pitch, timing, inflection, and pattern of speech to bring out his subtleties of thought and

feelings. He strives for a conversational manner and a flexible voice that aids in communication.

VARIATIONS IN VOICES

What accounts for variations in voices? Some people have better voices without training than others have with training. Some people make more progress in training than others. A few people seem to have pleasing, natural voices. Franklin D. Roosevelt's many attributes as an able man and speaker included a voice with a warmth that helped attract millions. His fireside chats over the radio introduced a new era in which a president discussed policies of his program directly with the people. These speeches did more to allay the fears of some people during the depression of the 1930s than the legislation that he advocated. On the other hand, Abraham Lincoln had a high-pitched, whining voice that repelled listeners. His speeches read better than they sounded. Consequently, he relied less on speech-making than did many other presidents. Why these differences in voice? The variations may be accounted for in part on the four bases that follow.

Variations are partly physical

Some people have better physical equipment for voice production than others. We do not have a voice mechanism separate from other life processes. Voice is produced as a secondary function of several structures whose primary functions are essential life processes. Variations in health and size of these organs from one individual to another account for some vocal variations. The length of the vocal cords accounts in part for vocal variations, as do the size and condition of the resonating chambers of the nose and mouth. A person with a flexible tongue and lips, well-formed palates, and well-aligned teeth has good physical equipment for articulation.

The general state of a person's health also affects voice production. A strong, healthy body gives vitality and force to one's voice. Chronic ill health or fatigue usually causes weak and indistinct voices that project poorly.

A few people have organic difficulties that prevent the production of normal speech. Studies reveal the total to be between 5 and 10 percent in the United States, depending upon the definition of a speech defect. The organic difficulties range from poorly spaced teeth to complete vocal paralysis. Almost all defects can be improved under the guidance

of speech pathologists and doctors. Their analysis and suggested treatment are not within the scope of this text, but those with speech defects should by all means consult a specialist.

Variations are due partly to environment

Speech is learned, not inherited. Although we are born with the physical mechanism for producing sound, the making of sound into speech must be learned. Since a child learns to use his voice largely through imitation, he acquires the voice characteristics of those with whom he associates during his early years. Later, his playmates, teachers, and performers in radio, television, and the movies exert an influence. So powerful is environmental influence that some children acquire slight impediments in speech from early associations.

Since vocal habits are learned and some vocal characteristics acquired, it stands to reason that we can correct some of our faults. The changes do not come easily, however, for poor vocal practices may have been developed over a long period. Persistent efforts will usually result in improvements.

Variations are due partly to personality characteristics

We learned in chapter 2 that chronic feelings of inadequacy affect communication abilities, including the voice. A tense person fails to relax his throat; thus the tension prevents free vibration of the vocal cords. Stage fright usually affects a person's breathing and in turn causes an uneven rhythm and breathiness. A timid person tends to speak either indistinctly in a high-pitched voice or in a blustering manner in an attempt to cover up his feelings of inferiority. Conversely, a relaxed person usually uses breathing, resonance, and articulation in a natural manner because the voice makes coordinated use of the organs of speech production. In one sense, proper voice production may be considered partly as social adjustment.

Your voice indicates your temperament and emotional attitudes. An aggressive, high-strung, hard-working person tends to speak rapidly, forcefully, and emphatically. An easy-going person usually speaks with moderate, normal force, and an even emphasis. An irritable, troubled person often speaks in a high-pitched voice that may approach whining. Since your voice tends to indicate your general temperament, beware of attempting radical changes in a short time. A hard-driving, aggressive person will probably never acquire the slow rate, moderate force, or even rhythm of an easy-going person, but by conscious effort he can bring undesirable voice qualities under control.

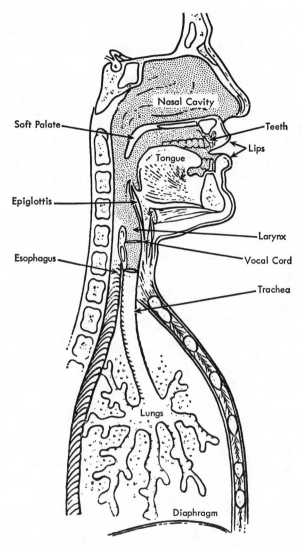

FIGURE 2 The human voice organs *

Variations are due partly to improper use

We sometimes acquire poor habits of voice for reasons not directly at-
tributable to any of the foregoing causes. We acquire poor techniques

* "The Speech Chain" by Peter B. Denes and Eliot N. Pinson. Copyright © Bell
Telephone Laboratories, Inc.

because of a lack of knowledge about proper voice control. The young man with a natural high pitch may force his voice down into his throat in an endeavor to acquire a deep voice. The young lady with a naturally thin voice may force her voice almost to a shout in an attempt to get more force. A person who thinks more rapidly than he speaks may acquire a halting, uneven rhythm. Some persons may attempt to emulate the voices of speakers or performers whom they admire when they have no natural propensities for such use. These types use their voices improperly from lack of knowledge about proper control.

The following sections of this chapter relate to the physical characteristics and methods for improving voice. With an understanding of voice production and methods of improvement and with conscientious practice, any normal person can develop an adequate voice.

THE PROCESS OF VOICE DEVELOPMENT

Voice development consists of (1) controlled breathing—regulating breathing habits for the initiation of sound; (2) phonation—relaxation of the throat and jaws to permit unhampered vibrations of the vocal folds; (3) resonation—taking full advantage of the resonating chambers of the throat, mouth, and nose; (4) articulation—shaping of the jaws, tongue, and lips for forming different speech sounds; and (5) ear training—learning to hear one's voice.

Breathing

Breathing is perhaps the most important factor in tone production. It exemplifies speech as an overlaid function. We do not breathe to speak but to supply our bodies with oxygen and rid them of carbon dioxide. In short, we breathe to live. Speech is a kind of by-product of breathing since we use the outgoing breath to make vocal tones. To use the outgoing breath to the best advantage, we must control our breathing habits. Lower-chest or diaphragmatic breathing serves most people best because it permits easier control, requires less effort, and results in less tension in the throat than does upper-chest breathing.

Breathing for speech requires more air than does breathing for life. Exhalation must, therefore, be controlled. In breathing for life we breathe regularly, rhythmically, and deeply about 15 times a minute. In breathing for speech the rhythm is irregular. We fill our lungs comfortably with air and keep them filled. We use the amount of air necessary to speak a phrase; we inhale quickly through our mouth instead of our nose and take in as much air as we have just used. Through this

process we keep a reserve supply of air in our lungs at all times. This type of breathing gives the speaker a feeling of adequacy. He realizes that he has sufficient reserve breath to make himself heard easily; he therefore feels no need to strain or tighten the muscles of his throat to produce an adequate tone. Excessive muscular tension results in the hoarseness and "tired throat" we so often associate with evangelists and teachers and others who speak often in public.

To motivate proper breathing habits, we should understand the mechanics of breathing. Air is taken into the body because of the expansion of the chest cavity. When the respiratory muscles contract, the diameter of the cavity increases from side to side because of the lifting of the ribs; it increases from top to bottom because of the contraction of the dome-shaped muscle called the diaphragm. The increase in the size of the chest cavity causes a decrease in the pressure within. Air rushes into the nose or mouth and fills the lungs with enough air to equalize the pressure. Upon the completion of inhalation, an elastic recoil of the muscles occurs and the air is squeezed out of the lungs. If the upper rib-cage is held high and allowed to participate little in the breathing process, the work of breathing must be done by the lower ribs and the diaphragm. Since the lungs are passive organs and can be acted upon only by the ribs and diaphragm, it follows that so long as the upper rib-cage is held high there will be a reserve supply of air in the lungs.

The floor of the thoracic cavity is a dome-shaped sheet of muscular fibers called the diaphragm. It separates the thoracic from the abdominal cavity. When the diaphragm contracts to draw breath into the lungs, it pushes down upon the organs of the abdominal cavity, resulting in a slight bulge of the upper abdomen. In exhalation, the diaphragm and the muscles that control the elevation of the ribs relax; the abdominal organs return to their normal position, and the air is forced out of the lungs. An understanding of this process helps the speaker exercise conscious control over the breathing mechanism.

The abdominal muscles are used in the controlled exhalation necessary for proper use of the voice. They press upon the viscera which in turn press upon the diaphragm. In this manner the abdominal muscles regulate the pressure and distribute the portions of air necessary to support tone production. Thus, they help control the rate at which the air leaves the lungs.

Proper breathing habits must be developed outside the communication situation. If the communicator concentrates upon the control of breathing rather than upon what he says, he will not communicate properly. His listeners will be conscious of his mechanics of delivery and will not concentrate upon what he says. Ideally, proper breathing habits should become so thoroughly learned that the communicator will use them at

all times, even in conversation, without being conscious of how he breathes.

Drills and exercises will help one acquire proper breathing habits. Practice the following:

1. Good posture is conducive to proper breathing. The following exercises, if practiced several times a day, will improve posture.

Stand with the heels, buttocks, and shoulders pressed against a wall. Press the middle of the back firmly against the wall until the spinal column is straight. With the upper part of the body relaxed, try to walk away from the wall, keeping the back straight.

Stand relaxed with the eyes closed. Take a fold of the skin at the base of the throat between the fingers and lift straight up. Keep the shoulders relaxed. Pull the body up tall. Keep the heels on the floor but imagine the whole body as being lifted. Lift the chest up from the waist. Feel a stretch between the lower ribs and the hip bones.

2. Place the hand flat on the upper abdomen. Pant quickly like a tired dog. Feel the alternate bulging and relaxation of the abdomen as the diaphragm pushes down to draw in air and relaxes to release it. Do this several times. Now pant slowly. Push hard with the hand and with the abdominal muscles on exhalation. Feel the thrust of the muscles as air is expelled from the lungs.

3. With the shoulders relaxed, place the heels of the hands flat on the lower ribs with the fingers touching over the abdomen. Inhale, pushing out against the hands with the lower ribs and abdomen. Make the fingers separate as far as possible. Exhale slowly through the mouth, prolonging the breath as long as possible. Push all of the air out of the lungs by tightening the abdominal muscles. Do this several times, working for greater expansion under the hands each time.

4. In the same position as in the above exercise, inhale until the lungs are comfortably full of air. As you exhale push with the hands and abdominal muscles but do not allow the upper chest to move. Keep the upper rib-cage high. Exhale only that air which can be controlled by the diaphragm. Inhale a short breath. Exhale as you keep the upper ribs from participating noticeably in the breathing process. Work at this exercise each day until you feel that all breathing activity takes place in the center of the body.

5. Start with the same position as for the two previous exercises. Inhale on the mental count of three. Push out against the hands. Hold the breath as you count three silently. Inhale again on the count of three and again hold your breath while you count three. Inhale again, taking in enough air to fill the lungs. Hold the breath while you count ten. Attempt to remain relaxed. To aid relaxation, roll the head around on

the shoulders as you hold your breath. Let the breath go slowly, exhaling the air through rounded lips and prolonging the exhalation as long as possible. Again push out all the air by contracting the stomach muscles. If the exercise is done properly, the upper abdomen will bulge a little on the first inhalation, a little more on the second, and still more on the third. It will remain without motion when the breath is held.

6. This exercise is the reverse of the last one. Start with the same position. Inhale until the lungs are comfortably full. Exhale as you count three, pushing against the abdomen with the fingers. Hold the breath as you count three. Do not cut off the breath at the glottis. Stop exhaling by stopping the action of the breathing muscles. Now exhale again on three, hold the breath on three, and finally push all the air out of the lungs by pressing the contents of the abdomen against the diaphragm. The upper rib-cage should be held high, the throat and shoulders relaxed.

7. This exercise correlates breathing and tone production. Fill the lungs comfortably with air. Hold the upper ribs high. Do not allow them to move any more than necessary. Push the air out with the abdominal muscles as you need it. Keep the throat and shoulders relaxed. Breathe quickly through the mouth, taking in as much air as was used to form the preceding phrase. Count aloud—one, two, three, breathe; one, two, three, breathe; one, two, three, breathe. This time count to five before you take a breath. Now drop back to a count of two. Be sure that the ribs remain high.

8. Using the same technique as in exercise 7, read the following passage; take a quick breath through the mouth at the places marked with a diagonal line.

> *This is the man all tattered and torn/ who kissed the maiden all forlorn/ who milked the cow with the crumpled horn/ that tossed the dog/ that worried the cat/ that killed the rat/ that ate the malt/ that lay in the house that Jack built.*

Phonation

The second step in tone production is the initiation of tone by the vibration of the vocal folds in the larynx. Air pushed up from the lungs passes through the bronchi, through the trachea, and finally to the larynx or voice box. The larynx is a shield-shaped box of cartilages situated at the top of the trachea. Stretched across the larynx are two tendinous folds or bands. These are not cords or muscular strings as some people believe, but folds or ledges of tough fibrous muscle.

Phonation aims at a free, open, relaxed throat which offers no impediment to the easy vibration of the vocal folds. A communicator can do little to bring this state about except consciously to relax the muscles of the neck, throat, and shoulders. The muscles that control the tensions of the folds operate automatically; they cannot be knowingly controlled. Any adjustments made in the larynx that improve vocal tone come through trial and error. The communicator must attempt to recognize a desirable tone and endeavor to reproduce the conditions which produced it, although he may not understand fully how he brought the condition about. He must rely on his ability to hear variations in tone.

A free, open throat during phonation is essential to proper tone production. Tensions caused from an endeavor to produce an adequate tone without sufficient breath support interfere with free vibration of the vocal folds. They rub against each other as they vibrate; this condition may cause irritation and a loss of tonicity. Tensions which give rise to this condition may arise from stage fright or excitement such as that felt at a football game.

The following exercises for improving phonation should help in achieving relaxation of the muscles of the throat, neck, shoulders, and jaws:

1. To relax the upper body, first swing the arms around vigorously in a full circle a dozen or more times. Then reverse their direction and continue to swing in a full circle until the arms are tired. Next, drop the head on the chest as you relax your shoulders. Let your arms, which should be feeling heavy at this point, pull your body over. Relax your back one section at a time until your upper body is hanging inert from the waist. Now begin again to take possession of your body; straighten the lower back, now the middle back, then the shoulders, and last the head. This exercise not only promotes relaxation but also results in an increase of the blood supply to the brain. It helps relieve tensions.

2. Drop the head vigorously from side to side until the jaw waggles loosely. Now take the chin between the thumb and first finger and move it up and down. Do not allow the jaw to offer any resistance to the fingers. Shake the head again to loosen the jaw and try again to move the chin using only the fingers.

3. Yawn widely. With the mouth open at its widest, say "Ah-a-a-a-" and gradually close your mouth. Attempt to recognize the sensation of an open, relaxed throat. Now go through the motions of yawning without really doing so. Open your mouth wide, keep the tongue low in the mouth, and intone "Ah." Do the same with "Oh" and "Aw."

4. Keeping the same open throat and relaxed jaw, read the following selections quietly and easily. Do not worry about purity of tone. Think

of the air's being pushed up from the center of the body and vibrating through the folds with no effort exerted in the throat.

SWEET AND LOW

Sweet and low, sweet and low,
Wind of the western sea,
Low, low, breathe and blow,
Wind of the western sea!
Over the rolling waters go,
Come from the dying moon, and blow,
Blow him again to me;
While my little one, while my pretty one, sleeps.

Sleep and rest, sleep and rest,
Father will come to thee soon;
Rest, rest, on mother's breast,
Father will come to thee soon;
Father will come to his babe in the nest,
Silver sails all out of the west
Under the silver moon;
Sleep, my little one, sleep, my pretty one, sleep.[1]

ANNABEL LEE

For the moon never beams without bringing me dreams
Of the beautiful Annabel Lee;
And the stars never rise but I see the bright eyes
Of the beautiful Annabel Lee;
And so, all the night-tide, I lie down by the side
Of my darling, my darling, my life and my bride,
In her sepulchre there by the sea—
In her tomb by the sounding sea.[2]

Resonation

The tone initiated in the larynx is thin and weak. To be adequate for communication, it must be amplified and reinforced. Amplification comes through resonating the tone in cavities of the head.

The first resonating cavity after the larynx is the pharynx. The muscles

[1] Alfred, Lord Tennyson, *The Works of Alfred, Lord Tennyson* (London: Macmillan and Co., 1884), p. 41.

[2] Edgar Allan Poe, *The Works of Edgar Allan Poe* (New York: Harper & Row, Publishers, 1849), *4*, 50.

of the pharynx are flexible and capable of changing the shape and the texture of the walls of the organ. If the walls of a resonating cavity remain soft, they tend to soften the high overtones and to reinforce the more pleasing low frequencies. If you were to place an alarm clock in a large tin pan and allow the bell to ring, the noise would be unpleasant. Line the same pan with pillows, thus softening the resonating walls, and the alarm bell would lose much of its unpleasantness. The walls of the larynx function somewhat like the pan. If the muscles of the larynx are tense, the vocal tones become unpleasant. Conversely, a soft-walled pharynx causes pleasing original tones. A relaxed throat helps create the proper condition for the pharynx.

A flexible resonator can direct the flow of air toward the front of the mouth or focus the tone forward. Although we frequently hear the term *tone placement,* we know that physically a tone cannot be placed. The vowel *ah* or consonant *k,* for example, would lose their identity if made anywhere except in the back of the mouth. We also know, however, that the quality of a tone can be improved when it is "thought forward." This improvement is due in part to the directing of the air forward in the pharynx and the rounding of the lips to focus the tone.

The mouth is the largest resonating cavity. It aids resonance because it can change its size and shape by action of the tongue, jaws, and velum. To gain the most from resonance, one should keep the mouth open so that it may function properly. If one speaks habitually with tight jaws and with the teeth almost meeting, he leaves little room for oral resonance.

The nasal cavity also aids in resonating the tone. In making all of the vowels and most of the consonants, the velum or soft palate rests against the back of the pharynx, thus directing the flow of air into the mouth. In making the nasal consonants *m, n,* and *ng,* the velum relaxes and leaves a passage for the air to enter the nasal cavity where it is resonated.

Some people tend to nasalize vowels when they occur before or after a nasal consonant. A communicator who produces a clear *a* in *cat* may nasalize the same vowel in the word *man.* We tend to practice economy of effort. It hardly seems worthwhile to make an adjustment of the velum after the *m* and again after the *a,* so we frequently send all three speech sounds through the nose, to the detriment of quality.

For the most effective resonance we must gain control of the velum. There must be full passage into the nose for the consonants *m, n,* and *ng;* but in the formation of the vowel sounds, the velum must be so controlled that only that amount of air which makes for a pleasing quality in our particular vocal process be allowed to pass. Again, we see the necessity for ear training. We must hear, recognize, evaluate, and regulate the amount of nasal resonance in our own vocal tone.

The following exercises should improve resonance:

1. With the throat relaxed, open the mouth wide and sing "Ah." Now with the teeth almost together sing "Ah." Listen to the difference in quality.

2. Intone "m," "n," and "ng," using a great deal of force. Make the nasal cavity vibrate with sound, but do not tighten the throat.

3. Place the heels of the hands under each side of the chin, the little fingers along the nose, and the other fingers spread over the temples and upper jaws. Intone "ah," "oh," and "oo." Fill the head with sound so that it vibrates under your fingers.

4. To check the amount of air that goes through the nose, try this exercise: Place a small lighted candle about an inch under your nose. Hold a sheet of stiff paper over the mouth so the air from the mouth will not reach the candle. Now count vigorously from one through ten. The candle flame should flicker on one, seven, nine, and ten but should remain unaffected during the counting of the other numbers.

5. Say "Jack goes to high school." Now hold the nose tightly and repeat the sentence. Since there are no nasal consonants in the sentence, there should be no noticeable change in quality. Try the candle test described in exercise 4 on this sentence. The candle flame should not waver.

6. Intone "hung-ah-ng-ah-ng-ah-ng." Sense the relaxation of the velum on "ng" and the "pulling down" on "ah." Sense the "ng" in the back of the throat. Place the "ah" forward toward the front of the mouth. There should be no noticeable nasal resonance on "ah."

7. Prolong the vowel in the words below. Be sure that no air comes through the nose; then relax the velum on the nasal consonant and send the air out through the nose.

home	loan	sing
ten	sun	lawn
hung	fan	tong

8. Direct the column of air toward the front of the mouth as you say the phrases listed below. Open the jaw wide, relax the lips, and "think the tones forward." Think of projecting the tones as you say each phrase several times.

"Focus tones forward."
"Fee, fi, fo, fum."
"Most men make money."
"Ten top tunes."

Articulation

Rather than thinking of articulation as the last step in tone production, consider it as the shaping of the resonated tone into the sounds of speech and as joining these sounds together in words and phrases. These processes are accomplished by the articulatory organs—the lips, jaws, tongue, and velum—and must be accomplished with lightning speed. Each speech sound requires a different adjustment of the many muscles controlling the articulatory organs. For example, consider the word *adventure;* it has seven different speech sounds and each sound requires its particular adjustment of the muscles which produce it. We can pronounce this word in half a second. Imagine a sentence containing a half dozen such words. The pronunciation of the sentence, requiring perhaps five seconds, involves so many intricate, delicate, and precise resonance and articulatory adjustments that one wonders how the mechanism is capable of producing it in so short a time. Is it any wonder that it usually takes a child four to seven years to perfect speech?

If the individual sounds are not clearly made, mumbling and indistinct speech will result, requiring careful concentration from an audience. Poor articulation arises from one or more of the following conditions: 1) lazy, inactive lips; (2) stiff jaws; (3) a thick, clumsy tongue; or (4) a flaccid, inactive velum.

We must develop flexible articulators and learn to control them quickly to produce articulate speech. In the following exercises, keep the jaws and throat relaxed. Direct the air forward in the mouth. Think of all the words in the exercises as made in the front of the mouth. Practice proper breathing while you do them. Keep the chest high, and take a quick breath through the mouth when you have exhausted the air controlled by the lower ribs and diaphragm.

1. Bite the tip of the tongue lightly until you feel the pressure of the teeth. Flip the tongue rapidly back and forth against the front teeth. Pass the tip of the tongue over the hard palate and on back until it touches the soft palate. Stretch it as far as it will go.

2. Keep the mouth open as wide as possible without strain as you say:

"*La lay lee ly low, la lay lee ly low, la lay lee ly low.*"
"*Rah ray ree ry row, rah ray ree ry row, rah ray ree ry row.*"

3. Trill the *r*'s in this sentence: "Around the rocks the ragged rascal ran."

4. Attempt to keep each sound clear as you say the following rapidly.

"Tip o' the tongue, tip o' the tongue, tip o' the tongue."
"Thistle zither, thistle zither, thistle zither, thistle zither."

5. Keeping the jaws relaxed, exaggerate the action of the lips as you repeat the following:

"Lippity lippity lop, lippity lippity lop, lippity lippity lop."
"Linoleum, linoleum, linoleum, linoleum, linoleum, linoleum, linoleum."
"Ee dee ee do, ee dee ee do, ee dee ee do, ee dee ee do, ee dee ee do."
"Oh ah, oh ah, oh ah, oh ah, oh ah, oh ah, oh ah, oh ah, oh ah, oh ah, oh ah."

6. Open the mouth as wide as possible and sense the action of the velum with the following:

"Gurgle, gurgle, gurgle, gurgle, gurgle, gurgle, gurgle, gurgle."
"Ng uh, ng uh, ng uh, ng uh, ng uh, ng uh, ng uh, ng uh, ng uh."

7. Observe all the things you have learned about breathing, relaxation, and articulation in saying the following tongue twisters; say each three times rapidly:

1. "She sells sea shells on the sea shore."
2. "He saw six slim, sleak, slender saplings."
3. "Rubber baby buggy bumpers."
4. "A big black bear ate a big black bug."
5. "Sam shipped six slippery, slimy eels in separate crates."
6. "The ship's masts were splintered by the sharp September blasts."
7. "The little lowland lubber was a lively lad, lucky, liberal, and likable."
8. "Tell the tall tramp that there's advantage to him and to the community if he keeps on traveling."
9. "Two terrible, tedious, tiresome talkers took advantage of the debating team."
10. "The sharp, shrill shriek of the bat shatters the shadowy silence."
11. "While we waited for the whistle on the wharf, we whittled vigorously on the white weatherboards."
12. "Some varieties of fish are fiercely vicious, fighting vigorously and often inflicting physical hurt on the fishermen."

13. "The view from the veranda gave forth a fine vista of waves and leafy foliage."
14. "He mangled his ankle as he bungled a shot out of the bunker."
15. "We climbed up the high incline, deciding to visit the shrine reminding mankind not to be unkind."
16. "We apprehensively battled with the bragging apprentices, but they broke away from our blows and beat a poor retreat."
17. "Sid said to tell him that Benny hid the penny many years ago."
18. "Three gray geese in the green grass grazing; gray were the geese and green was the grazing."
19. "The seething sea ceaseth and thus the seething sea sufficeth us."
20. "Fanny Finch fried five floundering fish for Frances Fawlie's father."
21. "The sixth sheik's sixth sheep's sick."
22. "Limber Lena leaped laughingly after Lazy Lally."
23. "Meaninglessly meandering Melina managed to master Monday's memory work."
24. "Grass grew green on the graves in Grace Gray's grandfather's graveyard."

Ear training

Voice training includes ear training; you must first hear your voice. You must train yourself to listen to it analytically and critically. Perhaps you have always taken your voice for granted, much as you have your nose or hair. To improve your voice for communication, you must learn to listen to it objectively. The tape recorder is invaluable for this purpose. No one can tell you exactly how to produce a good tone. You can learn how to support the tone with well-filled lungs, how to round the lips, how to relax the jaw, and why you should open your mouth; but in the end you must listen to the resulting tone to evaluate it. Then you must either try to repeat a well-made tone or change the relationship of the different parts of the process to achieve more pleasing results. This trial-and-error method applies when trying to overcome nasality, harshness, breathiness, or any other unpleasant defect in tone production. Through ear training you will eventually acquire a proper auditory image so that when you finally produce a good tone you will recognize it as such.

In summary, tone production starts with breathing. Proper breathing for speech results from the control of an adequate amount of air. When the outgoing breath strikes the vocal folds, sound is initiated. Relaxation of the body, especially the throat and neck, helps to avoid strain and thus aids phonation. The initial vibrations are transmitted to the resonating chambers of the throat, mouth, and nose, where the sound

becomes amplified. Relaxation also aids in this amplification process. Finally, through use of the organs of articulation—the tongue, teeth, jaws, lips, and palates—sounds are formed into words. Proper voice training starts with ear training; one must learn to hear his voice so that he can analyze, evaluate, and improve it.

VARIETY IN VOCAL UTTERANCE

To gain the most advantage from your voice, avoid monotony in its use. Variety may be achieved in quality, time, pitch, and force.

Quality

Variation in voice quality is determined by emotional understanding and response. If the communicator learns to control his voice mechanism, if he has a clear understanding of the logical and emotional content of his material, and if he has no physical defects to mar the timbre of his voice, he may attain variety in voice quality.

The emotional aspect of quality cannot be attained by mechanical means. All other things being equal, an emotionally responsive and uninhibited person will produce the desired emotional aspect. Emotional responsiveness may be developed, in part, through real and vicarious experiences. The person who reads, understands, and responds to the emotional content in good literature will be greatly aided in attaining emotional responsiveness. A healthy body and a healthy mind aid the communicator in developing emotional color in his voice.

Time

Communicators usually have so much material to cover and so little time in which to cover it that they tend to acquire a rapid rate of speech. This rapidity, which gives little time for pause, may defeat the communicator's purpose. Any discussion of time should include a consideration of rate, phrasing, and pause. Time aids the expression not only of logical content but of emotional content as well.

Rate means the speed of utterance, the number of words spoken per minute. The normal rate for most people is from 120 to 150 words per minute. Variations in rate depend upon such factors as the importance of the material, the desire for emphasis, and the mood of the content. One would not describe the dire conditions of poverty in city slums at the same rate that he would describe a horse race. Neither should a com-

municator race through point after point simply because he considers his message important. Actually his listeners would be more impressed by two or three well-developed points delivered at a normal rate than they would be by ten points hastily developed and more hastily given.

Proper phrasing makes clear the communicator's meaning. "For every selection or speech paragraph there is a maximum number of words beyond which one cannot go without destroying meaning." [3] Phrases may be defined as thought units. If a person ignores these thought units and groups words together regardless of their meaning for the convenience of breathing, he decreases his chances for presenting a successful message. He should group words according to meaning and control his breathing so that he can pause slightly at the end of the phrase and get a breath at the same time.

Pauses serve not only to help the communicator control his general rate, but they also provide him the opportunity to emphasize and point up a thought. A communicator pauses to give his listeners time to get the full significance of what he says. While a communicator speaks, he has a threefold task: he must think, he must organize his thoughts, and he must choose words that express his thoughts. Pauses also permit the communicator to think ahead, to weigh the significance of what he plans to say next, to anticipate and empathize with the next thought. An occasional pause will give him time to do these things well. It is better to hesitate a moment to choose the right word than to say the first word that comes to mind.

If a communicator fails to pause often enough or long enough, he gives his listeners a feeling of frustration. While the listener attempts to digest an idea, the communicator leaps ahead before the listener is ready for another idea. The amateur often fails to pause because he fears that if he stops talking his listeners will think he has forgotten his message. A rapid rate with few pauses indicates lack of poise. A communicator's failure to pause may cause his listeners to stop trying to listen.

Pitch

Pitch means the key or place of the voice on the musical scale and the variations up and down the scale. The pitch of the voice grows higher as one becomes aggressive or excited. A noticeable rise in pitch level decreases effective delivery. Conversely, a voice kept on the normal key at all times becomes monotonous. A person should attempt to find his

[3] C. H. Woolbert and J. F. Smith, *The Fundamentals of Speech* (New York: Harper & Row, Publishers, 1934), p. 221.

normal pitch level and vary the level in keeping with the emotional content of his material.

To bring out fine distinctions in meaning, make use of key variations, or inflections and steps. A rising inflection within a word or phrase or at the end of a sentence denotes incompleteness of thought, indecisiveness, or doubt; a falling inflection denotes finality and completeness of thought. For making the finest distinction between logical and emotional meaning, however, a combination of the two may come within a single syllable. For example, the word "yes" means an affirmation when spoken with a downward or falling inflection; when spoken with a rising inflection it denotes doubt or question; when given a combination of the two, a circumflex, it may mean "no" or "yes" with reservations. Beware of developing an inflection pattern, a preponderance of either falling or rising inflections. To help correct an inflection pattern, make a voice recording for the purpose of self-criticism.

Inflection relates primarily to gradual changes in pitch within a word or syllable; the *step* concerns abrupt changes in pitch between words and phrases or sentences. No communicator wants to bore his listeners by speaking all of his words, phrases, and sentences in the same pitch. For example, "Give me liberty or give me death," would vary widely in range. To say all the words of such a sentence at the same pitch level would destroy its full meaning.

Force

Force or stress applied to individual words and phrases helps to convey meaning. For example, "I am going to town" may be made to mean that *I,* not somebody else, will go to town by stressing the word *I:* "*I* am going to town." The same sentence may be given a note of defiance by stressing the word *am:* "I *am* going to town." Still different meanings may be given by stressing the words *going* and *town.*

Variety in force applies as well as variety in other aspects of voice. One who speaks in a bombastic tone or with explosive force throughout a message will be likely to wear his listeners out. They will be unable to hear what he says because of the noise he makes. The person who continually speaks with little vocal energy or force will not be heard well and will lose listener attention. The listeners will feel that such a person is convinced neither of the importance of his material nor of his desire to communicate.

Your voice can be one of your greatest assets. To make the most of your natural ability, spend much time developing your voice and learning to use it advantageously.

ACQUIRING ACCEPTABLE PRONUNCIATION

Although articulation means the producing and joining together of speech sounds, pronunciation concerns choosing the correct sound and placing the proper stress upon the syllable or syllables to be accented. One cannot know, just by looking at a word, how to pronounce it. The English alphabet is not consistently phonetic. A letter may be pronounced one way in a certain word and another way in a different word. The letter *a*, for example, is pronounced differently in each of the following words: *rain, apple, autumn, among, what,* and *care.* Although certain rules for pronunciation prevail, the great number of exceptions make the rules practically useless. The only way to determine the pronunciation of a word is to look it up in a dictionary.

The compilers of a dictionary do not decide pronunciation arbitrarily. Instead they record the pronunciation currently in use by the majority of educated people. If usage justifies, they record two or more pronunciations. Some dictionaries record the pronunciations without any thought to preference; others record first the pronunciation used by most people. The trend toward multiple pronunciations is greater today than formerly.

The majority of words have only one pronunciation other than the normal deviations within a phoneme, a family of related speech sounds. We have only to consult the dictionary to know the correct pronunciation. But students often hear two or more pronunciations of the same word, and they find more than one pronunciation given when they look it up. They may insist on knowing which is right. In fact, all are correct. Although one may choose the desired pronunciation, the best choice consists of that pronunciation used by the majority of educated people in one's particular section of the country. The best pronunciation passes unnoticed in any cultured group. An unusual pronunciation for a particular region, although given in the dictionary, calls attention to itself and sometimes interferes with listener concentration.

We do not have one standard American pronunciation in the United States as do some other countries. In France, a standard pronunciation is used by those who speak so-called Parisian French. In Spain, the educated classes speak Castilian Spanish. In England, the dialect used by Oxford and the public schools, the pronunciation of Southern England, is considered standard. In the United States we have regional standards instead of one standard dialect.

Almost all writers divide the speech of the United States into three groups, based on the geographical regions where they are used: (1) Eastern dialect, spoken in eastern New England and New York City; (2)

Southern dialect, spoken in those states usually considered the "Old South"; and (3) General American dialect, spoken elsewhere in the United States.

Since approximately two-thirds of the people of the United States use General American speech, the national television and radio systems use this dialect. Dictionaries also record the General American pronunciation since they base pronunciation on that used by the majority of the cultured population. For the same reason, the use of Southern British diction for the American stage is rapidly disappearing.

Some people think that Southern and Eastern dialects will slowly be assimilated by the General American and that eventually we will have one standard American pronunciation. Many people regret this trend because they like the variations of the crisp, brisk accent of the Bostonian and the mellow, resonant drawl of the Southerner. Standardization would destroy much that we consider distinctively American.

Pronunciation is represented in print by several methods. The International Phonetic Alphabet provides the most accurate and scientific method. This alphabet uses a symbol for every sound in the language and only one symbol. The national news services use a system of respelling and capitalization to show pronunciation. The most common method, that used by most dictionaries, indicates pronunciation by means of diacritical marks. Diacritical marks are signs added or placed adjacent to a letter to distinguish it from another or similar form. Dictionaries give a chart of diacritical symbols and illustrative words with diacritical marks; some dictionaries also give the corresponding phonetic symbols. An aural recognition of speech sounds and the ability to record them by means of phonetic symbols or diacritical marks should improve one's pronunciation.

Many words in the English language are commonly mispronounced. They may be classified and analyzed according to the divisions that follow. Look up each word in the dictionary and write the pronunciation in diacritical marks as explained in the guide to pronunciation for your dictionary.

1. Words mispronounced because of improperly placed accent:

admirable	electoral	positively
alias	genuine	superfluous
awry	horizon	theatre
beneficent	impotent	vehement
comparable	mischievous	vehicle
coupon	police	

Phonetic and Diacritic Equivalents *

Consonants

I.P.A.	Merriam [1] Webster	American [2] College	Webster's [3] New World	Standard [4] College	Key Word
p	p	p	p	p	pep
b	b	b	b	b	bib
t	t	t	t	t	tot
d	d	d	d	d	dead
k	k	k	k	k	kick
g	g	g	g	g	gag
f	f	f	f	f	fat
v	v	v	v	v	van
θ	th	th	th	th	thin
ð	th	th	*th*	th	these
ʃ	sh	sh	sh	sh	she
ʒ	zh	zh	zh	zh	leisure
m	m	m	m	m	me
n	n	n	n	n	not
ŋ	ŋ	ng	ŋ	ng	sing
l	l	l	l	l	let
r	r	r	r	r	run
j	y	y	y	y	yet
w	w	w	w	w	we
h	h	h	h	h	hot
hw, ʍ	hw	hw	hw	hw	when
s	s	s	s	s	see
z	z	z	z	z	zeal

Affricates

I.P.A.	Merriam	American College	Webster's New World	Standard College	Key Word
tʃ	ch	ch	ch	ch	church
dʒ	j	j	j	j	judge

Vowels

I.P.A.	Merriam	American College	Webster's New World	Standard College	Key Word
æ	a	ă, â	a, â	a, a	cat
ɑ	ä, ȧ	ŏ, ä	o, ä	a, a	what
ɔ	ȯ	ô	ô	ô	fall
e	ā	ā	ā	ā	chaotic
ɛ	e	ĕ, â	e	e	set
ɪ	i	ĭ	i	i	sit
i	lē, lē, ē	ē	ē	ē	neat
o	ō	ō	ō	ō	obey
ʌ	lə, lə	ŭ	u	u	cup
ə	ə	ə	ə	ə	connect
ʊ	u̇	o͞o	o͞o	o͞o	cook
u	ü	o͞o	o͞o	o͞o	cool
ju	yü	ū	ū	ū	you
ɝ	ər, ər	ûr	ûr	û(r)	burn
ɚ	ər	ər	ẽr	ər	persuade

Diphthongs

I.P.A.	Merriam [1] Webster	American [2] College	Webster's [3] New World	Standard [4] College	Key Word
eɪ	ā	ā	ā	ā	vein
ou	ō	ō	ō	ō	soul
aɪ	ī	ī	ī	ī	time
aυ	aú	ou	ou	ou	owl
ɔɪ	ȯi	oi	oi	oi	toil

* Cecil May Burke, *A Phonetic Primer* (Berkeley: McCutchan Publishing Corp., 1964), pp. 56–57. Reprinted by permission of Professor Burke.

[1] By permission from Webster's Third New International Dictionary. Copyright © 1963 by G. and C. Merriam Co., Publishers of the Merriam-Webster Dictionaries.

[2] Reprinted from *The American College Dictionary,* Copyright 1947, © Copyright 1965, by permission of Random House, Inc.

[3] From *Webster's New World Dictionary* of the American Language, College Edition. Copyright © 1964 by The World Publishing Company.

[4] From *Funk and Wagnalls Standard College Dictionary.* Copyright © 1963 by Funk and Wagnalls Company, Inc. Reprinted by permission of the publishers.

2. Words mispronounced because of a reversal of sounds:

cavalry	larynx	pharynx
children	modern	prescription
hundred	perspiration	realtor

3. Words mispronounced because of adding a sound or syllable:

athlete	elm	mischievous
business	film	parliament
calm	miniature	umbrella
drowned		

4. Words mispronounced because of omitting a sound or syllable:

accurate	company	popular
antarctic	diamond	positively
believe	different	really
bona fide	experiment	regular
candidates	generally	regulate
capital	geography	sophomore
carburetor	history	suppose
chocolate	interesting	usually
circular	literature	vice versa

5. Words mispronounced because they are pronounced as they are spelled:

chic hiccough victuals
flaccid salmon Worcestershire
handkerchief

6. Words mispronounced because of an awkward repetition of sound:

February horror secretary
governor library terror
government mirror usury

7. Words mispronounced because of improper association with a word or part of a word which is similar but pronounced differently:

column (volume) grievous (previous) penalize (penalty)
comely (homely) hearth (earth) pronunciation
despicable (despise) height (length) (pronounce)
February (January) impious (pious) put (but)

SUMMARY

An adequate voice aids in communicating ideas; it also gives cues to one's personality and emotional state. Although not an end in itself, a good voice serves as a means to an end—the communication of ideas, information, and emotions. An adequate voice is intelligible, pleasing in quality, free of affectations, and flexible.

Variations in voices are due (1) partly to physical characteristics, (2) partly to environmental conditions, (3) partly to personality characteristics, and (4) partly to improper use. Some speakers have better natural voices than others, but most people can improve their voices by conscientious efforts.

One does not have a separate speech mechanism; all organs of the body used in producing speech have other important life functions. An adequate voice requires proper breathing, phonation, resonation, and articulation. To develop an adequate speaking voice, try to acquire controlled breathing, a relaxed body, flexible articulation, and acute hearing.

Variety in vocal utterance comes by learning to control quality, time, pitch, and force. Proper control helps in avoiding monotony and in causing the voice to realize its maximum effect for oral communication.

Acceptable pronunciation is that used by the majority of educated

people in a given region. Phonetic symbols and diacritical marks are the best guides to pronunciation. Acquire the dictionary habit for improving pronunciation.

QUESTIONS

1. What advantages accrue to a communicator from a good voice? List several disadvantages of a poor voice.
2. List four requisites of an adequate voice for oral communication. Discuss each briefly. Do you think the requisites discussed in this chapter are adequate? Explain.
3. List and discuss four causes of variations in voices. Can you add to the causes discussed in this chapter?
4. Dicuss briefly the process of voice production. Of what significance is the fact that all organs of the body used in producing voice have other important life functions?
5. In what ways can one develop variety in use of the voice?

ASSIGNMENT

For your oral assignment, choose a novelist, a playwright, or a poet from the list below. Make a five-minute speech, using this outline: (1) a brief biographical sketch, (2) a brief discussion of his principal writings, and (3) a critical evaluation of one of his works.

Novelists

James Baldwin	Ernest Hemingway	Boris Pasternak
Saul Bellow	Sinclair Lewis	J. D. Salinger
Willa Cather	Thomas Mann	John Steinbeck
Theodore Dreiser	Somerset Maugham	Mark Twain
William Faulkner	Carson McCullers	John Updike
Graham Greene	James Michener	Thomas Wolfe

Playwrights

Edward Albee	George S. Kaufman	Terence Rattigan
Maxwell Anderson	Arthur Miller	Neil Simon
Samuel Beckett	Clifford Odets	George Bernard Shaw
Henrik Ibsen	Eugene O'Neill	Tennessee Williams

Poets

W. H. Auden	Archibald MacLeish
John Ciardi	Edgar Lee Masters
e e cummings	Phyllis McGinley
Emily Dickinson	Edna St. Vincent Millay
T. S. Eliot	Marianne Moore
Robert Frost	Ezra Pound
Gerard Manley Hopkins	Edward Arlington Robinson
James Weldon Johnson	Carl Sandburg
Vachel Lindsay	Wallace Stevens
Amy Lowell	William Carlos Williams
Robert Lowell	William Butler Yeats

READINGS

ANDERSON, VIRGIL A., *Training the Speaking Voice,* chaps. 2, 3, 4. New York: Oxford University Press, 1961.

BURKE, CECIL MAY, *A Phonetic Primer.* Berkeley: McCutchan Publishing Co., 1964.

DEVITO, JOSEPH A., JILL GIATINO, and T. D. SCHON, *Articulation and Voice.* Indianapolis: The Bobbs-Merrill Co., 1975.

EISENSON, JON, and PAUL H. BOASE, *Basic Speech,* 3rd ed. New York: The Macmillan Company, 1975.

FISHER, HILDA B., *Improving Voice and Articulation,* 2nd ed. Boston: Houghton-Mifflin, 1975.

JEFFREY, ROBERT C., and OWEN PETERSON, *Speech: A Text with Adapted Readings,* 2nd ed., chap. 14. New York: Harper & Row, Publishers, 1975.

LEUTENEGGAR, RALPH, *The Sounds of American English.* Glenview, Ill.: Scott, Foresman, 1963.

MONROE, ALAN H., and DOUGLAS EHNINGER, *Principles and Types of Speech Communication,* 7th ed., chap. 6. Glenview, Ill.: Scott, Foresman, 1974.

ROSS, RAYMOND S., *Speech Communication,* 3rd ed., chap. 6. Englewood Cliffs, N.J.: Prentice-Hall. 1974.

PART **4**

Special areas of communication

Resolving conflicts through debate

Parts 1, 2, and 3 discussed the basic principles of oral communication; part 4 applies those principles to the specialized fields of debate and speeches for special occasions. Discussion in small groups, as a type of problem solving, was included in chapter 5; conflict-resolving through debate is the subject matter for this chapter; and speeches for special occasions are treated in chapter 15.

An eminent lawyer who specializes in workman-compensation cases reported that only about 3 percent of personal damage claims ever reach the courtroom. The other 97 percent are settled outside the courts either by the litigants or by lawyers representing them. In deliberative bodies, solutions to a majority of problems are effected around the conference table. Only a small percentage require debate and a vote. In everyday business activities, decisions are reached largely in conferences between the proponents of the proposal and the executives of the organization. Only a minority of proposals require action by the executive boards. In short, a majority of decisions in a democracy are made by means of investigation, discussion, and compromise. Yet the small percentage of decisions that cannot be made by compromise vitally affect the business of free people. Debate comes into play to complete the process, by resolving conflicts that cannot be settled through conference. Debate may be said to begin where conferences end.

The debater performs an essential function in the democratic process. Without him, democracy could not operate. For example, in law the accused must have his case presented in its most favorable light or injustices may result. His lawyer uses debate to build the strongest case possible for him consistent with the facts. In deliberative assemblies, when legislative measures have been narrowed to a specific proposal, the

advocate of each side presents the strongest case possible for his side. In human relations, any cause must have its ideals promulgated or progress becomes impossible.

The nature of a general textbook in oral communication does not permit a full treatment of the principles of advocacy, the process of pleading a case for another or for a cause. This chapter discusses only the salient principles of debate employed in college and high school forensic programs.[1] Although the procedural methods used in these training programs are somewhat simulated, the student thus trained can easily adapt his acquired skills to life situations of advocacy.

PROCEDURAL PRINCIPLES OF DEBATE

The procedures for college debate call for opposing teams, termed affirmative and negative. Each speaker on a team has a constructive and a rebuttal speech in which to build his case and tear down his opponent's case. The affirmative team proposes a change in an existing economic, social, or political policy. The affirmative side is analogous to the plaintiff in a law case or the proponent of a measure in a legislative assembly. The negative speakers oppose the proposed change and resemble the defendant in a law case or the opponent to a measure in a legislative body.

Each team proposes constructive cases consisting of the basic arguments on its side of the question. The basic arguments are known as the main issues; when stated in the form of arguments, the issues become the main contentions for the side advancing them. Not only must each side build a case, but each team must attack the case of the opposing team and defend its own arguments against attacks.

In brief, debate involves a threefold process: (1) a constructive process in which each team develops a case sufficient to prove its side, (2) a destructive process in which each team attempts to weaken or destroy the opposing case, and (3) a reconstructive process in which each team rebuilds its own case. These processes call for an understanding of procedural principles designed to give debate order and arrangement. What are these principles?

The affirmative must present a prima-facie case

A prima-facie case means one sufficient to prove the proposition. In a policy proposition the case must prove these issues: (1) A problem exists

[1] For a detailed treatment see Glenn R. Capp and Thelma Robuck Capp, *Principles of Argumentation and Debate* (Englewood Cliffs, N.J.: Prentice-Hall, 1965).

with sufficient force to demand a change. (2) The suggested proposal can solve the problem. (3) The solution will correct the evils in a satisfactory way. The case must be sufficient to overcome the natural advantage in favor of present conditions. Existing conditions are presumed to be best until proved deficient. Since the presumption of the argument favors the negative at the beginning of the debate, the affirmative must overcome this presumption by presenting a prima-facie case.

In recent years a somewhat different type of case has come into vogue. Known as the *comparative-advantage* case, it bypasses the "need for a change" issue and claims that regardless of whether a need exists, the affirmative proposal will result in an advantage over the status quo. For this type of case to be prima-facie, the advantages presented must in fact show a comparative advantage over the present system.

The affirmative assumes the burden of proof

This principle comes from legal procedures. In criminal law a man is presumed innocent until proved guilty. The burden rests on the state to prove its case by a preponderance of evidence. This same principle applies with any existing order—political, social, or economic; it cannot be condemned without cause. The affirmative side has the obligation to prove its case because it advocates a change. It must show that its proposal will be preferable to the existing order; otherwise, why change?

What obligations accrue because of the affirmative's burden of proof? The affirmative must prove a prima-facie case as explained in the preceding section. Furthermore, the affirmative side must gain the advantage on each basic issue. If the negative side can defeat any of the affirmative's main contentions, it will win. Each basic contention in the affirmative's case is essential to the case.

To illustrate, for the proposition, "Resolved, that the United States should adopt the essential features of the British system of education," the affirmative's main contentions may be stated as follows: (1) Defects in the United States' system of education demand a change. (2) Adopting the essential features of the British system of education will correct the defects. (3) The proposed plan is a desirable solution. All three contentions are essential to a prima-facie case and must be advanced and defended by the affirmative.

The negative side may choose to counter all the main issues, or it may concentrate on one or more. If the negative could prove that no defects exist, there would be no need to counter issues two and three. Conversely, the negative may admit the defects and concentrate its attack on the workability or desirability of the proposal.

In the comparative-advantage case, the affirmative usually presents its proposal first and then develops the advantages that will accrue over

the status quo. The first affirmative speaker may present all the alleged advantages or they may be divided between the first and second speakers. In either event, to fulfill its burden of proof, the affirmative side must prove that an advantageous condition will result over the existing system.

The affirmative defines the proposition

Since the affirmative side must prove its case, it has the right to say what the proposition means. This statement does not mean an unqualified right; it does mean that the affirmative has the right to define specific terms and give shades of meaning to the proposition. For example, the proposition that the United States should adopt the essential features of the British system of education gives the affirmative the right to name the essential features. Those features specified must in fact be essential, but their selection and order of presentation rest with the affirmative.

The affirmative should interpret the proposition so that the affirmative and negative positions are clearly distinguishable. For example, the affirmative on the proposition stated above may favor selective education, central control, compulsory study programs, and teacher certification based on subject-matter courses. Conversely, the negative should contend for mass education, decentralized control, individual choice in selecting programs of study, and emphasis on pedagogy courses for teacher certification. Why? Because these are, in fact, some of the basic differences between the British and American systems of education. The affirmative should interpret the proposition to bring out these basic differences.

The affirmative sets forth the basic issues

The affirmative advances the main issues and the negative counters them. The right to set forth the issues does not mean an unqualified right, because the main issues inhere in the proposition. On policy questions the affirmative must develop the problem, make a proposal to correct or improve the situation, and prove its proposal desirable. The right to advance them in the order and manner desired resides with the affirmative.

Each team has the burden of rebuttal

This principle means that each team must respond to an argument advanced by the other or lose it by default. Once the affirmative presents its prima-facie case, the negative side must answer it. If the negative makes a successful rejoinder, the burden of rebuttal shifts to the affirmative. This burden shifts from one side to the other on each argument throughout the debate.

Constructive cases must be completed in the constructive speeches

The prima-facie case must be presented in its entirety in the constructive speeches; new issues may not be presented in the rebuttal speeches. This principle does not mean that new material cannot be presented in the rebuttals on issues already introduced into the debate. New supporting material and new alignment of arguments in rebuttals prevent these speeches from becoming a rehashing of the constructive speeches. Refutation may be included in constructive speeches, but no new issues can be introduced in the rebuttals.

In the comparative-advantage case, all the advantages must be presented in the constructive speeches; no new advantages may be introduced in the rebuttal speeches.

The negative has a choice of stands

The negative may take one of four possible stands: (1) It may present an entirely destructive case of refutation of the affirmative contentions. The negative permits the affirmative to set the issues and argues its case with pure refutation. (2) The negative may uphold the status quo. It need not argue present conditions as entirely satisfactory, only that the system is sound in principle. (3) The negative may uphold the status quo with modifications. The proposed modifications should conform to the principles of the present system. Otherwise, the inadequacy of the status quo would be admitted. (4) The negative may present a counterplan—a program that differs from both the status quo and the affirmative proposal. This stand automatically admits the inadequacy of the present system and resolves the debate into a comparison of two proposed solutions. The negative assumes the burden of proof on its proposal and must show it superior to both the affirmative proposal and the status quo.

Not any of the above stands is superior to the others in principle, but one may be the best when applied to a specific proposition. The choice should be based upon reason, not upon simple preference.

For the comparative-advantage case the negative may contend that the affirmative proposal will not work; that the advantages will not indeed accrue, and/or that the disadvantages will outweigh the alleged advantages. If it can prove any of these contentions it will establish a valid negative case.

REQUIREMENTS OF THE PROPOSITION

Only propositions, or resolutions, can be debated. They call for specific proposals that specify the affirmative and negative positions. For exam-

ple, you cannot debate about the powers of the presidency, but you can debate the proposition, "Resolved, that the power of the presidency should be significantly curtailed."

Types of propositions

There are three types of propositions—fact, value, and policy. (1) Propositions of fact pertain to the truth or falsity of an assertion; for example, "Resolved, that the open shop helps labor." Only questions of fact that cannot be determined by investigation are debatable. (2) Propositions of value question the worth of a proposal; for example, "Resolved, that demonstrations by college students are justifiable." Such questions involve the philosophy or worth of proposals, not whether they should be changed. (3) Propositions of policy propose a change in an existing order; for example, "Resolved, that students should be represented on the governing boards of all universities." Such resolutions aim at a debate on the advantages of a proposed change in policy. Policy questions are superior for formal debate because they are the type most frequently argued in life, especially in conflict-resolving groups.

Phrasing of the proposition

The wording of propositions often determines their worth as questions for debate. Poorly worded topics may be so ambiguous or one-sided as to render them useless. Observe the following suggestions for proper phraseology:

1. State the topic in resolution form. You do not argue *about* a proposition, but *for* or *against* it. For a discussion, the topic may be "How can the United States improve its system of education?" Stated thus, the question has many sides and varying viewpoints. For debate, the topic must be stated in resolution form, as follows: "Resolved, that college students should be represented on all university committees." A resolution has only two sides—pro and con. The resolution does not ask, "What should be done about education?" It proposes that "all university committees should have students represented on them." Thus, the affirmative and negative positions become apparent from the statement of the proposition.

2. State the topic to provide a balance of arguments. Excellent topics may be resolved into poor debate propositions by a statement that favors one side. "Resolved, that the United States should oppose communism" puts an imposing burden on the negative because almost all Americans dislike communism. "Resolved, that the Communist party

should be outlawed in the United States" makes a better-balanced proposition because Americans disagree on this method of opposing communism.

Properly balanced propositions set up a standard for comparison. "Resolved, that the ministry is a nobler profession than law" has no common standard for comparison because both professions are essential. They operate in different areas that are hardly comparable.

3. State the topic as an affirmative resolution. The affirmative must propose a change just as the plaintiff must bring the charge in a law case. Thus, the proposition must be worded affirmatively. "Resolved, that the United States should retain the income tax" does not call for positive action. The affirmative would have no burden to uphold. "Resolved, that the United States should establish a maximum income-tax rate of 25 percent" properly calls for a change in policy.

4. State the topic to embrace one central idea. Propositions that include two or more proposals make poor resolutions. "Resolved, that the president of the United States should be elected by direct vote of the people for a six-year term" includes two proposals. The negative could win by defeating either proposal; it might deliberately ignore one proposal. Yet the affirmative must establish a case for each proposal to fulfill its obligation.

5. State the topic to avoid ambiguous and prejudiced terms. Terms subject to more than one legitimate interpretation lead to confusion. "Resolved, that the income tax is superior to the sales tax" involves the meaning of "superior." What standards measure superiority? Does it mean which is more productive, easier to collect, more equitable, or meets better with public approval? The term instead of the basic principles of taxation might conceivably form the central point of controversy.

Avoid terms which assume points at issue. "Resolved, that unnecessary government restrictions on business should be abolished" assumes a point that the affirmative should be asked to prove. If government restrictions are assumed as unnecessary, who could prove that they should be retained? Avoid prejudiced terms that give either side an advantage.

6. State the topic to restrict its scope. "Resolved, that the American foreign policy should be revised for the space age" encompasses too broad a field. "Resolved, that the United States should recognize Communist China" restricts the proposition to one phase of our foreign policy. Some excellent topics are worded into poor propositions by failure to narrow and restrict them properly.

In summary, propositions for college debates resemble questions debated in life situations of advocacy. The prosecuting attorney charges the

defendant as guilty; the proponent of legislation advocates a solution; the college debater proposes a change in an existing order. Properly worded propositions permit these comparisons to hold.

ANALYSIS OF THE PROPOSITION

Through analysis the debater breaks down the proposition into its component parts and discovers the main issues. The main issues are the inherent, vital points of controversy which form the basis of the case.

Types of issues

To understand the importance of the main issues, consider the following types: potential, admitted, and real.

Potential issues inhere in the proposition. They must be established by the affirmative as prerequisite to a prima-facie case. On policy questions, they take the form of stock issues: (1) need, (2) solution, and (3) desirability of solution. The following issues illustrate for the proposition, "Resolved, that the United States should adopt the essential features of the British system of education."

I. Is a change in the United States system of education needed?
II. Would the adoption of the essential features of the British system of education meet the need?
III. Is the proposed solution the most satisfactory solution?

In the comparative-advantage case the affirmative presents its specific proposal and then develops certain advantages that its proposal will have over retaining the essential features of the American system of education. Thus the potential issues may be said to be the issues of the proposition as distinguished from the issues of a particular debate.

Admitted issues consist of those affirmative issues conceded by the negative. Usually negative teams concede issues on which they feel they have a disadvantage and concentrate on those in which they anticipate an advantage in order to build a stronger case. For example, the negative may admit the problem and concentrate its attack on the proposed solution. All concessions should be made for cause, not simple preference.

The real issues of the proposition, as distinguished from the potential issues, become the ultimate points of controversy in a debate. They consist of the potential issues minus the admitted issues. Upon the establishment of the real issues the case stands or falls. The real issues may vary

from debate to debate, depending on whether the negative concedes one or more issues.

Steps in analysis

You perform analysis as you do research in preparing the questions. Consider the following preliminary steps: (1) Determine the present significance of the question. (2) Study the origin and history of the question. (3) Dispose of irrelevant and admitted matter. (4) Interpret the proposition. (5) Discover the underlying philosophy of the proposition. (6) Contrast affirmative and negative main contentions.

1. Determine the present significance of the question. What changes in conditions give the proposition significance now? During the past 30 years, free trade has been chosen three times as the national intercollegiate debate topic. On each occasion changed world conditions gave the subject new significance. Debaters have debated government reform periodically for many years, but the Watergate scandals and related events have given new impetus to the proposition, "Resolved, that the United States should adopt the essential features of the British parliamentary system of government." Circumstances that give a question current significance aid in analysis.

2. Study the origin and history of the question. You cannot understand a question thoroughly without knowledge of its origin and history. Often history reveals the reasons for present problems which may be interpreted best in the light of their historical development. A knowledge of the origin and history of a problem gives a basis for intelligent analysis.

3. Dispose of irrelevant and admitted matter. Not all matters about a proposition can be in dispute. Some may be irrelevant or trivial. You must separate the important from the unimportant. On the proposition that the United States should adopt the essential features of the British system of education, some differences do not apply as essential features; for example, length of school day, proportion of private to public schools, and the distinction between elementary and secondary schools are all irrelevant. The differences in basic principles, not differences in minor procedural methods, form the basis of argument. The disposal of irrelevant and minor differences permits concentration on the basic issues.

4. Interpret the proposition. An understanding of what the proposition involves forms an essential part of analysis. Unless both teams agree on what the proposition means, they may argue about its meaning and neglect to debate the issues. In arriving at a basic interpretation, you must consider specific terms first; then consider these terms together for an

overall interpretation. A single term may point up the basic difference between the affirmative and negative sides. For example, the words *essential features* form such a term on the proposition stated above; it is the heart of the proposition.

5. *Discover the underlying philosophy of the proposition.* Almost all propositions that propose a change in an existing social, political, or economic order involve a fundamental change in philosophy. They introduce a change in basic concepts, in the implications that underlie the arguments. For example, for the proposition that the United States should adopt the essential features of the British system of education, the affirmative proposal calls for a change from the American concept of mass education to a restricted program of education for the superior student. This basic philosophy should permeate the entire case of the affirmative; it serves as a cohesive force which unifies all the arguments advanced to prove the case.

6. *Contrast affirmative and negative main contentions.* The preceding five steps provide the bases for contrasting the affirmative and negative positions on the main issues. On the first issue of *need* for a change in the education system, the affirmative must discover the main defects of the United States system of education that can be corrected by adopting the British system. The negative side must decide upon the possible positions it may take. It may either contest the issue or admit it, depending upon which position will make the strongest case. If existing evidence favors the indictment, the negative should plan to admit the evils and concentrate on the practicality or the desirability of the proposed solution. The mental process of weighing advantage against disadvantage should be applied to each basic issue during the analysis stage in deciding on the strongest case possible for presentation during the debate.

As a result of analysis you discover the meaning of the proposition and the basic arguments in support of each side. You learn to separate the essential from the nonessential, the fundamental arguments from the trivial, and the main issues from subordinate ideas.

PROOF OF THE PROPOSITION—EVIDENCE

Argumentation makes its basic appeal on logical proof. Evidence and reasoning form the basis of logical proof. Evidence consists of the facts and opinions used to support an argument; reasoning consists of the inferences made from the evidence. Proof is the result of both evidence and reasoning.

Types of evidence

As we explained in chapter 8, evidence takes two forms: facts and opinions. Facts consist of the circumstances or conditions of a situation, the tangible or concrete findings. Opinions are statements of belief about the proposition. If you say, "The 586,000 square miles and 375 million acres in Alaska compose one-fifth the area of the United States," the statement is factual. If you say, "Alaska has the greatest potential for economic development of any of the states," the statement is opinion.

Note how one debater used factual material in debating the unicameral legislature.

> *In 1777 Georgia adopted a one-house legislature which lasted for 12 years. . . . The Pennsylvania constitution of 1776 provided for a one-house legislature. In 1790 a convention was called which revised the constitution and provided for a two-house plan. . . . In 1777 Vermont adopted a constitution providing for a one-house legislature. . . . A Constitutional convention of 1836 scrapped the plan and submitted a bicameral legislature. . . . We ask the affirmative to reconcile the failure of the plan they are proposing to these instances. . . .*[2]

Later in his speech the debater quoted the opinions of experts to support his contentions.

> *Mr. William E. H. Lecky points out in his book,* Democracy and Liberty, *that ". . . of all the forms of government that are possible among mankind, I do not know any which are likely to be worse than the government of a single, omnipotent democratic chamber. . . ." Mr. Ellis P. Oberholtzer in* The Referendum in America *in discussing the reasons for the failure of the one-house plan in Pennsylvania stated, "A body of men upon whose action there was no vote, was a source of danger in the state. . . ."*[3]

The first excerpt typifies factual evidence. The historical examples gave evidence of the failure of unicameral legislation. The circumstances of the examples constituted the evidence. This type of factual evidence compares to the facts elicited from witnesses in courts of law. Witnesses testify about the facts, not what they think about the facts.

[2] Taken from classroom debate.
[3] Taken from classroom debate.

The second excerpt illustrates opinion evidence. The two authorities gave their opinions about the effects of one-house legislatures. Opinions have probative force only if the persons quoted qualify through training and experience to make value judgments. This type of evidence is analogous to expert opinion in court trials. The courts may permit an expert to give his opinion about the facts. For example, the ballistics expert may testify if a particular gun fired the fatal bullet, or the doctor may testify about the sanity of the defendant.

Opinion statements are rarely sufficient within themselves to establish proof. On most policy questions the experts disagree. Although opinion statements lend prestige and dignity to conclusions, their effect may be more persuasive than logical.

Classification of evidence

Knowledge of the legal classification of evidence will aid you in understanding the place of evidence in argumentation. The following are the kinds of legal evidence:

1. Direct or circumstantial. Direct evidence comes from persons who witnessed the happening about which they testify. The witnesses testify about what they saw, not what they infer. Circumstantial evidence goes beyond the facts; it infers a conclusion from facts. If Jones saw Brown run the stop sign and crash with Johnson's automobile, he gives direct testimony about what he saw. Suppose that Brown passes Jones on the highway at an excessive rate of speed, in a no-passing zone, and with the highway patrol in pursuit. Upon arriving at the wreck, Jones infers that Brown crashed into Johnson's automobile. In the first instance, what Jones witnessed constitutes direct evidence. In the second instance, he infers a conclusion based upon prior circumstances that he witnessed.

Direct evidence is factual evidence and applies the same in debate as in law. Circumstantial evidence in law is analogous to opinion evidence in debate; the conclusion requires a statement of belief.

2. Oral or written. Oral evidence consists of spoken statements. It constitutes the principal method for introducing evidence into legal trials. Written evidence comes from books, official documents, pamphlets, or other published materials. Written evidence serves the debater best because it may be more easily documented. Suppose your opponent challenges your source of evidence. If you can cite a published source, greater reliability accrues than if you give an oral source. The procedures for college debate do not allow for direct oral testimony.

3. Expert or ordinary. If facts come from a recognized authority, the

evidence is expert; otherwise it is ordinary. The industrialist who testifies about the causes of labor unrest gives expert testimony; if the same industrialist expresses his opinion of the effect of cigarettes on lung cancer, he gives ordinary testimony. The courts rule out opinion evidence by nonexperts. Before an opinion becomes admissible, the person testifying must be qualified as an authority. In debate, greater reliability is placed on opinions of qualified persons than on those of unqualified persons. Yet some debaters quote well-known persons without regard to their qualifications. Debaters often quote nonexperts because they are known and respected by their immediate hearers, not because of their competence. To avoid this common mistake, quote persons in the field of their competence only.

4. Original or hearsay. Original evidence emanates from the person presenting it. Hearsay evidence consists of statements which one receives from another. If Smith sees the automobile accident, he gives original evidence when he testifies. If Jones tells Smith what he saw, Smith gives hearsay evidence when he repeats what Jones told him. Courts of law rule out hearsay evidence except for clearly defined exceptions. Courts rule that the best evidence is more likely to come from an original than from a secondary source.

The hearsay rule has only partial application in debate. The debater gets much of his evidence from published sources. Material from source books, textbooks, or other recognized works carries more weight than evidence obtained from popular magazines, handbooks, or propaganda pamphlets.

5. Positive or negative. Positive evidence consists of existing facts or opinions. The presence of dust in the gun barrel indicates that it has not been fired recently. The worn steps in a building testify to its long use. The high price of food testifies to inflation. Conversely, the lack of evidence may serve as a basis for inference. That no marks were found on the victim's body indicates that he was not beaten. The absence of open criticism of the recreational program indicates either approval or apathy.

The absence of evidence where one might reasonably expect to find it may be significant. The lack of fingerprints on the open safe indicates that the robber took precautions not to leave evidence. The debater relies mostly on positive evidence.

6. Real or personal. Real evidence in law consists of objects such as the ransom note, photographs, or the lethal weapon. Personal evidence consists of statements of witnesses. A copy of a will illustrates real evidence; opinion of a witness about the testator's mental condition when

he made the will exemplifies personal evidence. Real evidence applies more to law than to college debates. The procedural methods in contest debate prevent extended use of real evidence.

7. Deliberative or casual. Deliberative evidence consists of premeditated statements by witnesses with knowledge of their intended use. Casual evidence consists of spur-of-the-moment statements without knowledge of their future use. If the newspaper reporter asks your opinion of the poverty program, you will strive for a carefully reasoned opinion because you realize that you may be quoted. If a friend asks the same question, you would probably answer without much deliberation.

Industry makes use of casual suggestions through "brain-storming sessions." Subjects are broached without warning and participants make spontaneous suggestions. Some industries claim valuable benefits from such programs. Deliberative evidence is used more extensively in debate than casual evidence because most published material is deliberative.

In summary, a knowledge of the legal classification of evidence should cause you to weigh your evidence carefully. You will rarely need to make fine distinctions among the kinds of evidence, but a knowledge of the distinctions will aid you in the choice and effective use of facts and opinions.

Tests of evidence

Review the test for each type of evidence discussed in chapter 8. In addition, consider the following general tests: source, quality, and quantity.

1. Sources of evidence. In evaluating evidence, first inquire into the source from which the material came. The source may be deficient because of prejudice or lack of qualifications.

Prejudiced evidence comes from organizations or persons affected by the outcome of a problem; they disseminate only evidence favorable to their cause. Ordinarily they do not present false evidence, but they omit facts prejudicial to their position. The American Manufacturers Association presents facts favorable to capital while labor unions present facts favorable to labor. The Nixon Administration attempted to play down the facts about Watergate; some news media enlarged on the facts. The White Citizens' Council publishes only facts unfavorable to social equality for blacks, while the National Association for the Advancement of Colored People seeks evidence favorable to social equality. Democracy operates through pressure organizations; almost all professional and business organizations make use of propaganda agencies. The student of argumentation, however, must learn to distinguish the biased evidence they disseminate from objective evidence.

The research divisions of universities and educational foundations conduct objective studies. They seek true-to-fact information only. The evidence they publish is not prejudiced or biased.

The source of evidence may also be questioned on its qualifications. The person must be qualified by training and experience to know the facts and to interpret them properly. A carefully researched history book written by a recognized historian has more prestige than one hurriedly written for popular consumption.

2. Quality of evidence. Evidence could meet the tests of source and still be unreliable; it may be inconclusive or inconsistent. A limited survey may indicate a probable conclusion, not statistical certainty. The public-opinion poll may be worthless because the persons questioned were not objectively chosen. The questions in an interview may have been phrased to indicate the desired answer. The quotation may have been lifted from its context so that it distorts the author's views. These and other unscientific methods may make the evidence unreliable.

Reliable evidence is consistent within itself and with evidence derived from similar studies. One source of evidence may contradict another. Two sets of price indexes showed a discrepancy of 10 percent in the cost of living. The discrepancy occurred because one source used the base years 1957–59 and the other used the years 1967–69. Several tobacco companies formerly advertised that their cigarettes contain less nicotine than any other cigarettes. Obviously all these conflicting claims cannot be true. The inconsistency could probably be explained if we knew the basis of each test. Discrepancies in statistical material usually result from the use of conflicting units. Evidence published by pressure groups sometimes seems inconsistent because they choose only those facts favorable to their position.

3. Quantity of evidence. How much evidence is necessary to prove a contention? Much depends upon the nature of the argument and the beliefs of the audience. The sufficiency of evidence makes a perplexing question in legal procedure. Varying standards have been formulated, such as "beyond a reasonable doubt," "beyond a shadow of a doubt," and "sufficient to prove to the average reasonable and prudent person."

Debaters may state conclusions that go beyond the evidence. Such practices as quoting one or two unqualified authorities, citing limited statistics, and giving one or two isolated examples do not provide sufficient evidence to prove a contention.

To prove that the energy crisis warrants rationing of gasoline would take considerable evidence. To prove that the crisis caused price increases for gasoline would take considerably less evidence. To prove that evils exist takes less evidence than to prove that the evils warrant a change.

The sufficiency of evidence also depends upon the beliefs of the audience. To prove that labor does not receive its just share of production would take less evidence for an audience of laborers than for an audience of industrialists. The adaptation of arguments to the beliefs of the audience should follow the analysis of the audience discussed in chapter 4.

In summary, although the sufficiency of evidence presents a difficult problem, it is better to err with too much than with too little. Corroborate one type of evidence with other types. Variety in both types and sources helps avoid the error of insufficient evidence.

PROOF OF THE PROPOSITION—REASONING

Suppose evidence shows that the United States system of education discriminates against superior students, encourages mediocre scholarship, makes ineffective use of facilities, and provides teachers of low caliber. What does this evidence mean? What caused this condition? How can the situation be remedied? The process of drawing inferences from evidence is termed reasoning. Evidence alone cannot establish a case; the proper relationship must be established between evidence and the conclusion drawn from it. Through inference we assess cause and effect relationships.

Argumentation appeals to understanding in order to influence belief. Conviction comes through reasoning. Logic distinguishes between good and fallacious reasoning. It tests the thinking processes to determine if they conform to established rules. Evidence and reasoning constitute the component elements of logic. This section shows how reasoning works with evidence to complete the process of logical proof.

Inductive and deductive reasoning distinguished

Reasoning may be classified broadly as inductive and deductive. Inductive reasoning proceeds from the particular to the general; from an examination of specific cases we draw a general conclusion on the basis of the cases examined. Deductive reasoning reverses the process; it proceeds from a general statement to a particular conclusion. Given a general statement, we examine a particular case of the classification contained in the general statement and draw a conclusion relative to the specific case. The following illustrates:

Induction

School enrollments have increased in New York.
School enrollments have increased in California.

School enrollments have increased in Illinois.
School enrollments have increased in Florida.
Therefore, school enrollments have increased in the United States.

Deduction

School enrollments have increased in the United States.
The Far West is a part of the United States.
Therefore, school enrollments have increased in the Far West.

The process of induction

Inductive reasoning takes two forms, perfect and imperfect. Through perfect induction all members of a class are examined; if certain characteristics are found to be common among them, we conclude that the characteristics inhere in the class. For example, we investigate the state governments of the fifty states of the United States and find that all have welfare programs. We conclude that welfare programs are characteristic of the states of the United States. In reality no reasoning is involved; the conclusion is based on established fact. It involves no inference from the known to the unknown. The process resembles scientific investigation; a general rule is established by examining all cases.

Imperfect induction involves reasoning; it draws a general conclusion from an examination of part of the class. For instance, we conclude that welfare programs are characteristic of the states from an examination of five representative states—Oregon, Kansas, Pennsylvania, Maine and Georgia.

The principal form of induction consists of reasoning by example, termed generalization. Reasoning by analogy and causal relation may also take the form of induction.

1. Reasoning by example—generalization. We generalize when we examine known instances of a class and draw conclusions regarding the entire class. If certain factors appear in the cases examined, we infer that they also exist in the cases not examined. The part represents the whole. For example, we infer that college debaters make superior academic records because we find this true at Northwestern, Harvard, Tulane, Stanford, and Kansas Universities.

If we assume that the five universities examined represent a true sampling of American universities, we establish a high degree of probability for our conclusion. We do not warrant that there are no exceptions, but we infer a probable general conclusion. To test the validity of generalization, apply the following tests:

Have a sufficient number of examples been given? The number of ex-

amples required for a generalization depends upon the proposition. For example, we would be justified in concluding that unemployment exists in the automobile industry by citing that this condition exists in Detroit, Dearborn, and Willow Run because they form the center of automobile manufacturing. If we wished to prove unemployment in all of American industry, we should have to add cities that have unemployment in a variety of industries. Usually the more cases cited, the stronger the generalization becomes. The fallacy of generalizing from too few instances is termed hasty generalization.

Are the examples representative of their class? The examples used for generalizing must be representative of those not used. You cannot generalize that all labor leaders are corrupt because a few have been exposed. That a few public officials have accepted bribes does not mean that the majority do. That prices have risen little in certain obsolete industries cannot be used to generalize that prices in general have not increased. To show the true index of prices, use representative examples like steel, clothing, and housing.

Can negative cases be discredited? Negative cases are exceptions to those chosen for generalization. Negative instances do not necessarily invalidate a generalization if they can be shown as exceptions to the general rule. Suppose you conclude by generalization that minor league baseball is decreasing in popularity. Your opponent gives an example of Columbus, Ohio, where attendance reached an all-time high during the previous season. If you can show that Columbus led the league in a closely contested race, you will explain away the exceptional case.

Negative instances must be accounted for if they exist in appreciable numbers. Otherwise your generalization will be weakened or possibly destroyed. In choosing examples for generalization, make sure that either few negative instances exist or that you can satisfactorily explain them.

2. Reasoning by analogy. For purposes of reasoning, analogy assumes that if two things are alike in germane known respects they will also be alike in unknown respects. We infer that the profit-sharing plan in Industry X will be successful in Industry Y because the two industries are similar in size and purpose. We reason that the honor system will be as successful in University X as it has been in University Y because the two universities are similar in size, curricula, student interests, and purposes. We infer that the resemblances in known particulars extend to unknown particulars. Apply the following tests:

Do the similarities outweigh the differences? A multiplicity of differences between the things compared may weaken the analogy. Conversely, that many similarities exist between two objects does not always warrant an inference that they are fundamentally alike. The

strength of the similarities counts more than the number. The comparisons are more qualitative than quantitative.

For example, in the analogy that a profit-sharing plan would be successful in Industry Y because it has been successful in Industry X, suppose that Industry Y is a marginal industry with little profits but that Industry X makes large profits. This major difference may outweigh many similarities. Irrelevant details cannot serve as the basis for a valid comparison regardless of their number. In using the analogy, check both the number and the importance of the points of similarity.

Can the differences in the cases compared be explained? Nonessential differences will not necessarily invalidate a comparison. For example, in the comparison that the honor system would be successful at University X because it has been successful at University Y, suppose that the two universities differ greatly in size of campus. This difference could hardly affect the success of an honor system because it has little to do with the point at issue.

On the other hand, suppose that University X has strict entrance examinations but University Y requires minimum academic standards. The opposing team could show the analogy to be false, for this difference applies specifically to the success of an honor system because it affects the quality of the student body. Superior students are less likely to cheat because they have little reason for cheating. In reasoning by analogy, show either that no differences exist between the things compared or that the differences are irrelevant.

3. Reasoning by causal relation. Reasoning from causal relation is based upon the universal belief in causation—nothing happens without cause. Normally, every effect must be produced by some cause and every cause will produce its effect. For example, we note that labor unions obtained wage increases; we infer an increase in the cost of living. We observe a bumper cotton crop and infer that the farmers received adequate rainfall. We read about increases in unemployment and infer decreases in production. These inferences are based upon observation of numerous past instances. We assume high prices during periods of prosperity because high prices have always paralleled prosperous times. Thus, causal reasoning is largely inductive in form because it depends upon generalization. Our acceptance of the conclusion depends upon observation of past instances. The principal methods of causal reasoning are from effect to cause and from cause to effect.

In effect-to-cause reasoning, we observe an effect and attempt to determine the cause. We contend that observed effects resulted from the cause or causes that we ascribe. The argument is from "what comes after" to "what has gone before." To illustrate, we observe fewer new automobiles

on the highways than formerly; we infer poor economic conditions. We observe an increase in juvenile delinquency; we infer a breakup in home life. We observe increased applications for unemployment compensation; we infer increased unemployment. We start with a known effect and attribute it to a specified cause or causes.

Effect-to-cause reasoning must establish a strong connection between the known effect and the alleged cause. For example, the teacher surplus may be attributed to decreased school enrollments. Equally important causes may be overemphasis on teacher training during the 1960s, poor general economic conditions, and the decrease in the space program that released aerospace workers and others qualified to be teachers. The probative force of argument from effect to cause depends largely upon the strength of the probability that no other cause or causes than those alleged could produce the known effect. Most effects result from several causes; beware of omitting contributory causes.

Reasoning from cause to effect infers an effect as probable because of operating causes sufficient to bring it about. We start with circumstances sufficient for a cause and infer what the effect will be. We note increased criticism of the party in power and infer a change in administration at the next election. We observe the plentiful rainfall and anticipate a bumper crop. Argument from cause to effect attempts to establish the most probable effect of operating causes. For example, decreases in taxes tend toward stimulation of business, but that factor alone may not be sufficient to combat recession. Programs for combating recessions include lessening of loan restrictions, increased government spending, and higher wages. In reasoning from cause to effect, make sure that the suggested cause is sufficient to produce the alleged effect.

A cause may be sufficient to produce an alleged effect but intervening conditions may prevent the cause from operating in its usual manner. For example, the wheat farmers anticipated low prices because of an oversupply of wheat, but the government adopted a price-support program. Normally, an oversupply of a product results in lower prices. In this case, the government's price-support program kept the cause from operating in its usual manner. If the opponent can show other forces sufficient to prevent the given cause from operating in its usual way, he can weaken the argument from cause to effect.

The process of deduction [4]

We learned in the preceding section that through induction we arrive at general conclusions by examining specific cases. Conversely, deductive

[4] A full development of the rules of deductive reasoning is beyond the scope of this chapter. For a fuller explanation, see Glenn R. Capp and Thelma Robuck Capp, *Principles of Argumentation and Debate*, chap. 9.

reasoning arrives at a particular conclusion about a specific case brought under the classification of a general rule. Deduction is a form of reasoning, not a method of argument. Thus we may reason logically from false premises and arrive at factually false conclusions. The deductive form does not test the validity of the premises. Unacceptable premises must be established by induction. Given two related statements, the deductive form arrives at a conclusion regarding their relationship.

1. The syllogism. The syllogism constitutes the principal form of deduction. It contains three propositions so arranged that the last can be inferred from the first two. These propositions are known as the major premise, minor premise, and conclusion.

The major premise takes the form of a general proposition. The minor premise brings a particular statement within the classification of the major premise. The conclusion relates to the particular case contained in the minor premise. The following illustrates:

Major premise: All basic industries have experienced price increases.
Minor premise: Steel is a basic industry.
Conclusion: Steel has experienced price increases.

2. The enthymeme.[5] Arguments in debate are rarely presented in formal syllogistic style. Either one of the premises or the conclusion is assumed. This incomplete type of syllogism is termed *enthymeme.* For example, the foregoing syllogism would be restated as follows:

Major premise: All basic industries have experienced price increases.
Conclusion: Steel has experienced price increases.

The minor premise, "steel is a basic industry," is assumed. In the same manner, the major premise or the conclusion may be assumed with the presence of the other two parts of the syllogism.

3. Sorites. Deductive reasoning may be expressed as a chain of reasoning termed *sorites.* This form consists of a chain of syllogisms or enthymemes with all but the last conclusion suppressed. For example.

High wages increase purchasing power.
Increased purchasing power causes expansion of production.
Expansion of production decreases unemployment.

[5] For a discussion of the enthymeme and probability, see James H. McBurney and Glen E. Mills, *Argumentation and Debate: Techniques of a Free Society* (New York: The Macmillan Company, 1964), pp. 145–51.

Full employment leads to inflation.
High wages lead to inflation.

REBUTTAL AND REFUTATION

An important part of debate consists of tearing down the arguments of the opposing side and rebuilding one's own arguments. The processes are termed rebuttal and refutation.

The terms *rebuttal* and *refutation* are sometimes used synonymously. One distinction should be understood: refutation consists of attacks on opposing arguments; rebuttal consists of attacks on one's opponent's arguments and the reconstruction of one's own arguments. In formal debates, separate speeches are assigned for rebuttal as distinguished from the constructive speeches. Refutation may be an important part of both the constructive and rebuttal processes.

Methods and forms of refutation

You may weaken your opponent's arguments by attacking either the reasoning or the evidence, or both. Errors in reasoning are termed fallacies. Fallacies are committed by violating any of the tests for reasoning discussed in the preceding two sections of this chapter.

Errors in evidence may be committed by violating the rules of evidence explained in chapter 8 and in the second section of this chapter. You may show the insufficiency of your opponent's evidence, its misapplication, its inaccuracy, or its unreliable source.

Rebutttal arguments may be classified as follows:

1. Reduce an argument to an absurdity. This form, termed *reductio ad absurdum,* assumes the truth of an opponent's statement, extends the argument to its ultimate conclusion, and shows the absurdity of it. For example, your opponent argues that the United States should not adopt the principle of selective education because it is an untried plan. By the same process of reasoning, we should never have attempted public education, coeducation, or mass education because they were untried plans when adopted, for all original proposals are untried. The absurdity of the argument appears by extending the reasoning to its logical conclusion.

2. Reduce an argument to a dilemma. The dilemma claims an argument leads logically to only two conclusions, each untenable. The two untenable alternatives become the horns of the dilemma. The classic example, "Have you quit beating your wife?" illustrates the dilemma. If you answer "yes," you admit you once did beat her; if you answer "no," you imply you are continuing the practice.

To illustrate, suppose your opponent argues that to improve education, the United States must either increase revenue or divert to education funds now used for space development. You argue that either procedure would be unsatisfactory; thus, no satisfactory method remains for increasing revenue.

3. Expose inconsistencies. An inconsistency contains a contradiction within an argument or between arguments. Inconsistencies apply either to reasoning or to the presentation of evidence. If your opponent claims mass education is superior to selective education in one argument and then later claims that many cities are correcting the evil of mass education through adopting selective-education plans, you can weaken his argument by pointing out that the one contention contradicts the other.

4. Appropriate opposing arguments. The process of appropriating opposing arguments may be called "turning the tables." By this method, you interpret the evidence or the reasoning of your opponent so as to prove your contentions. To illustrate, your opponent claims that the United States extends education to the masses and thus discriminates against superior students. You counter that best results accrue in a democracy from educating the masses and that a system of mass education need not discriminate against superior students. Education can be extended to the masses with special consideration for superior students through honors programs. Thus, you appropriate an opponent's argument to prove your case.

5. Expose opposing arguments as irrelevant. You expose an opponent's argument as irrelevant by showing that it does not advance his case. This method is sometimes called the "so what?" method; granted the argument, what does it prove? For example, your opponent claims that rural sections do not have schools comparable to urban areas; thus, the American system discriminates against rural communities. You counter by claiming this charge irrelevant. Students from rural districts are transported to the better schools in urban areas. They receive superior training without the added cost of maintaining expensive facilities in sparsely settled districts.

PREPARING FOR REBUTTAL AND REFUTATION

Although final organization of rebuttal points must be made during the debate, some preparation can be made in advance. You can anticipate many of your opponent's arguments and plan your answers. This prior preparation may take the following forms:

1. Through analysis, decide on the possible arguments of your opponent.
2. Plan possible methods of attack on each anticipated argument.
3. List reasons and assemble evidence on each anticipated point.
4. Decide on methods of attacking specific items of evidence.

Let your plans remain adaptable to your opponent's specific arguments. Your prior plans and preparation should enable you to adapt to your opponent's arguments during the debate.

Organize your rebuttal points into a logical sequence of ideas during the debate. Do not take notes in a haphazard manner, but group your points under headings of main issues. Answer all arguments pertaining to an issue before proceeding to the next issue.

Each rebuttal point includes three steps: introduction, body, and summary. In introducing a rebuttal point, make clear what point you plan to refute and the issue to which it pertains. In the body of the point, present reasons and evidence to refute your opponent's argument and to rebuild your own. In summary, show clearly wherein your refutation has weakened your opponent's argument and the status of the debate as the result of your refutation.

SUMMARY

Many problems are solved through conferences in a democracy. If they cannot be solved in this manner, debate must be employed to settle the conflict.

To participate effectively in debate, you must understand certain procedural principles: (1) prima-facie case, (2) burden of proof, (3) right of definition, (4) right of setting forth issues, (5) burden of rebuttal, and (6) no new issues in rebuttal speeches.

Debate requires a proposition. There are three types: fact, value, and policy. Policy questions are best for debate. The question must be phrased properly, as follows: (1) in resolution form, (2) for equal balance of arguments, (3) as an affirmative resolution, (4) to include one central idea, (5) to avoid ambiguous and prejudiced terms, and (6) to restrict its scope.

Through analysis the main issues emerge; they include three types: potential, admitted, and real. The steps in analysis include: (1) determining present significance of topic, (2) studying its origin and history, (3) disposal of irrelevant and admitted matter, (4) interpretation of the proposition, (5) discovery of the underlying philosophy, and (6) contrast of affirmative and negative main contentions.

Evidence constitutes an essential part of logical proof. Evidence consists of facts and opinions. Evidence may be classified as (1) direct or circumstantial, (2) oral or written, (3) expert or ordinary, (4) original or hearsay, (5) positive or negative, (6) real or personal, or (7) deliberative or causal. To test evidence, consider its source, quality, and quantity.

Reasoning forms a component part of logical proof. Reasoning may be broadly classified as inductive and deductive. Inductive reasoning proceeds from the specific to the general and includes reasoning by example, analogy, and causal relations. Deductive reasoning proceeds from the general to a specific conclusion and takes the form of the syllogism. The enthymeme and sorites are other methods of deductive reasoning.

Rebuttal and refutation form an essential part of advocacy. Refutation may question evidence or reasoning, or both. Rebuttal points may take the form of (1) *reductio ad absurdum,* (2) exposing a dilemma, (3) exposing inconsistencies, (4) appropriating opposing arguments, and (5) exposing irrelevant arguments. Rebuttal points should be organized during the debate. General preparation for rebuttal should be made before the debate.

QUESTIONS

1. Explain briefly the following procedural principles of debate: (1) burden of proof, (2) prima-facie case, (3) burden of rebuttal, and (4) right to interpret the proposition.
2. Distinguish among fact, value, and policy propositions. Discuss the requirements for phrasing a debate proposition.
3. Define and explain analysis of a proposition. Explain the steps in the process of analysis.
4. Distinguish between evidence and reasoning as they relate to logical proof. What are the principal tests for evidence?
5. Differentiate between rebuttal and refutation. Explain several forms that refutation may take.

ASSIGNMENTS

For your oral assignment you have a choice of two plans. The choice should be made by vote of the class upon recommendation by the professor. If class time permits, both exercises should prove profitable. Plan A requires less class time and is probably more interesting. Plan B permits more individual participation.

1. Plan A includes the following steps:
 a. Organize the class into a legislative assembly. Let each member of the class suggest topics for a debate. Discuss the suggested topics in class and select one, by vote if necessary.
 b. Conduct a public-opinion poll among class members to determine their attitudes toward the selected topic. On the basis of this poll, divide the class into three sections: (1) those favorable to the proposal, (2) those opposed, and (3) those who are neutral. The favorable and opposed group should be near the same size. The neutral group may be smaller.
 c. Seat the favorable group on the left side of the classroom; they constitute the liberal party. Seat the opposed group on the right side of the classroom; they are the conservatives. Seat the neutral group in the rear of the classroom; they hold the balance of power.
 d. Elect a chairman from the neutral group, preferably one who understands parliamentary procedure. Through an understanding with the neutral group he shall see that no motion to adjourn, to table the motion, or to cut off debate will receive a favorable vote until near the end of the class period.
 e. The liberals introduce the proposition, move its adoption, and speak for it in an opening speech of not more than eight minutes. Next, the chairman recognizes the leader for the opposition for a speech of not more than six minutes. Thereafter, he recognizes alternating speakers for each side who will be limited to four-minute speeches. A timekeeper should be appointed from the neutral group.
 f. Near the end of the class period the chairman will see that the measure is brought to vote. The neutral group will vote individually on the basis of which side did the most effective debating. In case of a tie the chairman may vote.
 g. Members of the neutral group may ask questions of either side but shall not speak to the issue unless they join one side during the debate. In that event they give up their neutral position.
2. Plan B calls for individual debates on different topics selected by the class:
 a. Form two-member teams, the number depending on the size of the class. Assign an affirmative and a negative team to each proposition.
 b. Each speaker shall have a seven-minute constructive speech and a three-minute rebuttal speech. The affirmative shall speak first in the constructive speeches and the negative first in rebuttal.
 c. The class shall vote at the conclusion of the debates on the basis of which side did the most effective debating, not on their beliefs on the proposition.

READINGS

ABERNATHY, ELTON, *The Advocate: A Manual of Persuasion.* New York: David McKay Co., 1964.

CAPP, GLENN R., and THELMA ROBUCK CAPP, *Principles of Argumentation and Debate.* Englewood Cliffs, N.J.: Prentice-Hall, 1965.

COURTNEY, LUTHER W., and GLENN R. CAPP, *Practical Debating.* Philadelphia: J. B. Lippincott Co., 1949.

EHNINGER, DOUGLAS, *Influence, Belief, and Argument.* Glenview, Ill.: Scott, Foresman, 1974.

EHNINGER, DOUGLAS, and WAYNE BROCKRIEDE, *Decision by Debate.* New York: Dodd, Mead, 1963.

FREELEY, AUSTIN J., *Argumentation and Debate: Rational Decision Making,* 3rd ed. Belmont, Ca.: Wadsworth Publishing Co., 1971.

RIEKE, RICHARD D., and MALCOLM O. SILLARS, *Argumentation and the Decision Making Process.* New York: John Wiley, 1975.

THOMPSON, WAYNE N., *Modern Argumentation and Debate: Principles and Practices.* New York: Harper & Row, Publishers, 1971.

————, *The Process of Persuasion: Principles and Readings.* New York: Harper & Row, Publishers, 1975.

WALTER, OTIS M., *Speaking Intelligently: Communication for Problem Solving.* Riverside, N.J.: Macmillan Publishing Co., 1975.

FIFTEEN

Communication for special occasions

The principles of public communication discussed in this book apply to messages for all occasions. We have applied them to the basic types of messages—informative, persuasive, and argumentative. In this chapter we apply the principles to special types of messages and make suggestions for their composition and delivery. Although some informal and small-group communication situations call for these special types of messages, they apply primarily to public-communication situations. Our discussion will include the following types of speeches: introduction, welcome and response, presentation and acceptance, eulogy and dedication, after-dinner speeches, and radio and television messages.

THE SPEECH OF INTRODUCTION

Speeches of introduction are made on almost all speaking occasions except those like religious services, classroom lectures, and workshop programs that have permanent lecturers. Despite their frequent use, speeches of introduction are often poorly done. Two examples illustrate: A professional organization employed a principal speaker for its convention. The speaker was allotted 45 minutes at a breakfast session, but the toastmaster took 20 minutes to introduce him. The toastmaster made such extravagant statements about the speaker's qualifications that he embarrassed him. He anticipated the speaker's address and stated his own views on the subject. He talked about himself, his experiences, his accomplishments; finally, he made several unsuccessful attempts at humor. Most objectionably, he talked much too long.

On another occasion, the superintendent of schools in a small town introduced the commencement speaker as follows:

> *We are happy to have Professor Jones as our speaker tonight. I know nothing about him since I met him only a few minutes ago. He was secured by the commencement committee. However, he should be good because he has been a speech teacher at Poe University for more than twenty years. I had better turn the meeting over to Professor Jones now before I reveal my own poor speech; speech teachers make me nervous. Anyway, the college that I attended—how many years ago is top secret—didn't teach expression. Professor Jones is such a permanent fixture around these parts, however, that he needs no introduction. Professor Jones, it's all yours.*

These two speeches exemplify most of what is bad in speechs of introduction, and little that is good. Unfortunately, they are real instances, not hypothetical. How can we avoid the mistakes of these negative examples? Consider the following discussion.

The purpose

The purpose of the speech of introduction is threefold: (1) to create a pleasant atmosphere, (2) to give the qualifications of the speaker, and (3) to stress the importance of the subject. The introducer should not be the "life of the party," call attention to himself, or anticipate the speaker's speech. Consider the introducer as the advance agent of the speaker; he should unobtrusively increase the audience's respect for the speaker. The audience should hardly be aware of the introducer, because he should center attention on the speaker.

On some occasions, it may not be necessary to stress all three purposes listed above. For example, prior events on the program may have created the proper atmosphere; the speaker may be well known to the audience; the importance of the subject may be obvious. The introducer must analyze the speaking situation and adapt his speech to prevailing conditions.

Suggestions for preparation

What principles can we isolate from the foregoing examples of poor speeches of introduction? Four positive and four negative suggestions follow:

1. Consult the speaker. Consult the speaker for ideas he might like included and for advice on what you plan to say. Be a good host to

the speaker. Be prepared to answer his questions about the audience and the occasion and to provide materials that he might request.

2. Make the speech of introduction a separate speech. Do not make the speech a part of announcements or expressions of courtesy. If the presiding officer does not know the speaker well, he may ask an acquaintance or a close associate of the speaker to introduce him. If the chairperson presents the speaker, he should make a transition from his previous remarks to the speech of introduction; for example, "Now we come to the main feature of our program—the principal speaker. I shall present him at this time."

3. Be brief but thorough. The length of the speech depends on how well the speaker is known to the audience; the better known the speaker, the shorter the introduction. Because of the prestige of the president of the United States, he is usually presented simply as "Ladies and gentlemen, the president of the United States." Yet to present a less-known person so briefly shows poor taste and leaves the audience dissatisfied. Unless the listeners already know about the qualifications of the speaker, the introducer should state them. The length of the speech of introduction will, therefore, vary with the circumstances. If you should introduce the president of your university to a campus organization, you would need few qualifying statements. If you presented him to a club in your home town, you would need to say more. Rarely should the speech of introduction run less than 30 seconds or more than three minutes.

4. Use humor in good taste. The introducer may create a pleasant atmosphere by the judicious use of humor. Humor should never be used, however, to depreciate the qualifications of the speaker or to minimize the importance of the subject or occasion. Humor can help set the keynote of a meeting. Ask yourself, "What atmosphere would serve the speaker best?" If he plans an entertaining speech, use humor in the introduction. If he plans a serious speech, use humor sparingly.

5. Do not overpraise the speaker. To attempt to make an ordinary mortal appear superhuman embarrasses both the speaker and the audience. Stress the speaker's qualifications and prestige with restraint and in good taste. Avoid flowery language, extravagant claims, and an effusive manner.

6. Do not talk about yourself. As the introducer, you are the agent of the main speaker, not the main speaker. You succeed in proportion to how well you cause the audience to respect the speaker, not to how well the audience thinks you speak. Statements about your previous

association with the speaker may help establish a bond between you, the speaker, and the audience; but such statements should enhance the speaker's prestige, not yours. One introducer told about an incident when he was president and the speaker was vice-president of their class in college. This incident obviously violates the principles discussed here.

7. Do not stress the speaker's speaking ability. Such statements as "The speaker should be good because he teaches speech" or "The speaker has established an outstanding reputation as an orator" put the speaker at a disadvantage. The listeners will likely center their attention on the speaker's skills instead of his ideas. Stress the speaker's training, experience, and honors; avoid mention of his speaking ability.

8. Avoid trite and hackneyed language. Speeches of introduction often include worn-out phrases, such as "The speaker needs no introduction," "It gives me great pleasure," "I am pleased and honored," "I consider it a unique privilege," "It is appropriate to this auspicious occasion," and "I am too pleased for words." Use fresh and original expressions appropriate to the occasion.

The arrangement of ideas

Organize the speech of introduction through four steps: (1) direct attention to the occasion, (2) focus attention on the speaker, (3) stress the importance of the subject, and (4) present the speaker. These steps can best be accomplished by the traditional organizational pattern—introduction, body, and conclusion.

1. The introduction. In the introduction, catch the immediate interest of the audience and set the keynote for the speech to follow. Use any of the methods explained in chapter 9 for these purposes. For example, the late Irving T. Bush, president of Bush Terminal Company of New York City, opened his speech introducing former Chief Justice Charles Evans Hughes with humor: "I have always thought that the ideal introductory speech was that of a certain gentleman of German extraction from the Middle West who was asked to introduce the senator of his state. He said, "I am asked to introduce Senator Jones who will speak to you. I have done it. He will do it.' " [1] Former Ohio State University Professor Henry R. Spencer's opening sentence when introducing columnist and Pulitzer prize-winner Anne O'Hare McCormick was: "If this is a man's world, we have surely made a mess of it. But as

[1] W. P. Sandford and W. H. Yeager, *Business Speeches by Business Men* (New York: McGraw-Hill Book Co., 1930), p. 697.

we are young we are resolved to learn, and we turn therefore to the other sex." [2]

2. The body. In the body of the speech, present information to increase the prestige of the speaker and to enhance interest in the subject. Tell about the speaker—his position, his training, his experiences, and any honors or distinctions that increase his prestige. If the speaker has traveled widely, written books, or headed important enterprises that bear on his subject, stress these points. Show the importance of his subject to the audience, but do not try to anticipate how the speaker will develop his subject or to express your opinion about it. If your opinion about the speaker's subject differs from his, expressing it might make his task more difficult. Arrange your points in climactic order, ending with the presentation of the speaker.

3. The conclusion. As the final step, present the speaker and give the title of his speech; for example, "I present Mr. Joe Doe, who will speak on the subject, 'Hook Your Wagon to a Star'—Mr. Doe"; or "For a discussion of the important subject, 'Government in Business,' I present Senator Peter Poe."

The manner of presentation

Effective presentation follows the suggestions made in part 3—reasonable poise, pleasing and intelligible voice, uninhibited bodily action, and communicative language. Enthusiasm, tact, and sincerity should characterize your manner. Do not read a speech of introduction. Speak extemporaneously from a mental outline with as original an approach as you can devise.

Sample speech

The following speech of introduction was given at the annual banquet of the Baylor University chapter of the American Association of University Professors. The principal speaker was known by some members of the audience, but not intimately.

"If a man be endowed with a generous mind, this is the best kind of nobility." This statement by Plato characterizes our speaker for tonight. Dur-

2 William Hayes Yeager, *Effective Speaking for Every Occasion* (Englewood Cliffs, N.J.: Prentice-Hall, 1951), p. 127.

ing the more than twenty years that I have known Dr. Sartain, I have become increasingly impressed, not only with his generous and penetrating mind, but with his kindly spirit.

A risk that one runs in introducing a cherished friend is that he may deal in extravagant statements. I find myself in somewhat of a paradoxical situation this evening because a simple factual recital of the training, accomplishments, and contributions of Dr. Sartain appears to be overstatement. I am tempted to dwell at length on such matters as these:

1. His writings, which include co-authorship of a recent textbook, Human Behavior in Industry, *his forthcoming textbook to be published by Prentice-Hall, and numerous articles in professional journals.*

2. The important positions which he has held at Southern Methodist University, where he was first the director of forensics, later professor of psychology, and now is chairman of the Department of Personnel Administration. He also has more than a passing interest in Baylor University, having taught recently as visiting professor in our summer session.

3. His membership in important organizations. For example, he served recently as president of the Southern Methodist University chapter of the American Association of University Professors. He is president of the Southwestern Psychological Association, a fellow of the American Psychological Association, and a member of the Association for the Advancement of Science.

Rather than dwelling on these matters, may I say simply that I congratulate you for securing Dr. Sartain for this occasion. In my association with Dr. Sartain, I have been impressed with the excellence of his forensic teams but even more with him as a man—his pleasant disposition, his sense of fair play, his high ethical standards, and his ability as a scholar. I present to you my friend and the friend of all teachers—Dr. A. Q. Sartain.[3]

THE SPEECH OF WELCOME

Numerous occasions in our modern society call for speeches of welcome. Most of us belong to several organizations which sponsor meetings that call for speeches of welcome. The principal occasions are these: (1) conventions of professional organizations; (2) meetings such as homecoming gatherings, speech tournaments, workshops, institutes, orientation programs, and career-day programs; (3) ceremonies for welcoming a distinguished guest to a city; and (4) programs for welcoming new members to an organization. Speeches of welcome to convention delegates and distinguished guests are usually made by public officials; for special gatherings and for welcoming new members to organizations, the president of the sponsoring group often makes the speech.

[3] Unpublished speech, Glenn R. Capp.

The purpose

The purpose of the speech of welcome is twofold: (1) to express appreciation for the organizaton or person welcomed, and (2) to create goodwill. Look upon the speech as a public act of courtesy; the host desires to establish friendly relations with the visiting organization. The speaker should indicate by his manner and words that he considers the meeting important and he hopes it will be profitable for the visitors. The sentiment expressed should be genuine, the manner pleasant, and the spirit friendly.

Suggestions for preparation

Speeches of welcome are often stereotyped and perfunctory, especially when given by busy public officials. To keep them individual and original, consider the following suggestions:

1. Use tact and good taste. Try not to leave the impression that you are performing a routine assignment or that the meeting imposes on your time. If you must leave immediately after your speech, have the chairperson comment on the reasons; for example, "Thank you, Mayor Jones. The mayor has a council meeting at ten o'clock. We hope that he may have the opportunity to drop in on some of our future sessions." If possible, remain for a few minutes until there is a break in the meeting; then leave as unobtrusively as possible.

2. Be optimistic and enthusiastic. Speeches of welcome are usually arranged for the opening sessions of conventions or at the beginning of programs when new members are received into organizations. These speeches usually precede other expressions of courtesy, explanations, and announcements. Opening sessions aim at creating a friendly and optimistic atmosphere; they set the keynote for future sessions. The speech of welcome should conform with this purpose.

3. Make the speech brief. Rarely should the speech of welcome exceed five minutes except when included as part of a principal address. When it is so arranged, the speaker gives the welcome as a part of the introduction to his principal address. The length of the speech of welcome depends in part on how closely the speaker is associated with the sponsoring organization. For example, if the mayor of a city gives the welcoming speech to a convention of educators, the speech normally will be brief; if the president of the local university gives the speech, it will perhaps be longer because of the community of interests between the

president and the delegates. On some occasions, two or more speeches of welcome may be arranged representing different interest groups. For example, both the mayor of the city and the president of the local university may welcome the convention of educators. For occasions that have multiple speeches of welcome, brevity becomes increasingly important.

4. Avoid emotionalism. Although optimism and friendliness should characterize the speech of welcome, emotionalism has little place in it. For occasions that welcome convention delegates and workshop participants, the mood may be somewhat dignified and formal. For ceremonies that welcome a guest to a city, the program may take the form of a ritual. Little cause for emotionalism exists. Conversely, meetings such as homecoming gatherings, reunions, and programs for welcoming new members lend themselves to emotionalism. To guard against excessive emotionalism on such occasions, keep your remarks in a light vein; inject well-chosen humor and emphasize the festive nature of the occasion.

5. Avoid flowery platitudes and stereotyped forms. The following objectionable expressions have been noted in speeches of welcome: "You people are the salt of the earth." "Our hearts glow with pride because of what you have accomplished." "Welcome back to your dear old alma mater." "You represent the Alpha and Omega of all that is good." "I know you will work like a Trojan, but . . ." "A Herculean task confronts you." "There are no losers in a speech contest." "Like the sword of Damocles . . ." "Let's make them eat crow." "Let us not rob Peter to pay Paul." "We find ourselves on the horns of a dilemma." "Yours is no fool's paradise." Although such forms are expressive, they have lost their force through overuse. Attempt to make the speech of welcome novel, fresh, and alive; avoid overpraise and exaggeration.

The arrangement of ideas

The speech of welcome calls for novel and original treatment; as in the speech of introduction, this can be achieved best within the framework of the traditional pattern—introduction, body, and conclusion.

1. The introduction. Attempt to capture the attention and interest of the audience with your opening statement; for example, one public official began his speech to a convention of funeral directors with, "I presume you have come to praise Caesar, and not to bury him." A mayor began his speech at a convention of theater teachers with "All the world's a stage; the mayors simply give speeches of welcome." Another public official opened his speech to a workshop of law-enforcement of-

ficers with "I understand there are two types of pedestrians—the quick and the dead."

Indicate for whom you speak. Speeches of welcome are made in behalf of an organized group—a city, a university, another organization—or by the representative of the sponsoring organization to its various branches. Identify your relation to that group unless the chairperson does so in introducing you.

2. The body. The body of the speech should perform two functions: (1) express appreciation for the group welcomed, and (2) give information about the place where welcomed. Seek out the philosophy behind the organization welcomed; learn about its background and history, and facts about its aims and purposes; demonstrate your knowledge of these facts by complimenting the visiting organization. Tell about the city or organization which you represent—places of interest which the delegates may visit, recreational facilities, and unusual places to eat. In short, pay tribute to both the visiting delegation and to the organization that welcomes them.

If an out-of-town representative of the sponsoring organization welcomes the convention delegates, he would omit information about the local city and would stress the purpose of the meeting and the common aims of the delegates. If a local person preceded him with a speech of welcome, the organization's representative would reply briefly by expressing appreciation to the local speaker before giving his speech welcoming the delegates.

3. The conclusion. Conclude the speech of welcome by expressing hope that the meeting will be successful, by pledging the cooperation of the welcoming organization, and by inviting the delegates to return for a future meeting. James G. Stewart, the mayor of Cincinnati, ended his speech with, "And we hope you will like it [Cincinnati] so much that, in the words of the late President, 'you will come here again, again, and again.' " [4]

The manner of presentation

In presenting the speech of welcome, use all the principles of effective voice, bodily action, language, and poise previously discussed. The manner should be sincere, cordial, and gracious. Make the spirit fit the occasion. Use direct, conversational, communicative speech without oratorical flourish.

[4] Yeager, *Effective Speaking for Every Occasion*, p. 134.

Sample speech

The following speech of welcome was given at the twenty-fifth annual high school speech tournament sponsored by Baylor University.

We welcome you this morning to our twenty-fifth birthday celebration— to the original and oldest college-sponsored tournament in Texas for high schools. Since the first meeting in the spring of 1935, the tournament has grown to perhaps the largest debate tournament held annually in the United States. This year we have 958 registered speakers and an additional 250 forensic directors, chaperons, and alternate speakers—a total attendance of over 1,200.

The 324 debate teams and 652 speakers in the other speaking contests will require 866 judging assignments and 162 contest rooms. You may wonder how all these facilities are possible. They would not be possible without the co- operation of a large number of people. The tournament is now sponsored jointly by Baylor University, Waco High School, and the Heart O' Texas Lions Club; also cooperating are the Waco Chamber of Commerce, the News Tribune *and* Times Herald, *Waco civic clubs, the Waco Hotel Association, and the Seventh and James Street Baptist Church.*

You may wonder why we would go to all the trouble. The answer is partly selfish—we would like to have many of you as future students. Further, we think you are engaged in an extremely worthwhile activity. I agree with the famous American philosopher Alexander Meiklejohn when he said, "It seems to me that stronger than any other group, tougher in intellectual fiber, keener in intellectual interest, better equipped than any others to battle with coming problems are the debaters—the students who, apart from their regular studies, band themselves together for intellectual controversy with each other and with their friends from other schools."

The large folders of letters of appreciation which I have in my files from former participants and from my own favorite ex-debaters proclaim that the activity is more than worthwhile. Numbered among these letters are those from United States Senators, ambassadors to foreign countries, college presi- dents and teachers, the owner of a fifty-million-dollar corporation, and min- isters, lawyers, and doctors of prominence. Almost without exception, these former students testify to the interest created by the competition for the loving cups which you see on display here on the stage. More important, they testify to the permanent assets received from their training in forensics. These bene- fits will be remembered long after you have forgotten whether you won or lost. We welcome you this morning to membership in the distinguished club of more than twenty thousand former participants in this meeting. We wish for you both a pleasant and profitable visit in our city and on our campus.[5]

5 Unpublished speech, Glenn R. Capp.

Reply to speech of welcome

Some occasions call for a response to a speech of welcome; others do not. At conventions the presiding officer usually thanks the speaker and the sponsoring organization in behalf of the convention. Responses are rarely made to speeches of welcome on occasions such as workshops, institutes, tournaments, and festivals or to a speech welcoming several new members into an organization. If the speaker singles out one person for extended praise or if a city welcomes a distinguished guest, a response is expected.

The speech of response follows the same general principles as the speech of welcome. The speaker should respond to the mood created by the speech of welcome. Normally, he should arrange his ideas in the following order: (1) Indicate for whom he speaks if he represents a welcomed group. (2) Express appreciation for being honored. (3) Compliment the group that gives the welcome. (4) Express pleasant anticipations for the meeting or for the personal honor.

Although the speech of reply must remain adaptable to the speech of welcome, it should not be impromptu. Plan the speech in advance and make whatever changes seem advisable at the moment. The speech should be brief, cordial, and sincere.

THE SPEECH OF PRESENTATION

Many occasions call for speeches of presentation. Civic organizations honor citizens for outstanding service to the community; industrial and educational institutions honor employees for years of service when they leave their places of employment or when they retire; universities and colleges confer honorary degrees on outstanding citizens; fraternal and service organizations present earned degrees and awards for superior accomplishments; schools, clubs, and industries award scholarships, medals, trophies, and plaques for competitive winners; and political organizations honor public officials upon retirement from office. Almost all of these occasions call for speeches of presentation and the awarding of symbolic tokens of appreciation.

The purpose

The purpose of the speech of presentation is threefold: (1) to honor the recipient, (2) to honor the donor, (3) to increase morale in an organization. Tribute to the recipient constitutes the primary purpose, because

the person or organization making the presentation desires to reward faithful service and outstanding accomplishment. Tribute to the donor recognizes those who have supported the organization by making the awards possible. By suggesting attributes of the recipient and the donor that others may emulate, the speaker may enhance the spirit and morale of others.

Suggestions for preparation

Speeches of presentation allow for more individual differences than do most speeches for special occasions because of the variety of occasions that use them. The suggestions that follow apply generally and can be adapted to these occasions.

1. Know the recipient. The speech of presentation may be cold and impersonal unless the speaker knows the recipient well. To create a friendly spirit and improve morale, the speech must show warmth and sincere feelings of appreciation. If the presiding officer does not know the recipient well, he should appoint someone familiar with his virtues to make the presentation speech. For competitive awards, the director of the program or the donor should make the presentation speech. Above all, the speech should be personal; stereotyped speeches of presentation are easily detected.

2. Know the occasion. The speaker should be familiar with the occasion, the origin and history of the award, and the standards by which one qualifies. On one occasion the president of a university agreed to present the awards in a competitive speech tournament. He arrived late and apparently without proper instructions. His speech revealed that he knew little about the meeting; he was not aware of the distinction among the various awards or the basis upon which they were awarded. The winners felt disappointed because they did not receive appropriate recognition. An understanding of the occasion makes for a successful presentation speech.

3. Show proper restraint. Speeches of presentation sometimes tend to overpraise and exaggerate. Service awards, competitive trophies, and scholarship honors are usually given annually; although the winners should be congratulated, they should not be praised too highly. Beware of emotionalism when presenting awards to persons upon their retirement. Emphasize the happy side, inject well-chosen humor, and keep the spirit of the occasion light. Restraint is important on most occasions, but especially when making speeches of presentation.

4. Recognize the losers. Often competitive events are won by the

narrowest of margins. The bounce of the ball may decide the football game; the system for breaking ties may determine the oratory winner; the peculiarities of the judge may decide the band competition; and a figurative toss of the coin may award Miss America her title. Although we seem committed to deciding the "champion," most people recognize that chance is often a deciding factor. Without detracting from the honor of the winners, bring the losers into your speech for recognition.

5. Speak briefly and extemporaneously. There is little need for long speeches of presentation. The length will vary with the occasion, but brevity has its merits regardless of the occasion. When presenting awards of the same type to several persons, make one presentation speech; then have the recipients come forward for their awards without additional speeches. When you honor one person on his retirement or because of unusual accomplishments, the presentation may be a part of a major address; the presentation usually comes at the end of the address.

Rarely should a speech of presentation be read. Parts of the speech may be read without prejudice, such as special citations or the standards for the award; but the overall approach calls for extemporaneous speech. A spirit of spontaneity and informality can best be achieved by speaking extemporaneously.

The arrangement of ideas

The organization of speeches of presentation may vary with the type of occasion and the intent of the speaker. The following general instructions follow the pattern of introduction, body, and conclusion.

1. The introduction. Capturing attention and holding interest usually present little problem with speeches of presentation. The spirit of enthusiasm of the occasion performs these functions. The introduction should give pertinent information about the award—its origin and history, including the standards upon which the award is made, the name of the donor, and the names of previous winners.

2. The body. The body should be organized to bring out three factors: (1) the virtues and accomplishments of the recipient, (2) appreciation for the donor, and (3) a brief description of the gift or award. Support these points with specific information. In praising the recipient, give instances of his deeds and virtues; show how the donor has advanced a worthy cause by his award; display the award and explain its significance.

3. The conclusion. In concluding the speech of presentation, call the recipient forward, congratulate him, and shake his hand as you

present the award. Then express your appreciation of the recipient in your closing statement. For example:

> *In behalf of all civic clubs in the city, Dr. Doe, we express our sincere appreciation for your pioneering work in establishing the Civic Welfare Center. To show our love and appreciation, and to make your future work a little easier, we present you with these keys to a new automobile which is now parked in front of this banquet hall. With this token of appreciation go our best wishes for your continued success.*

The manner of presentation

Let your manner of speaking reflect sincere sentiment. Speak in a conversational, communicative style without flowery language or an effusive manner. Call the recipient forward at the conclusion of your speech; to keep him standing while you speak may be awkward and embarrassing to him. Identify the award, and do not obstruct its view as you present it. Put into practice the principles of voice, bodily action, poise, and language discussed in part 3.

Sample speech

The following speech awarded the honorary degree of Doctor of Laws to Mr. Joe L. Allbritton, a distinguished alumnus of Baylor University, at its annual commencement exercises on May 22, 1964.

> *Mr. President, Members of the Board of Trustees, Members of the Graduating Class, Ladies and Gentlemen:*
>
> *I take more than the usual pleasure in presenting Mr. Joe Allbritton for the degree of Doctor of Laws because he is one of my favorite former students who has remained a cherished personal friend since his college days. I first recognized Mr. Allbritton's unusual ability while he was still a high school student, a debater for Sam Houston High School in Houston. A special invitation to him to come to Baylor resulted in four years of pleasurable association in a student-teacher relationship. In the fifteen years since his graduation I have watched his unusual successes with increasing pleasure and pride—for no greater satisfaction can come to a teacher than to observe the successes of his former students.*
>
> *Mr. Joe L. Allbritton was born on December 29, 1924, at D'Lo Simpson County, Mississippi, the son of Lewis A. Allbritton and Ada Carpenter Allbritton. He attended public schools in Houston, Texas, and was graduated from Sam Houston High School in 1942. After attending Baylor University for one year, he joined the Navy in which he served for three years. After*

World War II, he returned to Baylor where he received the LL.B. degree in 1949, and was admitted to the Texas Bar the same year.

Mr. Allbritton is honored first for his accomplishments—both in the field of business and the professions. Time prevents naming all of them but among his accomplishments are: (1) chairman of the board, Pierce National Life Insurrance Company, Los Angeles; (2) president and director, San Jacinto Savings Association, Houston; (3) chairman of the board, Mineral Oil Refining Company, Dickinson, Texas; (4) chairman of the board, Pierce Brothers Mortuaries, Los Angeles; (5) partner in the law firm of Allbritton, McGee, and Hand, Houston; (6) director, Bank of the Southwest, Houston. For his accomplishments, Mr. Allbritton ranks high.

Second, Mr. Allbritton is honored because of his contributions to civic, educational, and religious enterprises. In many ways what a man contributes to his society in time and effort counts more heavily than what he accomplishes. Mr. Allbritton has contributed in many ways: (1) vice chairman of the board of trustees, Baylor University College of Medicine; (2) trustee and member of executive committee, Baylor University; (3) member, Texas Medical Center Joint Administrative Committee, Houston; (4) chairman of trustees, Garden Oaks Baptist Church, Houston. For his contributions to society, Mr. Allbritton ranks high.

More important, Mr. Allbritton is honored because of the type of person that he has become. Emerson once said that what a man is speaks so loudly that I cannot hear what he says. Mr. Allbritton has spoken eloquently today, but his life speaks even more eloquently than what he has said. In our long acquaintance, I have been impressed by the many things which Mr. Allbritton has accomplished, but I have been even more impressed with him as a man— what he is: his pleasant disposition, his kindly spirit, his modesty, his sense of fair play, and his desire to be of service to mankind. For the type of life that he lives, Mr. Allbritton ranks highest.

For these reasons, President McCall, I take pleasure in presenting Mr. Joe L. Allbritton for the conferring of the degree Doctor of Laws.[6]

Reply to speech of presentation

Some speeches of presentation call for speeches of acceptance. When several people receive similar service awards or competitive trophies, one person may be chosen to represent all the recipients, or the presiding officer may express their appreciation. On occasions honoring one or a few individuals, separate speeches of acceptance are in order. In accepting a gift, conform to the mood created by the speaker who presented it. Avoid sentimentality or emotionalism. Injecting well-chosen humor helps keep the spirit light.

Organization of the speech of acceptance may follow the following sequence: (1) In the introduction, express sincere appreciation for the

6 Unpublished speech, Glenn R. Capp.

honor. (2) In the body, recognize the help of others or refer to the other competitors in the contest and pay tribute to the donors. (3) In the conclusion, accept and display the gift as you again express appreciation for the award.

Beware of both self-depreciation and self-glorification. Let your manner reflect sincere appreciation. Avoid phrases such as "I am speechless," "I don't know what to say," "I don't deserve all this," and "I can't thank you enough." A simple "I thank you" is preferable to a stammered expression of irrelevant remarks; conversely, expressions of surprise hardly apply if you have a well-prepared speech of acceptance. Show appreciation both by what you say and by your manner of saying it.

THE FORMAL EULOGY

The formal eulogy resembles the speech of presentation except it is more formal and does not include a gift. Formal eulogies apply in at least four situations: (1) a tribute to a living person for unusual accomplishments; (2) a tribute upon the death of a person, or shortly thereafter; (3) a tribute on the anniversary of the birth or death of a person; and (4) a speech nominating a person for office. Eulogies are usually given on formal occasions such as the founders-day programs of organizations and institutions, patriotic meetings before school assemblies or civic organizations, or special occasions like United Nations Day or Fourth-of-July celebrations.

The purpose

The eulogy serves one or a combination of the following purposes: (1) to pay tribute to a person for an outstanding accomplishment or because of his influence on some movement or institution; (2) to increase respect for a person because of his influence on principles and institutions; (3) to set forth principles in a distinguished person's life for emulation by the listeners. The following occasions illustrate: a school assembly honors Abraham Lincoln on the anniversary of his birth; a convention of labor union leaders honors Samuel Gompers for his influence on the union movement; a convention of scientists honors Albert Einstein for his influence on scientific development.

Suggestions for preparation

The speech commemorating a person requires more knowledge and preparation than most other types of speeches for special occasions. The following suggestions apply:

1. Know the subject well. A speaker usually uses incidents in the life of the person eulogized to illustrate his points. A thorough understanding and feeling for the person affect the speaker's manner; his knowledge of his subject must come from more than a surface study of facts to be found in encyclopedias or biographical references. He must know the problems and issues of the era in which the person lived and his significant contribution to the solution of those problems. He must understand the influence that the person had on important movements or institutions. Knowledge of one's subject helps on all occasions; it is essential to a successful eulogy.

2. Evaluate the subject accurately. In the speech of eulogy, do more than enumerate the accomplishments, virtues, or incidents in a person's life. Omit unimportant events and insignificant details; stress major beliefs and philosophies. Emphasize his ideas, ideals, and basic contributions. Often a person's major accomplishments result from his struggle to overcome handicaps or from his strong convictions. Franklin D. Roosevelt made a significant contribution to the treatment of infantile paralysis largely because of his efforts to overcome his physical handicap; Clarence Darrow's aversion to capital punishment was partly responsible for his phenomenal success as a criminal lawyer; Booker T. Washington's efforts to overcome his early environment account in part for his efforts to improve the plight of his race. Assess cause-and-effect relationships in evaluating your subject, and humanize him by making an accurate and objective appraisal.

3. Avoid flowery style and oratorical flourish. The eulogy tends toward exaggeration, one-sided evaluation, and the use of ornate style. Regardless of how much you may admire your subject, show restraint in your feelings and in your choice of language. Avoid such statements as "The greatest man of his day," "The most significant contribution in history," and "The most beloved man of his era." Show your admiration for his qualities and contributions, but do so in a direct, conversational manner.

4. Choose interesting support. Since the means of developing the eulogy consist largely of biographical data, select incidents that have human interest and appeal. The speech may appear dull if one simply lists such facts as date of birth, places of residence, positions held, and honors received. Select those facts that contribute to the person's greatness or that show qualities important in his life. Examples that show action and that appeal to basic drives hold interest well. We remember incidents like Washington's chopping down the cherry tree, Lincoln's walking many miles to return a borrowed book, and Theodore Roose-

velt's hunting big game. Such incidents show action, exemplify human traits, and appeal to the factors of interest. They help in getting attention and holding interest.

The arrangement of ideas

The organization of the speech of eulogy may be either biographical or selective. The biographical method selects events in a person's life and develops them chronologically from birth to death. The selective method chooses such factors as the person's virtues, accomplishments, or characteristics as the main points of the speech.

1. The introduction. The occasion which gives rise to the speech of eulogy is usually well understood; therefore, little time need be given to centering the listener's attention on the occasion. Start with an interesting incident from the life of the person eulogized, a pertinent virtue that characterizes him, or a reference to how you became interested in him. Then indicate how you intend to develop your speech, by either the biographical or the selective method.

2. The body. The biographical method separates the person's life into divisions that form the main points of the speech. Chronological order determines the arrangement of material. For example, for a speech eulogizing George Washington, the main points may be (1) Washington's boyhood and training, (2) Washington's military experiences, (3) Washington's administration as president, (4) Washington's declining years. His life is developed chronologically, with facts and incidents of his life as supporting material.

In the selective method, a person's virtues, characteristics, or accomplishments become the main points of the speech. The speaker uses only the biographical incidents that support the main points in this organization. For example, a speech stressing Washington's accomplishments might include (1) Washington's contributions to agriculture, (2) Washington's contributions to the military, and (3) Washington's contributions to the government. Again, a speech on Washington's characteristics may use these main points: (1) Washington's personality, (2) Washington's commanding physical presence, and (3) Washington's leadership qualities. The selective method uses biographical data as supporting material but not as the basis for the organizational pattern.

3. The conclusion. Conclude the eulogy on a note of praise—a personal tribute, a striking statement, or a provocative quotation. Rarely is a detailed summary needed, although a brief reiteration of the main

points may be included in the statement of praise. For example, consider the following conclusion to a speech eulogizing George Washington:

> *Let us pledge anew our faith in the founders of our nation. The freedom that we now enjoy was gained by the sacrifices of men like Washington. We can best honor his memory by assuming our obligations and responsibilities to the nation which he helped establish.*

The manner of presentation

Occasions for the speech of eulogy are usually formal and dignified; the manner of speaking should conform to the occasion. Direct, communicative speaking is preferred to bombastic oratory; simple and colorful language fits the occasion better than a flowery or ornate style; restrained bodily action is more appropriate than gross action. Although the occasions for eulogies may be charged with emotion, show restraint in expressing genuine feelings of appreciation for the person eulogized.

Sample speech

The following eulogy was presented by the senior author as a tribute to Joe Allbritton nine years after he gave the speech of presentation included in the preceding section of this chapter. Mr. Allbritton was honored at homecoming, October 25, 1974, as distinguished alumnus of 1974.

> *A recent issue of* Time *magazine told the story of a 5 ft. 4 in., "tall" young Texan, who with $25 million cash in hand, purchased a 37 percent interest in Washington Star Communications Incorporated, owners of the Washington* Star-News, *three television stations, three radio stations, and a syndicated service. The paper had been slipping in circulation since the 1950s and reportedly lost an estimated $6 million last year alone. So young Joe faces another challenge; but his life may be characterized as meeting impossible challenges—and with remarkable successes.*
>
> *As a member of the debating team at Baylor University in his undergraduate days, Joe faced another challenge. He and his colleague had qualified as one of four teams in the entire Southwest to participate in the National Debate Tournament at West Point, New York. This invitation was one of the highest honors that could come to a college debater, but we faced a problem—the not-too-ample forensic budget had been almost exhausted. How could we finance so extensive a trip? Joe solved the problem by buying a new Hudson automobile to transport us, footed much of the travel expenses*

himself, and proceeded to win round after round of debates until he won second place in the nation. This incident gave indications of things to come. Perhaps "the impossible does take a little longer" but, with Joe, not much.

Soon after graduation a news item came out of Houston, Texas, saying that Joe's unusual business acumen had netted him $10 million. When questioned about the story, he said, "Well the amount is about right, but other parts of the story are a bit misleading—I don't own $10 million, I owe $10 million." Even as a student debater Joe made trivial distinctions like that, but apparently time changes things. Records in the ex-debaters' files at Baylor reveal that he owns substantial interest in 19 business enterprises, and that does not include his recently-acquired Washington interests. The fact that ". . . he came to Washington with $25 million cash in hand" illustrates.

As I said nine years ago in presenting Mr. Allbritton for the honorary degree of Doctor of Laws, "I first recognized his unusual abilities while he was still a high school student, a debater for Sam Houston High School in Houston. A special invitation to him to come to Baylor resulted in four years of pleasant association in a student-teacher relationship. In the twenty-five years since his graduation I have watched his unusual successes with increasing pleasure and pride—for no greater satisfaction can come to a teacher than to observe the successes of his former students."

His rapid rise in the business and professional world is well known. Simply to list his varied accomplishments and contributions to civic, educational, and religious enterprises would take all my allotted time. Perhaps even more important than his accomplishments and contributions, is the type of person that he has become. Time *magazine termed him "a shy, unostentatious Baptist . . ." with what friends call ". . . an absolute genius for making money." He is that, and more too. His many acts of kindness and philanthropy are unpublicized, and perhaps will continue to be. He does not seek the limelight but will probably forgive his old "prof" for writing this tribute because he knows that if he did not, someone else would. One incident will suffice: while negotiating for his new enterprises in Washington, he broke off negotiations temporarily so he could fly to Waco to be with his friends on the occasion of the dedication of the new Castellaw Communication Center. Not all his acts of kindness are financial; he also gives freely of himself.[7]*

The speech of nomination

The speech nominating a person for office often takes the form of a eulogy. The instructions for the eulogy apply, with this additional suggestion: An appropriate speech of nomination discusses (1) conditions and problems of the office which must be met, (2) qualifications for the

[7] Adapted from Glenn R. Capp, "1974 Distinguished Alumnus: Joe Allbritton," *The Baylor Line,* 36 (October 1974), 16.

office which the candidate must meet, and (3) qualifications of the proposed candidate to meet the needs of the office.

In informal situations like club meetings, a brief statement such as "I nominate Mr. Jones" will suffice. In situations like nominations for political office or for officers in professional organizations, the nomination speech should employ the principles of persuasion discussed in part 2. Develop each point with reasoning and evidence. Support your opinions about the candidate with proof. Use positive suggestions: do not talk about the weaknesses of other candidates; stress the virtues and qualifications of your proposed candidate.

The speech of dedication

On some occasions, institutions or movements are eulogized rather than persons. Typical situations are (1) programs commending some great movement or organization such as universities, political parties, and labor unions; (2) programs commending great occasions such as American Independence Day, Lincoln's Emancipation Proclamation, or Veterans' Day; (3) programs laying the cornerstone for or dedicating buildings and monuments.

The purpose of the dedication speech may be (1) to eulogize the occasion and increase the listeners' respect for it, (2) to cause increased devotion for the cause represented by the dedication, (3) to bring about a renewed striving for the objectives of the thing eulogized, and (4) to lay down principles and ideals which the listeners may emulate. These formal and dignified occasions pay tribute to organizations, institutions, and movements and have much in common with occasions that eulogize persons.

In preparing for the speech of dedication, familiarize yourself with the events and circumstances of the thing dedicated. Develop the philosophy behind the movement or institution, not trivial problems relative to its function. The chronological order, past-present-future, suggests an appropriate organizational pattern. In developing the past, explain the principles and aims upon which the organization was founded; in developing the present, show how the movement has attained its aims and lived up to its principles; in developing the future, enumerate the tasks ahead, the new ideals for which the listeners should strive.

Since the occasion is formal and dignified, the manner of speaking should conform to the occasion. Sincerity and restraint should mark the delivery. Avoid overstatement, flowery language, and oratorical style. Speak in a conversational and communicative manner, with the aim of communicating ideas and genuine feelings.

THE AFTER-DINNER SPEECH

In chapter 6 the entertaining speech was discussed as one of the three basic types, the others being the informative and the persuasive. Entertainment may be a part of any speech, but the entertaining speech has humor and interesting diversion as its primary purpose. Numerous occasions, such as club meetings, assemblies, parties, dinners, and any other gathering where weighty discussions appear inappropriate, call for entertaining speeches. Dinner or banquet occasions provide the most common setting, thus the term *after-dinner speech.*

Not all after-dinner speeches have entertainment as their primary purpose. Some dinner occasions call for speeches with a serious purpose; the banquet or dinner simply provides the setting for speeches of explanation or persuasion. The instructions given in other parts of this textbook apply to the serious after-dinner speech; this section discusses the entertaining after-dinner speech.

The purpose

The after-dinner speech aims to provide interesting diversion and pleasantry. It develops a trend of thought in a pleasant and entertaining manner. It may be informative or persuasive so long as these ends do not constitute the principal purposes. The chief purpose, to entertain, forms the main highway which the speech travels. As expressed by Professor Clark S. Carlile of Idaho State College, "The humor is achieved by hitting a few bumps, skidding around a bit, getting stuck in a mud hole, having a flat tire, and flirting with the farmer's daughter, all the time keeping to the main highway. Thus when you arrive at your destination, you have traveled a straight road but you've had a pleasant time doing it." [8] The after-dinner speech has a specific purpose, a central idea, and main points, the same as do other types; but, unlike other speeches, the forms of support are chosen for their entertainment value, not for their logical adequacy.

Suggestions for preparation

For many speakers, the after-dinner speech is the most difficult type. Some speakers lack a flair for the unusual, a light touch; others lack

[8] Clark S. Carlile, *Project Text for Public Speaking* (New York: Harper & Row, Publishers, 1953), p. 125.

knowledge about how to plan an entertaining speech. The following suggestions should help one gain knowledge about the speech:

1. Seek novel subjects and original ideas. The choice of subjects for after-dinner speaking has few limits so long as fresh points of view appropriate to the audience and occasion are presented. Choose subjects from your field of specialization, interests, and experiences that you can treat in an original manner. For example, one student talked about the presidential election at a banquet of his fellow political-science majors during a presidential campaign. He used the topic as a springboard for relating much of the fresh humor then prevalent about the youth, inexperience, beliefs, and campaign promises of the candidates. He succeeded because he chose a timely and appropriate subject, had a basic understanding of his subject, knew the interests of his listeners, and used fresh and appropriate humor.

A forensic director talked on "The Lighter Side of Debate Coaching" at an annual banquet of forensic students. He related humorous incidents in his experience as a forensic director under three headings: (1) slips of the tongue by debaters, (2) peculiarities of debate judges, and (3) unusual happenings at tournaments. He succeeded because he chose an appropriate subject in which his audience was interested and because he had a long experience upon which to draw for subject matter.

2. Adapt plans to the audience and occasion. Stereotyped plans and stock humor will not do. The after-dinner speech must be planned for a particular audience and adapted to the occasion. A speech on devices used to induce speech teachers to give free talks would probably be hilarious to an audience of speech teachers, only mildly entertaining to other faculty members, not at all entertaining to businessmen, and insulting to women in a study club. Humor must be personal; to use the same type of humor for all audiences invites failure. Badinage may be an excellent source of humor; but one cannot rail against the weaknesses or beliefs of people without intimate knowledge of how they think and feel; otherwise, what may be intended as good-natured fun may prove offensive.

A good after-dinner speaker remains adaptable to the occasion; he capitalizes on remarks of the toastmaster or previous speakers, pokes fun at well-known persons in the audience, and treats the commonplace in a novel way. He uses such devices as exaggeration, clever wording, and twisting ideas in an original and amusing manner.

3. Avoid heavy subject matter and complicated arrangement. Weighty problems and controversial issues have little place in the after-dinner speech. An audience expects to be amused, not burdened, by

speeches on social occasions. Avoid a complicated arrangement of ideas; use main points as a cohesive force for light illustrative material and well-chosen humor. Use anecdotes and illustrative material in preference to statistics and detailed examples. Avoid contentiousness; amuse your listeners, do not antagonize them. Tell amusing stories, jokes on yourself, and stories with surprise endings; use a variety of support for an uncomplicated arrangement of ideas.

4. Avoid a string of unrelated jokes. After-dinner speeches that do not have a central theme usually result in a series of unrelated and disconnected jokes. If a speaker selects his ideas to permit him to use his stock stories, his illustrations will likely appear irrelevant. Neither should the after-dinner speech consist of a single story or narrative. Jokes, episodes, and stories should be used to illustrate the theme of the speech and to develop the main points. The central theme, not the illustrative material, should govern the organization of the speech.

5. Use a variety of humor. The excessive use of one or two types of humor may tire an audience; use a variety. In addition to the methods for achieving humor already discussed, consider the following:

Incongruity—present the familiar in an unusual way, make unfamiliar combinations of familiar things, or put unfamiliar things into familiar surroundings.

Puns—use words that are pronounced alike to produce an incongruous idea or double meaning; for example, "She looks to be in her middle flirties." "Keep drinking and you will become a grave man."

Exaggeration—overstate an idea to the extent that the exaggeration becomes obvious. The overstatement may be either in the idea or in the language used to express the idea.

Irony—say a thing in such a way that the opposite is obviously intended. The statement contains a contradiction between the literal and intended meaning.

Burlesque—present a humorous caricature that treats lofty material ludicrously or ordinary material with mock dignity. Burlesque may take the form of a parody in which something insignificant is treated as important.

6. Use appropriate humor. Humor should be in good taste, never low and degrading. It should be adapted to the occasion and to the cultural level of the audience. On some occasions broad, obvious humor may be in order. On other occasions delicate, subtle humor is best. On all occasions humor should be spontaneous and relevant to the discussion. Genial and light humor should never give way to biting sarcasm and scathing barbs. Humor should provide relaxation, enjoyment, and entertainment for the listeners.

The arrangement of ideas

As with other types of speeches, organization of the after-dinner speech may be considered under the divisions of introduction, body, and conclusion.

1. The introduction. Strive for an immediate, overt response from the audience. Set the keynote for the speech and prepare the audience to be entertained. Begin with an incongruous statement, capitalize on a remark made by the chairman or a previous speaker, tell an amusing story, refer to a recent humorous happening, or poke fun at yourself or someone in the audience. Let your opening remarks lead directly to the body of the speech. One speaker, who had obviously been lauded excessively by the chairman, began, "I have never heard so many deserved compliments about a speaker." Another speaker said, "What a splendid speech of introduction; I thought it was pretty good when I wrote it for the chairman."

2. The body. The points in the speech should be stated simply. Avoid a complicated arrangement of ideas. Introduce the points with an amusing anecdote or illustration; then expand the basic idea of each point by additional illustrations, stories, and jokes. Do not attempt to maintain sustained amusement; give the listeners time to rest during explanations and transitions. Build each point to a climax of interest; reserve some of the most amusing illustrative material for the last part of the speech.

Present ideas through illustrations, analogies, anecdotes, allusions, and figures of speech; use a minimum of explanation, reasoning, statistics, and restatement. Any method for arranging ideas discussed in chapter 9 may be adapted to the after-dinner speech. For example, the problem-solution method may be used by presenting an obviously fictitious problem and suggesting an absurd solution. The method of arrangement is not so important as the novelty and originality employed in using it.

3. The conclusion. The conclusion for the after-dinner speech differs from that of other types. In many instances, the formal conclusion may be omitted; simply end on a point of amusement. When a conclusion seems advisable, omit a detailed summary as used in informative or persuasive speeches; restate the barest suggestion of the points, preferably in a statement which epitomizes them. Do not let the conclusion become an anticlimax. Close swiftly with an amusing illustration, a story of action, or a brief restatement of your theme.

The manner of presentation

Make the delivery of the after-dinner speech swift-moving and vivid. Let your manner suggest enjoyment. Be optimistic, genial, and good-natured. A pseudo-serious speech given in a deadpan manner often serves well. Your manner of speaking should reflect the mood of the occasion; avoid contentiousness, dogmatism, and argumentation. Converse with your audience with intimacy and good humor.

ADAPTING MESSAGES TO RADIO AND TELEVISION

Radio and television, like the automobile and the airplane, are here to stay. We need to recognize their enormous potential. Almost every family in the United States owns from one to a half-dozen radios, and the number of television sets in use is increasing by the thousands yearly. Famous speeches of a century ago were heard by only a few thousand people; epic-making speeches of recent years have been heard by radio and television audiences estimated at 100 to 500 million. Radio and television have revolutionized the leisure-time activities and cultural opportunities of Americans. Furthermore, television has the potential for revolutionizing the American educational system and has already made steps in that direction. Fifty years ago the average citizen rarely came in contact with the great minds, artists, and speakers of that age; now all these opportunities are available at the turn of a dial. Although the scope of this text prevents a full discussion of radio and television, the adaptation of public messages to these media is considered briefly.

We can begin with the premise that good communication is good communication regardless of the medium for disseminating it. The instructions given in parts 2 and 3 about composition and delivery apply to radio and television messages just as to other types. However, there are differences in application.

Differences in listeners

Chapter 4 treats audience analysis in detail from the viewpoint of listeners' interests, attitudes toward the speaker, attitudes toward the speaker's subject, and varying facts about different audiences. These factors can be pinpointed with considerable accuracy for live audiences; they are less easily gauged for the radio and television audience, for the following three reasons:

1. Greater variety of interests. Assembled audiences frequently have common primary and secondary interests, similar attitudes toward the speaker and his subject, and like educational and cultural backgrounds. Conversely, radio and television listeners have a diversity of interests, attitudes, and backgrounds. Furthermore, radio and television listeners are sometimes less motivated to listen than assembled audiences because many factors compete for their attention. The man who listens in the privacy of his home may be torn between his desire to read the evening paper and his desire to listen to the television program; he may even decide to do both at the same time. If he decides in favor of the television program, he may have several interruptions—the telephone may ring, his son may ask for help with his homework, or his wife may decide to rearrange the furniture. As a result he may only half-listen.

On the other hand, on some occasions a broadcast audience may be highly motivated. The speaker, the topic, or the occasion may be of such interest as to command undivided attention. These conditions prevailed on such occasions as when Franklin D. Roosevelt spoke for declaring war on Japan, when General Douglas MacArthur addressed Congress upon being relieved of his command, when President John Kennedy addressed the nation on television about the Cuban crisis, when President Nixon discussed his involvement in Watergate, and when Nelson Rockefeller was sworn in as vice president. Motivated listening conditions prevail when students take classes by television, when speeches in political campaigns become intense, when issues of momentary interests are discussed. Furthermore, under ideal listening conditions, fewer distractions may be evident for broadcast listeners than for assembled audiences. Those who listen alone or in small groups may be less subject to the distractions of a crowd or outside noises than those who listen in assembled audiences. These ideal listening conditions are, however, the exception. In speaking over radio or television, the speaker normally loses the advantages of the psychological factors which motivate an assembled audience to listen. Why are these factors important to the radio and television speaker?

The television speaker must make his appeals to interests as universal as possible. Since his audience consists of people of all ages, economic and cultural backgrounds, professions and businesses, he cannot find a community of primary interests to which he may appeal. He must, therefore, appeal to factors of unusual momentary interests, factors that concern all people. Furthermore, his appeals to the factors of motivation must be universal. Chapter 3 discusses seven basic motives of man to which speakers must appeal to insure efficient listening. These factors of self-preservation, property, power, reputation, affection, sentiment, and taste affect the basic desires and needs of people. Different motives apply to different groups of people, so a speaker must use a variety of appeals;

what may motivate a young, well-educated, professional man may not motivate an elderly, uneducated, unskilled laborer.

2. Widely dispersed groups. An assembled audience constitutes a social group that imposes restraints on each listener. Listeners rarely walk out on a speaker, eat their lunch, read newspapers, or talk back audibly, because they feel the inhibiting pressures of a social group. Radio and television listeners do all these things; they make up many small, widely dispersed, intimate groups that feel few pressures of a social gathering. They feel comfortable, relaxed, and uninhibited. The speaker who talks in the grand style appears ridiculous. Family groups do not invite speakers into their living rooms to be harangued; they expect him to be warm, intimate, informal. The television speaker should, therefore, speak in a direct, communicative manner, much as he would in conversing with a half-dozen people.

3. Inability to gauge response. A speaker can learn much from an assembled audience by observing his listeners' physical and audible reactions. He can gauge whether the listeners understand, accept, or enjoy his message. His impressions of audience response may cause him to modify his message as he talks—to restate an idea, to omit an illustration, to show more animation, or to inject humor. The radio and television speaker has no way of determining listener reaction and cannot adjust to listeners' response. Furthermore, he loses the effect of audience stimulation, the "feel" of an audience. He has no encouragement to reach emotional heights, to put forth his best efforts, to please his listeners.

All these differences between an assembled audience and broadcast listeners point up the difficulties in interesting radio and television listeners; they add to the complexity of the speaking situation. These added complexities may be met, in part, by adjustments in the method of preparation and delivery.

Preparing the broadcast message

The principles of analyzing and evaluating material, selecting forms of support, deciding on main points and subpoints, and arranging ideas as discussed in part 2 apply also to radio and television communication. The following factors pertain to the adaptation of these principles to broadcast listeners:

1. Decide on the desired listeners. On many occasions messages given before live audiences are also broadcast. For example, President Roosevelt spoke to a joint session of Congress on December 8, 1941, to

declare war against Japan; the speech was also heard by a radio audience estimated at 60 million people. The Reverend Billy Graham spoke at the 125th anniversary convocation at Baylor University on February 1, 1970; his immediate audience consisted of some nine thousand people, but his radio and television audiences numbered in the millions. On occasions such as these, interest in the occasion is sufficient to hold broadcast listeners; the speaker may direct his message to his assembled audience. On television the presence of the microphone adds importance to the occasion. But what about the politician who campaigns for election or the organization's representative who desires to influence public opinion? Their assembled audiences may consist of only a few hundred people, but the broadcast listeners may number into the hundreds of thousands. Such speakers may accomplish their objectives better by directing their messages to the broadcast listeners. Use the informal, direct methods discussed in the preceding section because they apply best to intimate, dispersed groups with a disparity of interests.

2. Use simple patterns of organization. Since the attention of broadcast listeners may be easily diverted, avoid a complicated arrangement of ideas. With broadcast listeners in mind, review chapter 9 on "Organizing Your Message." Begin with an unusual statement or a striking illustration to win immediate interest in your subject. State the central theme in a brief, slogan-like phrase and repeat it often. Either make your main points few in number or develop only one main point. State the main points in short sentences that bear easy repetition. Use a simple organizational pattern like the problem-solution form, or the chronological, simple enumeration, or logical order. Proceed from the simple and familiar to the more complex and unfamiliar ideas. In concluding, give a brief summary, restate the central idea, and indicate the desired action. Beware of overamplification of ideas; make each statement count. Arrange your message so that your listeners can capture your central theme and follow your sequence of ideas.

3. Select interesting and concrete forms of support. Use illustrative material liberally, especially examples and analogies. Specific instances serve better than detailed examples because they are easier for the listeners to grasp and take less time to develop. Keep in mind the diversity of interests of broadcast listeners; select supporting material that has broad appeal. Avoid technical and philosophical discussions that require detailed explanation and abstract theorizing. Leonard Bernstein interested many people in classical music by his nontechnical discussions and demonstrations. Carl Sandburg and Robert Frost introduced poetry to many people by their interesting television messages and readings.

Visual aids may be particularly valuable on television because they enable one to use both visual and auditory methods. Through the use of close-up shots, such visual aids as maps and drawings may be shown in detail. Visual aids also provide the action and variety necessary for holding listener interest. The instructions given in chapter 8 on the preparation and use of visual aids apply to television messages, with these added suggestions: (1) Avoid visual aids that reflect light unduly, such as glossy prints, slick paper, or drawings with a white background. Television studios have the proper type of display boards for visual aids. If you prefer to hold the visual aid in your hands, mount it on dull-finish cardboard and use black lettering. (2) Use visual aids which correspond with the shape of television screens. For example, use a cardboard mounting 9 inches high by 12 inches wide or 12 inches high by 16 inches wide. (3) Do not use visual aids simply because television lends itself well to their use. Use only those aids that will help make your ideas and explanations meaningful.

4. Prepare the manuscript and outline carefully. Proper timing of the broadcast message is essential since broadcast stations operate on a strict schedule. Time the manuscript carefully during rehearsal; but to allow for variations, include a paragraph near the end which may be either included or omitted to adjust to the time limit. Allow time for the station break, the commercials, and the introduction of the program.

Broadcast messages may be read from the manuscript, read by use of a teleprompter for television, or spoken extemporaneously. Formerly radio stations required a written manuscript, but today most stations permit individual preferences. Reading from a manuscript finds favor with many radio speakers because preparation of the manuscript permits careful choice of language and prevents digressions. Conversely, reading may prove least effective for television because the manuscript decreases eye contact and directness. The teleprompter, a mechanical device placed outside the range of the camera, permits the television speaker to read while facing the camera. This method rarely succeeds in camouflaging a read message; the constant stare of the speaker appears artificial. Those who speak fluently from an outline prefer to speak extemporaneously. This method permits easy adaptation to the time limit and encourages direct, conversational communication. The use of the extemporaneous method, however, does not relieve one of the necessity for careful preparation. When using this method for television, arrange a system of signals or provide advance instructions to the cameramen for the use of visual aids.

Leave nothing to chance when preparing the broadcast message. A

well-prepared manuscript or outline and several rehearsals will improve the chances of successful communication.

Presenting the broadcast message

The principles for effective presentation—poise, language, voice, and bodily action—discussed in part 3 apply to the broadcast message. In addition, consider the following factors:

1. Adjust to the microphone. For radio, talk into the microphone in much the same manner as was explained in chapter 11 for using a public-address system. In using the microphone, observe these precautions: (1) Avoid sudden changes in volume that may cause a blasting effect on the amplifier. Speak in an animated, conversational style much as if you were talking to a few people in the privacy of your living room. (2) Do not move outside the range of the microphone. Avoid swaying movements or changes in stance that cause variations of volume. Maintain a constant position as you talk directly into or slightly across the microphone. (3) Beware of extraneous noises caused by the rustling of papers, the rattling of coins, the shuffling of feet, or drumming on the table. The sensitive microphone picks up these noises, which often irritate listeners. Use an inexpensive pulp paper for your manuscript; it causes less noise when the pages are turned or shuffled than does bond or onion skin paper. (4) Be particularly careful when pronouncing the sibilants: *s, sh, z, zh, j,* and *ch.* A noticeable hissing sound irritates listeners. Speaking across the microphone may help eliminate these hissing sounds.

For speaking on television, the microphone presents less difficulty than for speaking on radio. Television stations use several types of microphones that may be moved as the speaker moves. The instructions, however, on sharp changes of volume and the avoidance of extraneous noises and hissing sounds apply to television as well as to radio speaking.

2. Adjust to the invisible listeners. The lack of a visible audience constitutes an important adjustment that speakers must make for radio and television. The adjustment may be made in part by simply visualizing people sitting before their radio and television sets; imagine their reactions as being much like those of assembled audiences that you have previously addressed. By projecting your imagination, you can acquire the "feel" of your listeners, although you cannot see them.

You may prefer to invite a few people into the studio to serve as a live audience. By speaking to them in a conversational manner, you can approximate the condition of your invisible listeners as they sit in small groups before their radios and television sets. This practice will likely

make you less inclined to use the grand manner; instead, you will speak directly and communicatively.

3. Avoid delivery mannerisms. For radio, voice and language must carry the load of the presentation skills; television adds bodily action. Many speakers prefer to use bodily action in radio speaking because it helps them to become animated and to visualize the invisible listeners. In speaking on television, avoid sweeping and sharply made gestures. Facial expressions and the lesser bodily movements of the head and shoulders serve best.

Delivery mannerisms apply with force to radio and television speaking. A mannerism of delivery consists of any action used with such frequency that it calls attention to itself. In speaking on radio, be careful of long pauses; since the listeners cannot see the speaker, they become impatient with excessive deliberation. Unusual dialects, mispronounced words, and halting speech prove especially distracting. Check the manuscript carefully for the pronunciation of words; rehearse the speech until it can be read or spoken fluently. Avoid such mannerisms as clearing the throat, repeating words and phrases, and vocalizing pauses with "ah" and "uh" or with connective words like "and," "thus," "but," and "so."

When speaking on television, add the mannerisms of bodily action to the above list. The following mannerisms become especially noticeable on close-up shots: (1) adjusting glasses or clothing; (2) looking away from the camera; (3) showing a deadpan facial expression; (4) using notes or other materials excessively; (5) moving the head and arms frequently; (6) carrying pencil, pen, or other articles in the hands; and (7) sitting or standing in a slouched position. Attempt to give an informal but poised appearance; avoid mannerisms that may detract from the thought of the message.

4. Adjust to the technical aspects of broadcasting. Many people complain about the distracting influences of broadcasting. For those inexperienced in broadcasting, a brief discussion of what to expect should prove helpful.

Almost all radio and television stations will ask you to report from 30 to 45 minutes early. The director will show you the broadcast set-up and instruct you on how to proceed. He will ask you to speak into the microphone so that he may adjust for your volume and position. He may ask you to rehearse the entire message. During your message you will face the control room so that you may see visual instructions from the engineer. The director will instruct you on the timing signals, but you may want to check the position of the studio clock so that you can glance at it from time to time. Ask the director for the exact time that you must conclude.

For television, the bright floodlights, the activities of the cameramen, and the visual instructions of the director may prove distracting. Others in the studio may go about their business of adjusting equipment or setting up for the next program without apparent concern for your speech. If the station uses two or more cameras, the cameramen may communicate with each other through hand signs, or the director may motion for you to face the live camera or make other adjustments in your position. The live camera always has a small red light termed the *tally light* just below the lenses; remember to face the camera with the red light.

How can you cope with these distracting influences? Although you must heed the visual instructions, the time signals, and the tally light, attempt to ignore the other activities in the studio and control room. Concentrate on the thought of your message and the invisible listeners. "Think the thought" of your message and visualize your listeners' reactions.

The floodlights generate considerable heat. Avoid wearing woolen suits or other heavy clothing. Also avoid wearing accessories such as tie pins, bracelets, or other articles that reflect the bright lights. White shirts or blouses also reflect light excessively. Light gray and blue appear white to the viewer and do not cause glare. Clothing with prominent stripes and figures should not be worn. Although proper dress and grooming matter little for radio speaking except for the psychological effect they may have on the speaker, they matter a great deal for television. Rumpled clothing, crooked ties, peculiar hats, and unusual adornment may prove more interesting than what you have to say.

SUMMARY

The basic principles of composition and delivery apply to messages for special occasions, namely: speeches of (1) introduction; (2) welcome and response; (3) presentation and acceptance; (4) eulogy, nomination, and dedication; and (5) after-dinner. The same principles apply in preparing messages for radio and television.

The speech of introduction attempts to create a pleasant atmosphere, to give the qualifications of the speaker, and to show the importance of the subject. Suggestions for preparing the speech of introduction include: (1) consult the speaker for advice and information, (2) make the introduction a separate speech, (3) make the speech brief but thorough, (4) use humor, (5) avoid overpraise, (6) avoid talking about yourself, (7) avoid stressing the speaker's speaking ability, and (8) avoid trite and hackneyed

language. The introduction attempts to get immediate interest and to set the keynote for the speech. The body presents information to increase the prestige of the speaker and to enhance interest in the subject. The conclusion presents the speaker and the title of his message. Enthusiasm, tact, and sincerity should characterize the speaking manner.

The speech of welcome applies on occasions like meetings of convention delegates, for special occasions, to honor distinguished guests, and to welcome new members to an organization. Its purpose is to express genuine appreciation to the organization or person welcomed and to set the keynote for the ensuing meeting. Attempt to bring freshness and originality to the occasion by (1) using tact and good taste, (2) being optimistic and enthusiastic, (3) speaking briefly, (4) avoiding emotionalism, and (5) avoiding flowery platitudes and stereotyped forms. In organizing the speech, attempt to capture the immediate interest of the audience and establish a pleasant keynote in the introduction. In the body, a local person would express appreciation for the group welcomed and give information about the place or organization to which the group is welcomed. An out-of-town representative of the sponsoring organization would stress the purpose of the meeting and the common aims of the delegates. In the conclusion, express your best wishes for a profitable meeting and pledge the support of your organization. Be sincere, cordial, and gracious. Response to the speech of welcome should follow the principles suggested for the speech of welcome.

Speeches of presentation apply when presenting gifts or awards to those who (1) are leaving a place of employment or are retiring, (2) have earned service awards, (3) have won prizes, and (4) are honored by their co-workers or employers. The purpose of the speech is to honor the recipient, honor the donor, and increase morale in an organization. Suggestions for preparing the speech of presentation are: (1) know the recipient, (2) know the occasion, (3) show proper restraint, (4) recognize the losers, and (5) speak briefly and extemporaneously. In organizing the speech of presentation, use the introduction to give pertinent information about the gift or award. Organize the body of the message to bring out the virtues and accomplishments of the recipient, show appreciation for the donor, and briefly describe the gift or award. Avoid flattery, flowery language, and an effusive manner. Replies to speeches of presentation should be brief and sincere.

The formal eulogy pays tribute to persons for significant accomplishments or for influence on movements or organizations. For proper preparation, (1) know the subject well, (2) evaluate the subject accurately, (3) avoid a flowery style, and (4) choose interesting illustrative material. In the introduction, focus attention on the person eulogized. The body

of the speech may arrange the divisions of the message chronologically or on a selective basis. Conclude on a note of praise with a personal tribute. Speeches of nomination and dedication are special forms of tribute.

The after-dinner speech provides entertainment. It develops an idea in a pleasant and humorous manner. To help make the speech a success, (1) seek novel subjects and original ideas, (2) adapt plans to the audience and occasion, (3) avoid heavy subject matter and complicated arrangement, (4) avoid a string of unrelated jokes, (5) use a variety of humor, and (6) use appropriate humor. The introduction should capture the immediate interest of the audience and set a keynote of pleasantry. The body should state the points simply and support them with abundant illustrative material. Conclude the speech on a note of pleasantry.

Speaking on radio and television requires certain adaptations of the basic principles of communication. Differences of broadcast listeners from assembled audiences should be noted: (1) broadcast listeners have a greater variety of interests than the assembled audience; (2) the broadcast listeners consist of widely dispersed groups; (3) the broadcast listeners cannot enable the speaker to gauge listener response. In preparing the broadcast message: (1) decide whether to speak primarily to the broadcast listeners or to the assembled audience in cases where the broadcast is being made of an attended event; (2) use a simple pattern of organization; (3) select interesting and concrete forms of support; and (4) prepare the manuscript and outline carefully. Factors of importance to presentation include (1) adjustment to the microphone, (2) adjustment to the invisible listeners, (3) avoidance of delivery mannerisms, and (4) adjustment to the technical aspects of broadcasting.

QUESTIONS

1. What is the principal purpose of the speech of introduction? Discuss several suggestions for arranging and presenting the speech.

2. What occasions call for the speech of welcome? Discuss briefly the preparation and presentation of the speech.

3. Differentiate between the speech of presentation and the formal eulogy. Evaluate the sample speech of eulogy.

4. What is the principal purpose of the after-dinner speech for social occasions? Discuss briefly the introduction, body, and conclusion of the speech.

5. What are the principal differences between broadcast listeners and an assembled audience? Make several suggestions for preparing and presenting the broadcast message.

ASSIGNMENT

Your final performance assignment consists of two parts:

1. Write out brief speeches of introduction, welcome, and presentation. State an imaginary setting for each speech. Your instructor will ask you to read one of these speeches before the microphone as he records the speech. Hand in all three speeches to your instructor.
2. Prepare a five-minute entertaining speech suitable for an after-dinner setting. Present this speech in class. Choose a topic from your background of information and experiences. Seek an original idea and use humor in developing your theme. Observe the precautions discussed in this chapter. Remember that your main purpose is to provide an interesting and pleasant diversion for the class.

READINGS

BRYANT, DONALD C., and KARL R. WALLACE, *Fundamentals of Public Speaking,* 5th ed., chap. 22. Englewood Cliffs, N.J.: Prentice-Hall, 1976.

CULP, RALPH BORDERN, *Basic Types of Speech.* Dubuque, Ia.: Wm. C. Brown Co., 1968.

HANCE, KENNETH G., DAVID C. RALPH, and MILTON J. WIKSELL, *Principles of Speaking,* 3rd ed. Belmont, Ca.: Wadsworth Publishing Co., 1975.

HYDE, STUART W., *Television and Radio Announcing,* 2nd ed. Boston: Houghton Mifflin, Co., 1971.

KING, ROBERT G., *Forms of Public Address,* chaps. 3, 4. Indianapolis: The Bobbs-Merrill Co., 1969.

McLUHAN, MARSHALL, *Understanding Media: The Extension of Man.* New York: McGraw-Hill Book Co., 1966.

MONROE, ALAN H., and DOUGLAS EHNINGER, *Principles and Types of Speech Communication,* 7th ed., chaps. 22, 23. Glenview, Ill.: Scott, Foresman, 1974.

ROSS, RAYMOND S., *Speech Communication: Fundamentals and Practice,* 3rd ed., chap. 14. Englewood Cliffs, N.J.: Prentice-Hall, 1974.

WHITE, EUGENE E., *Practical Public Speaking,* 2nd ed., chap. 15. New York: The Macmillan Company, 1964.

WRIGHT, CHARLES R., *Mass Communication,* 2nd ed. New York: Random House, 1975.

Student speeches for analysis, comparison, and evaluation

Why study
student speeches?

The student speeches in this appendix are among the best given by the senior author's students over the past 40 years. Some of them were first presented as classroom assignments, others for special occasions or as speeches for intercollegiate contests. Arranged chronologically, they give an insight into changes in student thinking and methods of composition, development, and style. The speeches may also be analyzed and evaluated on the basis of the rhetorical principles discussed in this text.

First, evaluate the speeches according to the standards for good speech discussed in chapter 1. Although you cannot analyze presentation skills from a printed speech, certain rhetorical factors can be pinpointed with considerable accuracy. The methods of arrangement discussed in chapters 9 and 10, for example, can be determined from a printed speech. First, attempt to discover the central idea—the philosophy and principles of the message. Then consider whether the speaker used one of the organizational patterns discussed in chapter 9—how he or she arranged the main points, subpoints, and forms of support to develop the central idea and accomplish the specific purpose. Were the introduction, body, and conclusion clearly discernible?

The forms for supporting ideas exemplify almost all the types discussed in chapter 8—explanation, quotations from authority, examples, analogies, statistics, illustrations, and restatement. Did the speakers use a variety of support and was it logically adequate and interesting? The basic types of appeal—ethical, emotional and logical—are also discernible although their determination may at times be difficult. Compare the speeches as to their relative reliance on the basic appeals.

The style or language as discussed in chapter 12 can well be analyzed. You should realize, however, that the speeches were prepared for oral, not written, communication and that a minimum of editing has been done so as to leave the speeches in basic oral style. Consequently, you

will notice more repetition, informality, and directness than you would in an essay, for example. You will also note that the earlier speeches use more flowery language—figures of speech, unusual words, and involved construction—than do the later speeches. Language reflects the standards that prevail at the time. Ornate language characterized oral style to a greater extent during the 'thirties than it does today.

Without exception, the earlier speakers in this collection have attained positions of prominence in such fields as education, law, and industry. All of them gave the authors permission to reprint their speeches, but some did so with reluctance. The speeches ought to be read with the realization that they were given by 18- to 22-year-old college students. As such, they provide you more realistic speeches for analysis and study than would speeches by prominent adults.

Advantages accrue from reading and analyzing student speeches: (1) they may suggest topics for your classroom assignments; (2) they may help increase your background knowledge; (3) they give an indication of changes in student thinking; (4) they exemplify the application of rhetorical principles; and (5) they may increase your appreciation of speaking. In short, they give you an opportunity to learn by example.

Each speech has been prefaced with a brief discussion of the speaker, the setting or occasion, and factors to look for in reading and analyzing the speeches. You will recall that chapter 1 emphasizes that communication takes place when you have a sender or speaker, who sends a message or speech to receivers or listeners. The speaker and the situation in which he or she speaks constitute integral parts of the communication process, essential to the analysis of the speech. The reading of these introductory discussions should make reading and analysis of the speeches more meaningful.

THE LIE OF WAR

Paul Geren, 1935

This speech was first presented at an assembly of Baylor University students in the spring of 1935, and later developed into a collegiate contest oration. After completing his Bachelor of Arts degree cum laude in 1936, Dr. Geren later earned a Master of Arts degree at Louisiana State University, then another M.A. degree and a Ph.D. degree in economics at Harvard.

Teaching at Judson College at Rangoon, Burma, when World War II was declared, he joined the British Army and later the American Army where paradoxically, in view of the title of his student speech, he received a battlefield commission and a bronze star for bravery behind enemy lines. He served later as college professor, college president, deputy director of the peace corps, and United States consul general. At the time of his untimely death in a traffic accident on June 22, 1969, he was president of Stetson University.

The mid-thirties witnessed a period of pacificism in the United States. Senate investigation committees exposed enormous profits made by manufacturers of war materials. Several bestsellers appeared that dealt with the problem under such titles as *Merchants of Death* and *Iron, Blood, and Profits*. Pacificist organizations were extremely active and circulated petitions on college campuses calling for students to sign that they would not go to war under any circumstances. Understanding the thinking on the issue of war at the time this speech was given should help you analyze it.

The speech has much to recommend it, but especially its composition and language. The speaker begins with a statement by Thomas Carlyle which brings the central idea of the speech into sharp focus. The refrain "war is a lie" runs throughout the speech, introducing each main point and acting as a unifying force for the central theme. The main points are developed largely through vivid illustrations which serve well in maintaining interest. By actual count, the speaker uses three quotations (one from the Bible), one set of statistics, three specific instances, three detailed illustrations, and one hypothetical example. Most important, the arrangement is easy to follow and the supporting material applies directly to the idea developed. He concludes with an amplification of the central idea and a provocative question, the answer to which stresses that "war is a lie."

The language shows force and action and is sometimes almost poetic. The speaker talks about people, incidents, and ideas; the people do and say things which create dialog and show action. Note the use of alliteration in the second paragraph: "We fought—and we got . . ." This repetition emphasizes the point being made. Although the language becomes somewhat flowery toward the end, it is direct, conversational, and forceful.

Thomas Carlyle, who had a way of going to the bottom of things, laid down a principle and demonstrated it in his work, *The French Revolution*. This was that principle: All wrong is based upon falseness, upon hypocrisy. I have applied that principle to what must surely be the greatest wrong in all the world—war. And that greatest of wrongs is based upon the greatest of deceptions. War is a lie.

War is a lie in the declaration of its motives. We fought the World War, we told ourselves, to make the world safe for democracy. We fought, and we got 14 new dictatorships. We fought the World War, we made ourselves believe, to usher in a new era of prosperity and plenty. We fought—and instead has come an era in which panic chokes the world and one out of every seven Americans is fed and clothed by the government. We fought the World War, we persuaded ourselves, for the guarantee of liberty and freedom to all men. We fought; and in the palms of dictator's hands all semblance of freedom was swept away. We fought the World War to solve the world's problems, and today the world is preparing with a greater zeal than then to fight another war to solve these same problems, not solved but only agitated by the last war. We did accomplish one thing when we fought. We made in America alone 200 millionaires of certain capitalists and industrialists. We fought for democracy, for prosperity, and for freedom. We got 14 new dictatorships, a panic, and—200 millionaires. That is the lie of war.

War is a lie because it seizes upon the highest in man and uses that as the instrument for the doing of the lowest things that a man ever does. They tell us to fight for honor's sake, for country's sake, for the love of mothers, wives, and sweethearts. Because we cherish honor, because we revere our country, and because we love our people we fight. We feed an Austrian boy gas that eats his vitals out because we love honor. We put a bayonet through a Bulgarian's middle because we love our country. We put a hole through the head of a German boy who, of course, doesn't love his mother and sweetheart, because we love our people. That is the lie of war. It is the highest in us that makes us do the lowest. We are stirred to commit wholesale slaughter by pretty words about love and honor.

I knew a man who went to the war. He was and is meek and mild and kind. They told him to go to the war in the name of kindness to the Belgian women and children who were having their hands cut off. He went. In the drive through the Argonne he and his company paused a moment for orders. At his feet a few yards away he saw a German soldier sodden with blood. Both of his legs were gone and he was wriggling and squirming in the mud that his blood had made, trying to reach a canteen of water a few inches beyond his grasp. A mere kick would put the canteen in his hands. It would not have been much trouble to merely kick it; but the man who went to war in the name of kindness did not so much as touch it, and his company marched on.

Harry Emerson Fosdick said it in these words. "Oh, War, I hate you most of all for this, that you lay your hands on the noblist

elements of human character with which we might make a heaven on earth, and you use them to make a hell instead."

Why could we not see that Germans were fighting us for the same idealistic reason that we were fighting them, that we were killing one another because each loved honor, his country and his people. That is the lie of war—a hideous grinning thing wrapped about in the gorgeous gowns of the mockery of idealism.

War is a lie because it deludes man in the highest relation of life—the relationship between a man and his God. On a Sabbath morning in 1914, (the great conflict had just begun) they held a prayer service in Berlin. The Kaiser was there. The aisles were jammed and packed. A German minister mounted to the stand and reading from the Old Testament the account of the battle between Gideon and the Midianites, (and how God favored the Midianites) drew across the centuries a 1914 parallel; and then they said, "Ein feste Burg ist unser Gott"—Our strength is our God. Then they prayed, "God of Germany, give the victory to Germany. God of righteousness, give the victory to right."

On that Sabbath morn they held a prayer service in Paris. The war ministers were there. The aisles were packed. A French priest mounted to the stand and reading from the Old Testament the account of the battle between the Israelites and the Philistines (and how God favored the Israelites) drew across the centuries a 1914 parallel; and then they sang "Il notre forte est le dieu de la France"—Our strength is our God. Then they prayed, "God of France, give the victory to France. God of righteousness, give the victory to right."

On that Sabbath morning they held a prayer service in London. The king was there. The aisles were packed. An English bishop mounted to the stands and reading from the Old Testament the account of the battle between David and his enemies (and how God favored David) drew across the centuries a 1914 parallel. Then they sang, "God of our fathers, God of England, give England the victory. God of righteousness, give the victory to right."

I wonder what God thought—if think is the word for what God does—I wonder what God thought when he looked down from Heaven and saw man, created in His image, praying to Him a prayer which carried to its literal conclusion meant this and could only mean this: God give us the victory; victory is to be gained by smashing the brains and smothering the lungs of the enemy until they are beaten into submission. God give us that victory. I wonder what He who said, "Not a sparrow falleth—" thought about a prayer like that?

DEFENSE OF THE JEW

Lester Kamin, 1941

An enthusiastic and highly successful member of the schools forensic program, Lester Kamin had his studies interrupted by World War II when he became an officer in the United States military forces. Returning to his hometown of Houston, Texas, following the war, he established the Kamin Advertising Agency, which soon expanded to include branches in Dallas, Austin, and San Antonio. Later associated with numerous business enterprises, he is now president of Public Radio Corporation with home offices in Houston and affiliate offices in several other cities.

This speech was originally presented to the forensic workshop at Baylor University and was later used with success in intercollegiate competition. The idea of the speech grew out of an incident in Palestine in the late 1930s which resulted in extreme persecution of the Jews, a problem which Mr. Kamin apparently felt deeply. Perhaps his successes in intercollegiate contests can be attributed to his sense of conviction and his sincerity of manner, but the speech also ranks high as an example of rhetorical excellence. Early in the speech he puts his audience into the hypothetical situation of serving as members of a jury in a court trial. As the defense attorney, Mr. Kamin introduces each point by stating the charge made by the prosecution against the Jew. This hypothetical setting creates interest and unifies the speech. The speech consists largely of reasoned discourse and uses a minimum of supporting material. His description of the plight of the Jew to point up the problem is especially noteworthy, as is his use of antithesis in the fifth paragraph. Evidential support comes from the citing of a survey from *Fortune* magazine, two examples of the treatment of Jews in Germany, and a specific incident about the Spanish Inquisition. He concludes by asking the jury to render its verdict.

With war raging in continental Europe the eyes of the world are focused on the outcome of that struggle. But regardless of the outcome of that conflict there is one war that will continue, and will grow in intensity as the years go on. I speak of the war against an international nation—the war against the Jew.

Because there is no immediate prospect of a let-up in this war, I say let us determine once and for all the course we shall follow in

the United States. We would like to take the side of right. But what is right regarding the problem of the Jew? In order to determine that course let us try the accused to ascertain his guilt or innocence.

Picture if you will a courtroom. Our chairman shall serve as his Honor, the judge. You ladies and gentlemen shall serve as the jury. It shall be my privilege to serve as defense attorney. The prosecuting attorney has just summed up his charges. Counsel for the defense speaks:

Your Honor, ladies and gentlemen of the jury, you have heard the charges of the prosecuting attorney. He has called the Jew a money-changer, an internationalist. one who refuses to become assimilated. But does the prosecuting attorney really understand the Jew? Such understanding is impossible without a knowledge of his past. I give you his past that you may understand him as he is today.

The Jew has a rich heritage. He once constituted the proudest nation in the world. Denied all means of development the Jew became stunted, avaricious, and self-seeking. The once proud Hebrew was beaten into the attitude of a suppliant. Christianity grasped the scepter and meted out the savage law of destruction until the whole world became a hell of torture to the despised Jew. Proud, he learned to endure the sufferings that were heaped upon him. Passionate, he cultivated humility and patience. Warlike, he learned to bow before physical force and succeeded through the subtle powers of his mind. Deprived of the opportunity of a livelihood as the gentle shepherd and farmer, he became the cunning money-changer—the product of hundreds of generations of repression and wrong. Driven into a corner he made that corner the monetary center of the world and he taught men the secrets of finance. When over all Europe hung the dark clouds of ignorance and superstition, this arch-criminal as alone as a lighthouse in a stormy night kept alive the lamp of learning. During all of this time he proclaimed his belief in a one God and he has been crying out to that one God for justice and for mercy. In return he has received the humiliations that have been heaped upon him. But his faith in that one God remains unshaken. Truly the Jew is a wanderer. He is of all nations and of all people and yet, he is of no nation and no people.

Thus you have a picture of the accused. He is a paradox in himself. On the one hand you have the avaricious money-changer and on the other hand you have the pious, religious benevolent Jew. What is the answer to this split-personality?

Is it as the prosecuting attorney has charged that the Jew is persecuted because he is a money-changer, an internationalist, and that he refused to become assimilated? As counsel for the defense it is

my contention that the Jew would still be persecuted even if these charges did not exist.

I cannot deny that the Jew is a shrewd businessman, but without that ability the Jew would have perished. It is his ability to earn a livelihood and control wealth that has made him a power, but it is only in those nations where it has been necessary that he turn to money for his self-preservation that he has done so. Here in the United States where the Jew has a haven of peace he has concentrated his energies in other fields. In a survey conducted by the *Fortune* magazine it was found that the Jew controls an infinitesimal share of the nation's wealth. Here he expresses his real self in the channels of art, literature, science and education.

I cannot deny that the Jew is an internationalist. But in spite of that internationalism he has been faithful to his nation. In the last world war thousands of Jews were slaughtered fighting for both sides. The Jews are a grateful people who are anxious to repay a nation that has sheltered and protected them.

The Jew has not become assimilated because assimilation is impossible for him. In the relentless persecution of the Jews by the Nazis all Germans who are of traceable Jewish descent are included. One hundred years ago the Jew was released from the ghettos of Germany to be dispersed and assimilated among all the people. Today the Jew is being herded into the concentration camp where he is left to die of starvation and disease.

Regardless of the answer to these charges the Jew is persecuted upon still more fundamental grounds. The Jew was persecuted because of his religious beliefs. In the centuries before Christ he was persecuted by pagans. We have all read of the merciless treatment of the Jews at the hands of the Pharaohs. At a much later date the systematized church persecution took place. What could be more atrocious than the Spanish Inquisition? It is a night in Madrid, there is to be a burning of Jews; the victims are brought and bound. The king himself stoops to light the faggots and a monk exclaims, "In the name of Christ."

But you will say that the Jew is no longer persecuted on religious grounds because the church has become enlightened. Yes, this is quite true, but nevertheless he is persecuted today on an even greater scale, and it is because he constitutes a minority. Demagogues have recognized this fact, and have used the Jew as a stepping stone into power. Hitler used the Jew as a stepping stone into war and has continued his merciless persecution of the Jew in order to keep his people in the dark as to his real motives.

I appeal to you, ladies and gentlemen of the jury. I appeal to you

because this same situation is arising in our democracy. The United States constitutes the last bulwark of freedom. If you accept the charges of the prosecuting attorney then you are condemning yourselves. Intolerance, hatred, and injustice have no place in the hearts of conscientious men and women. Anti-Semitism must be checked at the very beginning, for like the small grass fire, if allowed to go on unchecked it will become a raging forest fire sweeping all that is worthwhile in its path. We can check this small grass fire by removing from our hearts our prejudice against the minority group—a prejudice that is based upon fear; a fear that is based upon misunderstanding; a misunderstanding that has no just cause for existence, for in reality Judaism teaches the same principles as does Christianity. As I see it the tenets of the Christian faith as taught by the Great Teacher are service, mercy, and justice. Judaism also teaches service, mercy, and justice. It further teaches that the mission of all Jews should be to create the international brotherhood of man. The Jew has deviated from his course but we all know that he has done so because non-Jews have been prone to condemn him by accepting the charges of the prosecuting attorney and he has only retaliated in self-defense.

Ladies and gentlemen of the jury, the case for the defense is finished. It is up to you. If you accept the charges of the prosecuting attorney, then you will continue to admit that brute force shall be triumphant over culture. If you free him then your duty is half over. It then becomes your duty to understand him. When you understand him, then I believe that the maxim "peace on earth, goodwill unto men" will approach a reality.

TO HAVE LIVED WITHOUT REASON

Theodore Clevenger, Jr., 1951

In responding to a request from the author for permission to reprint this speech, Ted Clevenger wrote: "This speech was prepared as a collegiate contest oration, and the author thoroughly enjoyed delivering it. Nearly 20 years later, I realize that it raises many more problems than it solves, but I still believe in the validity of the central thrust of the message." Perhaps young people ought to raise more problems than they can solve, because locating problems must precede constructive

solution. At least the idea in this speech characterizes Dr. Clevenger as a student—an intelligent young man with an inquiring mind to whom "satisfactory" was never enough. As indicated by his recent experimental research in communications, his books, and his work in professional associations, apparently these characteristics still apply.

Dr. Clevenger was a student at Baylor University from 1949 to 1952, where he earned both his Bachelor of Arts and Master of Arts degrees. In 1958, he completed his Ph.D. at Florida State University. After teaching at the University of Illinois, the University of Pittsburgh, and the University of Texas, he became chairman of the department of communication at Florida State University and is now acting provost of the division of communication arts and sciences. In 1972 he served as president of the Speech Association of America.

This speech takes the form of problem-solution with major emphasis on the problem. The introduction captured interest well because it referred to a then recent happening which was uppermost in the minds of most people—the first atomic energy experimental explosion. The body develops four areas in which we have failed to apply reason: education, government, economy, and religion. The suggested solution calls for a return to reason in these and other areas. The speech uses reasoned discourse primarily and supports the reasoning by specific instances, detailed illustrations, and one quotation.

The speech appears especially effective in creating an imaginary dialog between the speaker and the audience; the audience seems literally to talk back. Use of the rhetorical question to introduce new ideas and to emphasize points as well as vivid description exemplified in the third paragraph help create action and thus make this speech move swiftly.

On the sixteenth day of July, in the year of our Lord nineteen hundred forty-five, a scientist in a remote section of New Mexico pulled a switch, and an assembled group of fellow-scientists and high-ranking military officials, peering miles away through slits in a solid concrete barrier, witnessed for the first time the unleashing and utilization of the basic powers of the Universe.

The test-tube boys had done it again! And by tinkering with his gadgets and adding up his equations, man had succeeded in scoring the final victory over his environment, for he had succeeded in directing to his own purposes the ultimate in the utilization of transmutation of matter.

But as they watched that huge, mushroom-shaped cloud billow skyward, in the minds of those men of science and men of war there was a single question: "What will come of this?" And in their hearts

was fear. That fear has since spread to the hearts and subconscious minds of all peoples, for we today live in constant mortal terror of what tomorrow's sunrise will bring. Will we wake to the singing of that robin in the sycamore outside the bedroom window, and walk to the office along comfortably shaded avenues? Or will the robin's song be forever silenced by the scream of supersonic rockets and the avenue blasted to oblivion by runaway electrons? Or, will we wake at all?

The obvious solution to this fear, world organization, has been tried and found pitifully lacking. It seems that you have created a bit of a problem for yourselves; consequently I should like to discuss that problem with you. It is a problem which has been in existence for the last 2000 years, but never before brought into sharp enough focus to warrant wide-spread public attention. It is a problem that now threatens the life, security and happiness of every living and unborn man, woman, and child.

I'd like to talk with you, Mr. and Mrs. Average Citizen: I'd like to talk about you, your education, your government, your money, and your religion.

Emanuel Kant, in his "Critique of Pure Reason," says that the basis of all intelligent living is logical reasoning. If this is true, and we have no reason to doubt its authenticity, then today's version of the human being, modern man, is living on a level slightly below that of his predecessor, the ape; for he certainly displays a good deal less intelligence.

Let's look first at your education. For 16 years you were beaten, practiced, tutored, coached and cursed through several grades of learning, and then pronounced educated. You emerged resplendent in a new pinstripe suit and a brand new degree. Whereupon, armed with a piece of parchment which proclaimed you Bachelor of Arts, Sciences, or Laws, or entitled you Doctor of Philosophy or Medicine, you set out on a protracted conquest of the world. You determined to make as much of the earth, its properties, its resources and its inhabitants, your own personal possessions as was humanly possible, for you had been educated—but without reason.

The light of your limited knowledge, however, gave you insight enough to realize that you were going to need some sort of a governing body, and so you organized it and you called it a government. Now, if you were sufficiently clever (or your colleagues sufficiently stupid) you immediately set yourself up as king, potentate, or dictator, and under the pretense of being divinely inspired, perpetrated atrocities which defied reason, and produced a condition of universal nausea and malcontent. Your fellow man, however, soon became

aware of the ridiculousness of his situation, and in one inspired moment, he cast you down from your golden throne into the dust from which you'd sprung. Undaunted, however, you soon devised a new form of government known as Democracy, and now if you shake enough hands, slap enough backs, kiss enough babies, and bribe enough voters, you can retain the position of authority and grandeur which you formerly enjoyed. You have instituted governments, but again without reason.

Your governments have coined money and regulated commerce, and almost without realizing it, you have given birth to varied forms of economy. You call yourselves Capitalists, or Socialists, or Communists, but I say that you are human beings, and that as such you have become beasts with an all-consuming desire for economic wealth. Why, you interpret capitalistic freedom of enterprise to mean that you are free to exploit not only your environment, but your fellowman as well, and to glorify your own ego, and satisfy your own desires at the expense of all humanity if necessary. Or you say, "I am a Socialist" or "I am a Communist, and I believe that all men should be economically equal." But if the opportunity for personal glorification presents itself, you add, "Yes, all men are equal, but some men (like me, for instance) are *more* equal." And thus you institute economics—once again, without reason.

"But," you say (and at this point your face takes on a pious glow) "man does not live by bread alone, he needs God." Whereupon you proceed to inaugurate religions. Calling yourselves Christians, or Hindus, or Moslems or Jews, you proceed to expound at great length upon the divinity of your own particular demi-Gods and saints. You set up moral codes and standards of belief, and prostituting your God-given reason for blind faith, you have the audacity to assert that those who fail to adhere to your own particular doctrines will rot in Purgatory, fry in Hell, or be reincarnated in the bodies of wart-hogs. All this in obvious disregard of the fact that there's not enough rot in ten Purgatories, or enough fire in 50 thousand Hells to consume the substance of your own misdeeds. You have followed perfectly good religions, but completely and totally without reason.

Indeed, in every phase of your daily lives: your education, your government, your economy, and your religion, you have forsaken the use of that one instrument at your disposal which separates you from the most savage orang-outang in New Guinea: reason. And you have lived without logic; you have lived without reason.

The situation, of course, is not beyond redemption. Through the darkened mass of problems you have created for yourselves, there

shines one faint glimmer of hope: a Utopian dream so fantastic in its beauty that we dare not envision its reality.

But the problem confronts us now. Tomorrow or the next day, or next week or month or year may be too late. The solution is within our grasp. It may take numerous forms, but in essence its motivation will come from, through, and by you. You, Mr. or Mrs. Average Citizen of China, Great Britain, Russia, or the United States. In your palm lies the solution to today's problem—lies the heart of tomorrow's hope. If you will educate, govern, economize and worship intelligently and with reason: if you will employ that God-given reason in your daily lives and apply it to your international problems, instead of confining it to your chemistry and physics laboratories, if you will use your reason as an instrument in the solution of your social problems as the scientist uses it in the solution of his material problems, if you will live *with* reason—then, and only then may today's Utopian dream become tomorrow's reality.

SHACKLED BY STEREOTYPES

George Schell, 1962

Mr. Schell was the only student in this group with whom the senior author had the privilege of working for six years—four years as an undergraduate, and two years as a graduate student in which Mr. Schell served as assistant and coach of debate. Perhaps the most successful debater in terms of victories in the school's history, he was voted the second-best debater in the West Point National Debate Tournament his junior year and the top speaker his senior year. Upon graduating with the Master of Arts degree in 1963, he joined the faculty of Loyola University in Los Angeles as instructor in speech and forensic director. Promoted to chairman of the speech department, his debate teams are consistently among the best in the nation.

This speech was delivered early in the period of demonstrations over the civil rights movement. It calls for the overthrow of time-worn, stereotyped thinking in an attempt to understand and cope with the problem. Although the central theme and specific purpose are perhaps less clear than in some of the foregoing speeches, it illustrates how the theme of a speech may be carried almost entirely through illustrative

material. Beginning with a quotation by Alexander Pope, the speaker makes a plea for us to revise our thinking on problems of social justice. He uses four quotations, three specific instances, and three detailed illustrations. The supporting material comes from current happenings, incidents from recent books, and illustrations from literature. He concludes with a quotation which reemphasizes the central idea of the speech.

"Be not the first by whom the new are tried nor yet the last to lay the old aside." This statement by Alexander Pope along with my professor's discussion made me realize how much like stereotypes you and I tend to become—how often we just go along with the crowd.

In the nineteenth chapter of the Book of John there is an account of the first Holy Week which says, "And from thenceforth, Pilate sought to release him, but the people cried out saying: 'If thou let this man go, thou art not Caesar's friend.'"

Crowds, you know, are strange things—made up of ordinary people like you and me, people who normally are decent, kind to children, genial over a cup of coffee. People, hearing an unusual noise, will run out into the street to see what it is, and will join others doing the same thing—curious, excited—about what is going on, not really knowing, and a push-over, most of us, for rumors and whispers. And as these ordinary folk join together, a new entity is formed, the crowd. No, it cannot think, this entity. At least, it will not think. But, it can act. And, right there is the crux of the problem.

It is not necessary to illustrate this idea with historical incidents in far-away countries. We can take a modern, 1959 look at Little Rock, Arkansas. Just let ordinary people swarm around a situation or a person where the crust of life-long customs and time-honored social traditions is breaking up, and there you have it: violence, hatred, dishonor, bloodshed, fear, destruction. In such a situation, as men, we must have a sense of direction or we ourselves will be dishonored and lost.

In the book, *Wind, Sand and Stars,* the author, St. Exupery, tells of being lost in an airplane over the Sahara desert at night with only the stars as an aid in setting his course. Each time as one guiding star twinkled out, another appeared decreasing his fear of being lost, but it soon became evident that he was in interplanetary space among a thousand inaccessible planets. Suddenly low on the horizon a brilliant point of light was unveiled, and to him there came an awareness that the beacon of an airport was there to guide him to safety.

This incident is a symbol of the intellectual predicament of

many of us. We feel lost pretty much as though we were flying
over a dark expanse, with no sense of direction. And, in our
desperation, we pin our hopes on the beckoning of one flickering light
after another, hoping to be guided back to the solid earth, to our
intellectual homes, where we can have unyielding ground beneath
our feet, again.

It was my pleasure to hear a sermon in which Bishop Hines made
this point very clear to me.

After being away for 20 years, he visited the first parish of his
ministry. Much about the contemporary picture was exciting and
hopeful to him, but one aspect was not. Twenty years ago in that parish
there was a small group of young men, bright-eyed, intelligent,
sensitive, inquiring. It was in the depths of the depression, and the
whole social order was yielding badly at its seams. Bread lines were in
evidence everywhere, as a community tried to keep a man's body
together without jeopardizing his soul. And these young men looked
at this thing, and wondered, and made resolutions and dreamed.

What had happened to them? What had 20 years done? Now they
were settled and complacent, middle-aged men. The spontaneity and
imagination of a younger day was now a vacant and fireless pit. They
would go to the office and then come back home. Their visions of
victory were largely concerned with shining automobiles and
air-conditioning and retirement security. They looked back upon
their earlier days before "the zipper of their stereotype pinned them
down" as a time of foolish dreams but actually that was the time
when they were really alive. They had arrived then, but in the
process, somehow, they had lost themselves. Certainly, their
individualism was threatened.

Now, many of you remember the story of the medieval blacksmith
who took such great pride in his work that he put a special secret
mark upon everything he produced. In the course of time his village
was conquered by an invading army and he himself was thrown into a
dungeon, and there shackled with heavy chains. But this did not
trouble him too much, for he was a powerfully built man, and he
knew all about chains, anyway. He was confident that he could find
the weakest link, and by bringing pressure to bear upon it, win
freedom. But as he passed the chain through his hands, searching
for the weakest link, he came upon that secret mark that told him
that he himself had forged that chain. Then he cried out in despair,
for he knew that there was no weak link within it. He was doomed to
bondage by the fetters he himself had forged.

To me this is a vivid picture of the severe problem of our lack of

independent thought, our tendency toward ineffective stereotype, bound by the chains of complacency, prejudice and fear that we ourselves have forged.

A more worldly illustration can be found in one of Mark Twain's books which tells how the Mississippi River cut through a narrow stretch of land one night. It seems a Negro, who went to sleep in Missouri, woke up to find the land on which he lived was now a part of Illinois, and that made him a free man. Oh, it was the same old land, mind you, but he saw it for the first time with the eyes of a free man.

Professor Arthur Schlesinger writes that "Our contemporary American society has little use for the individualist. Individualism implies dissent from the group; dissent implies conflict; and conflict suddenly seems divisive, un-American and generally unbearable."

Now obviously society had to evolve collective institutions to cope with the complex problems of the age, but the collective approach becomes outdone when it clamps an indiscriminate mold on individual thinking. It is not too difficult to find examples of this demand for mediocrity and conformity. Our schools emphasize the philosophy of "conform to the average or be ostracized." The constituent hostility of labor to the man of exceptional ability is unfortunately a matter of record. Our seemingly incessant will to blindly conform to set standards is equally evident on the management side of business. The conformity of the organization man of the typical corporation has become well-known.

Yet, if we are to maintain a healthy way of life, in fact, if we are to survive, it is necessary that we encourage individualism.

In closing, we could do well to consider the words of the Prussian philosopher Frederick Nietzsche: "He who seeks may go astray; all solitude is sin—so says the crowd."

YOUNG MEN WITH VISIONS

Dianne Ferrell, 1969

A 1969 graduate of Baylor with a major in history, Miss Ferrell was an unusually versatile speaker who did equally well in all types of forensic contests and in speeches before public audiences. She completed her Master of Arts degree at Tulane University and now resides in Nashville,

Tennessee. As an undergraduate, she was a campus leader in student government, president of Pi Kappa Delta forensic fraternity, and voted among the ten outstanding senior women.

Unlike many of the speeches in this collection, Miss Ferrell's speech was taken down as she spoke it. In her letter to the author of February 4, 1970, she states, "My speeches were prepared for the speaker, not the reader. Sentences run on, phraseology looks complicated, and punctuation is almost nonexistent. But the words are as I thought them—which, I think, enabled me to say them with meaning and effect." The speech was used as a college contest oration and with unusual success.

This speech calls for an understanding of students who rebel—the hippie, the student demonstrator, and those who rebel inwardly but not overtly. She raises and gives possible answers to the questions: Who is he? What does he want? What is his purpose in protesting? She also asks for greater perspective on the part of others in understanding him. Unlike the preceding two speeches, this speech consists largely of explanation and description, and has a minimum of illustrative materials. Her use of vivid description and the rhetorical question warrants special mention.

And the prophet uttered his forecast: Your old men shall dream dreams; but your young men, alas, your young men shall see visions. Amid the cacophony of protest so rampant in our nation today, I think it is a plausible and reasonable question as to just what all this noise is really about. In this brass-hat, brass-mortarboard world, what is it that has so triggered the consistently louder, more vitriolic complaints of a considerable number of our youth? Who is the young man and what is his vision? The sheer energy of his commitment has demanded not only parlor protest but the march, the sit-in, and the demonstration. Our man, literally on the street, speaks for the beleaguered individual in an impersonal society—whether Negro share-cropper, white welfare recipient, or college dropout. And above all, he shouts numerous invectives against the Viet Nam War. But who is he and how can he be identified? I do not think that I could adequately describe him, in all fairness, for just as the gamut has been run from men like Dr. Benjamin Spock to Rap Brown, so our young man may be quite difficult to identify. He may, quite obviously, be the long-haired hippie, just out to buck the Establishment: arty, soul-searching, laden with talent but little practical initiative, who wishes to reform the world from some position atop his soapbox. Or he might be the white-collared, well-groomed, smiling young man from a liberal, well-to-do family who envisions himself as some kind of philanthropic humanitarian. However it is far more likely that he is a combination of these; for regardless of dress or style of protest, he is

one who is earnestly exercising his individual conscience and increasingly expressing his moral sensitivity.

From a more urban way of life, he is better educated, more aware of his world, and more sophisticated than his forebears. For the past decade, he has grown up in an air of self-criticism; and consequently has learned to question tired, old American assumptions. Like Carl Schurz, he can exclaim: "When right, to be kept right; when wrong, to be put right." Angry at the human condition, he entertains the thought of driving conventional society to a constant, sometimes painful review of its own values. He distrusts the attempts of the multiversity to sterilize his imaginative and creative potential; and he fears, he honestly fears, the dark, wordy academic deaths which we all, once caught up in the stream of large-scale education, sooner or later die.

To him, Holden Caulfield is no enigma; and he understands only too well Salinger's concept of the Fat Lady. As he has made the transition from laissez-faire to savoir-faire, he is well aware of much data regarding the Church, the Bomb, and the Pill. Assuming his own special air of sophisticated folksiness, he embraces candid conversations about drug addicts and homosexuals—and more often than not, he enjoys one or both as friends. New experiments and achievements cause him to wonder whether he, a terrestrial animal, will not soon be outmoded by space-dwellers or by marine biologists scanning the ocean floor. Cybernetics, an engaging new field of mechanization, promises to catalog his scientific data or match him to a mate. He reads Art Buchwald, Art Hoppe, the Wizard of Id, and Peanuts; and he is re-reading such classics as *Alice in Wonderland* and *Huckleberry Finn,* for having discovered that they are heavily cloaked in symbolism, he realizes that they, like everything else today, are really for mature audiences only.

Our young man may search through musty attics and damp cellars for cheap editions of great books; but he simply won't buy cheap editions of great men. Finding himself in an age of deep introspection, unfortunately, he often withdraws from the context of society—all the while claiming his empathy with all human beings.

His vision is utopian and full of inner contradictions; but his recurrent theme is "Let the United States heal its own sick society before it presumes to treat others," and ultimately he doesn't want to reform society, but really, human nature. He feels, like Oscar Wilde, that "to be good according to the vulgar standard of goodness is quite easy. It merely requires a certain amount of sordid terror, a certain low passion for middle-class respectability." Not for him just chatter about apple pie, Motherhood, and the American way,

for his world is embodied in the dual concepts of—on the one hand, "It is a condition we face, not a theory"; and on the other, the idealistic plea, "It's too late for flags."

Is he a spiritual factor? Then where is his platform? He has no program, and how much he wishes to tear down only to replace the rubble with what? Herein lies the need for perspective: not only on the part of those who consider all protestors as unclean, unpatriotic, rebellious youth, but on the part of the protester himself as to what is his objection to society. For if he is to serve as a catalyst, that is as one who is to point out the evils and injustices of society without necessarily offering operative alternatives, then perhaps " 'tis a far, far better thing" he does than has been done in a long time. Some of the things which he is saying about contemporary American life need to be said and evoke certain echoes in anyone who has ever been raised to the pitch of white-hot anger over a slum, a piece of blatant hypocrisy, or the mere feeling of being lonely in the midst of a crowd.

A young man with a vision. His purpose—to reduce the gap between the theories of the American way and the facts of American life. And what is he saying—there is a revolution; there is a baby struggling to be born. And the determining factor—as always, the enigmatic future. To whom will the credit go? To the collegiate or the beat; to the noncommittal or the protester?

I don't know that this young man would agree with using words by Emerson, but on the other hand, I cannot expect his disagreement; and so I shall, by choice, use these words to sum up my personal feeling of confidence in this young man:

> So nigh is grandeur to our dust
> So near is God to man
> When duty whispers low, thou must
> The youth replies, I can.

Group approach
to oral
assignments

The oral assignments listed at the end of the first ten chapters present alternate plans: Plan A lists public speaking assignments for those who prefer this approach; Plan B provides for group activities and consists of small-group workshops and discussions combined with one public discussion and two public speeches.

The public speaking assignments for Plan A follow the same procedures as they did in the former editions of this book. The order of the assignments, from simple to complex, attempts to accustom the student gradually to the complexity of the total process of public communication. Early assignments call for simple reporting; later assignments combine reporting and original work; and the final assignments require completely original speeches. Oral activities are also included at the end of chapters 11 through 15 for those who teach two-semester courses or who prefer some of the more difficult assignments accompanying the latter chapters.

The group activities explained in Plan B accomplish two purposes: First, they prepare students for life situations, where most people communicate more person-to-person and in small groups than they do publicly; Second, they permit larger classes and thus satisfy administrative requests often made because of economic necessity. The authors have experimented with group assignments over the past four years with classes ranging in size from 42 to 60 students. We believe that as many as 48 students can be taught without sacrificing the skills approach or the number of oral assignments. This plan calls for nine participations: two informal classroom discussions, two group-workshop sessions, two small-group discussions, one public discussion, and two speeches before the entire class—plus one group critique.

I. ARRANGEMENT OF GROUPS

Divide the class into groups of eight students each for classes that meet 50 minutes and twelve students each for classes that meet for one hour and 20 minutes. For the two classroom sessions, lead the class in a discussion of "What are the important issues today?" The aim of these two sessions is to come up with a general topic for each group, one large enough in scope that it can be divided into subtopics for each member. For the remaining seven oral assignments, each student discusses or speaks about either the general subject for his group or his specific subtopic.

II. SAMPLE TOPICS

Group 1. Political Reform Financing elections, change in presidents' pardoning powers, selection of vice president, nominating conventions, third parties, retirement age for office holders, abolition of the electoral college, impeachment proceedings, powers of the president, filling a vacancy in the presidency, obligations to a deposed president, parliamentary government.

Group 2. The Economy Inflation, recession, tax reform, the stock market, interest rates, insurance, social security, federal housing, agriculture, opportunities in business, food scarcity, effect of urbanization, labor-capital relations, devaluation of currencies, energy crisis, overpopulation, the ecology, the gold market, national debt, poverty.

Group 3. Education—Problems and Solutions Financing, liberal or practical, faculty ratings, student representation, grading systems, compulsory class attendance, required courses, minority recruitment, honors programs, student government, social life, increasing costs, religious instruction, honor systems, independent investigation courses, censorship of school newspaper, semester or quarter system, coed housing.

Group 4. The Established Order—What's Wrong and What Can Be Done? Medical care, standards of morality, capital punishment, drugs, religion, voting rights, crime and punishment, abortion, marriage, divorce, mental illness, censorship, juvenile delinquency, busing, gun control, invasion of privacy, materialism, home life.

Group 5. Protest in America Women's liberation, student, teacher, labor, civil rights, consumer, amnesty, the generation gap, the elderly, religious, political, Indian, Anglo-American, war, the poor, the taxpayer, against government powers.

Group 6. Leisure Activities—Sports and Recreation Television, art, sports, travel, music, movies, theater, literature and reading, women in sports, horse racing, the olympics, hunting, writing, newspapers, magazines, radio.

III. ORAL ASSIGNMENTS

1. Open classroom discussion. Subject, "What are the important issues today?" This session considers broad topics that can be divided into significant subtopics for each member of a group. The topics should be interesting and profitable for study and for oral assignments throughout the semester, as exemplified by the foregoing sample topics.

2. Open classroom discussion (continued). In preparation for this assignment, each student submits three general topics broken down into subtopics that grew out of the first classroom discussion. Explain and defend your choices if called upon. Following this discussion, the professor draws up a preferential ballot of topics, based upon the classroom discussions and student lists, for vote at the next class period. From these ballots the professor can get the necessary information to arrange the groups and the general topics for each.

3. Organizational and get-acquainted session. The groups meet simultaneously under the direction of a temporary chairperson appointed by the professor, and follow this procedure: (1) Each member of the group gives a two-minute biographical sketch and answers questions about himself for one minute. (2) Elect a permanent chairperson and a secretary. (3) Select specific topics for each team member. (4) Exchange preliminary ideas on the general topic. (5) The secretary hands the professor a list of team members and their selected topics following this session. (6) The professor rotates among the groups to observe them in action.

4. Reporting session. The groups meet simultaneously and each student reviews a magazine article on his subtopic; time limit, five minutes. This assignment gives practice in reporting to a group and helps acquaint other members of the team with the issues of the subject. Proceed as follows: (1) State the magazine, date, author, and title of the article. (2) Review the article; abstract its content for the group. (3) Give a brief appraisal or evaluation of it. (4) Answer questions not to exceed one minute.

5. Small-group discussion. The groups present panel discussions before the entire class on their general topics, following the pattern for discussion explained in chapter 5. Emphasize: (1) the problem—evidence

of it, (2) possible causes—what brought the problem about, (3) solutions—what should be done. Reserve ten minutes at the end for an open forum.

6. Critique of panel discussions. Arrange a professor-student panel to critique the panel discussions held for the fifth assignment. The professor acts as chairperson and the panel consists of the chairpersons and secretaries for each group. Following the professor's criticisms of each group, panel members comment, ask questions of the professor, and offer additional criticisms. Reserve at least ten minutes at the end for an open forum.

7. Workshop session. The class groups meet simultaneously to plan a program of informative speeches for presentation to the entire class. Decide on plans for the program and how to make it interesting and profitable. Each student discusses the tentative plans for his speech; then other members of the group make suggestions for improvement.

8. Program of informative speeches. Each group presents its program of informative six-minute speeches before the entire class. The chairperson presides, calls on each speaker in turn, summarizes and concludes the program, and conducts an open forum if time permits. The professor writes a critique of each speech and/or fills out an achievement scale.

9. Workshop session. The groups meet simultaneously to arrange a program of persuasive speeches for presentation before the entire class. In these speeches, take a stand on some issue related to your subtopic and attempt to persuade the class members of your position. Decide on the organizational plan discussed in chapter 9 that best serves your purpose and review chapter 8 on how to support your points. Exchange ideas on each tentative speech and make suggestions for improvement, using the same procedures as outlined in assignment 7.

10. Program of persuasive speeches. Each group presents its program of persuasive speeches before the entire class. Follow the same procedures outlined for assignment 8.

IV. PROCEDURAL METHODS

1. The professor should have brief meetings with the chairpersons and secretaries before each group session to exchange ideas on how to make the sessions as profitable as possible. He should appoint the temporary chairperson carefully because the temporary appointee is frequently elected permanent chairperson. The secretary keeps the attendance

records and passes out materials. If the students fill out an information sheet at an early class meeting, these forms will be helpful in making the appointment of temporary chairperson.[1]

2. The professor should visit each group session at least once to see them in action. If a graduate student can be employed as assistant teacher, he can share the group visits, keep the records, and otherwise assist the professor.

3. The professor should fill out a critique sheet and give a grade for assignments 5, 8, and 10. He can use peer grading for assignments 3, 4, 7, and 9 by means of a single-sheet rating scale whereby each member rates every other member of his group.[2]

4. An average-size classroom will usually accommodate three groups strategically placed in the room. Small rooms such as seminar rooms and large offices may serve as meeting places for the remaining groups. An ideal arrangement consists of large rooms that will accommodate all the small groups.

V. ADVANTAGES OF GROUP ASSIGNMENTS

1. They permit a diversity of oral communication activities that approximate life communication situations. If a third public speech seems desirable, assignment 5 can be made a small-group session to allow time for it.

2. They permit larger enrollments without decreasing the number of oral assignments. Class size seems to be increasingly important economically; many administrators are apparently reluctant to expand programs that cannot approximate the average class size of the university.

3. They permit a study of a significant subject by each student and an in-depth study of a phase of that subject. Thus, the course adds to the liberal arts education of students.

4. They permit listeners to hear programs with significant content as the various groups present their programs to the class. Thus, the time spent in listening becomes more profitable.

5. They permit a decrease in the artificiality of classroom communication because the listeners seem to be interested in what the students have to say, rather than simply listening to them practice.

6. They permit the stimulus of group activity and thus motivate students to prepare thoroughly. For most students, working in groups increases interest in the class.

1 See appendix C for sample information sheet.

2 See appendix C for sample evaluation forms.

APPENDIX C

Forms for classroom use: information sheet, listening report, evaluation forms

Appendix C contains forms that the authors have found useful in teaching beginning courses in speech communication. The forms may be duplicated for classroom use; on the information sheets and listening reports, space can be provided for answers to the questions.

Since speech criticism is a highly individual matter, the professor needs to know as much as possible about each student. The *information sheet* elicits the type of information useful to the professor in evaluating the students' oral performances, especially for those students who fail to make normal progress.

The authors assign four *listening reports,* spaced throughout the semester, designed to expose the student to significant communication situations, to help him become a more intelligent listener, and to give him pointers on how to improve his communication. The listening report provides a comprehensive and logical plan of speech criticism and encourages students to attend important communication occasions outside class. Most universities underwrite lecture series that bring outstanding persons to the campus for lectures.

The *critic's speech evaluation form* may be used by the professor or by other students if their professors favor peer evaluation. The *professor's speech evaluation form* may be used for a more detailed critique of at least some of the student speeches. Perhaps oral critiques serve

best, but in large classes time can be saved by using these evaluation forms.

Professors who use the group approach to oral assignments explained in appendix B will find the student evaluation forms helpful. They should be filled out by each member of a group, except that a student will not evaluate himself or herself. Our experience has been that peer evaluation in group assignments encourages preparation and participation.

STUDENT INFORMATION SHEET

1. Give your full name, address, and telephone number.
2. How are you classified? (Freshman, sophomore, etc.)
3. Are you working for a college degree?
 What degree?
 Major subject?
4. What business or profession do you contemplate?
5. How important do you consider oral communication to that business or profession?
6. If employed, how many hours per day do you work, what is the type of work, and who is your employer?
7. Did you take any oral communication courses in high school? If so, state briefly the nature and extent of such training.
8. Did you engage in any oral communication activities in high school such as debate, discussion, plays, readings, or radio announcing? How extensive?
9. Have you had any other oral communication courses in college? If so, explain briefly.
10. Do you belong to any organizations that require you to speak in either formal or informal situations? If so, explain briefly.
11. What do you consider your principal weaknesses in oral communication?
12. What do you consider your principal assets in oral communication?
13. List what you consider the six outstanding qualities of a good communicator.
14. List what you consider the six principal shortcomings of communicators.
15. Explain any special reasons that you have for taking this course. Include any special aims or purposes that will help your professor evaluate your progress.

SPEECH LISTENING REPORT

1. List your name, course number, and section.
2. List name of speaker, title of speech, and occasion.
3. Give a brief summary of the speech.
4. How did the speaker introduce his speech? Did the introduction command your attention and arouse your interest? Explain.
5. What was the central idea of the speech?
6. What was the specific purpose of the speech? Did the speaker accomplish the purpose, in your opinion?
7. Did the speaker use a variety of materials? List some of them—such as examples, quotations from authority, statistics, personal experience analogies, narratives.
8. Characterize the organization of the speech.
9. How did the speaker conclude his speech? In your opinion, was it effective?
10. What use did the speaker make of emotional appeal?
11. Analyze the speaker's voice as to quality, rate, pause, force, and inflection.
12. Did the speaker use meaningful physical action? Explain.
13. Did the speaker have good eye contact? Explain.
14. Did you feel that the speaker was communicating with you? Why or why not?
15. Evaluate the speaker and the speech.

CRITIC'S SPEECH EVALUATION FORM

Speaker's name _____

Section _____ Topic _____

Rating scale: 1—Poor, 2—Fair, 3—Adequate, 4—Good, 5—Excellent.

 1. Clarity of purpose _____
 2. Organization of ideas _____
 3. Support of points _____
 4. Poise and manner _____
 5. Delivery skills _____
 6. Audience response _____
 7. Overall effectiveness _____

Comments and suggestions:

Signed _____

PROFESSOR'S SPEECH EVALUATION FORM [1]

Student _____ Class _____

Title _____

EVALUATION SCALE

	1	2	3	4	5
1. Choice of subject					
2. Clarity of purpose					
3. Forms of support					
4. Types of appeal					
5. Introduction					
6. Organization of ideas					
7. Conclusion					
8. Poise and self-confidence					
9. Choice of language					
10. Pronunciation					
11. Voice					
12. Control of bodily activity					
13. Evaluation of subject					
14. Audience reaction					
15. General effectiveness					

Comments: Total score _____

Rating scale: 1—Poor, 2—Fair, 3—Adequate, 4—Good, 5—Excellent
 Scoring: 67 to 75—Excellent, 54 to 66—Good, 41 to 53—Adequate, 28 to 40—Fair, 15 to 27—Poor

[1] Adapted by permission of the publisher from Harry Grinnell Barnes, *Speech Handbook*, 2nd ed., (© 1959, Englewood Cliffs, N.J.: Prentice-Hall, Inc.), p. 127.

STUDENT EVALUATION FORM FOR GROUP PROGRAMS

Topic _____ Date _____

Course _____ Section _____ Group no. _____

Instructions: List the participants' names and following the program rate each on content, delivery, and overall effectiveness. Use this scale: 1—Poor, 2—Fair, 3—Adequate, 4—Good, 5—Excellent.

Participants	*Content*	*Delivery*	*Overall*
1. _____	_____	_____	_____
2. _____	_____	_____	_____
3. _____	_____	_____	_____
4. _____	_____	_____	_____
5. _____	_____	_____	_____
6. _____	_____	_____	_____
7. _____	_____	_____	_____
8. _____	_____	_____	_____
9. _____	_____	_____	_____
10. _____	_____	_____	_____
11. _____	_____	_____	_____
12. _____	_____	_____	_____

Comments:

Signed _____

STUDENT EVALUATION FORM FOR WORKSHOP PROGRAMS

Topic _____ Date _____

Course _____ Section _____ Group no. _____

Instructions: List the participants in your group in the left-hand column. Following the workshop session, rate each student's effectiveness in contributing to the workshop. Use this scale: 1–Poor, 2–Fair, 3–Adequate, 4–Good, 5–Excellent.

Participants *Rating*

1. _____ _____
2. _____ _____
3. _____ _____
4. _____ _____
5. _____ _____
6. _____ _____
7. _____ _____
8. _____ _____
9. _____ _____
10. _____ _____
11. _____ _____
12. _____ _____

Comments:

Signed _____

Index

Able communicator, 34–40
Able-man theory, 8, 12
Able person, 35–37
Abstracting, 262–64
Accent in pronunciation, 307
Acceptable pronunciation, 306–7
Accurate use of language, 255–64
Achievement scales, 409–12
Action words, 275–77
Adler, Ron, 251
Admitted issues, 322
Affectations in voice, 288
After-dinner speaking, 363–67
Age of listeners, 81–82
Alfred, Lord Tennyson, 297
Allbritton, Joe L., 355–56, 360–61
Almanacs, 145
Ambiguous terms, 321
Analogy
 accurate use of, 175–76
 effective use of, 176–77
 exemplified, 174, 176–77
 meaning of, 174–75
 as reasoning, 330–36
 types of
 figurative, 175
 literal, 174–75
Analysis
 of debate proposition
 steps in, 323–24
 types of issues, 322–23
 as a goal, 30–31
 of listeners, 71–84
 of message material, 149–51
 in pattern for small groups, 99–101
 of occasion, 71–72, 85–88
Andersch, Elizabeth, 56
Anderson, Martin, 72
Anthologies of speeches, 141–43
Antonyms, 280
Anxiety
 causes of, 42–44

control of, 44–47
explained, 40–41
signs of, 42
Appeals to radio-television listeners, 368–69
Appearance, 249–50
Approaches to communication, 4
Approaches to language, 255–56
Appropriate language, 269–72
Appropriating arguments, 337
Aristotle, 13, 18–19, 35
Arnold, William, 262
Arrangement, 19. *See also* organization
Articulation, 300–302
Attitudes
 cooperative, 105
 passive, 105
 for research
 discriminating, 153
 inquiring mind, 151–52
 open mind, 152
 of scholar, 151
 of small-group participants, 96–97, 104–6
Audience analysis, 71–84. *See also* Listeners
Audiences for radio-television, 367–69
Auditory signs in delivery, 236
Averages, 167

Background knowledge, 138–41. *See also* Materials for messages
 reading habits, 138–40
 scope of interests, 140
 social life, 141
 varied activities, 140–41
Barriers of language, 97–98
Baylor University, 181
Benèt, Stephen Vincent, 176
Bibliographic Annual in Speech Communication, 3
Bibliographic indexes, 147

413

Bodily action, 239–49. *See also* Physical action
Body of speech, 197–207. *See also* Organization
Bois, J. Samuel, 264
Boren, Robert, 5
Bormann, Ernest G., 93–94
Bostrom, Robert, 56
Bradley, Bert, 43
Breakdown in listening, 52
Breathing for voice, 292–95
Broadcast messages, 367–74
Brooks, William D., 94
Bryant, Donald, 238
Buehler, E. C., 41
Burden of proof, 317–18
Burden of rebuttal, 318
Bureau of Public Affairs, 166
Burke, Cecil May, 308–9
Bush, Irving T., 345
Butler, Nicholas Murray, 132

Cameron, W. J., 276
Capp, Thelma Robuck, 162–63, 164
Carlile, Clark S., 363
Carlyle, Thomas, 383
Carroll, Arnold, 237–38
Casual evidence, 328
Causal reasoning, 333–34
Cause to effect
 organization, 205
 reasoning, 334
Central idea, 199–200
Characteristics of oral communication, 26–29
Chester, C. M., 132
Choice of subjects, 121–23
Cicero, 12, 35
Circular reaction, 7, 51, 84–85
Circumstantial evidence, 326
Classical rhetoricians
 sources of principles, 10
 teachings of, 10–13
 theories of
 Aristotle, 13
 Cicero, 12
 Corax, 10
 Plato, 11–12
 Quintilian, 12
 Tisias, 10
Clevenger, Theodore, Jr., 84, 126–27, 196, 233, 389–93
Collections of speeches, 141–43
Colorful words, 273–74, 281
Colorless words, 281
Communication
 circular response, 7, 51

history of, 28–29
nature of study, 4
nonverbal, 7, 236, 238–52, 286
oral, 27–29
process of, 7–10
small groups, 92–113
time spent in, 3
types of
 interpersonal, 5–6
 intrapersonal, 5
 verbal, 7
Complimenting listeners, 191
Composition. *See also* Organization
 principles of, 187–88
 restated graphically, 227
Conant, James B., 124
Concentration in listening, 62–63
Conclusions, 207–10. *See also* Organization
Confusion caused by language, 255–64
Connally, Tom, 81
Constructive cases in debate, 319
Conversational manner, 27
Corax, 10
Correspondence, 143–44
Covert action, 242
Credibility of speaker, 8, 35–36
Criteria for composition, 187–88
Criteria for good communication, 10, 17–22, 27–29. *See also* Standards
Critical listening, 33–34, 53, 64–66
Cues of voice, 250–51

Darrow, Clarence, 204, 261–62
Dating statements, 262
Dawson, Joseph M., 181–82
Debate
 analysis of proposition, 322–24
 comparative-advantage case, 317–19
 evidence in, 324–30
 procedures of
 advancing main issues, 318
 burden of proof, 317–18
 burden of rebuttal, 318–19
 constructive speeches, 319
 definition of terms, 318
 explanation of, 316
 listing of, 316
 negative positions, 319
 prima-facie case, 316–17
 propositions, 319–24
 reasoning in, 330–36
 rebuttal and refutation, 336–38
 tests of evidence, 328–30
Deductive
 organization, 202–3
 reasoning, 330, 334–36

Definitions
 of authority, 163
 of etymology, 163
 of exemplification, 164
 of explication, 164
 methods used in, 162–64
 of negation, 164
 of problems, 98–99
 of proposition, 318, 323–24
Deliberative evidence, 328
Delivery
 defined, 233
 as a goal, 32
 nonverbal, 238–52
 principles of, 234–38
 as rhetorical principle, 19–20
Democratic principles, 109–10
Denes, Peter B., 291
Descriptive gestures, 245
Desire for improvement, 34–35
Dewey, John, 98
Diacritical marks chart, 308–9
Dialect, 306–7
Dictionaries
 compilers of, 306–7
 listed, 147
 usage, 282
Differences in style, 264–65
Dilemma, 336–37
Direct communication, 27
Direct evidence, 326
Direct language, 272–73
Discriminating attitude, 153
Discussion, 92–113. *See also* Small-group
 communication
Divisions of message, 200–202
Douglas, Stephen, 39, 129
Dress and grooming, 249–50, 374
Dyad, 92

Ear training, 302–3
Economy of expression, 267–68
Effect to cause
 organization, 205
 reasoning, 333–34
Ehninger, Douglas, 35, 235–36
Eisenberg, Abne, 246–47
Eisenhower, Dwight D., 127–28, 203
Ellingsworth, Huber W., 233
Emerson, Ralph Waldo, 129–30, 399
Emotionalism, 18–19
Emotions
 defined, 163–64
 in listening, 60–61
Encyclopedias, 145
Entertaining messages
 after-dinner speeches, 363–67

occasions for, 20
 purposes of, 130–31
Enthymeme, 335
Enumeration-order organization, 204
Environment
 effect of, on voice, 290
 factors of, 251–52
Ethos, 37
Eulogy, 357–62
Euphemisms, 272
Evaluation of ideas, 30–31
Evans, Bergen, 269–70, 274
Evans, Cornelia, 269–70, 274
Evidence
 classification of, 326–28
 factual, 161
 forms of support, 157–83
 legal, 160–61, 326–28
 relation to logic, 324
 tests of
 quality, 329
 quantity, 329–30
 source, 328–29
 types of, 325–26
Examples
 accurate use of, 171–72
 detailed illustrations, 170–71
 effective use of, 172–74
 exemplified, 169–71, 173
 hypothetical, 170–71
 meaning of, 169–71
 real, 170
 specific instances, 169–71
 types of, 169–71
Exemplification, 164
Expert opinion, 177–82, 326–27. *See also*
 Testimony
Explanation
 definition of, 162–63
 explained, 158, 162–65
 with visual aids, 88, 165
Explication, 164
Extemporaneous speaking
 defined, 163
 methods of preparing for, 217–18
Extent of communication, 3
Eye behavior, 246–47

Face-to-face communication, 5–6, 92
Facial expression, 246
Facts, 165–69. *See also* Statistics
Factual evidence, 325–26
Faults in organization, 31. *See also* Organi-
 zation
Favorable attitudes
 of listeners, 76, 78–79
 toward sender, 78–79

Favorable attitudes (*continued*)
 toward subject, 76
Feedback, 7, 84–85
Ferrell, Dianne, 396–99
Figurative analogy, 175
Figurative language, 274–75
Figures, 165–69. *See also* Statistics
Fixed opinions, 96–97, 152
Flexibility of voice, 288–89
Force of voice, 305
Ford, Gerald, 178
Foreign phrases, 270–71
Forms for classroom use
 critic's evaluation, 409
 group programs, 411
 information sheet, 407
 listening reports, 408
 professor's evaluation, 410
 workshop evaluation, 412
Forms of support
 analogy, 158, 160, 174–77
 application of, 157–61, 206–7
 example, 158–59, 169–74
 expert opinion, 160–61, 178–82
 explanation, 158, 162–65
 facts, 159, 165–68
 listing of, 161
 reasoning, 161–62
 repetition and restatement, 182–83
 statistics, 159, 165–68
 testimony, 160–61, 177–82
Fosdick, Harry Emerson, 170, 177, 384–85
Fosdick, Raymond B., 203
Foster, William T., 35, 127, 163, 243
Freedom of discussion, 109
Freud, Sigmund, 262

General American dialect, 307
General purpose, 125–31. *See also* Purpose
General semantics
 abstracting, 262–64
 level of talk, 260–61
 meaning, 256–57
 time of talk, 261–62
 words as symbols, 257–60
Generalization, 331–32
Geren, Paul, 192, 383–85
Gestures
 characteristics of, 247–49
 appropriate, 248–49
 coordinated, 247–48
 definite, 248
 natural, 247
 spontaneous, 247
 timed, 247–48
 vary with idea, 248–49
 descriptive, 245

meaning of, 243
 traditional, 244–45
 wrong use of, 240, 243–44
Gettysburg Address, 14–15, 126, 197
Giffin, Kim, 252
Gilmer, E. M., 130, 190
Goals in speech training, 29–34
Goodman, Julian, 158–60
Government documents, 146–47
Graduate studies in speech, 3
Grady, Henry W., 39, 76–77, 78
Graham, Billy, 370
Gray, Giles, 264
Great speakers of history, 38–39
Grooming, 249–50
Group assignments
 advantages of, 404
 arrangements for, 401
 oral, 402–3
 procedural methods for, 403–4
 sample topics, 401–2

Habitual patterns of thought, 97
Hance, Kenneth G., 98
Hand, Learned, 198
Hands in delivery, 245
Hartman, Arthur A., 197–98
Hayakawa, S. I., 257
Heads and subheads, 219
Hearsay evidence, 327
Henrikson, Ernest, 41
Henry, Patrick, 39, 79–80, 209
Hoover, Herbert, 127
Hostile attitudes
 of listeners, 76
 toward sender, 79–80
 toward subject, 76–77
Hughes, Charles Evans, 345
Human interaction, 31–32
Human voice organs, 291
Humor
 appropriate use of, 365–66
 in introduction, 193
 methods for achieving, 365
Humphrey, C. J., 194–95
Hutchins, Robert M., 182–83
Hybels, Saundra, 92–93
Hypothetical example, 170–71

Illustrations, 169–74. *See also* Examples
Impromptu speaking, 216–17
Inconsistencies, 337
Indentation in outlining, 220–21
Indexes, 146
Inductive
 organization, 203
 reasoning, 330–34

Information sheet, 407
Informative messages
 forms of support for, 157–61
 occasions for, 20–21
 purposes of, 129–30
Inquiring mind, 151–52
Intelligibility of voice, 289
Interaction, 31–32
Interests
 of listeners, 189–91
 momentary, 57, 74–75
 primary, 56, 74
 scope of, 140
 secondary, 56–57, 74
 varied activities, 140–41
Internal stimulus, 7
International phonetic alphabet, 308–9
Interpersonal communication, 5–6, 92
Interpretation of debate proposition, 323–24
Interviewing specialists, 141
Intrapersonal communication, 5, 92
Introduction
 effect of, on speaker, 36
 of message, 188–99
 speeches of, 342–47
Invention, 19
Irrelevant arguments, 337
Issues in debate, 318

Jeffrey, Robert C., 25–26, 208
Jepson, R. W., 132–33, 158
Johnson, Lyndon B., 26, 128–29, 193

Kamin, Lester, 194, 386–89
Kant, Emanuel, 391
Keltner, John W., 93
Kennedy, Gerald, 162
Kennedy, John F., 208–9
Key of voice, 304–5
Key-word outline, 225–26
Khrushchev, Nikita, 259
King, Martin Luther, Jr., 190–91
Kirk, H. H., 132
Kissinger, Henry, 195–96, 207–8, 209–10
Knapp, Mark, 249, 251–52
Knowledge
 background, 138–41
 eloquence theory, 11–12
 of listener, 83
 of subject, 27–28
Korzybski, Alfred, 153

Language. See also General semantics;
 Words
 appropriateness of
 euphemisms, 272
 foreign phrases, 270–71
 name-calling, 271–72
 slang, 269–70
 triteness, 269
 vulgarisms, 271
 barriers, 97–98
 clarity of
 economy of expression, 267–68
 repetition and restatement, 268–69
 simple words, 265–66
 specific terms, 265
 technical terms, 266–67
 general semantics, 255–64
 importance of, 9, 255
 interesting
 action words, 275–77
 colorful words, 273–74
 direct and personal, 272–73
 figurative, 274–75
 limitations in small groups, 97–98
 purpose of, 255
Leadership in small groups, 107–13
Lecky, William E. H., 325
Lee, Irving J., 257–58
Level of talk, 260–61
Lewis, Wesley, 72
Limitations of small groups, 95–98
Lincoln, Abraham
 able-man theory exemplified, 13–15
 characterizes government, 263
 Gettysburg Address, 14–15, 126, 197
 Lincoln–Douglas debates, 39, 129
 use of analogy, 174, 176
 voice quality, 289
Listeners
 analysis of interests, 73–75
 attitudes toward sender, 78–81
 attitudes toward subject, 75–77
 effect on, 28–29
 facts about
 age, 81–82
 opinions, 83–84
 size of group, 82–83
 social background, 83
 training and knowledge, 83
 feedback, 7, 84–85
 radio, 367–69
 reactions of, 84–85
 as receivers, 7, 9–10
 show of interest, 85
 special interests, 56–57, 190–91
 television, 367–69
 why analyze, 71–72
Listening
 attitudes of, 55–56
 to communicators, 38–39, 144
 critically, 33–34, 53, 64–66

Listening (*continued*)
 effect on analysis, 53
 effect on communication, 54–55
 extent of, 52
 extent of breakdown in, 52
 rate of, 53
 reasons for, 52–55
 report form, 408
 requirements for
 attitudes for, 55–56
 emotional state, 60–61
 interests in, 56–57
 motivation, 57–60
 requirements of, 55–61
 in small groups, 105–6
 ways to improve
 concentration, 62–63
 critical attitude, 64–66
 note-taking, 66–67
 what to listen for, 63–64
Literal analogy, 174–75
Literary references, 145–46
Locke, John, 97
Loevinger, Lee, 256
Logical-order organization, 204–5
Logical pattern of discussion, 98–104. *See also* Small-group communication

McBurney, James H., 35, 98, 239
McCormick, Anne O'Hare, 345–46
McCoskey, James, 262
Magazines, 145
Main issues in debate, 318, 324
Main points, 200–202. *See also* Organization
Mannerisms, 373
Manuscript reading, 213–15
Material for messages
 analysis of, 149–51
 availability of, 125
 forms of support, 157–84
 sources of
 background knowledge, 138–41
 correspondence, 143–44
 interviewing specialists, 141
 listening to communicators, 144
 listing of, 138
 published speeches, 141–43
 questionnaires, 143–44
 research, 144–47
Mechanism of voice, 291
Memorizing a message, 215–16
Memory, 20
Methods theory, 12–13
Microphone use, 372
Mispronunciation, 307–10
Mizner, Wilson, 53

Momentary interests, 57, 74–75
Monitoring of listeners, 84–85
Monroe, Alan H., 35, 235–36
Mood of listeners, 190
Moss, Sylvia, 250–51
Motivation
 basic motives
 affection, 59
 power, 58
 property, 58
 reputation, 59
 self-preservation, 57–58
 sentiment, 59–60
 taste, 60
 effect of, on listening, 57–60
 of radio and television listeners, 368–69
Movement in delivery, 242–43
Multiple-meaning words, 281
Murray, James, 72

Name calling, 271–72
Narratives, 192–93
Negation, 164
Negative evidence, 327
Negative positions in debate, 319
News magazines, 139
Newspapers, 145
Nichols, Ralph G., 52, 60–61, 62
Nietzsche, Frederick, 396
Nixon, Richard M., 6, 80, 192
Nonverbal communication
 appearance, 249–50
 confusion from signs, 259
 environmental factors, 251–52
 meaning, 239, 255, 286
 message, 7
 physical action, 239–49
 visual signs, 236
 vocal cues, 250–51, 286
Norvell, Ralph, 164
Note-taking
 as aid to listening, 66–67
 plan for, 66–67, 147–49
 research, 147–49
 sources cited, 147–48
 specimen card, 148

Oberholtzer, Ellis P., 325
Objectivity in small groups, 105
Observing speakers, 38–39
Occasion
 analysis of, 71–72, 85–88
 appropriate subjects for, 120–21
 physical conditions of, 87–88
 platform equipment, 88
 purpose of, 86
 rituals of, 86–87

size of audience, 82–83
Open-minded attitude, 152
Opinion evidence, 325–26
Opinions of listeners, 83–84
Oral and written style distinguished, 264–65
Oral communication
 acceptable characteristics of, 27–29
 goals in training, 29–34
 meaning of, 26
Oral evidence, 326–27
Oral style, 277–82. *See also* General semantics; Language
Ordinary evidence, 326–27
Organization
 of after-dinner speech, 366–67
 of body of speech, 199–207
 of central idea, 199–200
 of conclusions, 207–10
 faults in, 31
 goals in, 31
 of ideas, 31
 importance of, 8, 19
 of introduction
 favorable atmosphere, 188–89
 partition, 197–99
 stimulating interest, 191–97
 of main divisions, 200–202
 methods of
 cause to effect, 205
 deductive, 202–3
 effect to cause, 205
 enumeration order, 204
 familiar to unfamiliar, 206
 inductive, 203
 logical order, 204–5
 problem-solution, 203
 simple to complex, 205–6
 time order, 204
 patterns of, 202–6, 216
 principles of, 187–88
 of subpoints, 201–2
 support of points, 206–7
Organs of voice, 291
Original evidence, 327
Outlining
 rules for
 complete sentence, 221
 compound sentences, 221–22
 consistent symbols, 218–19
 heads and subheads, 219
 introduction-body-conclusion, 218
 one symbol per statement, 219–20
 proper indentation, 220–21
 specimen, 222–26
 types of
 complete sentence, 222–24

key word, 225–26
 phrase, 224–25
Overly cautious persons, 96
Oversimplification, 97
Overt action, 241–42

Pace, Wayne, 5
Participating in small groups, 104–7
Partition of message, 197–99
Pattern for discussion, 98–104. *See also* Small-group communication
Patterns of organization, 202–6
Patton, Bobby, 252
Pause in utterance, 304
Personal experiences, 195
Personality characteristics in voice, 290
Person-to-person communication, 5–6
Person-to-persons communication, 6
Persuasive messages
 forms of support in, 157–61
 occasions for, 21
 purposes of, 126–29
Phillips, A. E., 57
Phonation, 295–97
Phonetic symbol chart, 308–9
Phrase outline, 224–25
Phrasing debate propositions, 320–22
Phrasing subjects, 132–34
Physical action
 meaning of, 239–40
 purposes of, 240–41
 types of, 241–47
 eye behavior, 246–47
 facial expression, 246
 gestures, 243–45
 posture, 245–46
 whole body, 242–43
 values of, 241
Physical appearance, 249–50
Pinson, Eliot N., 291
Pitch of voice, 304–5
Platform equipment, 88
Plato, 11–12
Poe, Edgar Allan, 297
Poise, 40–47. *See also* Anxiety
Pope, Alexander, 394
Positive evidence, 327
Posture, 245–46
Potential issues, 322
Practice communicating, 39–40
Preparing for presentation
 extemporaneous method, 217–18
 impromptu method, 216–17
 memory, 215–16
 reading manuscript, 213–15
Presentation, 27–28, 32, 234–38. *See also* Delivery

Presentation message, 352–57
Prima-facie case, 316–17
Primary interests, 56, 74
Principles
 of composition, 187–88
 of delivery, 234–38
 of leadership, 107–13
 of organization, 187–88
Problem-solution organization, 203
Problem-solving groups, 93–95. *See also*
 Small-group communication
Procedures in debate, 316–19. *See also* Debate
Process of communication
 explained, 7–10
 in small groups, 94–98
Professional journals, 146
Pronunciation. *See also* Voice
 acceptable, 306–7
 causes of mispronunciation, 307–10
 diacritic marks, 308–9
 phonetic symbols, 308–9
Proof
 evidence, 324–30
 reasoning, 330–36
Propositions. *See also* Debate
 analysis of, 322–24
 definition of terms, 323–24
 phrasing of, 320–22
 types of, 320
Provocative questions, 191–92
Public communication, 6
Public documents, 146–47
Published speeches, 141–43
Purpose
 in entertaining message, 130–31
 general, 125–31
 in informative message, 129–30
 language, 255
 in persuasive message, 126–29
 selection of, 125–31
 specific, 131–32
 speech training, 29–34

Quality of evidence, 329
Quality of voice, 287–88, 303
Quantity of evidence, 329–30
Questionnaires, 143–44
Questions
 interviewing, 141
 provocative, 191–92
 series of, 192
 small groups, 111–12
 stimulating, 191–92
Quintilian, 12, 35
Quotations
 from authority, 177–82

provocative, 194

Radio message, 367–74
Rapport with listeners, 238
Rate
 of listening, 53
 of speaking, 53
 voice, 303–4
Reactions of sender-receiver, 7, 51, 84–85
Reader's Digest, 133
Reading habits, 138–40
Reading the manuscript, 213–15
Real evidence, 327–28
Real example, 170
Real issues, 322–23
Reasoning
 deductive
 enthymeme, 335
 explanation, 334–35
 sorites, 335–36
 syllogism, 335
 inductive
 analogy, 332–33
 causal relation, 333–34
 generalization, 331–32
 relation to logic, 330
 support, 177–78
Rebuttal
 explanation of, 336
 methods of
 appropriating arguments, 337
 dilemma, 336–37
 inconsistencies, 337
 irrelevant arguments, 337
 reductio ad absurdum, 336
 preparing for, 337–38
Receiver, 7, 9, 51, 71
Reductio ad absurdum, 336
Refutation, 336–38. *See also* Rebuttal
Repetition, 182–83, 268–69
Reputation of speaker, 35–36
Requirements for training, 34–40
Requisites of voice, 287–89
Research. *See also* Materials for messages
 attitudes, 151–53
 sources of
 biographical, 145–46
 dictionaries, 147
 encyclopedias, 145
 government documents, 146–47
 literary references, 145–46
 newspapers and magazines, 145
 professional journals, 146
 source books, 145
Resonation, 297–99
Response to language, 259–60
Restatement, 182–83, 268–69

Results theory, 21–22
Rhetorical principles
 explanation of, 19–20
 of language, 255–56, 264–82
Rhetoricians, 10–13. *See also* Classical rhetoricians
Roberts, Henry G., 173
Rogers, Will, 125–26
Rogers, William P., 189–90
Roosevelt, Franklin D.
 Jefferson Memorial address, 126
 methods theory exemplified, 15–16
 use of repetition, 268
 war message, 13, 15–16, 169–70, 189, 369–70
 warmth of voice, 289
Rosson, Frank, 192–93
Sarett, Alma Johnson, 163, 243
Sarett, Lew, 35, 163, 243
Sartain, A. Q., 346–47
Schell, George, 393–96
Schindler, John A., 133, 163–64
Schlesinger, Arthur, 396
Schurz, Carl, 398
Secondary interests, 56–57, 74
Self-confidence, 40–47. *See also* Anxiety
Self-preservation, 57–58
Semantics. *See* General semantics; Language; Words
Sender, 7–8, 51, 71
Seneca, 35
Sentence outline, 222–24
Shriver, Sargent, 276–77
Simple-to-complex organization, 205–6
Simple words, 265–66
Size of audience, 82–83
Skills in presentation, 27–28, 37
Slang, 269–70
Small-group communication
 explained, 6, 92–94
 leading of
 attitudes, 107–8
 principles, 108–10
 techniques, 110–13
 limitations of
 language, 97–98
 method, 95–96
 participants, 96–97
 participation in
 attitudes on, 104–6
 number of contributions, 106
 quality of contributions, 106–7
 pattern for
 agreement on solution, 103
 analysis of problem, 99–101
 applying solutions, 103–4
 defining problem, 98–99

 possible solutions, 101–3
 process of, 94–95
 purposes of, 93
 relation to debate, 94–95
 size of groups, 93
Smith, Ralph, 246–47
Social background of listeners, 83
Social life development, 141
Solutions in small groups, 101, 103–4
Sophist theory, 10, 21
Sorites, 335–36
Source books, 145
Sources of evidence, 328
Speakers and rhetorical principles, 13–16
Specific instance, 169–71
Specific purpose, 131–32. *See also* Purpose
Specific terms, 265
Speech chain, 291
Speech Monographs, 3
Speed of utterance, 303
Spencer, Henry R., 345–46
Staats, Lorin, 56
Stage fright. *See also* Anxiety
 explained, 40–41
 of outstanding speakers, 45
Standards of communication
 able-man theory, 12
 criteria for, 10, 17–22
 knowledge theory, 11–12
 methods theory, 12–13
 organization, 188
 proper evaluation, 17–18
 rational appeal, 18–19
 rationality of, 18–19
 results of, 21–22
 rhetorical principles of, 19–20
 Sophistic theory, 10
 sources of, 10, 17
 worthy idea, 20–21
Statistics
 accurate use of, 166–68
 effective use of, 168–69
 example of, 166, 168
 meaning of, 165–66
Steps in composition, 227
Stevens, Leonard A., 60–61, 62
Stewart, James G., 350
Stimulating questions, 191–92
Stoddard, Alexander Jerry, 78–79
Student speeches
 analysis of, 381–82
 Clevenger, Theodore, Jr., 389-93
 Ferrell, Dianne, 396–99
 Geren, Paul, 383–85
 Kamin, Lester, 386–89
 reasons for study of, 381–82
 Schell, George, 393–96

Students speeches (*continued*)
 value of study of, 382
Study of famous speakers, 38–39
Style, 19. *See also* Language
Subheads, 219
Subjects
 adapting to time limit, 124
 appropriateness of, 124–25
 choice of, 121–23
 limiting factors, 123–25
 phrasing of, 132–34
 types of, 120–23
Subpoints, 201–2
Summaries, 110, 112–13, 182–83
Summary, 207–8. *See also* Conclusions
Supplementary texts, 142–43
Support of points, 157–83, 206–7. *See also*
 Forms of support
Syllogism, 335
Symbols in language, 257–60
Symbols in outlining, 218–20
Symington, W. Stuart, 130
Synonyms, 280
Syrus, Publius, 36

Tally light, 374
Tarkington, Booth, 130
Technical aspects of broadcasting, 373–74
Technical terms, 266–67
Teleprompter, 371
Television message, 367–74
Tenseness, 40–47. *See also* Anxiety
Testimony
 accurate use of, 178–80
 effective use of, 180–82
 effect of, 178, 181–82
 example of, 178
 meaning of, 177–78
 reasons for, 177–78
 types of, 177–78
Tests of evidence, 328–30
Thinking and speech, 29
Thompson, Dorothy, 126
Time
 and location of talk, 261–62
 spent in communicating, 3, 256
 and voice production, 303–4
Time-limit adaptation, 124
Time-order organization, 204
Tisias, 10
Titles, 119–25. *See also* Subjects
Tongue twisters, 301–2
Topics, 119–25. *See also* Subjects
Total person in delivery, 235–36
Total speaking situation, 236–37
Towne, Neil, 251
Trade journals, 146

Traditional gestures, 244–45
Trite words, 269, 282, 345
Truett, George W., 35
Tubbs, Stewart, 250–51
Two-person communication, 5–6, 92
Types of speeches
 after-dinner, 363–67
 entertaining, 20, 130–31, 363–67
 eulogy, 357–63
 informative, 20–21, 129–30, 157–61
 introduction, 342–47
 persuasive, 21, 126–29, 157–61
 presentation, 352–57
 radio, 367–74
 television, 367–74
 welcome, 347–52

Understanding language, 277–78
University of Texas, 181
Unusual statement, 192

Verbal communication, 7
Visual aids, 88, 165, 371
Visual signs in delivery, 236–37
Vocabulary building
 principal methods of, 278–79
 secondary methods of
 antonyms, 280
 colorful words, 281
 colorless words, 281
 many meanings, 281
 synonyms, 280
 trite-word substitutes, 282
 use of dictionary, 282
Vocal cues, 250–51
Voice
 affected by health, 289–90
 control of, 292
 development of
 articulation, 300–302
 breathing, 292–95
 ear training, 302–3
 phonation, 295–97
 resonation, 297–99
 diagram of mechanism, 291
 exercises for
 articulation, 300–302
 breathing, 294–95
 phonation, 296–97
 resonation, 299
 force of, 305
 mechanism explained, 291
 pitch of, 304–5
 pronunciation in dictionaries, 306–10
 quality, 303
 requisites of
 flexibility, 288–89

free of affectations, 288
intelligibility, 287
pleasing quality, 287–88
variations in
environmental, 290
explanation of, 289
improper use, 291–92
personality characteristics, 290
physical equipment, 289–90
variety
of force, 305
of pitch, 304–5
of quality, 303
of time, 303–4
Vulgarisms, 271

Wallace, George, 26
Wallace, Karl, 238
Washington, Booker T., 78, 170–71, 191
Washington, George, 359–60
Watergate hearings, 25–26
Weaver, Andrew, 258
Weaver, Richard, 92–93
Webb, Thomas, 195
Webster, Daniel, 39, 128, 138

Welcome speech, 347–52
Wellborn, Charles, 191
Wilde, Oscar, 398–99
Wilson, John, 237–38
Wilson, Woodrow, 77
Wise, Claude, 264
Wording subjects, 132–34
Words. *See also* General semantics; Language
connotative meaning, 258
denotative meaning, 258
high-level, 260–61
low-level, 260–61
number of, 256
reaction to, 259–60
related to meaning, 258–60
spoken per minute, 303
symbols, 257–60
Worthy message, 20–21
Wrage, Ernest J., 35, 239
Written evidence, 326–27

Yearbooks, 145
Young, Owen D., 133